*This book is dedicated
to my dear friend, colleague, and
one of Lightroom's guiding lights,
Winston Hendrickson.
You taught us so much, about so much.
We will miss you, always.
1962–2018*

ACKNOWLEDGMENTS

I start the acknowledgments for every book I've ever written the same way—by thanking my amazing wife, Kalebra. If you knew what an incredible woman she is, you'd totally understand why.

This is going to sound silly, but if we go grocery shopping together, and she sends me off to a different aisle to get milk, when I return with the milk and she sees me coming back down the aisle, she gives me the warmest, most wonderful smile. It's not because she's happy that I found the milk; I get that same smile every time I see her, even if we've only been apart for 60 seconds. It's a smile that says, "There's the man I love."

If you got that smile, dozens of times a day, for 29 years of marriage (in September of this year), you'd feel like the luckiest guy in the world, and believe me—I do. To this day, just seeing her puts a song in my heart and makes it skip a beat. When you go through life like this, it makes you one incredibly happy and grateful guy, and I truly am.

So, thank you, my love. Thanks for your kindness, your hugs, your understanding, your advice, your patience, your generosity, and for being such a caring and compassionate mother and wife. I love you.

Secondly, a big thanks to my son, Jordan. I wrote my first book when my wife was pregnant with him (21+ years ago), and he has literally grown up around my writing, so you can imagine how incredibly proud I was when he completed his first book (a 243 page fantasy novel) last year. It has been a blast watching him grow up into such a wonderful young man, with his mother's tender and loving heart, and compassion way beyond his years. As he heads into his senior year of college, he knows that his dad just could not be prouder, or more excited for him. Throughout his life he has touched so many people, in so many different ways, and even though he's still a young man, he's already inspired so many people, and I just cannot wait to see the amazing adventure, and the love and laughter this life has in store for him. Hey, little buddy—this world needs more "yous!"

Thanks to our wonderful daughter, Kira, for being the answer to our prayers, for being such a blessing to your older brother, for being such a strong little girl, and for proving once again that miracles happen every day. You are a little clone of your mother, and believe me, there is no greater compliment I could give you. It is such a blessing to get to see such a happy, hilarious, clever, creative, and just awesome little force of nature running around the house each day—she just has no idea how happy and proud she makes us. She's what happens when a magical unicorn, a leprechaun, and a fairy princess cosmically collide, and the result gets covered in chocolate sprinkles and cherries. It doesn't get much better than that.

A special thanks to my big brother, Jeff. I have so much to be thankful for in my life, and having you as such a positive role model while I was growing up is one thing I'm particularly thankful for. You're the best brother any guy could ever have, and I've said it a million times before, but one more surely wouldn't hurt—I love you, man!

My heartfelt thanks go to my entire team at KelbyOne. I know everybody thinks their team is really special, but this one time—I'm right. I'm so proud to get to work with you all, and I'm still amazed at what you're able to accomplish day in, day out, and I'm constantly impressed with how much passion and pride you put into everything you do.

A warm word of thanks goes to my in-house Editor, Kim Doty. It's her amazing attitude, passion, poise, and attention to detail that has kept me writing books. When you're writing a book like this, sometimes you can really feel like you're all alone, but she really makes me feel that I'm not alone—that we're a team. It often is her encouraging words or helpful ideas that keep me going when I've hit a wall, and I just can't thank her enough. Kim, you are "the best!"

I'm equally as lucky to have the brilliant Jessica Maldonado doing the design of my books. I just love the way Jessica designs, and all the clever little things she adds throughout. She's not just incredibly talented and a joy to work with, she's a very smart designer and thinks five steps ahead in every layout she builds. We hit the jackpot when we found you!

http://kelbyone.com

Also, a big thanks to our copy editor, Cindy Snyder, whom I feel very blessed to have still working with us on these books. Thank you, Cindy!

Thanks to my friend and business partner, Jean A. Kendra, for her support and friendship all these years. You mean a lot to me, to Kalebra, and to our company.

A big thanks to my dear friend, rocket photographer, professor of Tesla studies, unofficial but still official Disney Cruise guide, landscape photography sojourner, and Amazon Prime aficionado, Mr. Erik Kuna. You are one of the reasons I love coming to work each day. You're always uncovering cool things, thinking outside-the-box, and making sure we always do the right thing for the right reasons. Thanks for your friendship, all your hard work, and your invaluable advice.

Thanks to Jeanne Jilleba, my Executive Assistant, for constantly putting my wheels back on the track. I know even finding where I'm at in the building is a challenge, but you just seem to take it all in stride. I'm very grateful to have your help, talent, and immeasurable patience every day.

Thanks to Kleber Stephenson for making sure all sorts of awesome things happen, doors open, and opportunities appear. I particularly enjoy our business trips together where we laugh too much, eat way too much, and have more fun on a business trip than was previously scheduled.

High-five to the crew at Peachpit Press, and to my editor, Laura Norman, for taking over the helm and guiding my books safely to their birth.

Thanks to Rob Sylvan, Serge Ramelli, Matt Kloskowski, Terry White, and all the friends and educators who have helped and supported me on my Lightroom education journey. Thanks to Manny Steigman for always believing in me, and for his support and friendship all these years. Thanks to Gabe, Rebecca, Steve, Joseph, and all the wonderful folks at B&H Photo. It is the greatest camera store in the world, but it's so much more.

Thanks to these friends who had nothing to do with this book, but so much to do with my life, and I just want to give them the literary version of a hug: Jeff Revell, Ted Waitt, Don Page, Juan Alfonso, Moose Peterson, Brandon Heiss, Eric Eggly, Larry Grace, Rob Foldy, Merideth Duffin, Dave Clayton, Victoria Pavlov, Dave Williams, Larry Becker, Peter Treadway, Roberto Pisconti, Fernando Santos, Mike McCaskey, Marvin Derizen, Mike Kubeisy, Maxx Hammond, Michael Benford, Brad Moore, Nancy Davis, Mike Larson, Joe McNally, Annie Cahill, Rick Sammon, Mimo Meidany, Tayloe Harding, Dave Black, John Couch, Greg Rostami, Matt Lange, Barb Cochran, Jack Reznicki, Frank Doorhof, Karl-Franz, Peter Hurley, Kathy Porupski, and Vanelli .

I owe a debt of thanks to some awesome people at Adobe: Jeff Tranberry, who I nominate as the world's most responsive superhero. Lightroom Product Manager, Sharad Mangalick, for all his help, insights, and advice. Tom Hogarty for answering lots of questions and late-night emails, and for always helping me to see the bigger picture. You guys are the best!

Thanks to my friends at Adobe Systems: Bryan Hughes, Terry White, Stephen Nielson, Bryan Lamkin, Julieanne Kost, and Russell Preston Brown. Gone but not forgotten: Barbara Rice, Rye Livingston, Jim Heiser, John Loiacono, Kevin Connor, Deb Whitman, Addy Roff, Cari Gushiken, Karen Gauthier, and Winston Hendrickson, to whom this book is dedicated.

Thanks to my mentors, whose wisdom and whip-cracking have helped me immeasurably, including John Graden, Jack Lee, Dave Gales, Judy Farmer, and Douglas Poole.

Most importantly, I want to thank God, and His Son Jesus Christ, for leading me to the woman of my dreams, for blessing us with two amazing children, for allowing me to make a living doing something I truly love, for always being there when I need Him, for blessing me with a wonderful, fulfilling, and happy life, and such a warm, loving family to share it with.

OTHER BOOKS BY SCOTT KELBY

Photoshop for Lightroom Users

Professional Portrait Retouching Techniques for Photographers Using Photoshop

The Digital Photography Book, parts 1, 2, 3, 4 & 5

Light It, Shoot It, Retouch It: Learn Step by Step How to Go from Empty Studio to Finished Image

The Adobe Photoshop CC Book for Digital Photographers

The Photoshop Elements Book for Digital Photographers

The iPhone Book

Professional Sports Photography Workflow

Photo Recipes Live: Behind the Scenes: Your Guide to Today's Most Popular Lighting Techniques, parts 1 & 2

It's a Jesus Thing: The Book for Wanna Be-lievers

ABOUT THE AUTHOR

Scott Kelby

Scott is Editor and Publisher of *Lightroom Magazine*; producer of LightroomKillerTips.com, Editor and co-founder of *Photoshop User* magazine; host of *The Grid*, the influential, live, weekly talk show for photographers; and is founder of the annual Scott Kelby's Worldwide Photo Walk.™

He is President and CEO of KelbyOne, an online educational community for learning Lightroom, Photoshop, and photography.

Scott is a photographer, designer, and award-winning author of more than 90 books, including *Light It, Shoot It, Retouch It: Learn Step by Step How to Go from Empty Studio to Finished Image*; *The Adobe Photoshop Book for Digital Photographers*; *Professional Portrait Retouching Techniques for Photographers Using Photoshop*; *How Do I Do That In Lightroom?*; and *The Digital Photography Book* series. The first book in this series, *The Digital Photography Book*, part 1, has become the top-selling book on digital photography in history.

For six years in a row, Scott has been honored with the distinction of being the world's #1 best-selling author of photography techniques books. His books have been translated into dozens of different languages, including Chinese, Russian, Spanish, Korean, Polish, Taiwanese, French, German, Italian, Japanese, Hebrew, Dutch, Swedish, Turkish, and Portuguese, among many others. He is recipient of the prestigious ASP International Award, presented annually by the American Society of Photographers for "…contributions in a special or significant way to the ideals of Professional Photography as an art and a science," and the HIPA Special Award presented for his worldwide contributions to photography education.

Scott is Conference Technical Chair for the annual Photoshop World Conference and a frequent speaker at conferences and trade shows around the world. He is featured in a series of online learning courses at KelbyOne.com and has been training Photoshop users and photographers since 1993.

For more information on Scott, visit him at:

His daily Lightroom blog: **lightroomkillertips.com**

His personal blog: **scottkelby.com**

Twitter: **@scottkelby**

Facebook: **facebook.com/skelby**

Instagram: **@scottkelby**

Google+: **+ScottKelby**

TABLE OF CONTENTS

CHAPTER 1 1

▼ IMPORTING
GETTING YOUR PHOTOS INTO LIGHTROOM

First: Move All Your Photos onto One External Hard Drive . . . 2

What to Do When You See a Question Mark on
Your Photos Folder 3

You Need a Second Backup Hard Drive 4

And You Need a Cloud Backup, Too 5

Get Your Photos Organized FIRST, Before You
Launch Lightroom 6

Importing Photos Already On Your Hard Drive10

Choosing How Fast Your Photos Appear11

Importing from Your Camera (Easy Method)13

Importing from Your Camera (Advanced Users)15

Using Lightroom with a Laptop? You'll Love
Smart Previews .19

Save Time Importing Using Import Presets
(and a Compact View)20

Choosing Your Preferences for Importing Photos21

Converting RAW Photos to the Adobe DNG Format24

Four Things You'll Want to Know Now About
Getting Around Lightroom25

Viewing Your Imported Photos27

The Two Flavors of Full-Screen View29

CHAPTER 2 31

▼ GETTING ORGANIZED
MY SYSTEM FOR A HAPPY LIGHTROOM LIFE

Four Important Things to Know First!32

Want a Happy Lightroom Life? Use Just One Catalog34

Where to Store Your Catalog36

How to Make a Collection from a Folder37

Organizing Photos Already On Your Hard Drive38

Why You Need to Use Pick Flags Instead of Star Ratings40

Organizing Photos You're Importing from Your Camera42

Two Tools to Help You Find Your Best Shots:
Survey and Compare View48

Smart Collections: Your Organizational Assistant50

Reducing Clutter Inside Your Collections by Using Stacks . . .52

Adding Keywords (Search Terms)54

Face Tagging to Find People Fast58

Renaming Your Photos62

Finding Photos Using a Simple Search63

Lightroom is Automatically Organizing Your
Images on a Map .65

Map Organizing Even If Your Camera Doesn't Have GPS66

Making Collections from Locations on the Map68

Dealing with "The File Could Not Be Found" Message69

Lightroom Is Automatically Organizing Your Photos
by Date Behind the Scenes71

Backing Up Your Catalog (This Is VERY Important)74

CHAPTER 3 77

▼ ADVANCED STUFF
THAT NEXT LEVEL OF IMPORTING & ORGANIZING

Shooting Tethered (Go Straight from Your Camera,
Right Into Lightroom)78

Using Image Overlay to See If Your Images Fit Your Layout . . .82

Creating Your Own Custom File Naming Templates86

Creating Your Own Custom Metadata (Copyright) Templates .90

Using Lights Dim, Lights Out, and Other Viewing Modes92

Using Guides and Grid Overlays94

When to Use a Quick Collection Instead95

http://kelbyone.com

Using Target Collections (and Why They're So Handy)97

Adding Copyright Info, Captions, and Other Metadata99

From Laptop to Desktop: Syncing Catalogs on
Two Computers. 102

Dealing with Disasters (Troubleshooting) 105

CHAPTER 4 **109**

▼ CUSTOMIZING
HOW TO SET THINGS UP YOUR WAY

Choosing What You See in Loupe View. 110

Choosing What You See in Grid View 112

Make Working with Panels Faster & Easier 116

Using Two Monitors with Lightroom 117

Choosing What the Filmstrip Displays 121

Adding Your Studio's Name or Logo for a Custom Look . . . 122

CHAPTER 5 **127**

▼ EDITING YOUR IMAGES
HOW TO TWEAK YOUR IMAGES LIKE A PRO!

My Lightroom Editing Cheat Sheet 128

If You Shoot in RAW, You Need to Start Here 130

Setting the White Balance 135

Setting Your White Balance Live While Shooting Tethered . . 139

Seeing a Before and After 141

Want to Copy a Particular Look? Reference View Can Help . . 142

Auto Tone (It's Finally Actually Really Kinda Pretty Good). . . 143

Expanding Your Tonal Range by Setting Your
White and Black Points 144

Controlling Overall Brightness (Exposure) 146

My Power Trio: Combining Whites + Blacks + Exposure . . . 147

Adding Contrast (Important Stuff!) 148

Dealing With Highlight Problems (Clipping) 149

Fixing Backlit Photos and Opening Up Dark Areas 151

Clarity: Lightroom's Detail Enhancer 152

Making Your Colors More Vibrant 153

Removing Haze. 154

Automatically Matching Exposures 158

Putting It All Together (Here's the Order
I Use for My Own Editing). 159

CHAPTER 6 **163**

▼ PAINTING WITH LIGHT
THE ADJUSTMENT BRUSH & OTHER TOOLBOX TOOLS

Adjusting Individual Areas (Dodging & Burning) 164

Five More Things You Should Know About Lightroom's
Adjustment Brush 170

Selectively Fixing White Balance, Dark Shadows,
and Noise Issues 171

Retouching Portraits 173

Richer Skies Using the Graduated Filter. 177

Making Tricky Adjustments Easily Using Color
and Luminance Masking 180

Spotlight Effects (and Off-Center Vignettes)
Using the Radial Filter 185

CHAPTER 7 **189**

▼ SPECIAL EFFECTS
MAKING STUFF LOOK...WELL...SPECIAL!

Applying Filter-Like "Looks" Using Creative Profiles 190

Virtual Copies—The "No Risk" Way to Experiment 192

Changing Individual Colors. 194

TABLE OF CONTENTS

How to Add Vignette Effects 196

Getting That Trendy High-Contrast Look 199

Creating Black-and-White Images 202

Making Great Duotones 206

Creating a Matte Look 207

Using One-Click Presets (and Making Your Own!). 208

Sun Flare Effect. 213

Cross-Processing Fashion Look 215

Creating Panoramas 217

Adding Beams of Light 220

Creating HDR Images. 224

Making Streets Look Wet 228

CHAPTER 8 **231**

▼ **PROBLEM PHOTOS**
DEALING WITH COMMON IMAGE PROBLEMS

Fixing Backlit Photos 232

Reducing Noise. 234

Undoing Anything (or Everything!) 237

Cropping Photos 239

Lights Out Cropping Rocks!. 242

Straightening Crooked Photos 243

Removing Stuff with the Spot Removal Tool 245

Finding Spots and Specks the Easy Way 248

Removing Red Eye 251

Automatically Fixing Lens Distortion Problems. 252

Fixing Lens Problems Yourself Using Guided Upright. 256

Fixing Edge Vignetting 259

Sharpening Your Photos 262

Fixing Chromatic Aberrations (a.k.a. That
Annoying Color Fringe). 266

Basic Camera Calibration in Lightroom 268

CHAPTER 9 **271**

▼ **EXPORTING IMAGES**
SAVING JPEGS, TIFFS, AND MORE

Saving Your Photos as JPEGs 272

Adding a Watermark to Your Images 280

Emailing Photos from Lightroom 284

Exporting Your Original RAW Photo 286

Publish Your Images with Just Two Clicks. 288

CHAPTER 10 **295**

▼ **LR WITH PHOTOSHOP**
HOW AND WHEN TO USE PHOTOSHOP

Choosing How Your Files Are Sent to Photoshop 296

How to Jump Over to Photoshop, and How to Jump Back . . 297

Keeping Your Photoshop Layers Intact 303

Adding Photoshop Automation to Your
Lightroom Workflow 304

CHAPTER 11 **313**

▼ **PHOTO BOOKS**
CREATING BEAUTIFUL BOOKS WITH YOUR IMAGES

Before You Make Your First Book 314

Making Your First Book In Just 10 Minutes 316

Using Auto Layout to Automate Your
Layout Process 322

Making Your Own Custom Pages 326

Adding Text and Captions to Your Photo Book 328

Adding and Customizing Page Numbers 332

Four Things You'll Want to Know About
Layout Templates. 334

Customizing Your Backgrounds 336

Helping with Layouts and Printing
Outside of Blurb 338

http://kelbyone.com

Creating Cover Text. 339

Custom Template Workaround 342

CHAPTER 12 **345**

▼ PRINTING
UNLOCKING THE POWER OF THE PRINT

Printing Individual Photos 346

Creating Multi-Photo Contact Sheets. 350

Creating Custom Layouts Any Way You Want Them 358

Adding Text to Your Print Layouts 362

Printing Multiple Photos on One Page 364

Saving Your Custom Layouts as Templates 369

Having Lightroom Remember Your Printing Layouts 370

Creating Backscreened Prints. 371

The Final Print & Color Management Settings 374

Saving Your Layout as a JPEG (for Photo Lab Printing) 384

Adding Custom Borders to Your Prints 387

CHAPTER 13 **391**

▼ VIDEO
WORKING WITH VIDEO SHOT WITH YOUR CAMERA

Trimming Your Video Clips 392

Choosing the Thumbnail for Your Video Clip 394

Pulling a Photo from Your Video Clip 395

Editing Your Video Clip (the Easy, but More Limited, Way) . . 396

Serious Video Clip Editing (Using Lots of Goodies!) 397

Let's Make a Short Movie (and Even Save It in HD Quality)! . . 399

CHAPTER 14 **405**

▼ GOING MOBILE
USING LIGHTROOM ON YOUR PHONE/TABLET & MORE

Four Really Cool Things About Lightroom CC
on Your Mobile Device 406

Setting Up Lightroom on Your Mobile Device 408

How to Sync Collections over to Lightroom CC (Mobile) . . . 409

Working with Your Albums 410

Adding Pick Flags and Ratings to Photos 414

Editing Your Images on Mobile 416

Cropping & Rotating 424

Sharing Your Lightroom Albums on the Web. 426

Sharing a Live Shoot to a Phone, Tablet, or the Web 430

Lightroom Mobile's Advanced Search 432

The Built-in Camera (It's Pretty Sweet!) 434

The Desktop Version of Lightroom Mobile is Lightroom CC . 438

CHAPTER 15 **441**

▼ MY WORKFLOW
HERE'S MY TYPICAL START-TO-FINISH PROJECT

It Starts with the Shoot 442

Workflow Step One: Importing Your Images 443

Workflow Step Two: Sorting Your Images. 444

Workflow Step Three: Editing Your Selects 448

Workflow Step Four: Getting Client Feedback 454

Workflow Step Five: Printing the Image 456

Other Ways You Can Continue Learning with Me. 458

Index . 460

Seven (or So) Things You'll Wish You Had Known Before Reading This Book

I really want to make sure you get the absolute most out of reading this book, and if you take two minutes and read these seven (or so) things now, I promise it will make a big difference in your success with Lightroom Classic, and with this book, in general (plus, it will keep you from sending me an email asking something that everyone who skips this part will wind up doing). By the way, the captures shown here are just so there's not big, blank spaces—they're essentially for looks (hey, we're photographers—how things look, matters).

(1) This book is for Lightroom Classic users (the version of Lightroom that has been around for 11 years now—the one we all know and love). If your Lightroom looks like the one you see here, you're in the right place. If your Lightroom doesn't look like this (you don't see Library, Develop, Map, etc., across the top like you see here), you're using a different version of Lightroom that is based on storing your images in the cloud, and its name is Lightroom CC. While we do take a quick look at it toward the end of the book, this book does not cover this cloud-storage version. You are still welcome to stay and look at the pictures, though.

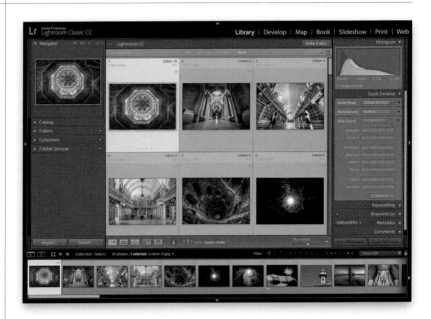

(2) You can download many of the key photos used here in the book, so you can follow along using many of the same images that I used, at **http://kelbyone .com/books/lrclassic7**. See, this is one of those things I was talking about that you'd miss if you skipped over this and jumped right to Chapter 1. Then you'd send me an angry email about how I didn't tell you where to download the photos. You wouldn't be the first.

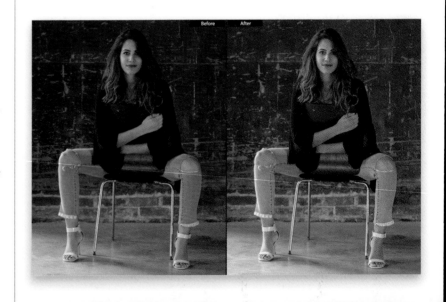

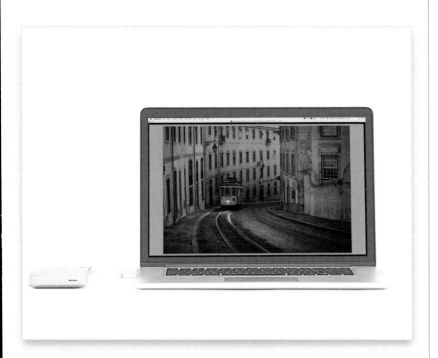

(3) If you've read my other books, you know they're usually "jump in anywhere" books, but with Lightroom, I wrote the book in the order you'll probably wind up using the program, so if you're new to Lightroom, I would really recommend you start with Chapter 1 and go through the book in order. But hey—it's your book—if you decide to just hollow out the insides and store your valuables in there, I'll never know. Also, make sure you read the opening to each project, up at the top of the page. Those actually have information you'll want to know, so don't skip over them.

(4) The official name of the software is "Adobe Photoshop Lightroom Classic CC" because it's part of the Photoshop family, and part of Adobe's Creative Cloud offering, but if every time I referred to it throughout the book, I called it "Adobe Photoshop Lightroom Classic CC," you would eventually want to strangle me (or the person sitting nearest you). So, from here on out, I usually just refer to it as "Lightroom" or "Lightroom Classic."

(5) Warning: The intro page at the beginning of each chapter is designed to give you a quick mental break, and honestly, they have little to do with the chapter. In fact, they have little to do with anything, but writing these quirky chapter intros is kind of a tradition of mine (I do this in all my books, and I even released a book of just the best chapter intros from all of my books. I am not making this up). But, if you're one of those really "serious" types, you can skip them, because they'll just get on your nerves. The rest of the book is normal, but that one single page, at the beginning of each chapter, well…it's not normal. Just so ya know.

Continued

(6) At the end of the book is a special bonus chapter, where I share my own start-to-finish workflow. However, don't read it until you've read the entire book first, or you might not know how to do certain things that I'll be telling you to do (that's why I put it at the end of the book).

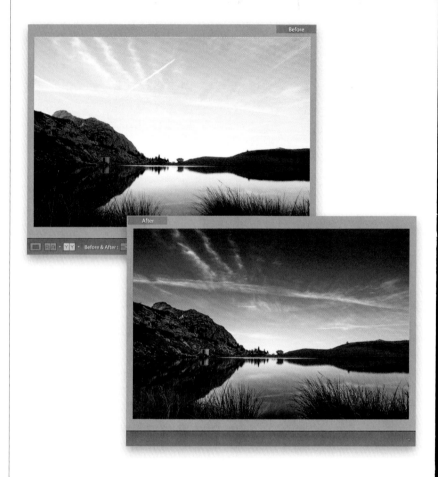

(7) Where are the chapters on the Web module and the Slideshow module? They're on the web (you'll find them at the address in #7.2). I put them there because Adobe has…well…I think they've kind of abandoned them (not officially mind you, but come on—they haven't really added any new features in the past four versions, so I can't [with a straight face] recommend that you use them at all). Though, I do have one really good use for the Slideshow module, and I put that in the Video chapter. But, just in case, I still posted those chapters on the web, so just think of them as bonus chapters you won't ever read for features you won't ever use.

(7.1) Who's up for some cool, free Lightroom presets? I think you've earned 'em (well, at least you will have by the time you finish this book). Now, if you're a brand-new user and you're not sure what presets are yet, they are basically "one-click wonders" that make your photos look awesome. There's a huge market for presets and people sell presets like these all day long (for bunches of money). But, because I dig you with the passion of a thousand burning suns (or because you bought this book—I'll let you decide which reason fits you best), I'm giving you a whole bunch of them we created here in-house. Anyway, the link to them, and samples of how they look, are found on the downloads page (mentioned below in #7.2). See, I care.

(7.2) I created a couple bonus videos for you. One shows you how to get started by moving all your images onto an external hard drive (which you'll learn about in Chapter 1), and the other shows you how to create a custom border in Photoshop that you can add to your prints (you'll learn how to do this in Chapter 12). You can find these at **http://kelbyone .com/books/lrclassic7**. Okay, now turn the page and let's get to work.

IMPORTING
getting your photos into Lightroom

Before you read even one word of this intro, it is absolutely imperative that you pause for a moment (hit the pause button; it's the one with two vertical lines on it), go back to page xiii, and carefully re-read #5 in "Seven (or So) Things You'll Wish You Had Known Before Reading This Book." The reason this is so important (it's a sad story, really) is that in the previous edition of this book, there was a reader who just kind of skimmed that section (I believe he was from Canterbury, England, quite near the birthplace of Austin D. Powers), so he had no warning for what he was getting into with my chapter intros. Anyway, he assumed the rest of the book was like this, and…well, quite frankly, it drove him mad. Mad, I tell you! He would dress each day in nothing but aluminum foil and he began selling goldfish sandwiches on the street. At some point, it was clear to everyone around him that he would have no choice but to run for political office. After

a narrow victory, he was sworn into office on a blustery November day back in 2015 (it was a Tuesday, if I remember correctly). He stood nobly on the steps of the courthouse, wind rippling through his foil gown, and he swore an oath to bear true allegiance to Her Majesty Queen Histogram, Her Heirs and Successors, according to law. He pledged to import his images into Lightroom in such a manner as to bring great honor and prestige to the sovereign base areas of Loupe View and the Keyword Islands. However, after being in office for just five months, a press conference was hastily called after rumors surfaced of missing image warnings and a corrupt catalog. When asked by *The Guardian* Senior Political Editor Simon Jollybotum if the rumors were true, he looked Simon dead in the eye and said, "Hashtag Fakenews, Hashtag Sad," and shouted at Simon to get off his lawn. You can't make this stuff up, kids.

First: Move All Your Photos onto One External Hard Drive

Before you dive into Lightroom, in fact, before you even launch it, to have a happy Lightroom life, start by setting up an external hard drive to hold all your photos (don't use the one in your computer—it will be full before you know it). This step is more important than it sounds, and it will save you loads of frustration down the road (and that road always gets here sooner than you'd think). The good news is, external hard drives have never been cheaper than they are today (I recently saw a 4-terabyte WD external hard drive for just $88, which is just incredible for that much storage).

Make That Move:

Okay, now that you've got your external hard drive connected to your computer, you are going to *move all* your photos onto that one, single, external hard drive. All of them. So, gather all your photos—from old CDs and DVDs, and other older portable drives—and put them all on this one external hard drive. Also, make sure you move them (don't just copy them—move them) from your computer onto your external hard drive (once you've verified that they're on your external hard drive, you can delete the copies still on your computer—you only want to be working with the images on that external hard drive). Getting these all together in one place takes a little doing (I made a short video that will help if you're stuck on how to do this—it's on the book's companion webpage; see page xv for the link). Besides the sheer peace-of-mind of finally having all your images in one, single, easy-to-back-up place, the good news is people have told me time and time again that doing this turned out to be much easier and faster than they thought it would be. TIP: When you buy your external hard drive, buy one that's way larger than you think you'll need (at least 4 terabytes minimum). Anyway, whichever external storage unit you choose, it will fill up faster than you ever imagined, thanks to today's crazy-high-megapixel cameras that have become standard (and they're only getting larger going forward). But, for now, go gather all your portable hard drives, CDs, and DVDs, and let's bring them all together onto this one external hard drive.

That question mark on a folder in Lightroom's Folders panel just means that when you moved your folders of photos off your computer and onto that external hard drive, Lightroom doesn't know where they are anymore. No biggie—you just have to tell Lightroom where you moved 'em, and it will relink the photos automatically. If you're an advanced Lightroom user, and you're switching to this organization system I'm teaching here in the book, you might be able to get around this whole question mark thing altogether (read on for how to get around it).

What to Do When You See a Question Mark on Your Photos Folder

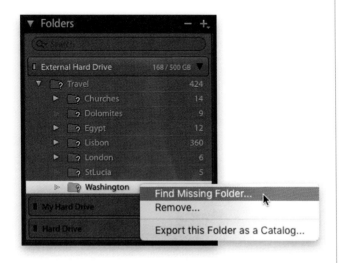

How to Tell Lightroom Where You Moved Your Folders:

After you've moved your images from your computer over onto that external hard drive, if you look over in the Library module's Folders panel, you'll see a bunch of grayed-out folders with question marks on them. That just means that Lightroom no longer knows where those original images are. The fix? Just tell Lightroom where you moved 'em—Right-click on any folder with a question mark, and from the pop-up menu, choose **Find Missing Folder** (as shown here). This brings up the standard Open dialog, so just navigate your way to your external hard drive, find the missing folder, and click the Choose button. That's it—Lightroom knows where they are now and it's business as usual.

Advanced Lightroom Users:

If you're really comfortable working in the Folders panel, instead of dragging the folders from your computer onto your external hard drive, go ahead and do it from right within the Folders panel itself. When you make the move within this panel, since you're moving them using Lightroom, it knows where you moved them, and you don't have to do any relinking. *Note:* If you plug in a new, empty, external hard drive, Lightroom won't recognize it (the drive won't appear in the Folders panel), so click the + (plus sign) button on the right side of the Folders panel header, navigate to the new external hard drive, and make a new empty folder on the drive. Now that drive will appear in the Folders panel and you can drag-and-drop your folders directly onto that external drive.

You Need a Second Backup Hard Drive

It's good that external hard drives are so cheap, because you're going to need *two* of them. Why two? Because all hard drives eventually crash and die (sometimes on their own, or we knock them over, or lightning strikes, or the dog pulls it off your desk by accident). It's not just hard drives that die—every media storage unit goes bad at some point (CDs, DVDs, portable drives, optical drives, you name it), and you're going to need a backup when yours goes to the place where hard drives go to die (the most prevalent theory is that they go to Cleveland, since that's where promising quarterbacks go to die. Sorry, somebody had to say it).

It Has to Be a Totally Separate Drive:

Your backup has to be a totally indepen-dent external hard drive from your main external hard drive—not just a partition or another folder on the same external hard drive. I talk to photographers who use partitions not realizing that, when your hard drive dies, both your main folder of photos and your backup folder on the partition will both die at the same time. The result is the same—all your images are probably lost forever.

Where to Keep Your External Hard Drives:

Not only do you need two separate drives, but, ideally, they would be kept in *two* separate locations. For example, I keep one at home and the other at the office, and about once a month I bring the one from home to the office and sync 'em up, so they have all the stuff I've added in the past month. By keeping them in two separate places, if a fire strikes or there's a break-in, or a flood, or a tornado, I still have a backup drive at a different location. Also, this is the reason why you can't use your computer as a backup (what if it dies in a flood or fire or is stolen?), and you cannot put your backup drive right there on your desk next to your main external hard drive (for the same reasons).

©ADOBESTOCK/DRUMCHEG

Oh, come on, this is overkill!!! Really, three backups? Yup. You've gotta have a cloud backup—ask anybody that experienced the epic floods in Houston or Hurricane Katrina or any of the myriad of natural disasters these past few years where people lost all their photos. We're talking about the visual history of your life here—irreplaceable photos, along with client images, and family photos, and stuff you just can't put a price on. This third leg of protection has never been more important. You don't have to do it, but you'll sure sleep better if you do.

And You Need a Cloud Backup, Too

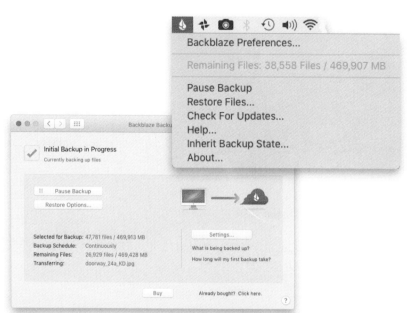

Why You Should Add a Cloud Backup, Too:

If a natural disaster (hurricane, major flood, etc.) hits your area, you could lose both your photo drives, even though they're in different locations. That's why I recommend having a cloud-based backup, as well (ask folks who have survived major hurricanes, but still lost everything). I use Backblaze.com as my cloud backup for one simple reason: it's only $5 per month for (get this) unlimited storage! It works in the background and automatically backs up your external hard drive to the cloud.

Don't Look at the Upload Progress:

The thing about Backblaze (or any cloud-based backup) is that you have to copy your entire photo library up to the cloud—terabytes of images, most likely—and that takes time. How much time? I'd say, for most folks, a month at the quickest, but probably six weeks to two months for serious photographers, and perhaps longer for working pros. The upload speed for most Internet connections is a fraction of the download speed, so I recommend that you don't even look at the upload progress for at least a month, or you'll be like "It's only 6%! Arg#%$&!" Save yourself the aggravation—tell it to back up your external hard drive, and then just go about your life. In six weeks from now, you can have your photo library fully backed up in the cloud...or not—the time is going to pass either way.

Get Your Photos Organized FIRST, Before You Launch Lightroom

I talk to photographers almost every day who are somewhat or totally confused about where their photos are located. They're frustrated and feel disorganized and all that has nothing to do with Lightroom. However, if you get organized first (I'm about to share a really simple way to do this), before you start using Lightroom, it will make your Lightroom life sooooooo much easier. Plus, not only will you know exactly where your photos are, you'll be able to tell someone else their exact location, even when you're not in front of your computer.

Step One:

Go to your external hard drive (see page 2) and, on that drive, create a single new folder. This is your main photo library folder and creating this one folder, and putting all your images (old ones you've taken in years past and new ones you're about to take) inside this one folder is the key to staying fully organized before you ever even get to the Lightroom part of this. By the way, I name this one all-important folder "Lightroom Photos," but you can name yours anything you like. Whatever you name it, just know this is the new home for your entire photographic library. Also know that when you need to back up your entire library, you only have to back up this one folder. Pretty sweet already, right?

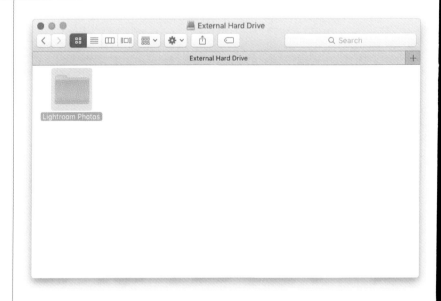

Step Two:

Inside that folder, you're going to create more folders and name them with topics of things you shoot. For example, I have nine separate folders: Architecture, Automotive, Aviation, Family, Landscapes, Misc, People, Sports, and Travel—all separate folders within my Lightroom Photos folder. Now, since I shoot a lot of different sports, inside my Sports folder, I have created separate folders for football, baseball, motorsports, basketball, hockey, and other sports. You don't have to do that last part; I just do it because, again, I shoot a lot of different sports and that makes it easier to find stuff when I'm not in Lightroom.

Step Three:

Now, you probably have lots of folders full of photos on your computer already. Your job (this is easier than it sounds) is to drag those folders from your computer onto your external hard drive, directly into the topic folder that matches what they are. So, if you have a folder with photos from your trip to Hawaii, drag that folder into your Lightroom Photos folder, and into the Travel folder. By the way, if your folder of Hawaii vacation images isn't named something really easy, like "Maui Trip," now would be the time to rename it. The simpler and more descriptive your folder names, the better. Let's continue: If you shot your daughter's softball championship game, drag that folder into your Lightroom Photos folder, and into the Sports folder. Now, you might decide, since the photos are of your daughter, to instead put them in your Family folder. No problem, that's your choice, but if you choose your Family folder, then from now on, all your kid's sports should go in that Family folder—not some in Sports and some in Family. Consistency is key.

Step Four:

So, how long will it take to move all these images from your hard drive into the right folders? Not as long as you'd think. A few hours tops in most cases. What does this accomplish? Well, for starters, you'll know exactly where every photo you've taken is, without even being in front of your computer. For example, if I asked you, "Where are your photos from your trip to Italy?" You would already know they were in your Lightroom Photos folder, in your Travel folder, in a folder called "Italy." If you went to Italy more than once, maybe you'd see three folders there—Italy Winter 2015, Italy Spring 2016, and Italy Christmas 2017—and I'd be totally jealous that you got to go to Italy three times, so I probably wouldn't ask you this question in the first place. But, if I did, at least you'd know the answer. But there's more.

Continued

Step Five:

There's a trap you might be tempted to fall into that I want to save you from, and that trap is organizing folders by date. It's a trap because it really relies on you remembering when you did…well…everything. Besides, Lightroom is already keeping track of the exact time and date (even the day of the week) that every single photo in your library was taken (it does this by looking at the camera info embedded by your camera when you took the shot). So, if you ever have the urge to see your photos organized by date, press the **\ [backslash] key** to bring up the Library Filter bar across the top of Lightroom's Grid view, then click on Metadata, and in the first column, choose **Date** from the pop-up menu. Now, click on any year, then on a month, to see just the photos taken on an exact date. It's already doing the date stuff for you, so you don't have to.

Step Six:

Now, if you shoot a lot of landscape photos, and I asked, "Where are your shots from Yosemite?" You'd say, "On my external hard drive, in my Lightroom Photos folder, inside my Landscapes folder." End of story. That's where they are, and your computer can put them in alphabetical order, making them even easier to find. How easy is that? As long as you use simple, descriptive names for all your shoot folders, like "Acadia National Park" or "Rome" or "Family Reunion 2016," you're in a happy place. Yes, it can be that easy. Just spend a little time now (again, probably not more than a few hours) dragging all your images into their proper topic folders, and you'll reap the glorious benefits forever (they're not actually glorious, but it's such an awesome adjective, and one I don't get to use often, so I exercised some artistic writer's license there).

Step Seven:

What if you're importing new images from your camera's memory card? You do the same thing: you'll copy them from the card directly into the right topic folder, and then inside that topic folder, you'd create a new folder for these images with a simple name describing the shoot. So, let's say you took photos at a KISS and Def Leppard concert (awesome show, by the way). They would go onto your external hard drive, inside your Lightroom Photos folder, inside your Concerts folder, and inside your Kiss_Def Leppard folder. (*Note:* If you're an event photographer, you might need a topic folder called "Events," with a bunch of other subfolders inside, like Concerts, Celebrities, Award Shows, and Political Events, to stay organized.)

Step Eight:

Another example: if you're a wedding photographer, you'd have a Weddings folder, and inside that you'd see other folders with simple names like Johnson_Anderson Wedding and Smith_Robins Wedding and so on. That way, if Mrs. Garcia calls and says, "I need another print from our wedding," you'd know exactly where their photos are: inside your Lightroom Photos folder, inside Weddings, inside the Garcia_Jones Wedding folder! Couldn't be easier (well, it actually can be easier, in Lightroom, but that comes later because you do all this organizing before you ever even launch Lightroom). This simple organization of your photo library is the secret. Now, while we're passing on secrets, here's the secret to a happy marriage. It's simple, but it works. The secret is… (wait for it, wait for it…) separate bathrooms. There. I said it. Two secrets, both in one book. Whodathunkit?

Importing Photos Already On Your Hard Drive

One of the most important concepts to understand about Lightroom is this: while Adobe calls this process "Importing," it doesn't actually move or copy images *into* Lightroom. Your images never move—they're still right on your external hard drive. Lightroom is just "managing" them now. It's like you told Lightroom, "See those images on my external drive? Manage those for me." Of course, they would be impossible to manage if you couldn't see them, so Lightroom creates thumbnail previews of the images and that's what you're seeing in Lightroom. Your actual images never actually move or get copied "into" Lightroom.

Step One:

First, make sure you read that intro above—it's the most important thing to understand—before you start to import your photos. Luckily, importing images into Lightroom is about the easiest thing in the world. Go to your external hard drive and simply drag-and-drop the folder of images you want to import directly onto Lightroom's icon (in your Dock on a Mac, or on your desktop on a PC). This brings up Lightroom's Import window (seen here). It assumes you want all the images imported, that's why there's a checkbox next to every one. If there's a photo you don't want imported, click on its checkbox to uncheck it, and it won't get imported. To see any image larger, double-click on it. To return to the regular thumbnail grid view, double-click again or press the letter **G** on your keyboard. If you want to see all these thumbnails larger, drag the Thumbnails slider (at the bottom) to the right.

Step Two:

All you have to do at this point is simply make sure Add is selected at the top of the window, then click the Import button at the bottom right (yes, for now, ignore all the buttons and knobs and stuff), and your images will appear in Lightroom. Pretty simple. There are a few options you can tweak (we'll get to those shortly), but that's really all there is to doing a simple import and having Lightroom manage those images for you.

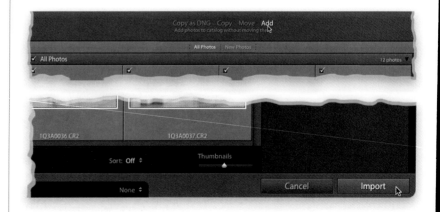

Lightroom builds image previews in different sizes: thumbnail, standard screen size, and 100% (called 1:1 in Lightroom speak). The larger the preview size, the longer it takes Lightroom to render it when you first import. Luckily, you can choose how fast these are displayed based on your personal level of patience. I have the patience of a hamster, so I want it to show me my thumbnails *now* (but, there's a price to pay for this speed)! You'll need to find which preview method suits your personality.

Choosing How Fast Your Photos Appear

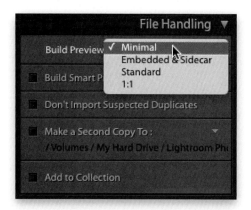

Choose from one of these:
At the top right of the Import window, in the File Handling panel, from the Build Previews pop-up menu, you get four choices for how fast your image previews (your thumbnails and sizes larger than just thumbnails) will appear when you zoom in on a photo in Lightroom. We'll go from the fastest to slowest:

(1) Minimal (for Very Fast Thumbnails)
If you shoot in RAW and choose this, Lightroom grabs the smallest JPEG preview it can from the one the camera manufacturer includes within the RAW image (the same JPEG preview you see on the back of your camera when you shoot in RAW). It uses that as your thumbnail and it appears super-fast! (*Note:* This is the option I always choose.) These super-fast Minimal previews are not the most color-accurate, so you're definitely trading color accuracy for speed. If you have to zoom in on a photo, that's pretty quick, too, as long as the camera manufacturer included a decent-sized preview with their RAW image. If they didn't, Lightroom will create those larger previews (you just have to wait a few seconds longer for them to appear). *Note:* If you shoot in JPEG, your thumbnails will appear quickly anyway—zooming in is quick too, and the color will be fairly accurate. Score two-points for JPEG!

TIP: Rendering Larger Previews
If you want larger, higher-quality previews for any embedded previews, just click on the little, black, double-arrow icon in the top left of the thumbnail in Grid view.

Continued

(2) Embedded & Sidecar

Choose Embedded & Sidecar to get the largest previews created by your camera. It puts thumbnails in Lightroom fairly quickly, and if you double-click to zoom in, you'll wait while it builds the larger preview before you can see it (you'll see a message onscreen that says "Loading"). If you zoom in even closer, you'll have to wait a few moments more (the message will read "Loading" again). That's because it doesn't create these larger, higher-quality previews until you try to zoom in.

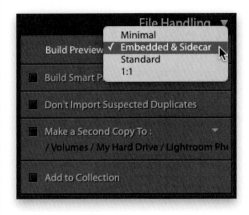

(3) Standard

Choosing the Standard preview means you're willing a wait a bit, until all the standard-sized previews are rendered, so when you double-click on images later, you won't get any of those "Loading" messages. Standard previews are what you see when you double-click on a thumbnail, or you take the image over to the Develop module. You'll still see the thumbnails appear, but wait until you see the progress bar up in the top-left corner show that all the previews are rendered before you start looking at your images at that larger size. However, if you zoom in even closer, to a 1:1 view probably, you'll have to wait a few seconds more while that 1:1 preview renders.

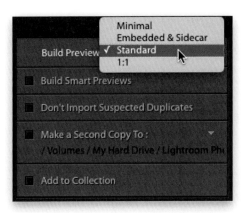

(4) 1:1 (Full 100% Size)

You choose this size if you never want to see a "Loading" message ever—you want crisp, super-large previews available anytime, and you're a very patient person. Rendering these full-sized previews is notoriously slow. It's a "sloth covered in molasses" type of slow. It's "click the Import button, maybe make a sandwich, and then mow the lawn" type of slow before it renders all the previews. But, when it's finally done, you're in the express lane—the "Loading" messages are behind you now and it's full speed ahead.

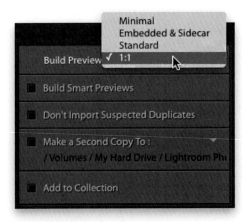

This easy method is designed for people who are new to Lightroom and might be concerned about where it's putting your images during the import process. (*Note:* If you've been using Lightroom for a while now, you can skip this and jump to page 15.) While this simple method doesn't make use of all the importing options, you'll still sleep better at night because you'll know exactly where the images you imported are stored.

Importing from Your Camera (Easy Method)

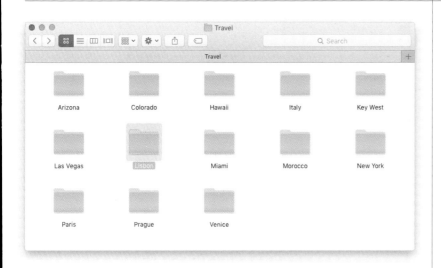

Step One:

Don't launch Lightroom (well, not yet anyway). Instead, just plug your card reader with your memory card into your computer, select all the photos on your card, and drag-and-drop them into the folder where you want to store them on your external hard drive. For example, if they're travel photos (like these photos from Lisbon), you'd drag them onto your external hard drive, into a folder named Travel, and inside your Travel folder, you'd make a new folder named, "Lisbon." That's where you drag them—into that new Lisbon folder. Now, is there any question where your photos are? Of course not—they're on your external hard drive, in your Travel folder, in a folder named Lisbon. This location, where they're at right now, will not change once you import them into Lightroom (your images don't move or get copied inside of Lightroom—they stay right there on your external drive).

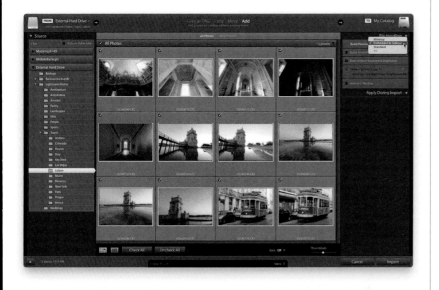

Step Two:

Now, take that Lisbon folder and drag-and-drop it onto Lightroom's icon (in your Dock on a Mac, or on your desktop on a PC). This brings up Lightroom's Import window (seen here). From the Build Previews pop-up menu (at the top right of the window, in the File Handling panel), choose how long you want to wait for your previews to build (we just looked at this on page 11). I chose Embedded & Sidecar, here, but there are a couple of other options you might consider.

Continued

Step Three:

There are other options in the Import window, but we haven't covered them yet (we will later on), so explaining them at this point wouldn't do a lot of good, but there's one option we can cover now—Don't Import Suspected Duplicates. When this option is turned on, if it sees a file already in the folder with the same exact filename, it skips it. This helps when you're downloading from the same memory card over a couple of days (like when you're on vacation), so you don't wind up with a bunch of duplicates of the same photo. Again, the other options we'll cover later (in the advanced import workflow, on the next page, but don't read that until you're really comfortable about where your photos are being imported and stored).

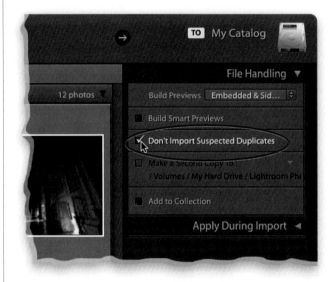

Step Four:

Now, just make sure Add is selected at the top of the window, then click the Import button at the bottom right and your images will appear in Lightroom, and you can start scrolling through the previews, double-clicking to see them larger, and even zooming in to 100% to check for sharpness. At this point, you can start the process of finding the best images from your shoot (and I'll take you through my process in the next chapter).

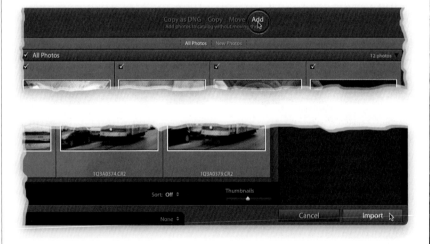

If you've been using Lightroom for a while now, and you're totally comfortable with where your photos are stored—you know exactly where they are and have zero amount of stress over where your images reside—then this is for you. When you're done with this section, you'll be importing images like a SpaceX re-entry booster lead engineer, and you'll be clicking so many features and options that even Adobe doesn't know what they do. In short, buckle up—let's light this candle!

Importing from Your Camera (Advanced Users)

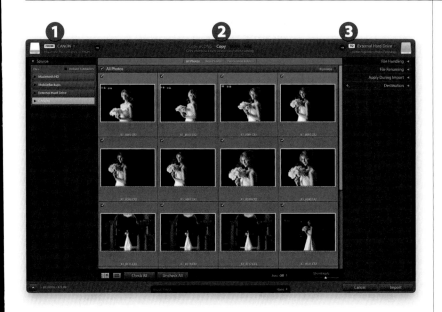

Step One:
If you have Lightroom open, and connect your camera or memory card reader to your computer, the Import window you see here appears over your Lightroom window. The top section of this Import window is important because it shows you what's about to happen. From left to right: (1) it shows where the photos are coming from (in this case, your camera's memory card); (2) what's going to happen to these images (in this case, they're getting copied); and (3) where they're going to (in this case, onto your external hard drive, into your Weddings folder).

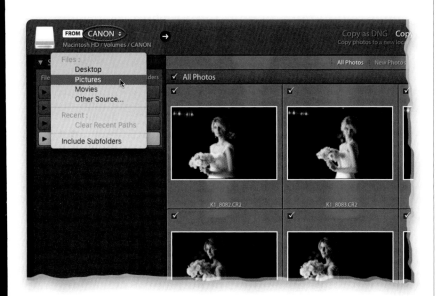

Step Two:
If your memory card is connected to your computer, Lightroom assumes you want to import photos from that card, and you'll see it listed next to "From" in the top-left corner of the window (circled here). If you want to import from a different card (you could have two card readers connected to your computer), click on the From button, and the pop-up menu you see here will appear. This is where you can choose your other card reader, or you can choose to import photos from somewhere else, like your desktop, or Pictures folder, or any recent folders you've imported from.

Continued

Step Three:

There is a Thumbnails size slider below the bottom-right corner of the center Preview area that controls the size of the thumbnail previews, so if you want to see them larger, just drag that slider to the right. If you want to see any photo you're about to import at a large, full-screen size, just double-click on it to zoom in, or click on it, and then press the letter **E**. Double-click to zoom back out, or press the letter **G**.

TIP: Shortcuts for Thumbnail Size

To see the thumbnails larger in the Import window, press the **+ (plus sign) key** on your keyboard or press the **– (minus sign) key** to make them smaller again.

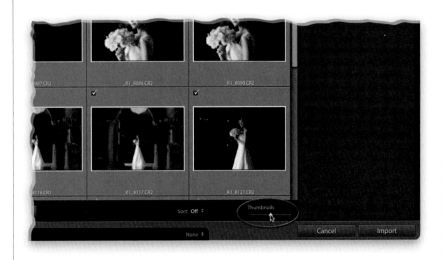

Step Four:

As I mentioned earlier, by default, all the photos have a checkmark at the top left of their grid cell (meaning they are all marked to be imported). If you see one or more photos you don't want imported, just turn off their checkboxes. Now, what if you have 300+ photos on your memory card, but you only want a handful of them imported? You'd click the Uncheck All button at the bottom of the window to uncheck every photo, then Command-click (PC: Ctrl-click) on just the photos you want to import, and then turn on the checkbox for any of these selected photos, and all the selected photos become checked and will be imported.

TIP: Selecting Multiple Photos

If the photos you want are contiguous, then click on the first photo, press-and-hold the Shift key, scroll down to the last photo, and click on it to select all the photos in between at once.

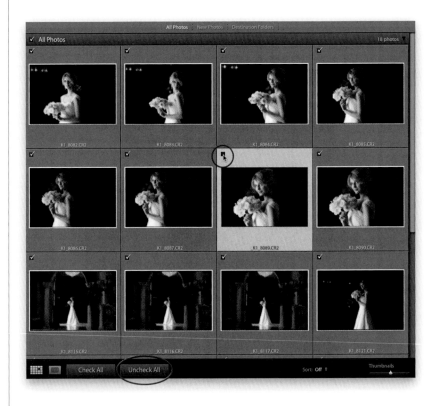

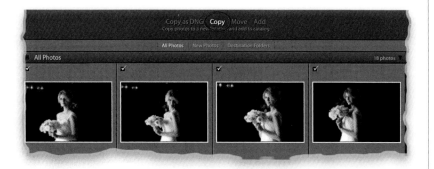

Step Five:

There are some other options at the top center of the Import window: again, Copy copies the files "as is" from your memory card (if they're RAW photos or JPEGs, they stay that way); Copy as DNG converts your RAW photos to Adobe's DNG format as they're being imported (see page 24 for more on DNG). I just leave mine set at Copy all the time. Neither choice moves your originals off the memory card (you'll notice Move is grayed out), it only copies them, so you'll still have the original images on your memory card. Below those are some view options: (1) All Photos (the default) displays all the photos on your memory card. (2) If you click on New Photos, it only shows the new photos on the card that you haven't imported yet, and it hides the rest from view.

Step Six:

On the right side of the window there are more options (but, if you're reading this advanced import process, you probably already know what these do): In the File Handling panel is the option to create smart previews (I only turn this on if I'm working on my laptop and I know I won't have the high-res original images with me, but I still need to edit them in the Develop module). There's an option to copy the images you're importing to a second external drive, but these second-drive backup photos don't get any of the edits you make in Lightroom—it's just a straight copy off the memory card. The last option in this panel is to import directly into an existing collection (or create a new collection from scratch and import into that). There's also the Apply During Import panel, where you can apply a Develop module preset to your images as they're imported, along with your copyright info (from the Metadata pop-up menu), and you can type in keywords (search terms) in the Keywords field, if you like.

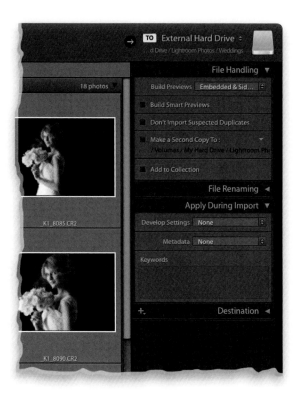

Continued

Step Seven:

Below the File Handling panel is the File Renaming panel, where you can have your photos renamed automatically as they're imported. I always use this to give my files a very descriptive name (in this case, something like Williams Wedding makes more sense to me than _K1_8115 .CR2, especially if one day I have to search for them). If you turn on the Rename Files checkbox, there's a Template pop-up menu where you have serveral different choices. I choose **Custom Name - Sequence**, so it adds my custom name "Williams Wedding" followed by a numeric sequence (so, they become Williams Wedding-1.CR2, Williams Wedding-2.CR2, and so on). Just by looking at the pop-up menu, you can see how it will rename your files, so choose whichever one you like best, or create your own by choosing **Edit** at the bottom of the menu (I take you through that whole process in Chapter 3).

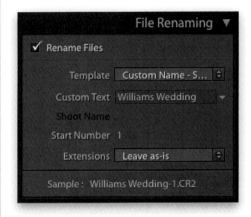

Step Eight:

Finally, if you click-and-hold on "To" at the top right, a pop-up menu appears (shown here) that lets you choose where you want the images you're importing stored. In our case, you'd want them stored on your external hard drive, so chose **Other Destination** from this pop-up menu and choose the category folder where you want these images stored (like Travel or Portrait or Family, or in this case, Weddings). In the Destination panel, I also turn on the Into Subfolder checkbox, name the subfolder with a descriptive name, like "Williams_Arnone Wedding," and choose Into One Folder from the Organize pop-up menu. So, at this point, you know three things: (1) the photos are coming from your memory card; (2) they're being copied from that card; and (3) those copies are going onto your external hard drive, into your Weddings folder, into a new folder inside it named "Williams_Arnone Wedding."

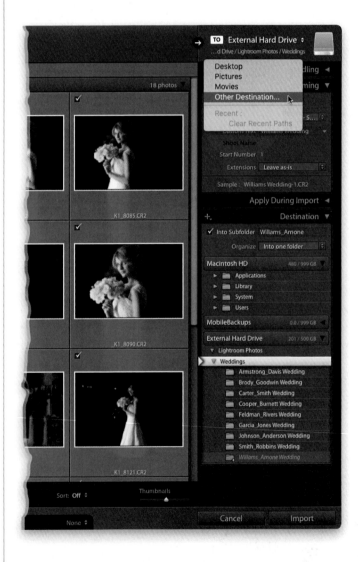

If you work on a laptop, you probably (hopefully) have stored your images on an external hard drive, but if you disconnect that drive, you can't change things like Exposure, or White Balance, and so on, because you don't have access to the original high-res files (which are on that external hard drive you disconnected). All you have now are thumbnails, which are handy for sorting and stuff, but you can't do any Develop module editing. Well, creating smart previews changes all that.

Using Lightroom with a Laptop? You'll Love Smart Previews

Step One:
To be able to still edit your images when they're "offline" (the external hard drive with your images is not currently attached to your laptop), you need to turn this feature on in the Import window. Just turn on the Build Smart Previews checkbox in the top-right corner (in the File Handling panel; it's shown circled here in red). This tells Lightroom to make a special larger preview that allows you to make edits in the Develop module, and later, when you reconnect your laptop to your external hard drive, it applies those same edits to your high-resolution images. It's a beautiful thing.

Step Two:
Once your images are imported, click on one of them, then look right underneath the histogram at the top right and you'll see "Original + Smart Preview," which lets you know that you're seeing the real original image (since the hard drive with the real original file is connected—look over in the left side Panels area here, in the Folders panel, and you'll see "External Hard Drive" listed as one of my mounted drives), but that the image also has a smart preview.

TIP: Smart Previews After Importing
If you forgot to turn on the Build Smart Previews checkbox on import, no sweat. In Grid view, just select the photos you want to have smart previews, then go under the Library menu, under Previews, and choose **Build Smart Previews**.

Save Time Importing Using Import Presets (and a Compact View)

If you find yourself using the same settings when importing images, you're probably wondering, "Why do I have to enter this same info every time I import?" Luckily, you don't. You can just enter it once, and then turn those settings into an Import preset that remembers all that stuff. Then, you can choose the preset, add a few keywords, maybe choose a different name for the subfolder they're being saved into, and you're all set. In fact, once you create a few presets, you can skip the full-sized Import window altogether and save time by using a compact version instead. Here's how:

Step One:
Here, we'll assume you're importing images from a memory card, and you're going to copy them onto your external hard drive, into your Lightroom Photos main folder, then into your Portraits folder. You want your copyright info added as they're imported (see Chapter 3), and we'll choose Embedded & Sidecar so the thumbnails and previews show up fast. Now, go to the very bottom center of the Import window, and click-and-hold where it says "None." From the pop-up menu that appears, choose **Save Current Settings as New Preset** (as shown here) and give it a descriptive name.

Step Two:
Click the Show Fewer Options button (the up-facing arrow) in the bottom-left corner of the Import window, and it switches to a compact view (as seen here). So, from now on, all you have to do is choose your preset from the pop-up menu at the bottom (as shown here, where I'm choosing my From Memory Card preset), and then enter just the few bits of info that do change when you import a new set of photos, like the descriptive name of the subfolder you want to save these photos inside. So, how does this save you time? Well, now you only have to choose a folder, then type in your subfolder's name, and click the Import button. That's fast and easy! *Note:* You can return to the full-size Import window anytime by clicking the Show More Options button (the down-facing arrow) in the bottom-left corner.

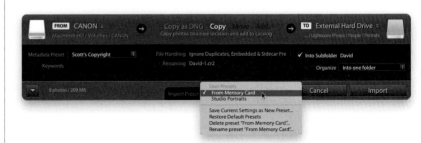

I put the import preferences toward the end of the Importing chapter because I figured that, by now, you've imported some photos and you know enough about the importing process to know what you wish was different. That's what preferences are all about (and Lightroom has preference controls because it gives you lots of control over the way you want to work).

Choosing Your Preferences for Importing Photos

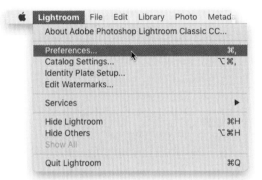

Step One:
The preferences for importing photos are found in a couple different places. First, to get to the Preferences dialog, go under the Lightroom menu on a Mac or the Edit menu on a PC, and choose **Preferences** (as shown here).

Step Two:
When the Preferences dialog appears, first click on the General tab up top (shown highlighted here). Under Import Options in the middle, the first preference lets you tell Lightroom how to react when you connect a memory card from your camera to your computer. By default, it opens the Import window. However, if you'd prefer it didn't automatically open that window each time you plug in a camera or card reader, just turn off its checkbox (as shown here). The second preference here was added back in Lightroom 5. In all previous versions, if you used the keyboard shortcut to start importing photos while in another module, Lightroom left whatever you were working on and jumped over to the Library module to show you the images as they were importing (basically, it assumed you wanted to stop working on whatever you were doing, and start working on these currently importing images). Now, you can choose to stay in the folder or collection you are in and just have those images import in the background by turning off the Select the "Current/Previous Import" Collection During Import checkbox.

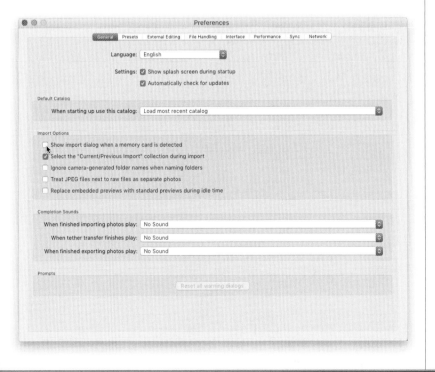

Continued

Step Three:

If you choose to use the Embedded & Side-car previews when you import photos (see page 11), there's an option you can turn on if you want to have Lightrotom build the larger previews when it's not doing anything else important. Just turn on the Replace Embedded Previews with Standard Previews During Idle Time checkbox and it will create those larger, more color-accurate previews in the background for you.

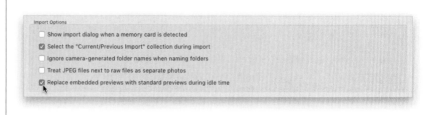

Step Four:

There are two other importing preference settings I'd like to mention that are also found on the General tab. In the Completion Sounds section, you not only get to choose whether or not Lightroom plays an audible sound when it's done importing your photos, you also get to choose which sound (from the pop-up menu of system alert sounds already in your computer, as seen here).

Step Five:

While you're right there, directly below the menu for choosing an "importing's done" sound are two other pop-up menus for choosing a sound for when your tether transfer finishes and for when your exporting is done. I know, the second one isn't an importing preference, but since we're right there, I thought…what the heck. I'll talk more about some of the other preferences later in the book, but since this chapter is on importing, I thought I'd better tackle these here.

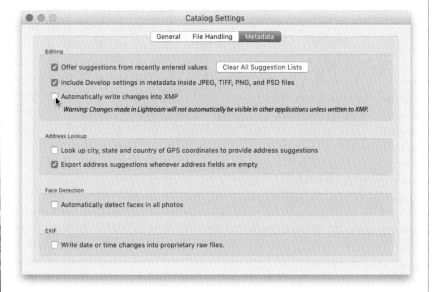

Step Six:

Now, close the Preferences dialog, and then go back under the Lightroom menu on a Mac or the Edit menu on a PC, and this time choose **Catalog Settings**. In the Catalog Settings dialog (shown here), click on the Metadata tab. Here you can determine whether you want to take the metadata you add to your RAW photos (copyright, keywords, etc.) and have it written to a totally separate file, so then for each photo you'll have two files—one that contains the photo itself and a separate file (called an XMP sidecar) that contains that photo's metadata. You do this by turning on the Automatically Write Changes into XMP checkbox, but why would you ever want to do this? Well, normally Lightroom keeps track of all this metadata you add in its database file—it doesn't actually embed the info until your photo leaves Lightroom (by exporting a copy over to Photoshop, or exporting the file as a JPEG, TIFF, or PSD—all of which support having this metadata embedded right into the photo itself). However, some programs can't read embedded metadata, so they need a separate XMP sidecar file.

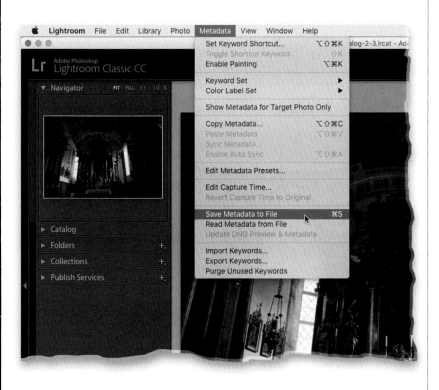

Step Seven:

Now that I've shown you that Automatically Write Changes into XMP checkbox, I don't actually recommend you turn it on, because writing all those XMP sidecars takes time, which slows Lightroom down. Instead, if you want to send a file to a friend or client and you want the metadata written to an XMP sidecar file, first go to the Library module and click on an image to select it, then press **Command-S (PC: Ctrl-S)**, which is the shortcut for **Save Metadata to File** (which is found under the Metadata menu). This writes any existing metadata to a separate XMP file (so you'll need to send both the photo and the XMP sidecar together).

Converting RAW Photos to the Adobe DNG Format

You have the option of converting your RAW images from your camera manufacturer's proprietary RAW format to Adobe's open format DNG (Digital Negative) format. DNG was created by Adobe out of concern that one day, one or more manufacturers might abandon their proprietary RAW format, leaving photographers shooting RAW out in the cold. Unfortunately, none of the big three camera manufacturers embraced this DNG format, and even I stopped converting my images a few years ago. However, if you want to convert to DNG, here's how:

Two DNG Advantages:

There are two advantages of the DNG format: (1) DNG files maintain the RAW properties, but are about 20% smaller in file size, and (2) if you need to share an original RAW image file with someone, and you want that file to include any changes you made to it in Lightroom (including keywords, copyright, meta-data, etc.), you don't have to generate a separate XMP sidecar file (a separate text file that stores all that info). With DNG, all that data is backed right into the file itself, so there is no need for a second file. There are disadvantages to DNG, as well, including importing taking longer because your RAW files have to be converted to DNG first. Also, DNGs aren't supported by many other photo applications. Just so you know.

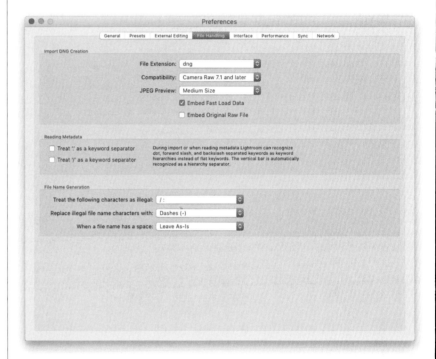

Setting Your DNG Preferences:

If you want to convert your RAW files to DNG format as they're imported, first press **Command-, (PC: Ctrl-,)** to bring up Lightroom's Preferences dialog, then click on the File Handling tab (as seen above). In the Import DNG Creation section at the top, you can choose the three-letter File Extension, how backward compatible with older versions of Adobe Camera Raw you want to make them, and the size of the preview that gets embedded in DNG images. Although you can embed the original proprietary RAW file, it adds to the file size, and pretty much kills advantage #1 above. By the way, you choose Copy as DNG at the top center of the Import window (as shown here).

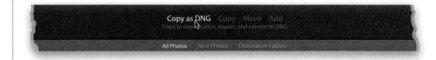

Now that your images have been imported, there are some tips about working with Lightroom's interface you're going to want to know about right up front that will make working in it much easier.

Four Things You'll Want to Know Now About Getting Around Lightroom

Step One:
There are seven modules in Lightroom, and each does a different thing. When your imported photos appear in Lightroom, they always appear in the center of the Library module, which is where we do all our sorting and organizing. The Develop module is where you do your photo editing (changing the exposure, white balance, tweaking colors, etc.), and it's pretty obvious what the other five do (I'll spare you). You move from module to module by clicking on the module's name up in the taskbar across the top, or you can use the shortcuts **Command-Option-1** for Library, **Command-Option-2** for Develop, and so on (on a PC, it would be **Ctrl-Alt-1, Ctrl-Alt-2**, and so on).

Step Two:
There are five areas in the Lightroom interface overall: that taskbar along the top, the left and right side Panels areas, a Film-strip across the bottom, and your photos always appear in the center Preview area. You can hide any panel (which makes the Preview area, where your photos are displayed, larger) by clicking on the little gray triangle in the center edge of the panel. For example, go ahead and click on the little gray triangle at the top center of the interface, and you'll see it hides the taskbar. Click it again; it comes back.

Continued

Step Three:

The #1 interface complaint I hear from Lightroom users is how they hate the Auto Hide & Show feature (which is on by default). The idea behind it sounds great: if you've hidden a panel and need it again to make an adjustment, you move your cursor over where the panel used to be, and it pops out. When you're done, you move your cursor away, and it automatically tucks back out of sight. Sounds great, right? The problem is one of those panels pops out anytime you move your cursor to the far right, left, top, or bottom of your screen. It really drives people nuts (I'm on that list), and I've had people literally offer me money to show them how to turn that "feature" off. To turn off Auto Hide & Show, Right-click on the little gray triangle next to any panel and choose **Manual** from the pop-up menu (as shown here). This works on a per-panel basis, so you'll have to do it to each of the four panels.

Step Four:

I use Manual mode, so I can just open and close panels as I need them. You can also use the keyboard shortcuts: **F5** closes/opens the top taskbar, **F6** hides the Filmstrip, **F7** hides the left side Panels area, and **F8** hides the right side (on a newer Mac keyboard or a laptop, you may have to press the Fn key with these). You can hide both side Panels areas by pressing the **Tab key**, but the one shortcut I probably use the most is **Shift-Tab**, because it hides all the panels at once and leaves just your photos visible (as shown here). Also, each module's panels kind of follow the same basic idea: the left side Panels area is used primarily for presets and templates and giving you access to your collections; the right side Panels area has all the adjustments.

Before we get to organizing our photos (which we cover in the next chapter), lets take a minute to learn the ins and outs of how Lightroom lets you view your imported photos.

Viewing Your Imported Photos

Step One:

When your imported photos appear in Lightroom, they are displayed as small thumbnails in the center Preview area (as seen here). You can change the size of these thumbnails using the Thumbnails slider that appears on the right side of the toolbar (the dark gray horizontal bar that appears directly below the center Preview area). Drag it to the right, and they get bigger; drag it to the left, and they get smaller (the slider is circled here). You can also press **Command-+ (PC: Ctrl-+)** to zoom in, or **Command-- (PC: Ctrl--)** to zoom out.

Step Two:

To see any thumbnail at a larger size, just double-click on it, press the letter **E** on your keyboard, or press the **Spacebar**. This larger size is called Loupe view (as if you were looking at the photo through a loupe), and by default it zooms in so you can see your entire photo in the Preview area surrounded by a light gray background. This is called Fit in Window view. If you don't like seeing that gray background, go up to the Navigator panel in the top left, click on Fill, and now when you double-click on a thumbnail, it will zoom in to fill the whole Preview area (no gray background). Choosing 1:1 will zoom your photo in to a 100% actual size view when it's double-clicked, but it's kind of awkward to go from a tiny thumbnail to a huge, tight, zoomed-in image like that.

Continued

Step Three:

I leave my Navigator panel setting at Fit, so when I double-click I can see the entire photo fitting in the center Preview area, but if you want to get in closer to check sharpness, you'll notice that when you're in Loupe view, your cursor has changed into a magnifying glass. If you click it once on your photo, it jumps to a 1:1 view of the area where you clicked. To zoom back out, just click it again. To return to the thumbnail view (called Grid view), just press the letter **G** on your keyboard. This letter "G" is one of the most important keyboard shortcuts to memorize. This is particularly handy, because when you're in any other module, pressing G brings you right back here to the Library module and your thumbnail grid, which is kind of "home base" for Lightroom Classic.

Step Four:

The area that surrounds your thumbnail is called a cell, and each cell displays information about the photo, from the filename, to the file format, dimensions, etc.—you get to customize how much or how little it displays, as you'll see in Chapter 4. But in the meantime, here's another keyboard shortcut you'll want to know about: press the letter **J**. Each time you press it, it toggles you through the three different cell views, each of which displays different groups of info—an expanded cell with lots of info, a compact cell with just a little info, and one that hides all that distracting stuff altogether (great for when you're showing thumbnails to clients). Also, you can hide (or show) the toolbar by pressing **T**. If you press-and-hold T, it only hides it temporarily—only for as long as you have the T key held down.

The default cell view is called Expanded and gives you the most info

Press J to switch to Compact view, which shrinks the size of the cell, hides all the info, and just shows the photos

Press J one more time and it adds back some info and numbers to each cell

There are two really large views that you'll probably use fairly often: One hides most of the panels and tools and stuff, and gives you a large clutter-free view. The other takes over your screen and hides everything but the photo. You'll find the one you like best, but give them both a try and see which one is for you.

The Two Flavors of Full-Screen View

Step One:
Press **Shift-Tab** to hide all the panels (left, right, top, and bottom), but Lightroom's menus and its title bar will still be visible along the top. If you keep the gray toolbar along the bottom of the Preview area visible, you'll also still see it in this Shift-Tab view. To toggle the toolbar on/off, press the letter **T**. If you are in Grid view and keep the Library Filter bar along the top of the screen visible, you'll still see that, too. To toggle it on/off, press the **\ (backslash) key**. (*Note:* If you have your Navigator panel [on the top of the left side Panels area] set to Fit, your entire image will fit onscreen, and you'll see a gray background around it [as seen here]. If you chose Fill instead, it will zoom in to fill the screen.) Lastly, pressing Shift-Tab will be bring everything back. Seems like a lot of decisions for just a larger view, right?

Step Two:
If you want a simple full-screen view, just press the letter **F** on your keyboard. To return to regular view, press F again. That's a whole lot easier.

GETTING ORGANIZED
my system for a happy Lightroom life

There are lots of ways to organize your images in Lightroom, and that's actually part of the problem—there are so many different schemes and methods that you'll hardly run into anyone who does it the same way as anyone else. The worst part is that many are so overly complex and confusing that some folks actually need to keep a spreadsheet printout next to their computer just so they can keep track of everything. That's crazy, and it's also precisely why a few years ago I set out to introduce a new organizational system that would be easy, efficient, and one anyone could employ. Now users would not only be able to quickly and easily find their images in Lightroom, they'd also be triple backed up in case of disaster. I call my system the "SLIM" system, which stands for the "Simplified Lightroom Image Management" system and you're going to learn that

very system in this chapter. This replaces a few earlier systems that I used that didn't pan out. The first was my "Catalog Hierarchy Unified Backup By Year" system or "CHUBBY" system for short. It was okay for a while, but many users complained that while they were CHUBBY, they had trouble with dates. Little by little, this system kept growing and growing until it reached some pretty large proportions. That's when I realized that this system could no longer fit comfortably into most situations. It had evolved into an even larger system, one that I would eventually call my "Filter And Tag" system. However, after taking my laptop with me on a cruise, I realized that my "FAT" system no longer fit— it had bloated into what I now call the "Pro Organizational Responsive Keyword Yield" system, which essentially just sits on your couch and eats chips.

Four Important Things to Know First!

In this chapter, you're going to learn an organizational system—the same one I use for organizing my own images. I call it the "SLIM" system, which stands for the "Simplified Lightroom Image Management" system. First, the good news: you've already tackled a good chunk of it, because all that organizing you did in Chapter 1 when you moved all your photos onto one external hard drive and sorted them into the topics that you shoot, that's a core part of the SLIM system because we mimic that in Lightroom. But, there are a few more things you'll need to know up front (well, four, to be exact).

#1: Stay Away from the Folders Panel

When I meet somebody with a sad story about losing some (or all) of their photos forever, it was because they were messing around in Lightroom's Folders panel. That's why I don't recommend working in the Folders panel at all. It's too risky—make a mistake there and it's forever. Here's a car analogy: we can drive around, get to where we want, and be happy just driving, but if we open the hood and start messing around with the engine, and we don't really know what we're doing, we can mess up our car, right? Treat the Folders panel the same way—you can live a happy life without opening Lightroom's "hood" and messing around with stuff. Now, the Folders panel (like your car's engine) is essential for Lightroom to operate, but let's consider it an "under-the-hood" part of Lightroom and just stay out of there.

#2: Lightroom Was Designed for You to Use Collections Instead

That's why the Collections panel is available in all seven modules, but the Folders panel is only in the Library module. Collections are safe. They're forgiving. They protect you from messing up. Plus, you can put the same photo in multiple collections (you can have a photo of your dog in your Dogs collection, and in your Family collection, and Pets collection, and all is still right with the world)—with folders, you can't. If you've already been working in folders, don't sweat it. To make any folder a collection, just Right-click on it and choose **Create Collection**. Can it really be that easy? Yup.

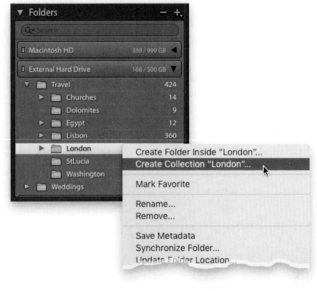

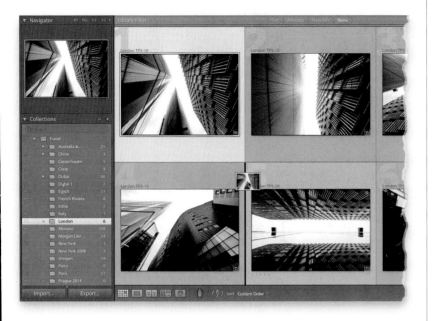

#3: Think of Collections as Photo Albums

Think back to the film days—we'd get our film developed, then we'd take our favorite prints and organize them in a photo album, right? Well, we do the same thing in Lightroom, but instead of calling them "photo albums," we call them "collections." We can drag-and-drop our favorite images into them, and arrange them in any order, and even have the same image appear in multiple collections. In short: collections are awesome!

#4: You Organize Your Collections Inside Collection Sets

If you've got a bunch of related collections, like collections from your trips to Italy and San Francisco, and Hawaii, and your trip to Paris, you can organize all those inside a collection set (and you'd probably name that set "Travel"). That way, all your travel collections are together (like the folders on your hard drive). If you look at a collection set's icon, it looks like that box you buy at Office Depot or Staples to put file folders inside of, and that's essentially what is it—a collection you can put other collections inside. You can even put other collection sets inside of it. For example, if you create a "Sports" collection set, you can put another collection set inside it called "Football," and then all the football games you shot can go inside that. If you shoot high school and college football, you can have a collection set for each of these—one with all your high school games ("Predators vs. Blazers," "Sabercats vs. Huskies"), then your college games in a separate collection set ("Buckeyes vs. Seminoles," "Vols vs. Crimson Tide"). Working with collections and collection sets also opens up a whole new world of features that you can only access if you work in collections. For example, if you want to work with Lightroom on your phone or tablet (see Chapter 14 for more on this), you have to use collections (you can't do this with folders). The future of Lightroom is a collections-based workflow, so no sense in fighting it, let's do it right from the start.

Want a Happy Lightroom Life? Use Just One Catalog

You may think it might be too late for you—you might already have a dozen different catalogs—but don't worry, it's not too late (we're about to learn how to fix that). If you want a happy, organized Lightroom life (and avoid a mountain of time-wasting frustration), go with just one single catalog for everything. So, how many images can you have in a single catalog and still work at full speed? We don't know the limit—Adobe has users with over 6 million images, and they're still rocking right along, so stick with one catalog and life will be good.

Step One:

If you're new to Lightroom, this is the easiest thing in the world. When you open Lightroom, what you see onscreen with your photos, that's your catalog. Just don't create a new one. That is your catalog, and that's what you're working with. But, what if you have three, five, or 15 different catalogs? You have two choices: (1) Combine all your catalogs into just one single existing catalog (ahhh, that's a beautiful place to be). Don't worry, it keeps everything intact—all your sorting, metadata, edits, and so on—that's why there's nothing hard about doing this. Start by opening whichever catalog is your favorite (or is the most complete, or the one you like the best etc.), and that will be the catalog you build upon. So, make that decision now.

Step Two:

Now, find your other catalogs and import them all (yes, all of them) into this one catalog. To do that, go under the File menu, choose **Import from Another Catalog**, then go to wherever you store your Lightroom catalogs on your computer (I'm guessing it's in a folder named "Lightroom" inside either your computer's Pictures folder or My Pictures folder). Once you find one of those catalogs, click Choose to start the process.

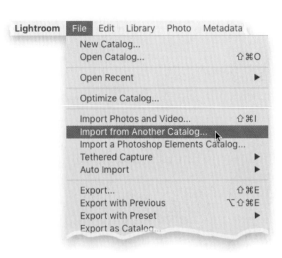

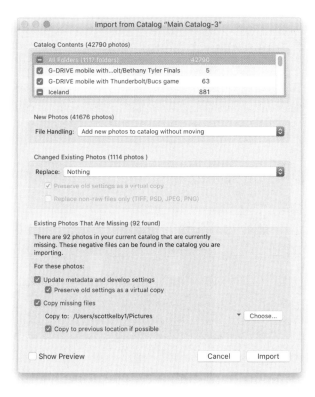

Step Three:

When you hit that Choose button, it's going to bring up the Import from Catalog dialog you see here. In the center is a list of all the collections in this other catalog and how many photos are in each. The only reason I would turn off one of these (and not have it import) is if I knew I already had a collection with the same name and photos as one in the catalog I currently have open. Also, leave the File Handling pop-up menu set to **Add New Photos to Catalog without Moving**. Otherwise, I just hit the Import button at the bottom right, and I go make a cup of coffee (it's a Keurig machine, so it's pretty quick), and then all those collections are added to my currently open catalog. Once I confirm they're there, I do two things: (1) I sort all the images into their proper collection sets by topic, and (2) I throw away the old catalog (there's no reason to keep it now—I've combined that catalog into this one). Now do that for all your other catalogs (this will take much less time than you think), and when you're done, all your photos are finally in just one catalog. Ahhhh, life is good.

Step Four:

The other option (2) is if you have multiple catalogs, but you really don't like any particular one, so you don't have one you want to start with. In that case, just create a brand new, clean, empty catalog and import all your other catalogs into it. Go under the File menu and choose **New Catalog**. This creates a new catalog with nuthin' in it, ready for you to start importing all your other catalogs using the method I just showed. The result is the same: one single catalog with all your photos in it, and you are on your way to a happy Lightroom life.

Where to Store Your Catalog

While we do want to store our images on an external hard drive, to get the best performance from Lightroom, you'll want to store your Lightroom catalog directly on your computer.

Step One:

If you've been using Lightroom for a while (or you just recently started), and you've stored your catalog on an external hard drive, it's easy to copy it back onto your computer (where you'll get the best performance), but you need to do this right, so everything works like it should. Before simply drag your catalog over to your computer, I recommend first creating a new folder on your external hard drive, naming it "Catalog Backup," and then dragging your existing catalog into that folder, along with the files named "Previews." That does two things: (1) It creates a backup we can use in the unlikely case that something goes wrong during this process (it won't, but just in case). And, (2) since you're changing the location of the catalog, if you were to launch Lightroom, it won't launch this backup catalog on your external hard drive by mistake.

Step Two:

Now go into that Catalog Backup folder and click-and-drag these files: (1) the one with the extension .lrcat (that's your actual catalog file); (2) the one with the extension .lrdata (those are your thumbnail previews); and (3) if you've created any smart previews, you'll see a third file with the .lrdata extension, but it will have "Smart Previews" in its filename. All three of those go onto your computer (put them inside your Pictures or My Pictures folder), inside a folder named "Lightroom" (you may already have one named that). Once that's done, double-click that .lrcat file you just copied onto your computer, and from now on, you'll be working from that catalog.

Okay, we've got to get off using folders—they're just too dangerous (and if you read that and you're like, "What?!" it just means you didn't read the "Four Important Things…" at the begitning of this chapter, so go back and read those now. Anyway, we're getting off folders before something bad happens, so here's how to make a collection from a folder. Now, just so ya know, we're not deleting any folders, we're just going to use collections instead. Those folders are sacred because our actual photos are inside, so we're just going to leave them alone once we make our collections.

How to Make a Collection from a Folder

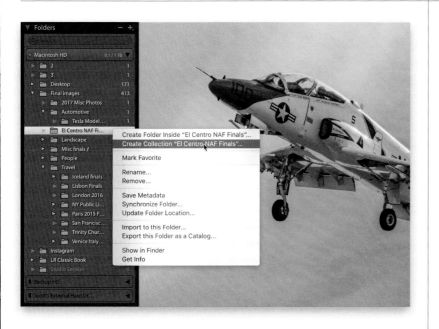

Step One:
This used to be more complicated, but thankfully Adobe made the process of creating a collection from a folder amazingly simple. Just go to the Folders panel, Right-click on the folder you want to also have as a collection, and from the pop-up menu that appears, choose **Create Collection**. Boom. Done. Drops the mic. That's really all there is to it. Go and look in the Collections panel and you'll see your new collection (they appear in alphabetical order).

Step Two:
If you have a folder with other folders inside of it, then you only change one thing: when you Right-click on the folder (the one with other folders inside it), choose **Create Collection Set**, instead. That creates a collection set and keeps all those nested folders inside intact, but now you've created collections from them. Everything's the same, but now you're working in collections, and it's a happy place, with puppies and rainbows, and where small animals will come up and eat from your hand. You're on your way to a happier, healthier Lightroom life using collections.

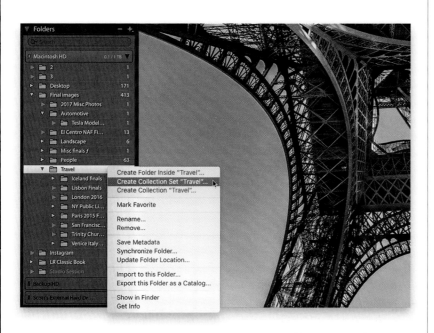

WARNING: I know I've said this before (like up in the introduction on this page), but now that you've made collections from your folders, *do not delete any folders*. They contain your actual image files. Just ignore them. Leave them alone. Don't mess with them, etc. You're a collections person now, so just ignore that old way of working.

Organizing Photos Already On Your Hard Drive

I'm going to take you through my simple system for organizing the images already on your external hard drive (I say "external hard drive" because I'm hoping you've already moved them all onto an external hard drive, but if for some reason you haven't done that yet, you can of course still use this exact system, so don't let that hold you back).

Step One:

Okay, I'm counting on you having already read the first part of this chapter, so we can dive right in. Here's what we're going to do: Remember those topic folders you created on your external hard drive back in Chapter 1? The ones you created to organize your images before you even launched Lightroom? Well, we're going to mimic that same setup here in Lightroom using collection sets and collections. So, start by going to the Collections panel, clicking on the + (plus sign) button on the right side of the panel header, and choosing **Create Collection Set**. Give it the name of one of those folders on your external hard drive.

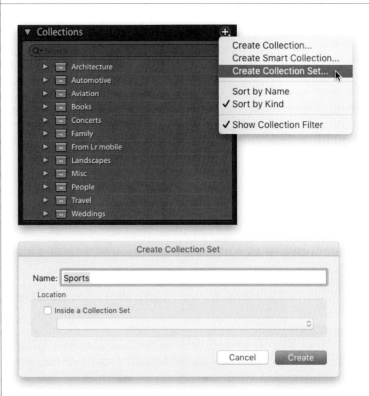

Step Two:

Once you create that first collection set, you're then going to drag your existing collections that fit into that topic inside this collection set. Let's say the first collection set you created is called "Sports," and you have collections from all the different sports you shoot. You simply drag-and-drop them right on this collection set and they move inside of it. If you have a lot of a particular topic, let's say you shoot a lot of car racing, you might need to create a Racing collection set inside that Sports collection set, and then drag your racing shoots inside that collection set. Inside my own Sports collection set, I have collection sets for Football, Baseball, Tennis, Motorsports, Misc Sports, Hockey, and Basketball. However, inside my Football collection set, I have a collection set for College and another for NFL, and inside NFL I have two more: one to keep all my Bucs games together and one for all my Falcons games.

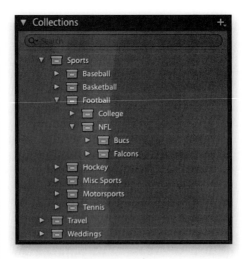

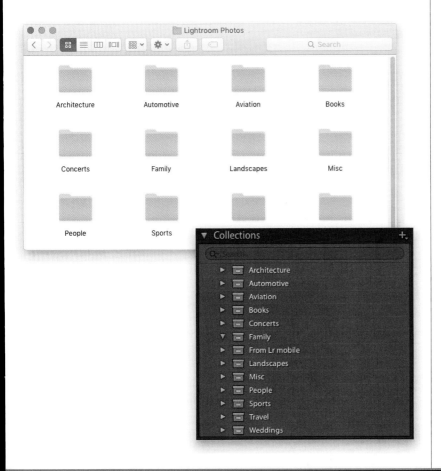

Step Three:

Now you're going to create a collection set for every topic folder you have on your external hard drive. Then, you're going to drag-and-drop any collections you've created from folders, or already had in your Collections panel, or whatever, and put them into their corresponding topics (here, I'm dragging my Oregon Landscapes collection into my Landscapes collection set). So, shots from a high school football game go in Sports; shots from your son's graduation get dragged into the Family collection set. That one time you shot close-up photos of flowers, goes in the Misc collection set (unless you start shooting flowers a lot, then you'd create a topic called Flowers at some point). Now, what if you have shots from your kid's football game, and you're not sure whether to put them in Sports or Family? Why not create a collection in both? That's the great thing about collections—your images can be in more than one location (whereas they can't if you're still using folders).

TIP: Deleting Collections

If you want to delete a collection or collection set, just Right-click on it, and from the pop-up menu, choose **Delete**. It'll remind you that the photos in that collection will still remain in your catalog (which is a good thing).

Step Four:

Here, at the top, is what it should look like on your external hard drive (you're seeing my topics—of course yours will reflect the topics you shoot), and here's what your Lightroom Collections panel should look like after you're done mimicking that structure with collection sets. If you click on a little "flippy" triangle, it expands the set and shows you all the collections inside.

Why You Need to Use Pick Flags Instead of Star Ratings

If I'm teaching a workshop and I see one of my students stuck, it's almost a lock that it's one of two things they're stuck on, and one of them is the massive time-suck that is the 1–5 star rating system. They'll ask me, "What do you think? Is this a 2-star or a 3-star?" Who cares? You're just wasting your time! Either it's one of your best shots or it's one of those out-of-focus, probably-should-just-delete shots (you should ignore the rest altogether). That's why Pick flags make so much sense. It's either a good shot or not. Here's how we use them as the core of our organizational system:

Step One:
When you boil it down, we're looking for the best photos from our shoot, and we also want to get rid of the photos where the subject is out of focus, you pressed the shutter by accident, the flash didn't fire, etc. There's no sense in storing photos that you'll never use, right? Pick flags make marking your "keepers" (shots that are in the running), and the really bad shots you need to delete, super-quick and easy. First, you'll want to see images at a large size, so double-click on a photo, and then either press **Shift-Tab** to hide all the panels, or press **F** on your keyboard to go full screen. Now, take a quick look at the photo (good photos stand out even at a quick glance), and if it's a good shot, press the letter **P** to mark it as a Pick. If you hid the panels, you'll see "Flag as Pick" appear near the bottom of the image (as seen here). If you're in full screen, you'll just see a small white flag appear onscreen.

Step Two:
That's that the plan—if you see a good shot, you press P; if it's not good, you don't do anything, you just move on by pressing the **Right Arrow key** on your keyboard. If you see a really bad shot (out of focus, like the shot here, the subject's eyes are closed, etc.), press the letter **X** to mark it as a Reject. If you mark an image as a Pick or Reject, and you change your mind, just press **U** to unflag that image.

TIP: Using Auto Advance for Picks
If you turn on **Auto Advance**, under the Photos menu, when you mark a Pick, it automatically moves to the next image.

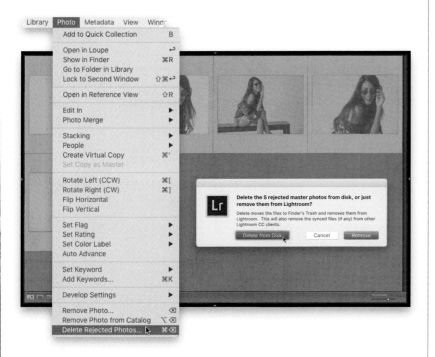

Step Three:
When we get into the system (starting on the next page), we'll get into what to do with those Picks, but at this point, you can just deal with those Rejects (you can really deal with them at any time, but the sooner you get them out of your life, the less time they'll appear onscreen just taking up space, so I like to deal with them early in the process). To get rid of all your Rejects at once, go under the Photo menu up top, and all the way at the bottom of the menu, choose **Delete Rejected Photos** (as shown here). When you're in Grid view, this displays all the photos you're about to delete (I guess to give you one last chance to change your mind). A dialog will appear asking if you just want these out of Lightroom or deleted from your disk. I always choose Delete from Disk because if I marked them as Rejects, they truly are rejects, and I want them out of my life.

Step Four:
So, do we ever use star ratings? Yes. But only one: the 5-star rating (here, I pressed the number **5** on my keyboard to assign a 5-star rating to this photo). We'll talk about why (and how it comes in handy having this second style of rating), but we don't use the 1-, 2-, 3-, or 4-star, just the 5-star). If you're an "anti-starite" and don't want to use stars, you could go with color labels instead, but the downside of these is that they don't transfer to Lightroom CC on mobile devices, so I skip them in my rating process. However, here's where I do use color labels: If I do a shoot with a professional model, and I have a makeup artist, fashion stylist, and hair stylist onset, I let them use color labels to mark their favorites. That way, I can quickly find their favorites, and I can email or text them finals for their portfolios or social media.

Organizing Photos You're Importing from Your Camera

Here, we're going to look at how to organize your images from a shoot you just imported, and I'm going to show you the same method I use for organizing my shoots. It's pretty straightforward, but like any part of this system, the key is consistency.

Step One:

In reality, of course, Step One is to import your photos from your camera's memory card, so we're going to pick this up from the point where you literally just imported your photos. When you import your photos, they appear in Grid view, waiting for you to sort, edit, etc., but before you do anything, go to the Collections panel, click the + (plus sign) button on the right of the panel header, and from the pop-up menu, choose **Create Collection Set**, and then give that new set a very descriptive name. In our example here, these are shots from Lisbon, so I'm naming the collection set (wait for it…wait for it…) "Lisbon." I have a collection set called "Travel" with all my travel photos inside, so in the Create Collection Set dialog, I'd turn on the Inside a Collection Set checkbox, choose **Travel** from the pop-up menu, then click Create.

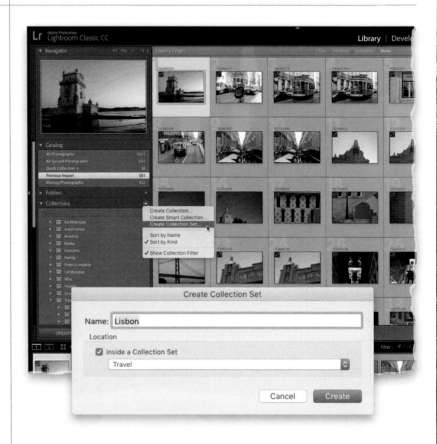

Step Two:

At this point, you have an empty collection set named Lisbon (inside your main Travel collection set), so go under the Edit menu and choose **Select All** (or press **Command-A [PC: Ctrl-A]**) to select all those photos from Lisbon you just imported. Go back to the Collections panel, click the + sign button again, but this time choose **Create Collection** from the pop-up menu. When the Create Collection dialog appears, name this new collection "Full Shoot" (that way, any time you want to see all the images from your Lisbon shoot, you'll just click on this Full Shoot collection).

Step Three:
In the Location section, turn on the Inside a Collection Set checkbox, and from the pop-up menu below, choose Lisbon (all the collection sets you've created will appear in this menu). Below that, in the Options section, the Include Selected Photos checkbox should already be turned on, but if for some reason it's not, turn it on (otherwise, it will ignore the photos you just selected to be in this new collection). Now you can click Create, and it puts this new "Full Shoot" collection inside of your Lisbon collection set. Okay, so far, so good. Now it gets more fun (not harder, it actually does get more fun at this point).

Step Four:
This is where I begin the process of finding my best images from the shoot using the Pick flag method I showed back on page 40. I double-click on the first image to see it larger onscreen (this puts it in what Lightroom calls "Loupe view"), then I get all the panels out of the way by pressing **Shift-Tab**, and then I start going through my images. If I see an image I like, I press **P** on my keyboard. If I don't like the photo, I don't do anything—I just hit the **Right Arrow key** on my keyboard and move on. If I see a photo that's so messed up it needs to be deleted, I press **X**. If I mess up doing either, I press **U** to unflag it. I do this pretty quickly, because I'll have an opportunity to be really choosy in the next stage, but for now, when the image appears onscreen, I make a quick decision—it's a Pick or I move on. You'll be amazed at how quickly you'll move through an entire shoot using this method. Okay, we're not done yet, but we're well on our way.

Continued

Step Five:

Once you've got your Picks and Rejects flagged, let's get rid of the Rejects. Switch back to Grid view **(G)**, and in the Catalog panel (press Shift-Tab again to make it visible), click on Previous Import. Then, go under the Photo menu and choose **Delete Rejected Photos**. This displays just the photos you've marked as Rejects, and a dialog appears asking if you want to remove them from Lightroom. Go ahead and click on the Delete from Disk button to remove them from your hard drive.

Step Six:

Now to see just your Picks (and hide the rest), click back on your Full Shoot collection in your Lisbon collection set, and make sure the Filmstrip along the bottom is visible. Near the top right of the Filmstrip, you'll see the word "Filter," and to the right of it are three grayed-out flags. To see just your Picks, click twice on the first flag (the white one), and it will display just your Picks. By the way, you only have to click twice like that the first time you use it, and just in case you were curious, clicking the center flag would display just the images you didn't flag.

TIP: Use the Other Picks Filter

You can also choose to see just your Picks, Rejects, or your unflagged photos from the Library Filter bar that appears across the top of the center preview area (if you don't see it, just press the **\ [backslash] key** on your keyboard). Just click on Attribute and a bar pops down. Click on the white Pick flag, and now just your Picks are visible.

Step Seven:

Now that only your Picks are visible, press **Command-A (PC: Ctrl-A)** to select all the currently visible photos (your Picks), and then let's put them into a collection. Press **Command-N (PC: Ctrl-N)**—that's the keyboard shortcut to create a new collection (well, to bring up the Create Collection dialog anyway), and this is a good one to know because you're going to create a *lot* of new collections. When the Create Collection dialog appears, name this collection "Picks" and, of course, you are going to choose to put this in that same Lisbon collection set, because these are the Picks from that shoot, so choose Lisbon from the Inside a Collection Set pop-up menu (if it's not already selected for you), leave the Include Selected Photos checkbox turned on (we always leave that on), and click Create. So, where are we now in this process? Inside our Travel collection set, we have a collection set named Lisbon, and inside of that we have a regular collection called "Full Shoot" and one called "Picks." We're almost there.

Step Eight:

Within our Picks collection, there are some shots that really stand out—the best of the best, the ones you actually will want to email to the client, or print, or add to your portfolio. So, we need to refine our sorting process a little more to find our best shots from this group of keepers—our "Selects." We're already done with our Pick flags since all our Picks are already in their own collection. So, we could just select all the photos in our Picks collection and press the letter U to unflag them all (as seen here), and then we could use the Pick flags all over again to narrow our Picks down to the best-of-the-best (our Selects). But what if, instead, we use that 5-star rating we've been saving for just such an occasion? Doing this will come in really handy later (when we get into smart collections) and those Pick flags won't help us then (more on this later).

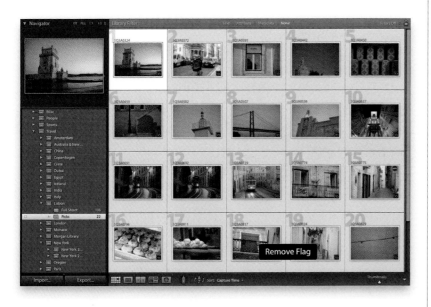

Continued

Step Nine:

So, we're going with just using the 5-star rating for separating our very best shots from the Picks—our "good shots" (you'll be glad later that you did it this way). Okay, now we're looking for our best-of-the-best shots from our shoot (again, I call these our "Selects"). Getting to these Selects is when we really take our time. We get much pickier (no pun intended) about which photos make the cut, and we don't zoom through the images (and we don't have to, because we're starting with our Picks and it should be a much smaller number of images than our full shoot). In your Picks collection, double-click on the first photo (the first thumbnail in the top-left corner) to make it larger (take it into Loupe view), press **Shift-Tab** (or go full screen), and let's start finding our 5-star images.

Step 10:

Start going through your images, and when you see a shot that's really good (one that you might fully edit, share online, send to the client, etc.), just press the number **5** on your keyboard, and you'll see "Set Rating to 5" appear onscreen (if you're in full-screen mode, you'll see five stars appear across the bottom of the screen. Not the words "5 stars," you'll actually see five stars).

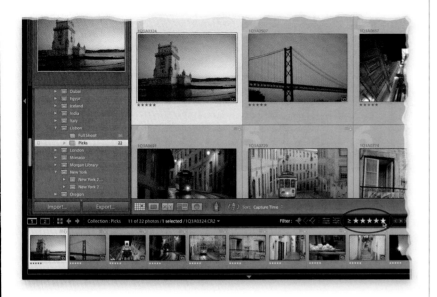

Step 11:

Once you've carefully made your choices on which Picks should be your 5-star images, it's time to put them in our third and final collection. But first, we have to see only those 5-star images. So, go to the Filmstrip again, and to the right of the Pick flags, you'll see five grayed-out stars. Click-and-drag your cursor from left to right to highlight all five stars (as shown here), and it filters out everything else, leaving your 5-star-rated images visible. You probably know what to do from here: select all and press Command-N (PC: Ctrl-N) to create a new collection, name it "Selects," and save it inside the Lisbon collection set.

Step 12:

Now, if you look in your Lisbon collection set, you'll see three individual collections: (1) Full Shoot, (2) Picks, and (3) Selects. From here on out, you'll probably just work with your Selects collection, and that's okay—those are your best images from the Lisbon shoot. If you need extra images (maybe for a photo book or slide show), you'd look in your Picks, because those are still at least "good shots." Okay, now that you know the routine, what would a portrait shoot's collection set look like? It would be in my Portraits collection set, named with my subject's name (like "Allison's Headshots"), and inside that collection set, you'd find three collections: Full Shoot, Picks, and Selects. What if it was a landscape shoot from Yosemite? Then, it would be in my Landscapes collection set, inside a collection set named "Yosemite," and inside that Yosemite collection set would be three collections: Full Shoot, Picks, and Selects. It doesn't matter what the topic is, each shoot breaks down the same way—Full Shoot, Picks, and Selects. Keep it consistent like this and the process gets really quick (and you'll be able to find anything really quickly).

Two Tools to Help You Find Your Best Shots: Survey and Compare View

Sometimes it's tough getting down to just a few shots that are your best of the best—especially if the shots look very much alike (like from a portrait shoot). But, there are two tools built into Lightroom that can help make the process easier: they are Survey view and Compare view.

Step One:

I use Survey view when I have a number of shots that are similar (like a number of shots of the same basic pose) and I'm trying to find the best ones from that group. You enter Survey view (seen here) by selecting the similar photos (click on one, then press-and-hold the Command [PC: Ctrl] key and click on the others— I selected a group of six images here), and then pressing the letter **N** on your keyboard. While it's hard picking which images from a similar set of shots are the best ones, it's much easier picking which ones from a set you like the least. That's what Survey view is all about—the process of elimination. See which image you like the least, then move your cursor over it and an "X" appears in the bottom-right corner (as shown here).

Step Two:

Click on that X to remove that image from screen. It doesn't delete it, and it doesn't remove it from the collection or anything like that, it literally just removes it from the screen for now (as seen here, where there are now just five images left onscreen). Then, do the same for the next image you like least, and the next, and so on, clicking on that X in the bottom-right corner of any image you don't like, and it's removed from the screen.

Step Three:
Here, I'm down to just three images. If you like all three, you could mark them all as 5-star images, or continue on, and when there's only one left, that's the shot that made it through (in this case) all six rounds of elimination. Press the number **5** on your keyboard to mark it as a 5-star image for your Selects collection. Another method for narrowing things down is using Compare view. Instead of putting a bunch of images onscreen at once, it's more like a head-to-head battle between two images at a time. Press **Shift-Tab** to hide all the panels, then start by selecting the group of images you want to narrow down, and press the letter **C** to enter Compare view. This puts one image on the left, called the "Select," and one on the right, called the "Candidate" (as seen below).

Step Four:
At the end, whichever image winds up as the Select is your favorite, but for now (when you first start), you need to decide which of these two you like better. If you like the image on the left (the Select) better than the one on the right (the Candidate), press the **Right Arrow key** on your keyboard. The Select image stays the same, but a new Candidate image appears to challenge your current Select. Or, if you like the Candidate better than the Select, click the Swap button (circled here) down in the toolbar, and it moves over to the left to become the Select and a new photo appears as the Candidate. (*Note:* If you don't see the toolbar, press **T**.) That's pretty much it. If you selected seven images to start, when you get to the last image to be compared, it stops there (no more images will appear as the Candidate). It's now down to these last two. If you still think the Select looks best, well, that's your favorite (it beat all the other contenders). If you like that Candidate best, hit the Swap button, then click the Done button in the toolbar to go to Loupe view, where you can then press 5 on your keyboard to mark the winning image as your Select. That's it.

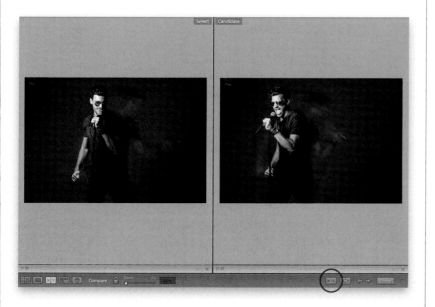

Smart Collections: Your Organizational Assistant

Wouldn't it be awesome to have an assistant that you could assign Lightroom housekeeping tasks to, like "Gather all my 5-star photos from the last 60 days, but only ones that were taken with my 5D Mark IV, and only ones that I shot horizontally, and that have GPS data, and put them in a collection for me automatically"? That's what smart collections do—they gather photos based on a range of criteria you choose, and put them in a collection for you automatically. Like an assistant. Or a magical photo butler. Let's go with that second one.

Step One:

To understand the power of smart collections, let's build one that creates a collection of all your best shots from the last year, and all in horizontal format, so you can create a calendar with your favorite shots as a gift for friends and family (ya know, in lieu of a really good gift ;-). In the Collections panel, click on the + (plus sign) button on the right side of the panel header, and choose **Create Smart Collection** from the pop-up menu. This brings up the Create Smart Collection dialog. In the Name field at the top, name your smart collection (maybe something like, "Best of 2017 for Calendar"), and from the Match pop-up menu, choose **All**, so any criteria we add will be included in our smart collection.

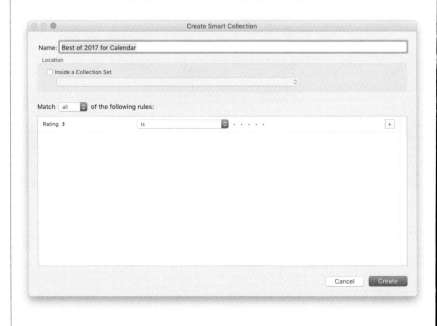

Step Two:

Then, from the pop-up menu beneath that, to the right of "Rating" (that's the default for the first pop-up menu), make sure it's set to **Is**, and you'll see five black dots to the right. Click on the fifth dot and it changes to five stars. If you clicked the Create button at this point, it would create a new collection with every 5-star image in your entire catalog, but let's add another line of criteria, so we get just the 5-stars from 2017. To create another line of criteria, click on the little + (plus sign) button on the far right of those stars. From the first pop-up menu, under Date, choose **Capture Date**, then from the menu to the right of that, choose **Is in the Range**, and then in the text fields that appear, enter "2017-01-01" to "2017-12-31."

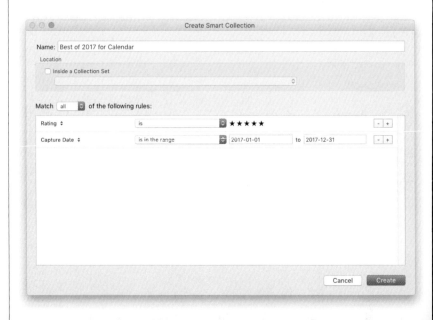

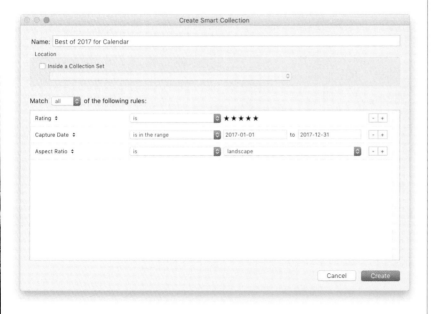

Step Three:

At this point, if you clicked the Create button, you'd have a collection of all your 5-star images from 2017. Pretty handy, but for our calendar, we need all the images to be wide (not tall), so let's add another line of criteria. Click the + button on the far right of the last line of criteria, and from the first pop-up menu, under Size, choose **Aspect Ratio**. From the next menu, choose **Is**, and then from the menu to the right of that, choose **Landscape**. Now, if you click Create, you'd get all your 5-star images from 2017 that are wide, and if you were to import a photo today that matches those criteria, it would be added to that smart collection automatically.

ADVANCED TIP:
Adding Sub-Criteria

If you're looking for even smarter smart collections, press-and-hold the Option (PC: Alt) key and the + button next to a line of criteria changes to the # (number sign) button. Click it, and it adds a sub-criteria line with more advanced options for creating smart collections.

Step Four:

So, when you hit the Create button, it compiles all the photos that match that criteria, puts them in a collection, and adds it to your Collections panel. You'll be able to instantly see which collections are smart collections because they have a little "gear" icon in the bottom-right corner of their collection icon. A couple of things to note: If you decide you want to change, add, or delete any criteria from this smart collection, just double-click on it and it opens the Edit Smart Collection dialog, where you can add (hit the + button) or take away (hit the – button) criteria. Also, smart collections don't have to have this level of depth—they can be "one liners" that compile any photos that don't have your copyright data added, or have a particular keyword (or are missing keywords altogether), or don't have GPS data (you can add missing GPS data—see page 66), so don't think they always have to be these in-depth multi-criteria searches.

Reducing Clutter Inside Your Collections by Using Stacks

One way to simply "de-clutter" any collection is to use Lightroom's Stacking feature, where you use one thumbnail to represent a bunch of photos that pretty much look alike. A great use for this would be when you shoot a pano with a bunch of frames (that look just slightly different) or an HDR, where you took seven frames, but just need one frame to represent all seven (since it's the exact same scene, just brighter or darker). You can do this manually, but you'll love the automatic method even more.

Step One:

Here, we've imported images from a model shoot, and you can see what I was talking about above, where there are several shots that include the same pose (I made the thumbnails really, really small and there are still parts of the shoot that aren't visible). To cut through the clutter of seeing all these similar images, we're going to group similar poses into a stack with just one thumbnail showing (the rest of the photos are grouped behind that photo), but with the number of photos behind it visible right on the thumbnail. Start by clicking on the first photo of a similar pose (as seen highlighted here), then press-and-hold the Shift key and click on the last photo that has the same pose (as shown here) to select them all (you can also select photos in the Filmstrip, if you prefer).

Step Two:

Now press **Command-G (PC: Ctrl-G)** to put all your selected photos into a stack (this keyboard shortcut is easy to remember, if you think of G for Group). If you look in the grid now, you can see there's just one thumbnail visible with that pose. It didn't delete or remove those other photos—they are stacked behind that one thumbnail (in a computery, technical, you'll-just-have-to-trust-that's-what's-happening kind of way). If you look in the top-left corner of that thumbnail, you'll see the number 28 in a small white box. That's letting you know there are 27 similar images stacked behind this one thumbnail.

Step Three:
Here, I selected each set of images of the same pose, pressed Command-G (PC: Ctrl-G) to stack them, and now I'm down to just these five thumbnails, which represent all the images you saw in Step One. Talk about cutting the clutter! The view you're seeing here is called the Collapsed view. To see all the photos in a stack, click on it and press the letter **S** on your keyboard, or you can click on that little number in the top-left corner of each stack's thumbnail, or click on one of the two little thin bars that appear on either side of the thumbnail. (To collapse the images back into the stack, just do any of these again.) To add a photo to an existing stack, just drag-and-drop it right onto the existing collapsed stack. To stop stacking, Right-click on a stack's thumbnail, and from the pop-up menu, under Stacking, choose **Unstack**.

TIP: Pick Your Stack Cover Photo
The first photo you selected when creating a stack becomes the cover thumbnail. To choose a different photo in your stack to be the cover thumbnail, expand the stack, hover over the photo you want, then click on its stack number in the top-left corner. That moves it to the front, and it becomes the new cover image.

Step Four:
Manually stacking takes time, which is why I love having Lightroom do it for me automatically, based on the time photos were taken. Go under the Photo menu, under Stacking, and choose **Auto-Stack by Capture Time** (as shown here). This brings up a dialog with a slider, and it shows how many stacks it would create automatically based on whether you want it to stack images with less time between them (drag left) or more time (drag the slider right). When you click Stack, it looks like nothing happened—that's because the stacks are expanded. To see the tidied up look, go back under the Stacking menu and choose **Collapse All Stacks**.

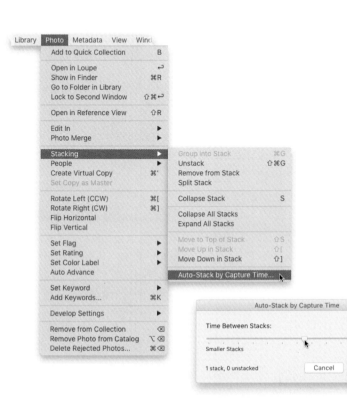

Adding Keywords (Search Terms)

There are a number of pros, including journalists, commercial photographers, and folks who sell their images as stock, who have to add keywords (search terms) as part of their job. For the rest of us, it just takes a lot of time, and it may even be a big waste of time if you're pretty organized, in which case, finding the images you're looking for is quick and easy even without keywords (I don't usually use keywords myself). If you're not organized, keywords are your only hope, and for those folks (and people who just like keywording), here's how to add them:

Step One:

I just want to mention up front that I'm going to start with the keywording basics, as most folks won't need the level of keywording I get into after just a couple of pages. But, if you're a commercial photographer, or if you work with a stock photo agency, keywording all your images is pretty much what you have to do. Luckily, Lightroom makes the process fairly painless. There are a few ways to add specific keywords, and there are different reasons why you might choose one way over another. We'll start with the Keywording panel in the right side Panels area. When you click on a photo, it will list any keywords already assigned to that photo near the top of the Keywording panel (as shown here). By the way, we don't really use the word "assigned," we say a photo's been "tagged" with a keyword, as in, "It's tagged with the keyword NFL."

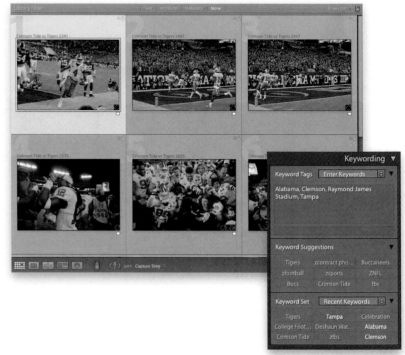

Step Two:

I tagged all the photos here with some kinda generic keywords when I imported them, like Alabama, Clemson, and Raymond James Stadium. To add another keyword, you'll see a text field below the keyword field where it literally reads, "Click here to add keywords." Just click in that field, and type in the keyword you want to add (if you want to add more than one keyword, just put a comma between them), then press the **Return (PC: Enter) key**. So, for the selected photo in Step One, I added the keyword "End Zone." Easy enough.

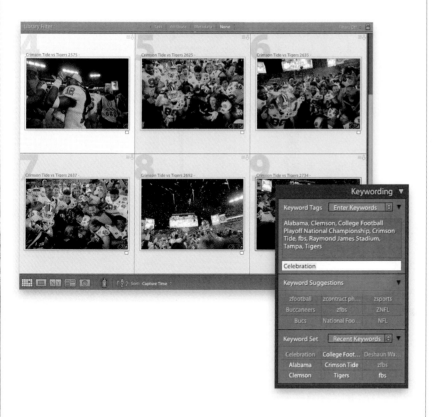

Step Three:
If you want to apply the same keyword(s) to a bunch of photos at once, like 71 photos taken during the celebration, you'd select those 71 photos first (click on the first one, press-and-hold the Shift key, then scroll down to the last one, and click on it to select all the photos in between), then in the Keywording panel, add your keyword(s) in the Keyword Tags text field. For example, here I typed "Cele-bration" and it added that keyword to all 71 selected photos. So, the Keywording panel would be my first choice if I needed to tag a number of photos from a shoot with the same keywords.

TIP: Choosing Keywords
Here's how I'd choose my keywords: I'd ask myself, "If, months from now, I was trying to find these same photos, what words would I most likely type in the Search field?" Then, I'd use those words. It works better than you'd think.

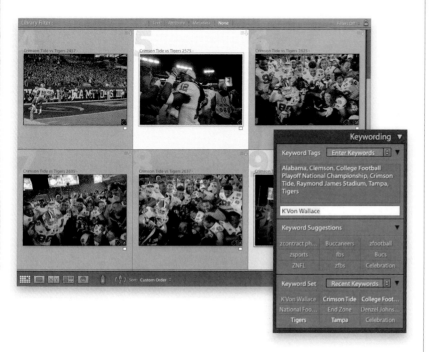

Step Four:
Say you wanted to add some specific keywords to just certain photos, like adding the name of a particular player to shots of just him. You'd Command-click (PC: Ctrl-click) on the photos of him to select them, then use the Keywording panel to add this keyword, and it would add it to just those photos.

TIP: Create Keyword Sets
If you use the same keywords often, you can save them as a Keyword Set, so they're just one click away. To create a set, just type the keywords in the Keyword Tags text field, then click on the Keyword Set pop-up menu near the bottom of the panel. Choose **Save Current Settings as New Preset** and they're added to the list, along with built-in sets like Wedding, Portrait, etc.

Continued

Step Five:

The next panel down, Keyword List, lists all the keywords you've created or that were already embedded into the photos you've imported. The number to the right of each keyword tells you how many photos are tagged with that keyword. If you hover your cursor over a keyword in the list, a white arrow appears on the far right. Click on it and it displays just the photos with that keyword (in the example shown here, I clicked on the arrow for Deshaun Watson, and it brought up the only two photos in my entire catalog tagged with that keyword).

TIP: Drag-and-Drop and Delete Keywords

You can drag-and-drop keywords in the Keyword List panel right onto photos to tag them and vice-versa—you can drag-and-drop photos right onto keywords. To remove a keyword from a photo, in the Keywording panel, just delete it from the Keyword Tags field. To delete a keyword entirely (from all photos and the Keyword List panel itself), scroll down to the Keyword List panel, click on the keyword, then click the – (minus sign) button on the left side of the panel header.

Step Six:

It doesn't take long for your list of keywords to get really long. So, to keep things organized, you can create a keyword that has sub-keywords (like College Football as the main keyword, then inside that is Alabama, Clemson, and so on). Besides having a shorter keyword list, it also gives you more sorting power. For example, if you click on College Football (the top-level keyword) in the Keyword List panel, it will show you every image in your catalog tagged with Alabama, Clemson, etc. But, if you click on Alabama, it will show you only the photos tagged with Alabama. This is a huge time-saver, and I'll show you how to set this up in the next step.

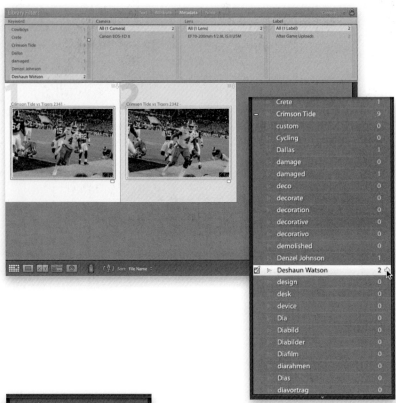

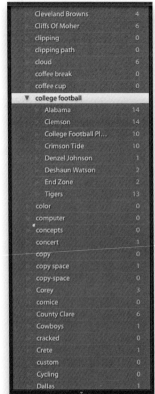

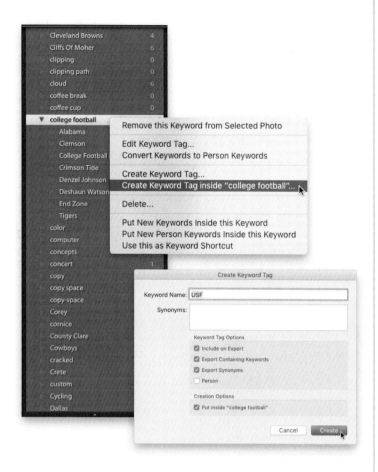

Step Seven:

To make a keyword into a top-level one, just drag-and-drop other keywords directly onto it. That's all you have to do. If you haven't added the keywords you want as sub-keywords yet, do this instead: Right-click on the keyword you want as a top-level keyword, then from the pop-up menu, choose **Create Keyword Tag Inside** (as shown here) to bring up a dialog where you can create your new sub-keyword. Click the Create button, and this new keyword will appear under your main keyword. To hide the sub-keywords, click the triangle to the left of your main keyword.

TIP: "Painting" On Keywords

Another way to add keywords is to paint them on using the Painter tool. Click on the Painter tool down in the toolbar, then from the pop-up menu to its right, choose **Keywords** and a text field will appear to its right. Type in your keyword(s) that relates to particular photos, then click-and-drag that paint can over just those photos you want to have that keyword(s). You'll see a confirmation appear onscreen as they're tagged.

Step Eight:

Besides working in the Keywording and Keyword List panels, once you've tagged your images with keywords, you can then use the Library Filter to search for images by their keyword. For example, if you're looking for shots of a particular player, you can just press **Command-F (PC: Ctrl-F)** and the Text Search field will appear in the top right, above your thumbnail grid. Type in the name of the player, and just the shots of him you tagged with his name will instantly appear in the grid below. Keywords really are just that—search terms. Some you add are generic (like NCAA football), but you can add more specific ones (like Deshaun Watson), as well.

Face Tagging to Find People Fast

Lightroom uses facial recognition software to help you find, and then tag, people easily. When it works, it's pretty helpful, but well…it's still "a work in progress," shall we say? If you're ever depressed and need a good laugh, turn on face tagging and watch it bring up things like a potato, as it asks, "Is this Larry?" Then, a bar of soap, "Is this Larry?" and then plate of scrambled eggs, "Is this Larry?" Sometimes it actually brings up Larry. Okay, it's not quite that bad, but it's not quite that good either. It may be worth using for tagging family members with their names (to use with keywords for searching).

Step One:

First, a heads-up: While we might refer to Lightroom's face tagging as "automatic," it's going to feel more semi-automatic because you do a lot of the initial work yourself. At first, it only recognizes that there's a face in the photo—it doesn't know who it is. That part is up to you, as you have to tell it who it is, so that it can go about its business of mis-assigning that face to the wrong person. So, if you have a decent-sized catalog, and you want your entire catalog set up with face tagging, you might need to set aside a morning to initially set this up. Okay, now that you know that, to start face tagging, go to the Library module and click on the People icon in the toolbar (shown circled here; or choose **People** from the View menu, or just press the letter **O** to jump there fast).

Step Two:

The first time you launch this, you get a screen that lets you know that it takes a while for Lightroom to go through your catalog and search each image for faces (luckily, it does this in the background, so it doesn't stop you from working). But, it does give you a choice: start now and do your entire catalog in the background, or just do it when you actually click the People icon. Choose whichever option you want, and it starts searching for faces. (By the way, as I'm writing this, Lightroom just displayed a lamp post, an archway, and a group of flags for faces. I am not making this up.)

Step Three:

As it finds what it thinks are faces, they'll be displayed in the Unnamed People section with a "?" below each thumbnail showing that it doesn't know whose face that is (which makes sense—you haven't told Lightroom who's who yet). It found some blurry faces of people in the background in some of the photos, which I don't need tagged, along with the face of the cover model on my last Lightroom book, so I would just delete those from People view. To remove faces you don't want tagged, move your cursor over a thumbnail and click the "X" icon that appears in the bottom-left corner of the thumbnail (as seen here in the last thumbnail in the third row). *Note:* It doesn't remove these photos from Lightroom, just from this People view.

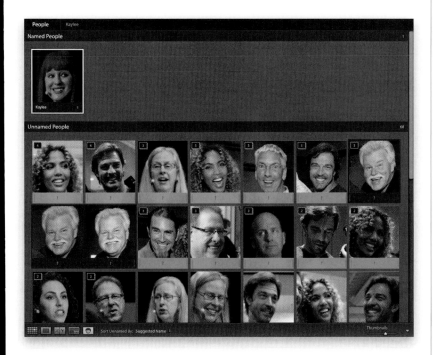

Step Four:

To tag any one of those photos with a name (you're actually tagging them with a special type of keyword used for searching), just click your cursor on the little question mark below the photo, and a text field appears. Type in their name and press the **Return (PC: Enter) key** on your keyboard. Once you tag a face with a name, it moves up top to the Named People section (seen here). If you see faces in the Unnamed People section that match someone in the Named People section up top, you can just drag-and-drop them right on their thumbnail in Named People.

Continued

Step Five:

If it recognize faces that it thinks are the same person, it groups them together in a stack to help keep things tidy. Take a look at the last thumbnail in the top row here— it found three similar faces and it grouped them together (there's a "3" in the top left of the thumbnail). To see the faces in a stack, click on its thumbnail, then press **S** on your keyboard and the stack expands (as seen here for that stack). To collapse it, press S again. To just take a quick peek inside a stack, press-and-hold the S key to see inside, then when you release that key, it collapses back again. If this stack appears in Unnamed People, click your cursor on the question mark below the thumbnail, so you can click and type in that person's name (that's Moose Peterson in those photos, so I tagged the first one "Moose"). After a few minutes, it will start "catching on" and a you'll start to see names followed by a question mark, like this: "Julieanne?" If it is her, click the checkmark button (as shown here at the bottom) and it moves that to her thumbnail up in Named People. If it's not, click the "No!" symbol. Also, once you tag someone, give Lightroom a minute or two to find and tag other similar faces. It learns as it goes.

Step Six:

At this point, we're at the stage where it has found all the faces it can find, and grouped the ones it thinks are the same person, and you're still left with a whole bunch of Unnamed People. So, it's now up to you to name them or drag-and-drop unnamed faces onto the proper thumbnails up in the Named People section. You'll see a green + (plus sign) appear when you're over the named thumbnail, letting you know that you're adding this face to that tag. This could be a quick process, or a long one, depending on which option you chose in Step Two (the full catalog or just the collection you're in). Either way, it's on you at this point to do the rest of the work.

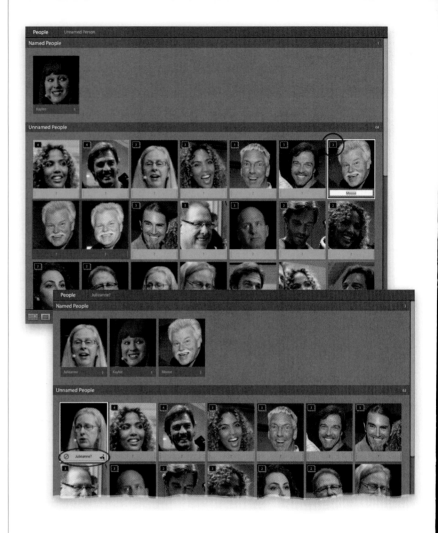

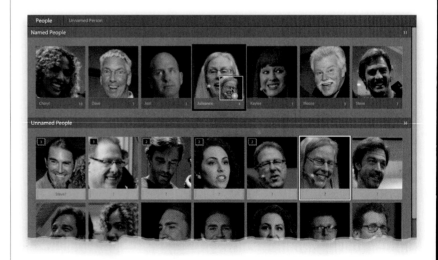

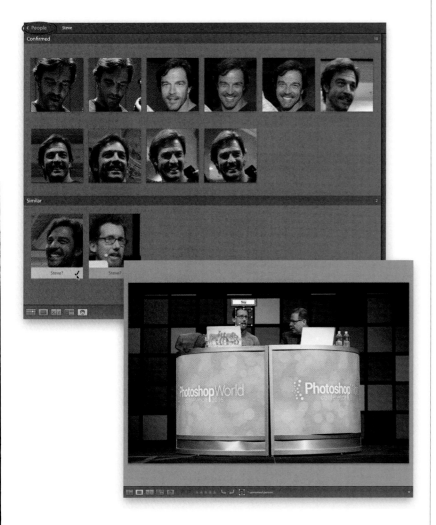

Step Seven:

If you double-click on a tagged photo in the Named People section, it takes you to the Confirmed section, which shows you which photos are confirmed to be that person. In the Similar section below, it shows you other photos it thinks may be that person (if you move your cursor over a thumbnail, a question mark appears after the person's name, as seen here. Expect this to happen pretty frequently). To confirm it's Steve, click on the checkmark, and that image moves up to the Confirmed section. Lightroom now uses that information to present other images, "How about these? These look similar, right?" Um. No. That's Trey in the Similar section. That's okay, because you can just return to People view by clicking on the word "People" in the top-left corner (shown circled here in red) and keep tagging other images. What happens if you double-click on an untagged photo? It opens the photo in a large Loupe-view-sized window and displays a rectangle around the region it thinks is a face. Click on the question mark and type in who that is. Also, you can create a new region over a face it missed, by simply clicking-and-dragging over a face. To remove an errant "face region," click on its little "X."

Step Eight:

Once you've got these people keywords applied, they work like regular keywords to help you find tagged images fast. Just go to the Keyword List panel (in this case, we're looking for images I tagged with "Moose"), and when you move your cursor over the Moose keyword, an arrow appears to its right. Click on that, and it now displays just those images that are tagged with "Moose." You can also search using the standard old **Command-F (PC: Ctrl-F)** text search by typing in the name of the person you're trying to find and they'll come right up.

Renaming
Your Photos

If you didn't rename your photos when you imported them from your camera's memory card, it's really important (for searching purposes, if nothing else) that you rename them now with descriptive names (we name collections, sets, photos—everything—with descriptive names). If all you have are the numeric names assigned by your camera, like "_DSC0035.jpg," your chances of finding your images using a text search are pretty dim. Here's how to rename your photos to something that makes sense (and makes searching easy):

Step One:
Press **Command-A (PC: Ctrl-A)** to select all of the photos in your current collection, then go under the Library menu and choose **Rename Photos**, or press **F2** on your keyboard to bring up the Rename Photos dialog (shown here). From the File Naming pop-up menu, choose whichever preset you want to use. I always use the Custom Name - Sequence preset, which lets you type in a custom name, and then it starts automatically numbering each image, starting with whatever number you like (I generally choose to start with the number 1). That's all there is to it.

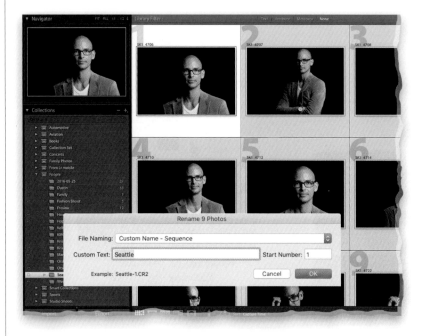

Step Two:
Now just click OK, and all the photos are renamed in an instant. This whole process takes just seconds, but makes a big difference when you're searching for photos—not only here in Lightroom, but especially outside of Lightroom in folders, in emails, etc., plus it's easier for clients to find photos you've sent them for approval.

To make finding our photos easier, we gave them descriptive names (either when we imported them, or when we renamed them afterward), and because we did that simple step, searching for our images by name is a breeze (of course, we can search by more than the name—we can search by everything from your camera's make and model, to the lens you used, and more).

Finding Photos Using a Simple Search

Step One:

Before you start searching, first you need to tell Lightroom where you want it to search. If you want to search just within a particular collection, go to the Collections panel and click on that collection. If you want to search your entire photo catalog, then look down on the top-left side of the Filmstrip and you'll see the path to the current location of the photos you're viewing. Click-and-hold on that path and, from the pop-up menu that appears, choose **All Photographs** (some other choices here are to search the photos in your Quick Collection, your last import of photos, or any of your recent folders or collections).

Step Two:

Now that you've chosen where to search, the easiest way to start a search is to use a familiar keyboard shortcut: **Command-F (PC: Ctrl-F)**. This brings up the Library Filter bar across the top of the Library module's Grid view. Chances are you're going to search by text, so just type in the word(s) you're searching for in the search field, and by default it searches for that word everywhere it can—in the photo names, in any keywords, captions, embedded EXIF data, you name it. If it finds a match, those photos are displayed (here, I searched for "Bucs vs Raiders"). You can narrow your search using the two pop-up menus to the left of the search field. For example, to limit your search to just captions, or just keywords, choose those from the first pop-up menu.

Continued

Step Three:

Another way to search is by attribute, so click on the word Attribute in the Library Filter and those options appear. Earlier in this chapter, we used the Attribute options to narrow things down to where just our Picks were showing (you clicked on the white Pick flag), so you're already kind of familiar with this, but I do want to mention a few other things: As for the star ratings, if you click on the fourth star, it filters things so you just see any photos that are rated four stars or higher (so you'd see both your 4-star and 5-star images, but of course I'm hoping you're following the system and not using any 4-star ratings at all). If you want to see your 4-star rated images only, then click-and-hold on the ≥ (greater than or equal to) sign that appears to the immediate right of the word Rating, and from the pop-up menu that appears, choose **Rating Is Equal to**, as shown here. You can also now use the Library Filter to see photos based on whether they've been edited yet using the Edits icons to the left of the star ratings.

Step Four:

Besides searching by text and attributes, you can also find the photos you're looking for by their embedded metadata (so you could search for shots based on which kind of lens you used, or what your ISO was set to, or what your f-stop was, or a dozen other settings). Just click on Metadata in the Library Filter, and a series of columns will pop down where you can search by date, camera make and model, lenses, or labels (as shown here). However, I have to tell you, if the only hope you have of finding a photo is trying to remember which lens you used the day you took the shot, you've done a really lame job of naming your files with descriptive names. This should truly be your "search of last resort."

Your camera doesn't need GPS to do this—in fact, you'll learn two easy ways to use this feature without even having GPS. But, if your camera does have built-in GPS, Lightroom places your images on a world map for you, automatically, behind the scenes without you even asking. Pretty amazing stuff! Next thing you know, they'll put a man on the moon and people will be driving around in electric cars.

Lightroom is Automatically Organizing Your Images on a Map

Step One:
If you've imported any photos that were taken with a camera that has built-in (or add-on) GPS, click on one of those photos, then in the Library module, go to the Metadata panel in the right side Panels area. Near the bottom of the EXIF section, you'll see a metadata field labeled GPS with the exact coordinates of where that shot was taken (shown circled here in red). Click on the little arrow that appears to the far right of the GPS field.

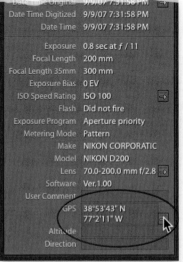

Step Two:
When you click on that little arrow, Lightroom takes you over to the Map module and displays a full-color satellite image with a pin at the exact location you were standing when you took the shot. How cool is that?! It's not just this one shot that's organized on the map—Lightroom automatically adds all your GPS-tagged shots to the map for you, so now you can find images by their location on the map, instead of just by name or keyword. To see all the photos represented by that little pin, hover your cursor over it and a preview window pops up that shows you a thumbnail of the first image. (By the way, if you double-click on the pin, the preview window pops up and stays.) To see more photos, just click the left and right arrows on the sides of the preview window (or you can use the **Left/Right Arrow keys** on your keyboard).

Map Organizing Even If Your Camera Doesn't Have GPS

There are two ways to add your photos to the global map, at the right location, without having GPS built-in to your camera. The first method gets your photos very close to the right location, and the second uses a clever trick to get your photos to the exact GPS location.

Step One:

The first method is to simply search the map and find the location where you took the shot (either with a simple city/country search for a general location, or by searching for an exact place or monument, like the Eiffel Tower in Paris or Rockefeller Center in New York City). You do this in the top-right corner of the Map module—in that Search field, type in the location you're looking for and a pin appears marking that location (here, I searched for Venice, Italy). *Note:* Lightroom's Map module uses a special version of Google Maps, so you'll have to be connected to the Internet for this GPS/map feature to work.

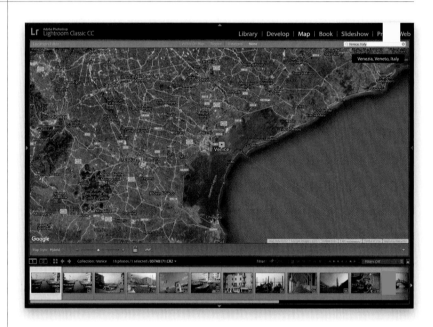

Step Two:

Now, in the Filmstrip along the bottom, select the images you took at that location, and then drag-and-drop them directly onto that pin on the map. Not only does it add those photos to the map, it also embeds that exact GPS data directly into the images (as seen here, circled in red). There's another method that's a bit more accurate, but you'll have to do a little trick to get the exact GPS coordinates without having GPS in your camera.

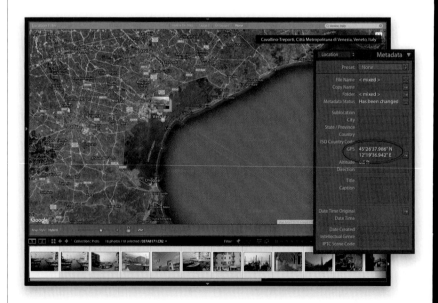

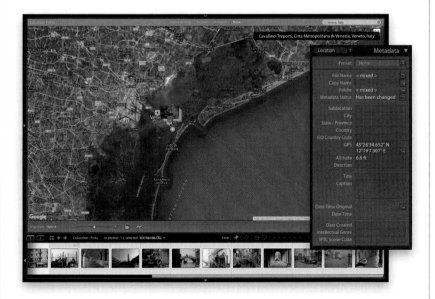

Step Three:

The second method starts while you're still at the location shooting. Before you leave, take one photo with your phone's camera. Your cell phone has built-in GPS, so that one shot will have the GPS coordinates embedded in it (if you have this feature turned on). Once you import the photos from your camera into Lightroom, import that one shot from your cell phone, too, because we're going to use its location on the map to add our non-GPS images to the map, as well.

TIP: Saving Your Favorite Locations

You can name any pin as a favorite location, so you can get back to it on the map without searching. First, click on a pin, then go to the Saved Locations panel (in the left side Panels area) and click the + (plus sign) button on the right side of the panel header. Give this location a name, then use the Radius slider to determine how far out you want other nearby photos tagged with that same location. As you drag the slider, it visually shows the radius as a white circle on the map, so you can see the area being covered. Turning on the Private checkbox tells Lightroom to strip out your GPS data if you save these files outside of Lightroom. Click Create, and this location is added to your Saved Locations panel.

Step Four:

Drag that cell phone photo into the same collection as your camera shots. Click on it, then go to the Metadata panel, down to GPS data, and click the little arrow to the right. This takes you to the Map module with a pin at the exact location where you took that cell phone photo. Now, go to the Filmstrip, select all the images you took with your regular camera at that location, and drag-and-drop them directly onto that pin where you took that cell phone photo. Not only does it add those camera images to the map, it's also embeds the GPS data directly into all the images.

Making Collections from Locations on the Map

Since now we know that behind-the-scenes Lightroom is automatically adding any of our images that have embedded GPS data to a map of the world, we can use that to make collections from any location. For example, if you see it added a bunch of shots you took in Paris to a tag over Paris in the Map module, you can instantly turn that tag into a collection, and then all those shots from Paris are instantly in a collection. It's almost too easy because Lightroom is pretty much doing all the work for you.

Step One:
Go to the Map module (I chose to view the map in a satellite view, here—you choose these different views from the Map Style pop-up menu in the left side of the toolbar). Here, you can see a pin representing 70 photos I took in Marrakesh, Morocco. Lightroom automatically added these images to the map for me because I had the GPS feature turned on in my DSLR. To put those 70 photos from Marrakesh into a collection, start by Right-clicking on the pin, and from the pop-up menu that appears, choose **Create Collection** (as shown here).

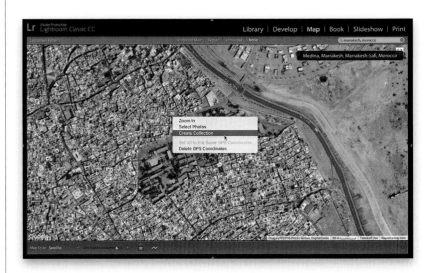

Step Two:
This brings up the Create Collection dialog (seen here) where you can name your new collection (I gave mine a rather obvious name), and of course, all the standard options for creating a new collection are here, including the option to add this new collection to an existing collection set (ya know, putting it under my Travel collection set sounds like a pretty good choice). Click the Create button, and your new collection is created and added to the Collections panel, with just those images from Marrakesh, and Lightroom did all the gathering of those images for you automatically. Not too shabby.

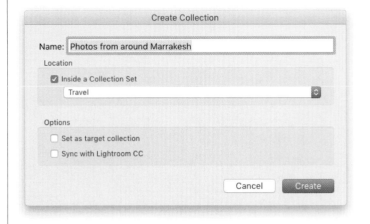

If you work for any amount of time in Lightroom, at some point, you're going to take an image to the Develop module and see the warning "The file could not be found." If you go back to Grid view, you'll see a little exclamation point icon in the top right of the thumbnail, which is telling you that Lightroom can't find the original photo. All this means is that you moved the photo and Lightroom doesn't know where you moved it to, and all you have to do to fix this problem is simply tell Lightroom where you moved it.

Dealing with "The File Could Not Be Found" Message

Step One:
In the thumbnails shown here, you can see one of them has a little exclamation point icon, letting you know Lightroom can't find the original high-resolution photo (so it only has this low-res thumbnail). If you took this photo over to the Develop module, you'd see the dreaded "The file could not be found" warning appear near the top of the image. This usually means that either (a) you moved the photo to another location, so Lightroom has lost track of it (nothing wrong with that—you should be able to move your photos wherever you want, right?), or (b) the original photo is stored on an external hard drive and that drive isn't connected to your computer right now, so Lightroom can't find it. Either way, it's a pretty easy fix, but first let's figure out which of those two scenarios it is.

Step Two:
To find out where the missing photo was last seen, click on that little exclamation point icon and a dialog will pop up telling you it can't find the original file (which you already knew), but more importantly, under the scary warning it shows you its previous location (so you'll instantly be able to see if it was indeed on a removable hard drive, flash drive, etc., or if you moved the file from where Lightroom last saw it).

"Morocco 6.jpg" could not be used because the original file could not be found. Would you like to locate it?

Previous location: /Volumes/External Hard Drive/Lightroom Photos/Travel/Lisbon/Finals/Morocco 6.jpg

Cancel Locate

Continued

Step Three:

Click on the Locate button, and when the Locate dialog appears (shown here), navigate your way to where that photo is now located. (I know you're thinking to yourself, "Hey, I didn't move that file!" but come on—files just don't get up and walk around your hard drive. You moved it—you just probably forgot you moved it, which is what makes this process so tricky.) Once you find it, click on it, then click the Select button, and it relinks the photo. If you moved an entire folder, then make sure you leave the Find Nearby Missing Photos checkbox turned on, so that when you find any one of your missing photos, it will automatically relink all the missing photos in that entire folder at once, and you can then edit your photos in the Develop module once again.

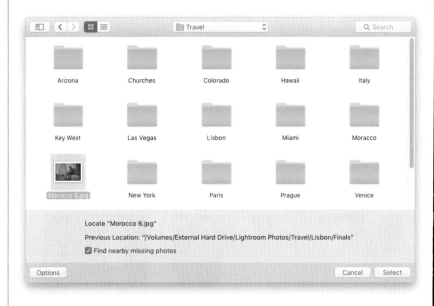

TIP: Keeping Everything Linked

If you want to make sure that all your photos are linked to the actual files (so you never see the dreaded exclamation point icon), go to the Library module, and under the Library menu up top, choose **Find All Missing Photos**. This will bring up any photos that have a broken link in Grid view, so you can relink them using the technique we just learned here.

NOTE: If You Work in Folders

If you use folders instead of collections (don't get me started), and the folder is grayed out with a question mark in the right corner of the folder icon, it's the same scenario: you either moved that folder of images, or the drive it's on is disconnected. Right-click on that folder in the Folders panel and choose **Find Missing Folder**. Then, navigate to its new location, choose it, and now Lightroom knows where this missing folder is located. If you can't find this folder anywhere, it's possible that you accidentally deleted it, or its contents (which is a big reason you shouldn't be working in folders in the first place), in which case, here's hoping you have a backup of it someplace.

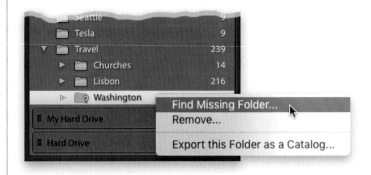

I mentioned earlier that you don't need to organize your photos by date, because Lightroom is actually already doing this for you automatically behind-the-scenes, using the exact time, day, month, and year embedded in the image file by your camera. Here's how to see your entire library organized by date:

Lightroom Is Automatically Organizing Your Photos by Date Behind the Scenes

Step One:
In the Library module, along the top of the Preview area is the Library Filter (if you don't see it, press the **\ [backslash] key** on your keyboard to bring it up). This searches based on where you're currently working in Lightroom (so if you're currently in a collection, it shows the details of what's in that collection), so go to the Catalog panel (near the top of the left side Panels area) and click on All Photographs, so we're looking at our entire catalog of images and not just one collection. There are four tabs across the top. Click on the Metadata tab, and it brings up four data columns: The first one on the left is your catalog sorted by Date, starting with the earliest year you have photos for in Lightroom.

Step Two:
To see the images taken in a particular year, click the right-facing arrow to the left of the year (in this case, I'm clicking on 2016), and it shows you each month in that year that I took a photo, and how many photos were taken in that particular month. Click on the arrow to the left of a month, and it displays all the days of that month represented by photos, along with the day of the week they were taken (helpful if you know the photos you're looking for were taken on a weekend) and the number of photos taken on that day. Click on one of those days, and the photos taken on that date are displayed in the grid below.

Continued

Step Three:

Did you notice that the other three columns to the right dynamically update to show you even deeper data on those photos? For example, I clicked on Monday, May 16, 2016, and in the second and third columns, it shows me which camera(s) I used to take the photos on that day, and it breaks down which lenses I used for each as well, so I can filter things down by camera make and model, or by lens used on that particular date. This is handy if you know you used a particular lens in the shot you're searching for (maybe you remember it was a fisheye shot, or maybe taken with a tilt-shift or a macro lens).

TIP: Searching by
Multiple Criteria

If you Command-click (PC: Ctrl-click) on more than one of the three search options in the Library Filter, they're additive. So, you could Command-click on Text, then Attribute, then Metadata, and they just pop down one after another. Now you can search for a photo with a specific keyword, that's marked as a Pick, with a Red label, that was taken at ISO 100, with a Canon EOS 5D Mark IV, using a 24–70mm lens, and is in Landscape (wide) orientation (and the results appear below it). You can even save these criteria as a search preset from the pop-up menu on the far right.

Step Four:
The last column is set to Label, by default, and shows you if any color labels were assigned to these photos, but if you click-and-hold directly on the column header "Label," you can choose from a long list of search attributes that might be more helpful to you (especially if you don't use color labels). You can change any of these four headers to search by whichever criteria you'd like.

Backing Up Your Catalog (This Is VERY Important)

All the sorting into collections, all the Develop module edits, all the copyright info, keywords, and stuff you do to your photos in Lightroom is stored in your Lightroom catalog file. As you might imagine, this is one incredibly important file, and if for some reason or another, one day you open up your catalog and get a warning that it has become corrupted, if you don't have a backup, you will be starting over from scratch. The good news is Lightroom will back up your catalog for you, and even ask you to do it, but you have to tell it to. Here's how:

Step One:

When you quit Lightroom, you'll notice that from time to time it will bring up the Back Up Catalog dialog, giving you the opportunity to make a backup of your all-important catalog (it has all your edits, sorting, metadata, Pick flags, etc., stored in its database). At the top, it even has a pop-up menu where you can choose how often to bring up this dialog, giving you the opportunity to back up from once a day to once a month (I would choose how often to back up based on how many days of work you're willing to lose if your catalog did become corrupt, and you had to use a backup catalog). By default, it stores this backup in a folder called (wait for it…wait for it…) "Back-ups" inside the Lightroom folder where your regular catalog is stored on your computer. *Note:* Even though you store your photos on an external hard drive, for the best performance, you should store your catalog right on your computer (we covered this back on page 36).

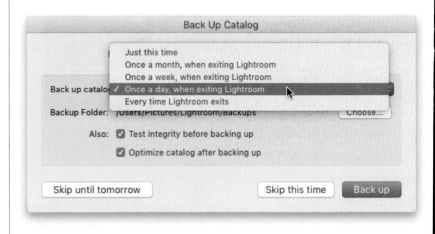

Step Two:

If you want, you can change the location where your backup catalog is stored (maybe to your external drive or to a cloud backup, in case your computer was to get stolen, so you'd still have a working backup). I leave the two Also checkboxes turned on just for good housekeeping.

Step Three:

So, what do you do if "the unthinkable" happens: you launch Lightroom one day, and you get a warning dialog letting you know that your catalog is "...corrupt and cannot be used or backed up until it is repaired"? Well, first you'd click the Repair Catalog button, and say a few prayers, and with any luck at all it will fix whatever was wrong with your catalog, and you're back up and running. But, what if, for whatever reason, you get the dialog seen here at bottom and it can't repair your catalog? Well, we go to Plan B.

TIP: Why You Might Not Need to Back Up At All

If you have an automated backup for your entire computer (I use Apple's Time Capsule for daily complete backups), then you may not need this Lightroom backup catalog because you already have a backup catalog on your backup computer hard drive.

Step Four:

Plan B is to restore your latest backup copy of your catalog. Here's how: In the "I can't repair your catalog" second warning dialog, click the Choose a Different Catalog button, and when the catalog chooser dialog appears (I have no idea if that's its proper name, by the way), click on Create New Catalog. You're doing this just so you can access Lightroom's menus (without a catalog open, you can't get to those menus), so name it "Trash Me," or whatever (it's just temporary). Once it opens this empty catalog, go under Lightroom's File menu and choose **Open Catalog**. In the dialog, navigate to your Backups folder (wherever you chose to save it in Step Two), and you'll see all your backups listed in folders by date and 24-hour time. Open the folder for the most recent backup, double-click on the .lrcat file (that's your backup), click the Open button, and you're back in business.

ADVANCED STUFF
that next level of importing & organizing

Editions of this book have been around for 11+ years, but this is the first one to have a separate advanced importing and organization chapter. I think by doing this I have created an entirely new genre of Lightroom braggadocio. Just imagine how reading this chapter could play out for you. You're out one night attending a gala Lightroom charity ball, and you're making your entrance on the red carpet (point of order: at Lightroom events like this, technically, it is always a neutral gray carpet, but for the TV viewers watching at home, E! and ABC still refer to it as a "red carpet"). Of course, the TV hosts wave you over to ask the usual questions: "Who designed that gorgeous outfit?" "Where's that stunning necklace from?" And, "How much is too much Clarity on a typical landscape image?" The usual stuff. You answer their questions with a casual grace and elegance, as a passing waiter hands you a glass of champagne. It's at that moment—when all eyes are upon you, as you're looking radiant in your Schiaparelli haute couture gown and Sergio Rossi shoes—that you breezily turn to the hosts and say, "Tonight's really not about me…I'm just happy to be supporting the great work of the charity, helping raise money for these wonderful kids, and of course, staying focused on my advanced importing and organizational work in Lightroom." Trust me, at that moment, it will be as if all the oxygen has been sucked out of the room. Children will start crying, guests will be fainting, entire plates of ginger-soy-glazed mahi mahi will crash to the ground. It's because, single-handedly, you just created a major seismic shift in the Lightroom upper echelon, and there won't be a person in that room who doesn't realize what they just witnessed. It will be just as the Oracle had prophesied: you are "The Advanced One."

Shooting Tethered (Go Straight from Your Camera, Right Into Lightroom)

One of my favorite features in Lightroom is the built-in ability to shoot tethered (shooting directly from your camera into Lightroom), without using third-party software, which is what we used to do. The advantages are: (1) you can see your images much bigger on your computer's screen than on that tiny LCD on the back of the camera, so you'll make better images; and (2) you don't have to import after the shoot—the images are already there. Warning: Once you try this, you'll never want to shoot any other way.

Step One:
The first step is to connect your camera to your computer using that little USB cable that came with your camera. (Don't worry, it's probably still in the box your camera came in, along with your manual and some other weird cables that come with digital cameras. So, go look there for it.) Go ahead and connect your camera now. In the studio, and on location, I use the tethered setup you see here (which I learned about from world-famous photographer Joe McNally). The bar is the Tether Tools Rock Solid 4-Head Tripod Cross Bar, with the TetherTable Aero attached, along with the Aero Secure-Strap and TetherPro USB cable.

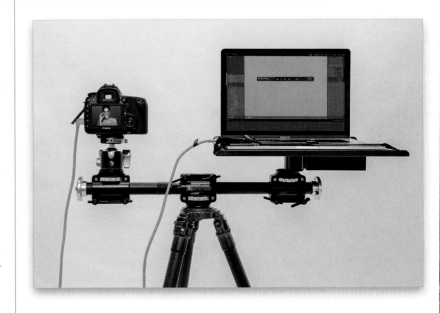

Step Two:
Now go under Lightroom's File menu, under Tethered Capture, and choose **Start Tethered Capture**. This brings up the dialog you see here, where you enter pretty much the same info as you would in the Import window (you type in the name of your shoot at the top in the Session Name field, and you choose whether you want the images to have a custom name or not. You also choose where on your hard drive you want these images saved, and if you want any metadata or keywords added—just like usual). However, there is one important feature here that's different—the Segment Photos By Shots checkbox (shown circled in red here)—which can be incredibly handy when you're shooting tethered (as you'll see).

Step Three:

The Segment Photos By Shots feature lets you organize your tethered shots as you go. So, let's say you're doing a location shoot, and you're shooting in two different locations there: one by a window, and the other outside. You can separate each of these locations into its own folder by clicking the Shot Name (this will make more sense in a moment). Try it out by turning on the Segment Photos By Shots checkbox and clicking OK. When you do this, a naming dialog appears (shown here), where you can type in a descriptive name for your first shoot.

Step Four:

When you click OK, the Tethered Capture window appears (seen here). If Lightroom sees your camera, its model name will appear on the left (if you have more than one camera connected, you can choose which one to use by clicking on the camera's name and choosing from the pop-up menu). If Lightroom doesn't see your camera, it'll read "No Camera Detected," in which case you need to make sure your USB cable is connected correctly, and that Lightroom supports your camera's make and model. To the right of the camera's model, you'll see its current settings, including shutter speed, f-stop, and ISO. To the right of that, you can apply a Develop module preset (see Chapter 7 for more on those, but for now, leave it set at None).

TIP: Hiding or Shrinking the Tethered Capture Window

Press **Command-T (PC: Ctrl-T)** to show/hide it. If you want to keep it onscreen, but you want it smaller (so you can tuck it to the side of your screen), press-and-hold the Option (PC: Alt) key and the little X in the top right that you'd click on to close the window changes into a – (minus sign). Click on that and the window shrinks down to just the shutter button. To bring it back full size, Option-click (PC: Alt-click) in the top right again.

Continued

Step Five:

The round button on the right side of the Tethered Capture window is actually a shutter button, and if you click on it, it'll take a photo just as if you were pressing the shutter button on the camera itself (pretty slick). When you take a shot now, in just a few moments, the image will appear in Lightroom. The image doesn't appear quite as fast in Lightroom as it does on the back of the camera, because you're transferring the entire file from the camera to the computer over that USB cable (or wireless transmitter, if you have one connected to your camera), so it takes a second or two. Also, if you shoot in JPEG mode, the file sizes are much smaller, so your images appear in Lightroom much faster than RAW images. Here's a set of images taken during a tethered shoot. The problem is if you view them in the Library module's Grid view like this, they're not much bigger than the LCD on the back of your camera. *Note:* Canon and Nikon react to tethering differently. For example, if you shoot Canon, and you have a memory card in the camera while shooting tethered, it writes the images to your hard drive and the memory card, but Nikons write only to your hard drive.

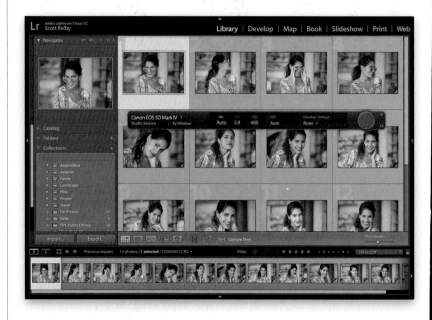

Step Six:

Of course, the big advantage of shooting tethered is seeing your images really large (you can check the lighting, focus, and overall result much easier at these larger sizes, and clients love it when you shoot tethered when they're in the studio, because they can see how it's going without looking over your shoulder and squinting to see a tiny screen). So, double-click on any of the images to jump up to Loupe view (as shown here), where you get a much bigger view as your images appear in Lightroom. (*Note:* If you do want to shoot in Grid view, and just make your thumbnails really big, then you'll probably want to go to the toolbar and, to the left of Sort Order, click on the A–Z button, so your most recent shot always appears at the top of the grid.

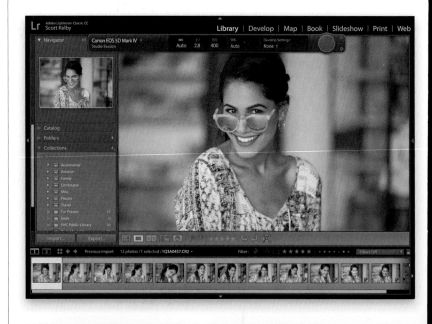

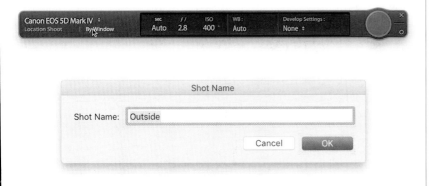

Step Seven:
Now let's put that Segment Photos By Shots feature to use. Let's say you finish this round of shots with your subject near the window and now you're going to shoot outside. Just click directly on the words "By Window" in the Tethered Capture window (or press **Command-Shift-T [PC: Ctrl-Shift-T]**) and the Shot Name dialog appears. Give this new set of shots a name (I named mine "Outside"), and then go back to shooting. Now these images will appear in their own separate folder, but all within my main Location Shoot folder.

TIP: Shortcut for Triggering Tethered Capture
You can trigger a tethered capture by pressing **F12** on your keyboard.

Step Eight:
When I'm shooting tethered, rather than looking at the Library module's Loupe view, I switch to the Develop module, so if I need to make a quick tweak to anything, I'm already in the right place. Also, when shooting tethered, my goal is to make the image as big as possible onscreen, so I hide Lightroom's panels by pressing **Shift-Tab**, which enlarges the size of your image to take up nearly the whole screen. Then lastly, I press the letter **L** twice to enter Lights Out mode (see page 92 for more on this), so all I see is the full-screen-sized image centered on a black background, with no distractions (as shown here). If I want to adjust something, I press L twice, then Shift-Tab to get the panels back.

Using Image Overlay to See If Your Images Fit Your Layout

This is one of those features that once you try it, you fall in love with it, because it gives you the opportunity to make sure an image you're shooting for a specific project (like a magazine cover, brochure cover, inside layout, wedding book, etc.) looks and fits the way you want it to, because you get to see the artwork as an overlay in front of your image as you're shooting tethered. This is a big time and frustration saver, and it's simple to use (you just need a little tweaking in Photoshop to set up your artwork).

Step One:
You'll need to start in Photoshop by open-ing the layered version of the cover (or other artwork) you want to use as an overlay in Lightroom. The reason is this: you need to make the background for the entire file transparent, leaving just the type and graphics visible. In the cover mock-up we have here, the cover has a solid gray background (of course, once you drag an image in there inside of Photoshop, it would simply cover that gray background). We need to prep this file for use in Lightroom, which means: (a) we need to keep all our layers intact, and (b) we need to get rid of that solid gray background.

Step Two:
Luckily, prepping this for Lightroom couldn't be simpler: (1) Go to the Back-ground layer (the solid gray layer in this case), and delete that layer by dragging it onto the Trash icon at the bottom of the Layers panel (as shown here). Now, (2) all you have to do is go under the File menu, choose Save As, and when the Save As dialog appears, from the Format pop-up menu (where you choose the file type to save it in), choose **PNG**. This format lets you keep the layers intact and, since you deleted the solid gray background layer, it makes the background transpar-ent (as seen here). By the way, in the Save As dialog, it will tell you that it has to save a copy to save in PNG format, and that's fine by us, so don't sweat it.

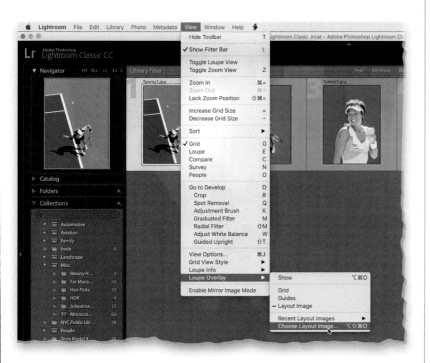

Step Three:

That's all you have to do in Photoshop, so head back over to Lightroom and go to the Library module. Now, go under the View menu, under Loupe Overlay, and select **Choose Layout Image** (as shown here). Then, find that layered PNG file you just created in Photoshop and choose it.

Step Four:

Once you select your layout overlay image, your cover appears over whichever image you currently have onscreen (as shown here). To hide the cover, go under the same Loupe Overlay menu, and you'll see that Layout Image has a checkmark by it, letting you know it's visible. Just choose Layout Image to hide it from view. To see it again, choose it again. Or press **Command-Option-O (PC: Ctrl-Alt-O)** to show/hide it. Remember, if you hadn't deleted the Background layer, what you'd be seeing here is a bunch of text over a gray background (and your image would be hidden). That's why it's so important to delete that Background layer and save in PNG format. Okay, let's roll on, because there are a few more features here you'll want to know about.

Continued

Step Five:

Now that your layout image overlay is in place, you can use the Left/Right Arrow keys on your keyboard to try different images on your cover (or whatever file you used). Here's what it would look like with a different shot.

Step Six:

When you look at the image in the previous step, did you notice that the word Photographer goes over part of her head? Luckily, you can reposition the cover to see what it would look like if you moved her over to the left a bit. Just press-and-hold the Command (PC: Ctrl) key and your cursor changes into the grabber hand (shown circled here in red). Now, just click-and-drag on the cover and it moves left/right and up/down. What's kind of weird at first is that it doesn't move your image inside the cover. It actually moves the cover. It takes a little getting used to at first, but then it becomes second nature.

Step Seven:
You can control the Opacity level of your overlay image, as well (I switched to a different image here). When you press-and-hold the Command (PC: Ctrl) key, two little controls appear near the bottom of the overlay image. On the left is Opacity, and you just click-and-drag to the left directly on the word "Opacity" to lower the setting (as seen here, where I've lowered our cover overlay to 45%). To raise the opacity back up, drag back to the right.

Step Eight:
The other control, which I actually think is more useful, is the Matte control. You see, in the previous step, how the area surrounding the cover is solid black? Well, if you lower the Matte amount, it lets you see through that black background, so you can see the rest of your image that doesn't appear inside the overlay area. Take a look at the image here. See how you can see the background outside on the left, top, and bottom of the cover? Now I know that this image has room for me to rearrange her position on the cover if I need to. Pretty handy, and it works the same as the Opacity control—press-and-hold the Command (PC: Ctrl) key and click-and-drag right on the word "Matte."

Creating Your Own Custom File Naming Templates

Staying organized is critical when you have thousands of photos, and because digital cameras generate the same set of names over and over, it's really important that you rename your photos with a unique name right during import. A popular strategy is to include the date of the shoot as part of the new name. Unfortunately, only one of Lightroom's import naming presets includes the date, and it makes you keep the camera's original filename along with it. Luckily, you can create your own custom file naming template just the way you want it. Here's how:

Step One:
Start in the Library module, and click on the Import button on the bottom-left side of the window (or use the keyboard short-cut **Command-Shift-I [PC: Ctrl-Shift-I]**). When the Import window appears, click on Copy at the top center and the File Renaming panel will appear on the right side. In that panel, turn on the Rename Files checkbox, then click on the Template pop-up menu and choose **Edit** (as shown here) to bring up the Filename Template Editor (shown below in Step Two).

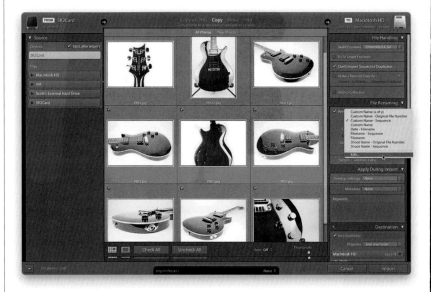

Step Two:
At the top of the dialog, there is a pop-up menu where you can choose any of the built-in naming presets as a starting place. For example, if you choose Custom Name – Sequence, the field below shows two blue tokens (that's what Adobe calls them; on a PC, the info appears within braces) that make up that preset: The first represents the text (to type in your own custom text, double-click on that blue Custom Text token and it highlights, so you can type in whatever name you like). The second blue token represents the auto numbering. To remove either token, click on it, then press the Delete (PC: Backspace) key on your keyboard. If you want to just start from scratch (as I'm going to do), delete both tokens, choose the options you want from the pop-up menus below, and it automatically inserts the tokens for you (there's no need to click Insert if you choose from a menu).

Step Three:
Let's go ahead and make one from scratch (this is only an example—you can create a custom template later that fits your needs). We'll start by adding a Custom Text token (later, when we're actually doing an import, we'll customize this name to fit the images we're importing), so near the bottom of the dialog, click the Insert button to the right of Custom Text to add a Custom Text token (as seen here). By the way, if you look right above where the tokens appear, where it says "Example," it shows you a preview of the filename you're creating. At this point, our name is just "untitled.RAW" (it will show whatever the actual file extension is, so if it's a JPG or CR2 or NEF, that's what it will show for the extension).

Step Four:
Now, let's add the month it was taken (dates are drawn automatically from the metadata embedded into your photo by your camera when the shot was taken), but if you just add the month, it doesn't put a space between the letters, so the month's name will butt right up against our custom name. Luckily, we can add a hyphen or underscore to create some visual separation. So, press-and-hold the Shift key, then press the hyphen (dash) key, and it adds an underscore after the custom name. Now, we'll have some visual separation when we add the month after it. Go down to the Additional section, and from the Date pop-up menu, choose **Date (Mon)**, as shown here. This gives you the month's three-letter abbreviation, rather than the full month (the letters in the parentheses show you how the date will be formatted. For example, choosing Date [MM] would show the two-digit month, like "06," instead of showing "Jun").

Continued

Step Five:

Now let's add the year (by the way, Lightroom is keeping track of all your images by date automatically—you can access this sorting by going to the Library Filter bar, clicking on the Metadata tab at the top, and choosing Date in the first column [see page 71]—so I don't actually add the date to my filenames. This is just to help you learn how to use the Filename Template Editor). You could add another underscore between the month and year, but to visually change things up, let's add a dash. Now let's choose the year. In this case, I went with the four-digit year option (as shown here), and it adds it after our dash. Take a look at our name example now, it's "untitled_Jun-2018.RAW."

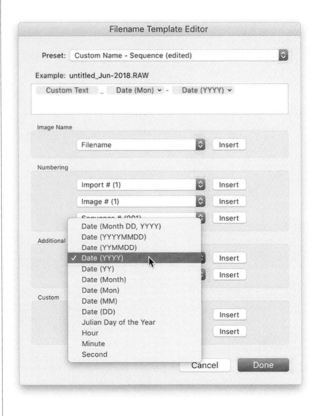

Step Six:

Lastly, you're going to have Lightroom automatically number these photos sequentially. To do that, go to the Numbering section and choose your numbering sequence from the third pop-up menu down. Here, I added a dash and then chose the Sequence # (001) token, which adds three-digit auto-numbering to the end of your filename. So, now my files will be named "untitled _Jun-2018-001.RAW," "-002.RAW," and so on (you can see this in the Example).

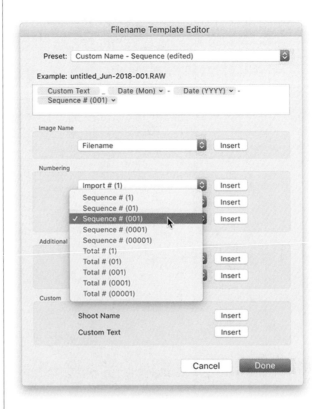

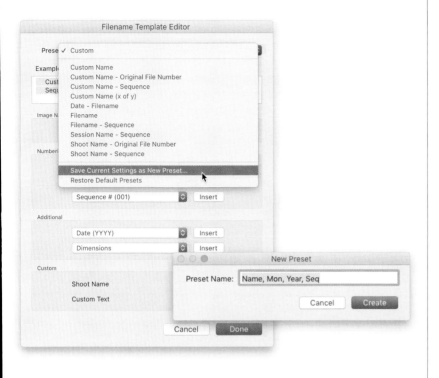

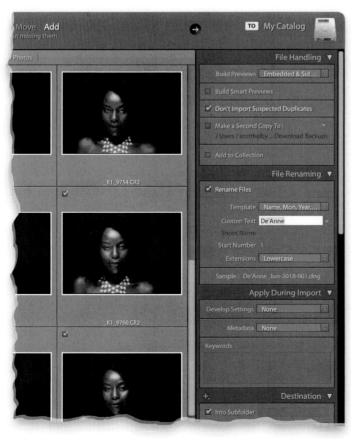

Step Seven:
Once the little naming example looks right to you, go under the Preset pop-up menu up top, choose **Save Current Settings as New Preset** (as shown here), and a dialog will appear where you can name your preset. Type in a descriptive name (so you'll know what it will do the next time you want to apply it—I chose "Name, Mon, Year, Seq"), click Create, and then click Done in the Filename Template Editor. Now, next time you're importing some images in the Import window and you click on the File Renaming panel's Template pop-up menu, you'll see your custom naming template as one of the preset choices (as seen selected in the next step).

Step Eight:
So, how does this work for other shoots? Smooth as glass. Here's why: After you choose this new naming template from the Template pop-up menu, click below it in the Custom Text field (this is where that Custom Text token we added earlier comes into play) and type in the descriptive part of the filename (in this case, I typed in "De'Anne"2—don't include spaces between words). That custom text will appear before an underscore, giving you a visual separator so everything doesn't run together (see, it all makes sense now). Once you type it in, if you look at the Sample at the bottom of the File Renaming panel, you'll see a preview of how the photos will be renamed. Once you've chosen all your Apply During Import and Destination panel settings, you can click the Import button.

Creating Your Own Custom Metadata (Copyright) Templates

I mentioned earlier in the book that you'll want to set up your own custom metadata template, so you can easily and automatically embed your own copyright and contact information right into your photos as they're imported into Lightroom. Well, here's how to do just that. Keep in mind that you can create more than one template, so if you create one with your full contact info (including your phone number), you might want to create one with just basic info, or one for when you're exporting images to be sent to a stock photo agency, etc.

Step One:
You can create a metadata template from right within the Import window, so press **Command-Shift-I (PC: Ctrl-Shift-I)** to bring it up. Once the Import window appears, go to the Apply During Import panel, and from the Metadata pop-up menu, choose **New** (as shown here).

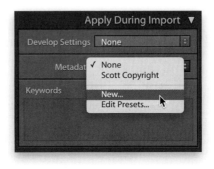

Step Two:
A blank New Metadata Preset dialog will appear. First, click the Check None button at the bottom of the dialog, as shown here (so no blank fields will appear when you view this metadata in Lightroom—only fields with data will be displayed).

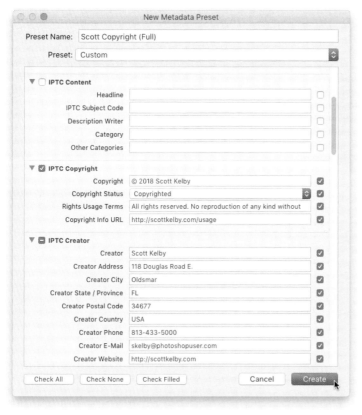

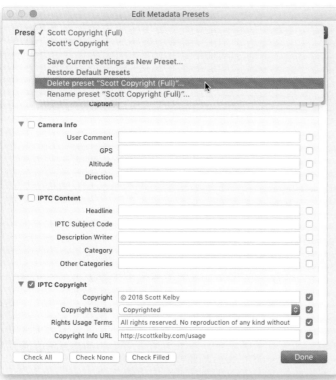

Step Three:

In the IPTC Copyright section, type in your copyright information (as seen here). Next, go to the IPTC Creator section and enter your contact info (after all, if someone goes by your website and downloads some of your images, you might want them to be able to contact you to arrange to license your photos). Now, you may feel that the Copyright Info URL (web address) that you added in the previous section is enough contact info, and if that's the case, you can skip filling out the IPTC Creator info (after all, this metadata preset is to help make potential clients aware that your work is copyrighted, and tell them how to get in contact with you). Once all the metadata info you want embedded in your photos is complete, go up to the top of the dialog, give your preset a name—I chose "Scott Copyright (Full)"— and then click the Create button.

Step Four:

As easy as it is to create a metadata template, deleting one isn't much harder. Go back to the Apply During Import panel and, from the Metadata pop-up menu, choose **Edit Presets**. That brings up the Edit Metadata Presets dialog (which looks just like the New Metadata Preset dialog). From the Preset pop-up menu at the top, choose the preset you want to delete. Once all the metadata appears in the dialog, go back to that Preset pop-up menu, and now choose **Delete Preset [Name of Preset]**. A warning dialog will pop up, asking if you're sure you want to delete this preset. Click Delete, and it is gone forever.

Using Lights Dim, Lights Out, and Other Viewing Modes

One of the things I love best about Lightroom is how it gets out of your way and lets your photos be the focus. That's why I love the Shift-Tab shortcut that hides all the panels. But if you want to really take things to the next level, after you hide those panels, you can dim everything around your photo, or literally "turn the lights out," so everything is blacked out but your photos. Here's how:

Step One:

Press the letter **L** on your keyboard to enter Lights Dim mode, in which everything but your photo(s) in the center Preview area is dimmed (kind of like you turned down a lighting dimmer). Perhaps the coolest thing about this dimmed mode is the fact that the Panels areas, taskbar, and Filmstrip all still work—you can still make adjustments, change photos, etc., just like when the "lights" are all on.

Step Two:

The next viewing mode is Lights Out (you get Lights Out by pressing L a second time), and this one really makes your photo(s) the star of the show because everything else is totally blacked out, so there's nothing (and I mean nothing) but your photo(s) onscreen (to return to regular Lights On mode, just press L again). To get your image as big onscreen as possible, right before you enter Lights Out mode, press **Shift-Tab** to hide all the panels on the sides, top, and bottom— that way you get the big image view you see here. Without the Shift-Tab, you'd have the smaller size image you see in Step One, with lots and lots of empty black space around it.

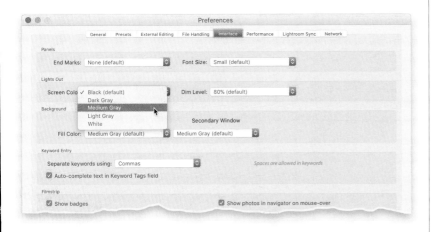

TIP: Controlling Lights Out Mode
You have more control over Lightroom's Lights Out mode than you might think: just go to Lightroom's preferences (under the Lightroom menu on a Mac or the Edit menu on a PC), click on the Interface tab, and you'll find pop-up menus that control both the Dim Level and the Screen Color when you're in full Lights Out mode.

Step Three:
If you want to view your grid of photos without distractions, first press Shift-Tab to hide all the panels. Then press **Command-Shift-F (PC: Ctrl-Shift-F)** on your keyboard. That makes the window fill your screen and hides the window's title bar and the menu bar at the top of your screen. If you really want the maximum effect, press **T** to hide the toolbar, and if you have the Library Filter bar showing across the top, you can hide it, too, by pressing the **\ (backslash) key** to get the view you see here at the top, which is just your photos on a solid, top-to-bottom gray background. If you want a black background behind your images with even the file names hidden, press L twice to see your grid in Lights Out mode (seen here at the bottom). Press L once to return to Lights On view, and then press **Shift-F** to return to your normal view.

Using Guides and Grid Overlays

Just like in Photoshop, Lightroom has its own moveable, non-printing guides (only these may be better than Photoshop's). But, beyond these guides, you also have the ability to put a resizable, non-printing grid over your image, as well (helpful for lining things up or for straightening a part of your image), but it's not just a static grid, and it's not just resizable. We'll start with the guides.

Step One:
To make the guides visible, go under the View menu, under Loupe Overlay, and choose **Guides**. A white horizontal guide and white vertical guide will appear centered on your screen. To move them in tandem, press-and-hold the Command (PC: Ctrl) key, then move your cursor directly on the black circle in the middle where they intersect. Your cursor changes from the zoom tool (magnifying glass) to the hand tool (as shown here), and you can then drag the two guide lines wherever you'd like. To move either guide individually, move your cursor away from the center, hover it right over either guide, and now you can drag that individual guide where you want it. To clear the guides, press **Command-Option-O (PC: Ctrl-Alt-O)**.

Step Two:
You also have a grid that pretty much works the same way. Go under the View menu, under Loupe Overlay, and choose **Grid**. This puts a non-printing grid over your image, which you can use for alignment (or anything else you want). If you press-and-hold the Command (PC: Ctrl) key, a control bar appears at the top of the screen. Click directly on the word "Opacity" to change how visible the grid is (here, I cranked it up to 100%, so the lines are solid). Click directly on the word "Size," to change the size of the grid blocks themselves—drag left to make the grid smaller or right to make it larger. To clear the grid, press **Command-Option-O (PC: Ctrl-Alt-O)**. *Note:* You can have more than one overlay, so you can have both the guides and grid visible at the same time.

Let's say you're having a business lunch with a potential client, and you learn that the client is a car buff. You have some collections of car shots you've taken, but you want to quickly put something together to show him some of your work. You won't need this after this meeting—you just want to go through your collections, find some favorites, and put them in a temporary collection to show him in a quick slide show. Well, that's a job for Quick Collections.

When to Use a Quick Collection Instead

Step One:
There are a lot of reasons why you might want a temporary collection, but most of the time, I use Quick Collections when I need to gather images from a number of different collections into one collection, just temporarily. We'll use the example I laid out in the intro above, and we'll look though our automotive collections and choose some of our individual favorites from each to be in our quick, simple slide show. So, start by looking in one of your automotive collections, and when you see a shot you might want to include, just press the letter **B** and that image gets added to your Quick Collection (you get a message right onscreen letting you know it has been added, as seen here).

Step Two:
Now go to another automotive collection and do the same thing—each time you see an image you want in your Quick Collection, press B and it's added. Using this method, in no time at all, I can whip through 10 or 15 "Select" collections and mark the ones I want in my Quick Collection as I go. (You can also add photos to your Quick Collection by clicking on the little circle that appears in the top-right corner of each thumbnail in Grid view when you move your cursor over the thumbnail—it'll turn gray with a thick black line around it when you click on it. *Note:* You can hide that gray dot by pressing **Command-J [PC: Ctrl-J]**, clicking on the Grid View tab up top, then turning off the checkbox for Quick Collection Markers, as shown on the bottom here.)

Continued

Step Three:

To see the photos you put in a Quick Collection, go to the Catalog panel (in the left side Panels area), click on Quick Collection (as shown here), and now just those photos are visible. To remove a photo from your Quick Collection, just click on it and press the **Delete (PC: Backspace) key** on your keyboard (it doesn't delete the original, it just removes it from this temporary Quick Collection). You can also click on any photo, press B again, and it will remove the image from your Quick Collection.

TIP: If You Want to Save This Quick Collection

If you decide you want your Quick Collection to be saved as a regular collection, just go to the Catalog panel, Right-click on Quick Collection, choose **Save Quick Collection** from the pop-up menu, and a dialog appears where you can give your new collection a name.

Step Four:

Now that your photos from all those different collections are in a Quick Collection, you can see these images as a slide show at any time by pressing **Command-Return (PC: Ctrl-Enter)**. This kicks in Lightroom's Impromptu Slideshow feature, which plays a full-screen slide show (as seen here) of the photos in your Quick Collection, using the Default preset in Lightroom's Slideshow module. To stop the slide show, just press the Esc key. So, when you're done, do you have to delete this Quick Collection? That's up to you. As I mentioned in the tip above, you can save it and make it a real collection (with its own name and all that) or you can clear all the photos out of that Quick Collection by Right-clicking on it (in the Catalog panel) and choosing **Clear Quick Collection**. Now you can use it for something else.

We just talked about Quick Collections and how you can temporarily toss things in there for an impromptu slide show, or until you figure out if you actually want to create a collection of those images, but something you might find more useful is to replace the Quick Collection with a target collection. You use the same keyboard shortcut, but instead of sending things to the Quick Collection, now they go to an existing collection. So, why would you want to do that? Read these two pages and you'll totally see why these are so handy (you are soooo going to dig this!).

Using Target Collections (and Why They're So Handy)

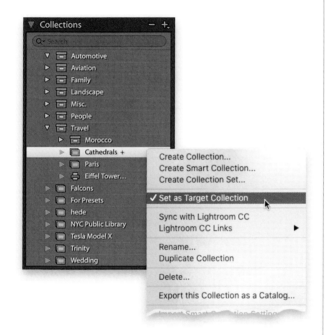

Step One:

Let's say, during your travels abroad, you wind up shooting a lot of cathedrals (if you take any guided tours when you're overseas, trust me, your tour operator will be taking you to every cathedral they can find). Well, wouldn't it be handy to have one collection of all your favorite cathedral images, so they're all just one click away? If that sounds handy to you (it sure does to me), then create a new collection and name it "Cathedrals." Once it appears in the Collections panel, Right-click on it and choose **Set as Target Collection**. This adds a + (plus sign) to the end of the collection's name, so you know at a glance it's your target collection (as seen here). *Note:* You can't make a smart collection into your target collection. Just so ya know.

Step Two:

Now that you've created your target collection, adding images to it is easy—when you see a cathedral image you like, no matter which collection it's in, press **B** on your keyboard (the same shortcut you used for Quick Collection), and that image is added to your Cathedrals target collection. For example, here we're looking at a shot of the ceiling in St. Stephen's Cathedral in Passau, Germany. It's in my Danube River collection, and I want it added to my Cathedrals target collection, so I clicked on it and pressed B. I get a confirmation onscreen that reads, "Add to Target Collection "Cathedrals,"" so I know it was added. It doesn't remove it from my Danube River collection, it just adds it to the Cathedrals target collection, as well.

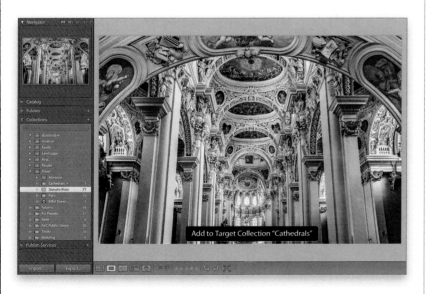

Continued

Step Three:

Now, if I click on that Cathedrals target collection, I see that St. Stephen's Cathedral image, plus cathedral images from other collections, as well, because now all my cathedral finals are in one place (I told you this was pretty handy, right?).

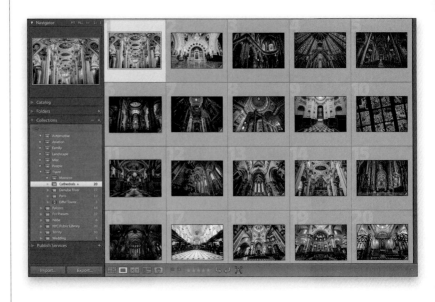

Step Four:

If you wind up creating these target collections fairly often, here's a time-saver: anytime you create a new collection, there's a checkbox in the Create Collection dialog that will make your new collection the target collection—just turn on the Set as Target Collection checkbox and this new collection is your new target collection. By the way, you can only have one target collection at a time, so when you choose a different collection to become the target collection, it removes the target from the previously selected collection (the collection is still there—it doesn't delete it. But, pressing B doesn't send images to that collection anymore—it sends them to the new collection you just designated as the target collection). Also, just keep in mind that if you want to go back to creating a Quick Collection (using the B keyboard shortcut), you'll need to turn off your target collection, by just Right-clicking on it and choosing **Set as Target Collection**.

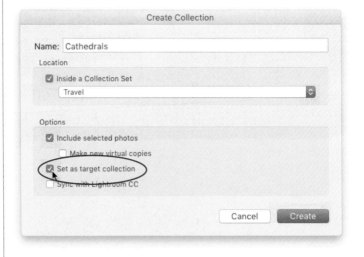

Your digital camera automatically embeds all kinds of info right into the photo itself, including everything from the make and model of the camera it was taken with, to the type of lens you used, and even whether your flash fired or not. Lightroom can search for photos based on this embedded information, called EXIF data. Beyond that, you can embed your own info into the file, like your copyright info, or photo captions for uploading to news services.

Adding Copyright Info, Captions, and Other Metadata

Step One:
You can see the info embedded in a photo (called metadata) by going to the Metadata panel in the right side Panels area in the Library module. By default, it shows you some of the different kinds of data embedded in your photo, so you see a little bit of the stuff your camera embedded (called EXIF data—stuff like the make and model of camera you took the photo with, which kind of lens you used, etc.), and you see the photo's dimensions, any ratings or labels you've added in Lightroom, and so on, but again, this is just a small portion of what's there. To see all of just what your camera embedded into your photo, choose **EXIF** from the pop-up menu in the left side of the panel header (as shown here), or to see all the metadata fields (including where to add captions and your copyright info), choose **EXIF and IPTC**.

TIP: Get More Info or Search
While in Grid view, if you see an arrow to the right of any metadata field, that's a link to either more information or an instant search. For example, scroll down to the EXIF metadata (the info embedded by your camera). Now, hover your cursor over the arrow that appears to the right of ISO Speed Rating for a few seconds and a little message will appear telling you what that arrow does (in this case, clicking that arrow would show you all the photos in your catalog taken at 400 ISO).

Continued

Step Two:

Although you can't change the EXIF data embedded by your camera, there are fields where you can add your own info. For example, if you need to add captions (maybe you're going to be uploading photos to a wire service), just go to the Caption field in the IPTC metadata, click your cursor inside the field, and start typing (as shown here). When you're done, just press the **Return (PC: Enter) key**. You can also add a star rating or label here in the Metadata panel, as well (though I usually don't do that here).

Note: This metadata you're adding is stored in Lightroom's database, and when you export your photos from Lightroom as either JPEGs, PSDs, or TIFFs, this metadata (along with all your color correction and image editing) gets embedded into the file itself at that moment. However, it's different when working with RAW photos (as you'll see in a moment).

Step Three:

If you created a Copyright Metadata preset (see page 90), but didn't apply it when you imported these photos, you can apply that now from the Preset menu at the top of the Metadata panel. Or if you didn't create a copyright preset at all, you can add your copyright info manually. Scroll down to the bottom of the Meta-data panel to the Copyright section, and just type in your copyright info (and make sure you choose **Copyrighted** from the Copyright Status pop-up menu). By the way, you can do this for more than one photo at a time. First, Command-click (PC: Ctrl-click) to select all the photos you want to add this copyright info to, then when you add the information in the Metadata panel, it's instantly added to every selected photo.

Step Four:

If you want to give someone your original RAW file (maybe a client or co-worker) or if you want to use your original RAW file in another application that processes RAW images, the metadata you've added in Lightroom (including copyright info, keywords, and even color correction edits to your photo) won't be visible because you can't embed info directly into a RAW file. To get around that, all this information gets written into a separate file called an XMP sidecar file. These XMP sidecar files aren't created automatically—you create them by pressing **Command-S (PC: Ctrl-S)** before you give someone your RAW file. After you press this, if you look in the photo's folder on your computer, you'll see your RAW file, then next to it an XMP sidecar file with the same name, but with the .xmp file extension (the two files are circled here in red). These two files need to stay together, so if you move it, or give the RAW file to a co-worker or client, be sure to grab both files.

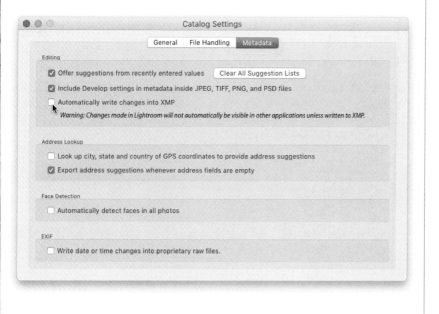

Step Five:

Now, if you converted your RAW file into a DNG file when you imported it, then when you press Command-S (PC: Ctrl-S), it does embed the info into the single DNG file (a big advantage of DNG—see Chapter 1), so there will be no separate XMP file. There actually is a Lightroom catalog preference (choose **Catalog Settings** from the Lightroom menu on a Mac, or the Edit menu on a PC, then click on the Metadata tab, shown here) that automatically writes every change you make to a RAW file to the XMP sidecar, but the downside is a speed issue. Each time you make a change to a RAW file, Lightroom has to write that change into XMP, which slows things down a bit, so I leave the Automatically Write Changes into XMP checkbox turned off.

From Laptop to Desktop: Syncing Catalogs on Two Computers

If you're running Lightroom on a laptop during your location shoots, you might want to take all the edits, keywords, metadata, and of course the photos themselves, and add them to the Lightroom catalog on your studio computer. It's easier than it sounds: basically, you choose which collection to export from your laptop, then you take the folder it creates over to your studio computer and import it—Lightroom does all the hard work for you, you just have to make a few choices about how Lightroom handles the process.

Step One:

Okay, we're on location (or on the road), and we've imported our images, organized them in a collection set, and tweaked some of them—we pretty much did everything we need to do to these images on our laptop.

Step Two:

Once you get back home, on your laptop, go to the Collections panel and Right-click on the collection set you created—the one you want to merge with your desktop computer in your studio. (*Note:* If you work in folders, instead of collections, the only difference would be you'd go to the Folders panel and Right-click on the folder from that shoot instead.) From the pop-up menu that appears, choose **Export this Collection Set as a Catalog** (as shown here).

Step Three:

When you choose this, it brings up the Export as Catalog dialog (shown here). First, let's choose where to save this exported catalog. Since you'll need to get these images from your laptop to your desktop computer, I recommend using either a small portable hard drive or a USB flash drive with enough free space to hold your exported catalog, previews, and your original images (you can get a SanDisk 16GB USB flash drive for $6. That's cheaper than an appetizer at Chili's). So, give your exported collection a name, choose that portable drive to save it onto, then turn on the Export Negative Files checkbox (near the bottom of the dialog), so that it not only saves your edits, but it saves your images to that portable drive, too. Make sure to turn on the Include Available Previews checkbox, as well (so you don't have to wait for them to render when you import them later). You can also choose to include smart previews if you'd like.

Step Four:

When you click the Export Catalog button, it exports your collection (it usually doesn't take very long, but of course the more photos in your collection or folder, the longer it will take), and when it's done exporting, you'll see a new folder on your portable drive (or USB flash drive). If you look inside that folder, you'll see three or four files (depending on whether you chose to export smart previews or not). You'll see (1) a folder with the actual photos; (2) a file that includes the previews; (3) a file that includes any smart previews, if you chose to export those; and (4) the catalog file itself (it has the file extension LRCAT (as seen here).

Continued

Step Five:

Now, on your desktop computer, go under Lightroom's File menu and choose **Import from Another Catalog.** Navigate to that folder you created on your portable drive, then inside that folder, click on the file that ends with the file extension LRCAT (that's the catalog file you're importing), and then click the Choose button. That brings up the Import from Catalog dialog (seen here). If you want to see thumbnails of the images you're about to import, turn on the Show Preview checkbox in the bottom-left corner, and the thumbnails will appear on the right side of the dialog (seen here). If, for some reason, you don't want one or more of these photos imported, uncheck the checkbox in the top-left corner of its thumbnail.

Step Six:

So far we're just importing your previews and the edits you made on your laptop, but we haven't moved the photos from that folder on your portable or USB flash drive over to your desktop computer's storage device (which I'm hoping is an external hard drive—see Chapter 1). To make sure your original images get moved over as well, go to the New Photos section on the left and, from the File Handling pop-up menu, choose **Copy New Photos to a New Location and Import** (as shown here). When you choose this, a button appears right below asking you to choose where you want these images copied to. In our case, they would go onto your desktop computer's external hard drive, inside your main folder, inside your Travel folder. So, navigate there and click the Choose button. Now, click Import, and your exported collection will be added to your desktop computer's catalog, with all your edits, previews, metadata, etc., all intact, and copies of your original images will be copied onto your external hard drive.

It's pretty unlikely that you'll have a major problem with your Lightroom catalog (after all these years of using Lightroom, it has only happened to me once), and if it does happen, chances are Lightroom can repair itself (which is pretty handy). However, the chances of your hard drive crashing, or your computer dying, or getting stolen (with the only copy of your catalog on it) are much higher. Here's how to deal with both of these potential disasters in advance, and what to do if the big potty hits the air circulation device:

Dealing with Disasters (Troubleshooting)

Step One:
If you launch Lightroom and you get a warning dialog like you see here (at top), then go ahead and give Lightroom a chance to fix itself by clicking the Repair Catalog button. Chances are pretty likely it'll fix the catalog and then you're all set. However, if Lightroom can't fix the catalog, you'll see the bottom warning dialog instead, letting you know that your catalog is so corrupt it can't fix it. If that's the case, it's time to go get your backup copy of your catalog (ya know, the one we talked about back in Chapter 2).

Step Two:
Now, as long as you've backed up your catalog, you can restore that backup catalog, and you're back in business (just understand that if the last time you backed up your catalog was three weeks ago, everything you've done in Lightroom since then will be gone. That's why it's so important to back up your catalog fairly often, and if you're doing client work, you should back up daily). Luckily, restoring from a backup catalog is easy. First, go to your backup hard drive (remember, your backup catalog should be saved to a separate hard drive. That way, if your computer crashes, your backup doesn't crash along with it), and locate the folder where you save your Lightroom catalog backups (they're saved in folders by date, as seen here, so double-click on the folder with the most current date), and inside you'll see your backup catalog.

Continued

Step Three:

Next, find the corrupt Lightroom catalog on your computer (on my computer, it's in my Lightroom folder that's in my Pictures folder), and delete that file (drag it into the Trash on a Mac, or into the Recycle Bin on a PC). Now, drag-and-drop your backup catalog file into the folder on your computer where your corrupt file used to be (before you deleted it).

TIP: Finding Your Catalog

If you don't remember where you chose to store your Lightroom catalogs—don't worry—Lightroom can tell you. Go under the Lightroom (PC: Edit) menu and choose **Catalog Settings**. Click on the General tab, then under Location it will show the path to your catalog. Click on the Show button, and it will take you there.

Step Four:

The final step is simply to open this new catalog in Lightroom by going under the File menu and choosing **Open Catalog**. Now, go to where you placed that backup copy of your catalog (on your computer), find that backup file, click on it, then click OK, and everything is back the way it was (again, provided you backed up your catalog recently. If not, it's back to what your catalog looked like the last time you backed it up). By the way, it even remembers where your photos are stored (but if it doesn't, go back to Chapter 2 where we looked at how to relink them).

TIP: If Your Computer Crashed...

If, instead of a corrupt catalog, your computer crashed (or your hard drive died, or your laptop got stolen, etc.), then it's pretty much the same process—you just don't have to find and delete the old catalog first, because it's already gone. So, you'll start by just dragging your backup copy of the catalog into your new, empty Lightroom folder (which is created the first time you launch Lightroom on your new computer, or new hard drive, etc.).

Step Five:
If you think your catalog's okay, but Lightroom has locked up or is just acting wonky, a lot of the time, simply quitting Lightroom and restarting will do the trick (I know, it sounds really simple, and kind of "Duh!" but this fixes more problems than you can imagine). If that didn't work, and Lightroom is still acting funky, it's possible your preferences have become corrupt and need to be replaced (hey, it happens). To do that, quit Lightroom, then press-and-hold **Option-Shift (PC: Alt-Shift)**, and relaunch Lightroom. Keep holding those keys down until the dialog appears asking if you want to reset your preferences. If you click on Reset Preferences, it builds a new, factory-fresh set of preferences, and chances are all your problems will be gone.

Step Six:
Next, if you have installed Lightroom plug-ins, it's possible one of them has gotten messed up or is outdated, so check the plug-in manufacturers' sites for updates. If your plug-ins are all up to date, then go under the File menu and choose **Plug-in Manager**. In the dialog, click on a plug-in, then to the right, click the Disable button, and see if the problem is still there. Turn each off, using the process of elimination, until you find the one that's messing things up. If you wind up disabling them all, and the problem is still there, then it's time to do a reinstall, either from the original install files (if you have Lightroom 6) or from the Adobe Creative Cloud app (if you use Lightroom Classic CC). Start by uninstalling Lightroom from your computer (it won't delete your catalogs), and then do your install. One of those will most surely fix your problem. If none of those worked, it may be time to call Adobe, 'cause something's crazy messed up (but at least you'll have already done the first round of things Adobe will tell you to try, and you'll be that much closer to a solution).

CUSTOMIZING
how to set things up your way

This chapter about is about personalizing your Lightroom experience, so it works best for you. But, before you read this chapter, you really should be a bit more advanced in your Lightroom learning. The problem is that there's no one really there to police this, to stop you from reading a chapter you're not really emotionally prepared to handle. This is the type of stuff we tell our 12-year-old daughter that falls under the broad and all-encompassing header of "It's inappropriate." This officially replaces the previous phrase adored and used liberally by parents all over the world, which was, "Because I said so." When you think about it, that was a really lame response (at least it was when I heard it from my parents) because there was a reason, but they didn't want to tell you what it was. Of course, the real reason could have ranged from they just didn't feel like dealing with it, to they were lazy,

mean, or all of the above, but not giving us some reasonable explanation was certainly frustrating. That's why we, as parents (and Lightroom book authors), love the phrase, "It's inappropriate," because it infers there is a reason, but if we explained the reason, our explanation would have to be deemed inappropriate, too. So, our kids just assume it's something naughty, and go about their day knowing their parents love and care deeply about them experiencing anything that could be inappropriate for their age group (or Lightroom experience level). So, just know, dear reader, that I love you and I'm concerned about you being exposed to naughty Lightroom features. You can take a peek at this chapter, but if you see anything that you don't understand, or after seeing it you're uncomfortable and need to talk, just know that's something you should go ask your mother.

Choosing What You See in Loupe View

When you're in Loupe view (the zoomed-in view of your photo), besides just displaying your photo really big, you can display as little (or as much) information about your photo as you'd like as text overlays, which appear in the top-left corner of the Preview area. You'll be spending a lot of time working in Loupe view, so let's set up a custom Loupe view that works for you.

Step One:
In the Library module's Grid view, click on a thumbnail and press **E** on your keyboard to jump to the Loupe view (in the example shown here, I hid everything but the right side Panels area, so the photo would show up larger in Loupe view).

Step Two:
Press **Command-J (PC: Ctrl-J)** to bring up the Library View Options dialog and then click on the Loupe View tab. At the top of the dialog, turn on the Show Info Overlay checkbox. The pop-up menu to the right lets you choose from two different info overlays: Info 1 overlays the filename of your photo (in larger letters) in the upper-left corner of the Preview area (as seen here). Below the filename, in smaller type, is the photo's capture date and time, and its cropped dimensions. Info 2 also displays the filename, but underneath, it displays the exposure, ISO, and lens settings.

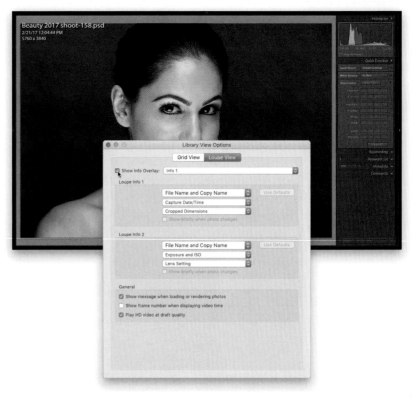

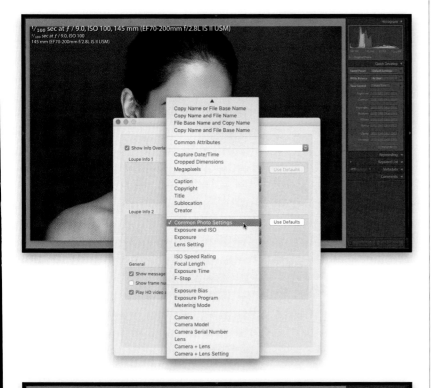

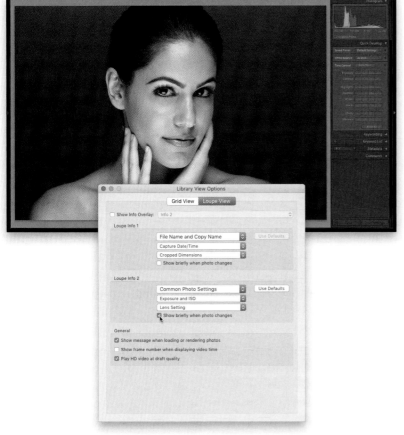

Step Three:

Luckily, you can choose which info is displayed for both info overlays using the pop-up menus in this dialog. So, for example, instead of having the file-name show up in huge letters, for Loupe Info 2, you could choose something like **Common Photo Settings** from the first pop-up menu (as shown here). By choosing this, instead of getting the filename in huge letters, you'd get the same info that's displayed under the histogram (like the shutter speed, f-stop, ISO, and lens setting) found in the top panel in the right side Panels area. You can customize both info over-lays separately by simply making choices from these pop-up menus. (*Remember:* The top pop-up menu in each section is the one that will appear in really large letters.)

Step Four:

Any time you want to start over, just click the Use Defaults button to the right and the default Loupe Info settings will appear. Personally, I find this text appearing over my photos really, really distracting most of the time. The key part of that is "most of the time." The other times, it's handy. So, if you think this might be handy, too, here's what I recommend: (a) Turn off the Show Info Overlay checkbox and turn on the Show Briefly When Photo Changes checkbox below the Loupe Info pop-up menus, which makes the overlay temporary—when you first open a photo in Loupe view, it appears on the photo for around four seconds and then hides itself. Or, you can do what I do: (b) leave those off, and when you want to see that overlay info, press the letter **I** to toggle through Info 1, Info 2, and Show Info Overlay off. At the bottom of the dialog, there's also a checkbox that lets you turn off those little messages that appear onscreen, like "Loading" or "Assigned Keyword," etc., along with some video option checkboxes.

Choosing What You See in Grid View

Those little cells that surround your thumbnails in Grid view can either be a wealth of information or really distracting (depending on how you feel about text and symbols surrounding your photos), but luckily you get to totally customize not only how much info is visible, but in some cases, exactly which type of info is displayed (of course, you learned in Chapter 1 that you can toggle the cell info on/off by pressing the letter **J** on your keyboard). At least now when that info is visible, it'll be just the info you care about.

Step One:
Press **G** to jump to the Library module's Grid view, then press **Command-J (PC: Ctrl-J)** to bring up the Library View Options dialog (shown here), and click on the Grid View tab at the top (seen highlighted here). At the top of the dialog, there's a pop-up menu where you can choose the options for what's visible in either the Expanded Cells view or the Compact Cells view. The difference between the two is that you can see more info in the Expanded Cells view.

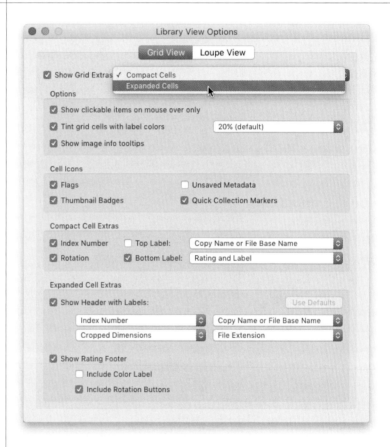

Step Two:
We'll start at the top, in the Options section. If you add a Pick flag and left/right rotation arrows to your cell, and turn on the Show Clickable Items on Mouse Over Only checkbox, it means they'll stay hidden until you move your mouse over a cell, then they appear so you can click on them. If you leave it unchecked, you'll see them all the time. The Tint Grid Cells with Label Colors checkbox only kicks in if you've applied a color label to a photo. If you have, turning this on tints the gray area around the photo's thumbnail the same color as the label, and you can set how dark the tint is with the pop-up menu. With the Show Image Info Tooltips checkbox turned on, when you hover your cursor over an icon within a cell (like a Pick flag or a badge), it'll show you a description of that item. Hover your cursor over an image thumbnail, and it'll give you a quick look at its EXIF data.

The thumbnail badges show you (from L to R) that a keyword has been applied, the photo has GPS info, it has been added to a collection, it has been cropped, and it has been edited

The black circle in the upper-right corner is actually a button—click on it to add this photo to your Quick Collection

Click the flag icon to mark it as a Pick

Click the Unsaved Metadata icon to save the changes

Step Three:

The next section down, Cell Icons, has two options for things that appear right over your photo's thumbnail image, and two that appear just in the cell. Thumbnail badges appear in the bottom-right corner of a thumbnail to let you see if: (a) the photo has had keywords added, (b) the photo has GPS info, (c) the photo has been added to a collection, (d) the photo has been cropped, or (e) the photo has been edited in Lightroom (color correction, sharpening, etc.). These tiny badges are actually clickable shortcuts. For example, if you wanted to add a keyword, you could click the Keyword badge (whose icon looks like a tag), and it opens the Keywording panel and highlights the keyword field, so you can just type in a new keyword. The other option on the thumbnail, Quick Collection Markers, adds a black circle (that's actually a button) to the top-right corner of your photo when you mouse over the cell. Click on it to add the photo to (or remove it from) your Quick Collection (it becomes a gray dot).

Step Four:

The other two options don't put anything over the thumbnails—they add icons in the cell area itself. When you turn on the Flags checkbox, it adds a Pick flag to the top-left side of the cell, and you can then click on this flag to mark this photo as a Pick (shown here on the left). The last checkbox in this section, Unsaved Metadata, adds a little icon in the top-right corner of the cell (shown here on the right), but only if the photo's metadata has been updated in Lightroom (since the last time the photo was saved) and these changes haven't been saved to the file itself yet (this sometimes happens if you import a photo, like a JPEG, which already has keywords, ratings, etc., applied to it, and then in Lightroom you added keywords, or changed the rating). If you see this icon, you can click on it to bring up a dialog that asks if you want to save the changes to the file (as shown here).

Continued

Step Five:

We're going to jump down to the bottom of the dialog to the Expanded Cell Extras section, where you choose which info gets displayed in the area at the top of each cell in Expanded Cells view. By default, it displays four different bits of info (as shown here): It's going to show the index number (which is the number of the cell, so if you imported 63 photos, the first photo's index number is 1, followed by 2, 3, 4, and so on, until you reach 63) in the top left, then below that will be the pixel dimensions of your photo (if the photo's cropped, it shows the final cropped size). Then in the top right, it shows the file's name, and below that, it shows the file's type (JPEG, RAW, TIFF, etc.). To change any one of these info labels, just click on the label pop-up menu you want to change and a long list of info to choose from appears (as seen in the next step). By the way, you don't have to display all four labels of info, just choose None from the pop-up menu for any of the four you don't want visible.

Step Six:

Although you can use the pop-up menus here in the Library View Options dialog to choose which type of information gets displayed, check this out: you can actually do the same thing from right within the cell itself. Just click on any one of those existing info labels, right in the cell itself, and the same exact pop-up menu that appears in the dialog appears here. Just choose the label you want from the list (I chose ISO Speed Rating here), and from then on it will be displayed in that spot (as shown here on the right, where you can see this shot was taken at an ISO of 200).

Step Seven:

At the bottom of the Expanded Cell Extras section is a checkbox, which is on by default. This option adds an area to the bottom of the cell called the Rating Footer, which shows the photo's star rating, and if you keep both checkboxes beneath Show Rating Footer turned on, it will also display the color label and the rotation buttons (which are clickable and will appear when you move your cursor over a cell).

Step Eight:

The middle section we skipped over is the Compact Cell Extras section. The reason I skipped over these options is that they work pretty much like the Expanded Cell Extras, but with the Compact Cell Extras, you have only two fields you can customize (rather than four, like in the Expanded Cell Extras): the filename (which appears on the top left of the thumbnail), and the rating (which appears beneath the bottom left of the thumbnail). To change the info displayed there, click on the label pop-up menus and make your choices. The other two checkboxes on the left hide/show the index number (in this case, it's that huge gray number that appears along the top-left side of the cell) and the rotation arrows at the bottom of the cell (which you'll see when you move your cursor over the cell, as shown here). One last thing: you can turn all these extras off permanently by turning off the Show Grid Extras checkbox at the top of the dialog.

Make Working with Panels Faster & Easier

Lightroom has an awful lot of panels, and you can waste a lot of time scrolling up and down in these panels just searching for what you want (especially if you have to scroll past ones you never use). This is why, in my live Lightroom seminars, I recommend: (a) hiding panels you find you don't use and (b) turning on Solo mode, so when you click on a panel, it displays only that one panel and tucks the rest out of the way. Here's how to use these somewhat hidden features:

Step One:

Start by going to any side panel, then Right-click on the panel header and a pop-up menu will appear with a list of all the panels on that side. Each panel with a checkmark beside it is visible, so if you want to hide a panel from view, just choose it from this list and it unchecks. For example, here in the Develop module's right side Panels area, I've hidden the Calibration panel. Next, as I mentioned in the intro above, I always recommend turning on Solo mode (you choose it from this same menu, as seen here).

Step Two:

Take a look at the two sets of side panels shown here. The one on the left shows how the Develop module's panels look normally. I'm trying to make an adjustment in the Split Toning panel, but I have all those other panels open around it (which is distracting), and I have to scroll down past them just to get to the panel I want. However, look at the same set of panels on the right when Solo mode is turned on—all the other panels are collapsed out of the way, so I can just focus on the Split Toning panel. To work in a different panel, I just click on its name, and the Split Toning panel tucks itself away automatically.

The Develop module's right side Panels area with Solo mode turned off

The Develop module's right side Panels area with Solo mode turned on

Lightroom supports using two monitors, so you can work on your photo on one screen and also see a huge, full-screen version of your photo on another. But Adobe went beyond that in this Dual Display feature and there are some very cool things you can do with it, once it's set up (and here's how to set it up).

Using Two Monitors with Lightroom

Step One:
The Dual Display controls are found in the top-left corner of the Filmstrip (shown circled in red here), where you can see two buttons: one marked "1" for your main display and one marked "2" for the second display. If you don't have a second monitor connected and you click the Second Window button, it just brings up what would be seen in the second display as a separate floating window (as seen here).

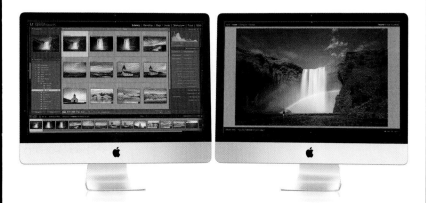

Step Two:
If you do have a second monitor connected to your computer, when you click on the Second Window button, the separate floating window appears in Full Screen mode, set to Loupe view, on the second display (as seen here). This is the default setup, which lets you see Lightroom's interface and controls on one display and then the larger zoomed-in view on the second display.

Continued

Step Three:

You have complete control over what goes on the second display using the Secondary Window pop-up menu, shown here (just click-and-hold on the Second Window button and it appears). For example, you could have Survey view showing on the second display, and then you could be zoomed in tight, looking at one of those survey images in Loupe view on your main display (as shown at bottom). By the way, just add the **Shift key** and the Survey view, Compare view, Grid view, and Loupe view shortcuts are all the same (so, **Shift-N** puts your second display into Survey view, etc.).

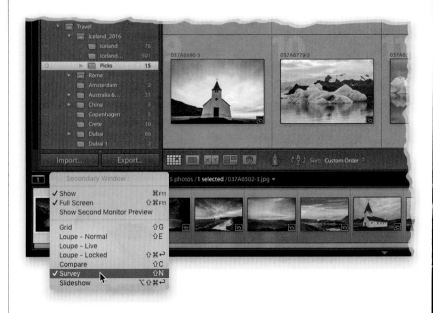

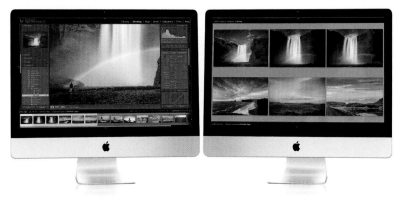

Step Four:

Besides just seeing things larger with the Loupe view, there are some other pretty cool Second Window options. For example, click on the Second Window button and choose **Loupe – Live** from the Secondary Window pop-up menu, then just hover your cursor over the thumbnails in the Grid view (or Filmstrip) on your main display, and watch how the second display shows an instant Loupe view of any photo you pass over (here, you can see on my main display the third photo is selected, but the image you see on my second display is the one my cursor is hovering over—the fourth image).

Step Five:
Another Second Window Loupe view option is called **Loupe – Locked** and when you choose this from the Secondary Window pop-up menu, it locks whatever image is currently shown in Loupe view on the second display, so you can look at and edit other images on the main display (to return to where you left off, just turn Loupe – Locked off).

Here's the second display default view, with the navigation bars at the top and bottom visible

Step Six:
The navigation bars at the top and bottom of your image area will be visible on the second display. If you want those hidden, click on the little gray arrows at the top and bottom of the screen to tuck them out of sight and give you just the image onscreen. You can also Right-click on either arrow to bring up the hide and show options for these bars.

Here's the second display with the navigation bars hidden, which gives a larger view

Continued

TIP: Show Second Monitor Preview

There's a feature found under the Secondary Window pop-up menu called Show Second Monitor Preview, where a small floating Second Monitor window appears on your main display, showing you what's being seen on the second display. This is pretty handy for presentations, where the second display is actually a projector, and your work is being projected on a screen behind you (so you can face the audience), or in instances where you're showing a client some work on a second screen and the screen is facing away from you (that way, they don't see all the controls, and panels, and other things that might distract them).

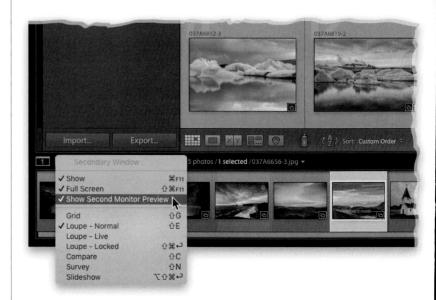

Just like you can choose what photo information is displayed in the Grid and Loupe views, you can also choose what info gets displayed in the Filmstrip, as well. Because the Filmstrip is pretty short in height, I think it's even more important to control what goes on here, or it starts to look like a cluttered mess. Although I'm going to show you how to turn on/off each line of info, my recommendation is to keep all the Filmstrip info turned off to help avoid "info overload" and visual clutter in an already busy interface. But, just in case, here's how to choose what's displayed down there:

Choosing What the Filmstrip Displays

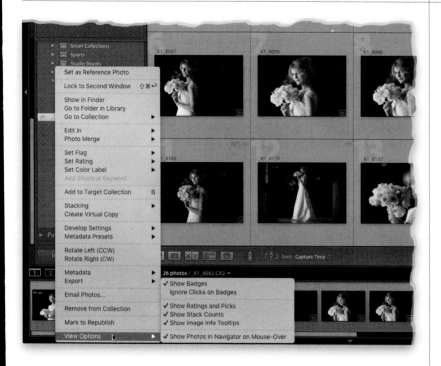

Step One:
Right-click on any thumbnail in the Filmstrip and a pop-up menu appears (seen here). At the bottom of it are the View Options for the Filmstrip. There are four options: Show Ratings and Picks adds tiny flags and star ratings to your Filmstrip cells. If you choose Show Badges, it adds mini-versions of the same thumbnail badges you see in Grid view (which show if the photo is in a collection, whether keywords have been applied, whether it has been cropped, or if it has been adjusted in Lightroom). Show Stack Counts adds a stack icon with the number of images inside the stack. The last choice, Show Image Info Tooltips, kicks in when you hover your cursor over an image in the Filmstrip—a little window pops up showing you the info you have chosen in the View Options dialog for your Info Overlay 1. If you get tired of accidentally clicking on badges that launch stuff when you're navigating around the Filmstrip, you can leave the badges visible but turn off their "click-ability" (if that's even a word) by choosing **Ignore Clicks on Badges** here, too.

Step Two:
Here's what the Filmstrip looks like when these options are turned off (top) and with all of them turned on (bottom). You can see Pick flags, star ratings, and thumbnail badges (with unsaved metadata warnings). I hovered my cursor over one of the thumbnails, so you can see the little pop-up window appear giving me info about the photo. The choice is yours—clean or cluttered.

Adding Your Studio's Name or Logo for a Custom Look

The first time I saw Lightroom, one of the features that really struck me as different was the ability to replace the Lightroom logo (that appears in the upper-left corner of the interface) with either the name of your studio or your studio's logo. I have to say, when you're doing client presentations, it does add a nice custom look to the program (as if Adobe designed Lightroom just for you), but beyond that, the ability to create an Identity Plate goes farther than just giving Lightroom a custom look (but we'll start here, with the custom look).

Step One:

First, just so we have a frame of reference, here's a zoomed-in view of the top-left corner of Lightroom's interface, so you can clearly see the logo we're going to replace starting in Step Two. Now, you can either replace Lightroom's logo using text (and you can even have the text of the modules in the taskbar on the top right match) or you can replace the logo with a graphic of your logo (we'll look at how to do both).

Step Two:

Go under the Lightroom menu (the Edit menu on a PC) and choose **Identity Plate Setup** to bring up the Identity Plate Editor (shown here). By default, the first Identity Plate pop-up menu at the top is set to Lightroom Classic CC (or Adobe ID), so you'll need to change it to **Personalized**. To have your name replace the Lightroom logo seen above, type it in the large black text field on the left side of the dialog. If you don't want your name as your Identity Plate, just type in whatever you'd like (the name of your company, studio, etc.), then while the type is still highlighted, choose a font, font style (bold, italic, condensed, etc.), and font size from the pop-up menus (directly below the text field).

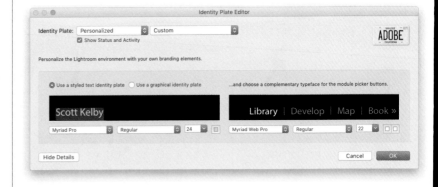

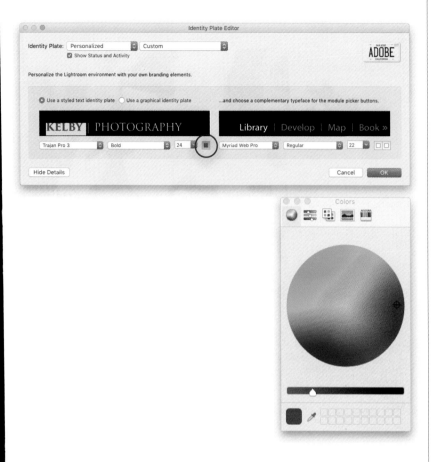

Step Three:

If you want to change only part of your text (for example, if you wanted to change the font of one of the words, the font size, or color of a word), just highlight the word you want to adjust before making the change. To change the color, click on the little square color swatch to the right of the Font Size pop-up menu (it's shown circled here). This brings up the Colors panel (you're seeing the Macintosh Colors panel here; the Windows Color panel will look somewhat different, but don't let that freak you out. Aw, what the heck—go ahead and freak out!). Just choose the color you want your selected text to be, then close the Colors panel.

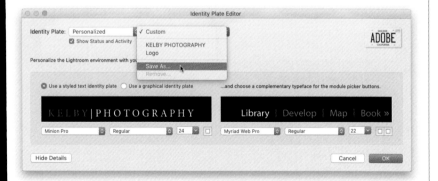

Step Four:

If you like the way your custom Identity Plate looks, you definitely should save it, because creating an Identity Plate does more than just replace the current Lightroom logo—you can add your new custom Identity Plate text (or logo) to any slide show, web gallery, or final print by choosing it from the Identity Plate pop-up menu in all three modules (see, you were dismissing it when you thought it was just a taskbar, feel good feature). To save your custom Identity Plate, from the second pop-up menu, choose **Save As** (as shown here). Give your Identity Plate a descriptive name, click OK, and now it's saved. From here on out, it will appear in that pop-up menu, where you can get that same custom text, font, and color with just one click.

Continued

Step Five:

Once you click the OK button, your new Identity Plate text replaces the Lightroom logo that was in the upper-left corner (as shown here).

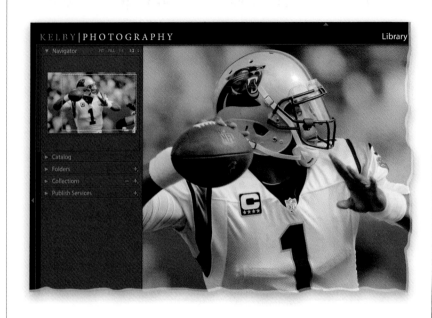

Step Six:

If you want to use a graphic (like your company's logo) instead, just go to the Identity Plate Editor again, but this time, click on the radio button for Use a Graphical Identity Plate (as shown here), instead of Use a Styled Text Identity Plate. Next, click on the Locate File button (found above the Hide/Show Details button near the lower-left corner) and find your logo file. You can put your logo on a black background so it blends in with the Lightroom background, or you can make your background transparent in Photoshop, and save the file in PNG format (which keeps the transparency intact). Now click the Choose button to make that graphic your Identity Plate.

Note: To keep the top and bottom of your graphic from clipping off, make sure your graphic isn't taller than 57 pixels.

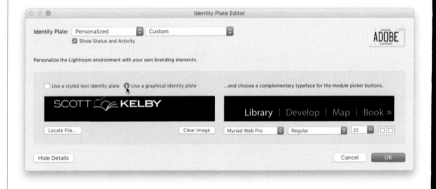

Step Seven:
When you click OK, the Lightroom logo (or your custom text—whichever was up there last) is replaced by the new graphic file of your logo (as shown here). If you like your new graphical logo file in Lightroom, don't forget to save this custom Identity Plate by choosing Save As from the second pop-up menu at the top of the dialog.

Step Eight:
If you decide, at some point, that you'd like the original Lightroom logo back instead, just go back to the Identity Plate Editor and change the first Identity Plate pop-up menu to **Lightroom Classic CC** (as shown here). Remember, we'll do more with one of your new Identity Plates later in the book when we cover the modules that can use it.

EDITING YOUR IMAGES
how to tweak your images like a pro!

If you're one of those lucky people for whom Lightroom was your first experience with editing digital images, you have no idea how lucky you are. Today, it's an incredibly mature, robust, fairly awesome program, but before Lightroom came along, it was a dark, dark time. Back then, we used Camera Raw (which was actually quite good), but it was part of a program called Adobe Bridge (which was actually quite bad). Well…now, I take that back. I don't want to say anything disparaging about Adobe Bridge, but if I did say something, it would be simply that it's absolute crap. Now, since a copy of all instructional books are included in the US government's National Archives within the Library of Congress, I think it's important that when talking about "The Bridge," for history's sake, we're accurate in our description, so tossing around a borderline word like "crap" is probably not going to sit well with the librarians there.

This is one of those cases where it will be vitally important (for official purposes) for you to "fill in the blanks" with more precise and articulate phrases than I was able to muster here. I will give you a descriptive phrase, and you will replace the last word of that phrase with a word that more accurately describes Bridge. Shall we begin? Let's. "Adobe Bridge is a steaming pile of 'carrots.'" Be thoughtful with your response—this is for posterior. Darn autocorrect! That was supposed to read, "this is for posterity." Let's try another: "Adobe Bridge is an absolute piece of 'steel.'" Time to pick your anus. Sorry, stupid autocorrect again. That was supposed to read: "Time to pick your answer." Okay, last one: "Adobe Bridge is a total pain in the 'ear.'" There are a number of prostate answers here. Rats! That was supposed to be "possible answers." Okay, that's it. I'm turning my autocorrect orifice! I mean, off! Ugh.

My Lightroom Editing Cheat Sheet

Here's a quick look at the sliders in the Basic panel (this isn't "official"—it's just how I think of them). By the way, although Adobe named this the "Basic" panel, I think it may be the most misnamed feature in all of Lightroom. It should have been called the "Essentials" panel, since this is precisely where you'll spend most of your time editing images. Also, something handy to know: dragging any of the sliders to the right brightens or increases its effect; dragging to the left darkens or decreases its effect.

Apply a RAW Profile:
From the Profile pop-up menu, you can choose the overall "look" you want to apply to your RAW photo. Do you want a flat, untouched starting point, or something a bit more colorful and contrasty?

Automatic Toning:
If you're not sure where to start, try clicking the much improved Auto button, which automatically tries to balance out the tones in an image for you. It's low risk—if you don't like the results, just press **Command-Z (PC: Ctrl-Z)** to Undo the Auto adjustment.

Brightening or Darkening:
I use these three sliders together: First, I set the white and black points to expand the image's tonal range (see page 144 for how Lightroom can do this for you automatically), and after that, if the image looks a little too bright or a little too dark, I tweak the overall brightness by dragging the Exposure slider to the left to darken or to the right to brighten.

Fixing Problems:
If there are exposure problems (often caused by the limitations of our camera's sensors), one or both of these sliders will usually provide the fix. I use the Highlights slider when the brightest areas of my photo are too bright (or the sky is way too bright), and the Shadows slider opens up dark areas in your photo and makes things "hidden in the shadows" suddenly appear—great for fixing backlit subjects (see page 151).

Fixing Flat-Looking Photos:
If your photo looks flat and drab, drag the Contrast slider to the right—it makes the brightest parts brighter, the darkest parts darker, and makes your colors punchier.

Enhancing Detail:
Technically, the Clarity slider controls midtone contrast, but what it really does when you drag it to the right is it brings out texture and detail in your photo. It also tends to make your photo a little darker if you apply a lot of it, so you might have to drag the Exposure slider a tad to the right after increasing the amount of Clarity.

Reducing Fog or Haze:
The Dehaze slider works miracles in reducing or even eliminating fog and haze—just drag it to the right. It's actually another form of contrast, so you can use it on non-hazy images to add heavy contrast. If you drag it to the left, it adds a hazy effect.

Getting Your Color Right:
These two White Balance sliders help you either correct the white balance in your image (i.e., you'd drag the Temp slider to the right to reduce a blue color cast, or to the left to remove a yellow color cast by adding in some blue), or you'll use these to get creative, like making a slightly yellow sunset a glorious orange, or a drab sky a gorgeous blue.

Making Your Colors More Colorful:
I drag the Vibrance slider to the right when my image needs a color boost (see page 153). You'll notice I didn't mention the Saturation slider. That's because I stopped using it years ago when Vibrance was introduced. Now, I only use the Saturation slider (dragging it to the left) if I want to wash out or remove color altogether. I never drag it to the right. Yeech!

If You Shoot in RAW, You Need to Start Here

In the spring of 2018, Adobe changed the way we process our RAW images (for the better), but it's important to understand what they did (and why they did it), so you can add it to your RAW editing workflow. On these first two pages, I'm going to explain something that will help you really understand why Lightroom does things a certain way, but to do that we have to start in your camera. If you're shooting in JPEG, you can skip these five pages altogether, and instead, your workflow starts on page 135 (shooting in JPEG is not a bad thing, but what I'm teaching here doesn't apply to JPEG images, so I don't want to waste your time or create confusion).

Step One:
Note: Again, this only applies to you, if you shoot in RAW. If you shoot in JPEG, skip these five pages.

When you shoot in JPEG, your camera automatically applies all sorts of processing adjustments to your JPEG images in-camera—like contrast, vibrance, sharpening noise reduction, and so on—to make your JPEG image look really good straight out of the camera. That's why JPEG images look so much better out of the camera than RAW images—RAW images don't have any of that stuff applied to them.

Step Two:
Besides JPEGs looking better by default, most cameras allow you to further tweak JPEGs by applying camera profiles right in your camera to make even better looking JPEGs. These profiles are named by the subject you're shooting, so for example, if you're shooting a landscape, you'd apply the Landscape camera profile to get more saturated colors, more sharpness, and more contrast. You can take it a step further by choosing Vivid, and now your image looks even more colorful. If you're shooting portraits, you can choose the Portrait camera profile and it provides flatter, less contrasty looks and tones that should be more pleasing for skin tones.

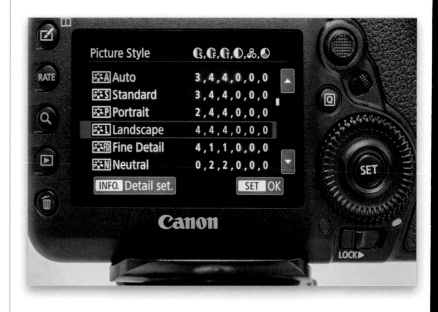

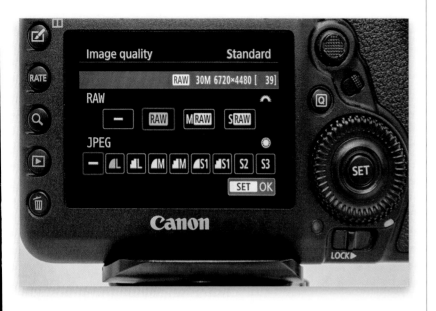

Step Three:

When you switch your camera to shoot in RAW mode, you're telling your camera, "Turn off the sharpening, the contrast, the vibrance, the noise reduction—turn off all that stuff that's added to make the image look great, and just give me the untouched RAW image, straight out of the camera, so I can add my own sharpening, contrast, and so on, in Lightroom (or Photoshop, or whatever)." This "turn all that in-camera stuff off" for RAW photos also applies to those camera profiles you just learned about. If you applied a Landscape or Portrait camera profile to your RAW photo, since it's RAW, Lightroom just ignores it (in short, they really only work for JPEG images). The good news is, you can apply these same types of camera profiles in Lightroom to RAW images. But, the news gets even better (well, not yet, in the step after the next step).

Step Four:

When your RAW image opens in Lightroom, for the sake of speed, it first displays the JPEG version of your photo (it's a small JPEG file embedded right into your RAW photo. That's what you see on the back of your camera—that JPEG preview. So, even through you're shooting in RAW, it still shows you the more colorful, more contrasty, sharper JPEG on the back of your camera. Good to know). So, that JPEG preview appears onscreen first, while Lightroom processes the actual RAW photo in the background (it displays a message onscreen that says "Loading," as seen here). Now, it used to process that RAW image using a profile Adobe engineers created 11+ years ago, which they felt provided the most accurate interpretation of what your camera captured. This profile (it was found in the Camera Calibration panel, as seen here) was called "Adobe Standard." I used to joke it should have been named "Adobe Dull" because the result was so flat looking, but it was very accurate as to what the camera captured.

Continued

Step Five:

So, for 11+ years, I've been telling photographers that they could have a better starting place than Adobe Standard by applying one of Adobe's camera profiles hidden down in the Camera Calibration panel (well, they were there in the previous versions of Lightroom anyway). They could choose Camera Landscape or Camera Vivid (depending on their camera), and their RAW image would then look more like the JPEG preview—with more contrast, more color, and a more JPEG-looking starting place for processing their RAW images. Well, in the spring of 2018, Adobe released a replacement for Adobe Standard, called "Adobe Color" (which is the new default RAW image look for Lightroom). This is such a better starting place, as Adobe Color gives your RAW image a more pleasing overall color with added warmth, contrast, and vibrance. Plus, Adobe moved the Profile options to the top of the Basic panel (as seen here). You don't have to do anything to use the Adobe Color profile— it's added by default. But, the even better news is, you now have more choices— more potential starting places that you might want to consider.

Step Six:

For example, from the Profile pop-up menu, choose the Adobe Landscape profile and it will look better for most landscape images (I think it looks even better than the in-camera profiles), and some images will look even better with Adobe Vivid applied. You won't know until you try 'em out. While Adobe added the Adobe RAW profiles as Favorites in the Profile pop-up menu, you can find others by choosing **Browse** (as shown here). You can also click the little icon with four squares just to the right of the Profile pop-up menu—either one will bring up the Profile Browser (seen in the next step).

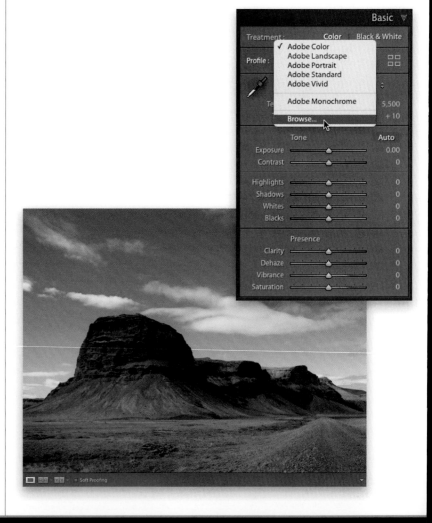

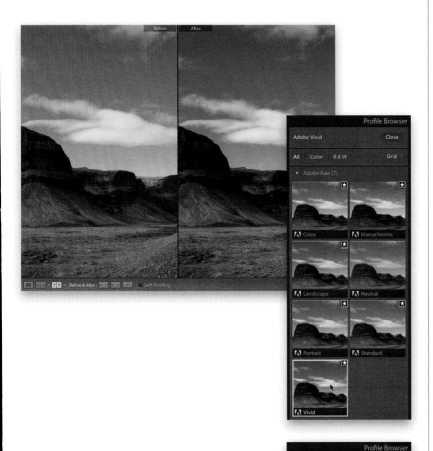

Step Seven:

In the Profile Browser, under Adobe Raw, you'll find the new RAW profiles. The thumbnails here give you a preview of how your image would look if you chose one of those profiles. Even better, if you hover your cursor over one of them, you get a full-size preview of how that profile would look on your image. Incredibly helpful. Here, I chose the Adobe Vivid profile, and look at how much better the After image on the right looks already (you can see a split-screen before and after like this by pressing the letter **Y** anytime you're in the Develop module. More about these on page 141). It made my starting place that much better!

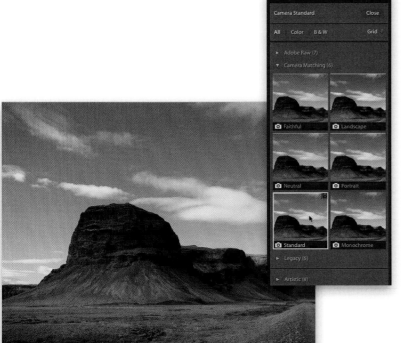

Step Eight:

Besides Adobe's new and improved RAW camera profiles, you still have access to the camera profile choices from earlier versions of Lightroom. These are found under Camera Matching, and they're named Camera Matching because these are same profiles you could have applied in your camera if you were shooting in JPEG mode (the list will look somewhat different depending on your camera make). These old camera profiles are there in case you wanted to work on a RAW image you previously edited in an older version of Lightroom where you had applied one of those older profiles without it being automatically changed to a new profile. That being said, I wouldn't recommend applying these old Camera Matching profiles to new photos you've just imported into Lightroom—they're not nearly as good as the new ones—but if you have bad taste in editing, at least you know they're there.

Continued

Step Nine:

If you want, you can change the thumbnail options in the Profile Browser. The standard view is called "Grid," which is what you see here at the far left. For larger thumbnails, choose **Large** from the pop-up menu near the top right (as shown here, in the center) to get large, single-column, full-width thumbnails, or choose **List** (as shown, far right) to see just a text-only list. To see even larger thumbnails, you can make the entire right side Panels area wider by clicking-and-dragging the left edge of the Panels area out to the left (you'll hit a point where it stops and you can't drag any farther, but you can make these panels quite a bit wider than their default settings).

The default: Grid Large size List view (text only)

Step 10:

To save a profile as a Favorite (so it appears in the Profile pop-up menu—no more scrolling through panels, digging for profiles), move your cursor over the profile thumbnail you want to save and click the star icon that appears in the upper-right corner (as shown here, left). Now that profile will appear in the Profile pop-up menu (as seen here, at right) when the Profile Browser is hidden, and also under Favorites when it's open (just click on a star icon, again, to remove a Favorite). There is a Monochrome choice in both the Adobe Raw and Camera Matching profile sets, and we'll cover those when we look at converting to black and white in Chapter 7. Lastly, you'll notice that below the Camera Matching profiles there are even more profiles. Those are actually creative effects you can apply to get certain "looks" (kind of like presets, but better). More on these also in Chapter 7—they're pretty awesome (and you can also add these to your Favorites if you find you use some of them often).

I start editing my photos by setting the white balance first. I do this for two reasons: (1) Changing the white balance affects the overall exposure of your image big time (take a look at the histogram while you drag the Temp slider back and fourth a few times, and you'll see what a huge effect white balance has on your exposure). And, (2) I find it hard to make reasonable decisions about my exposure if the color is so off it's distracting. I find that when the color looks right, my exposure decisions are better. But hey, that's just me. Or is it?

Setting the White Balance

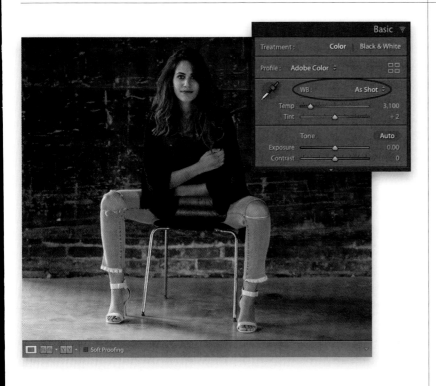

Step One:

The White Balance controls are found near the top of the Develop module's Basic panel. Your photo reflects whichever white balance you had selected in your camera, so that's why the WB pop-up menu is set to "As Shot"—you're seeing the white balance "as it was shot," which in this case, is way too blue (I had been shooting under fluorescent lights earlier, then wound up shooting in this natural light setting and forgot to change my white balance to match the lighting conditions). There are three ways to set the white balance in Lightroom, and I'm going to show all three, but I use the third way most of the time because it's just so fast and easy. Still, it's important to know all three methods because you might prefer one of the other methods for certain types of photos.

Step Two:

First, you can try the built-in White Balance presets. If you shot in RAW, click-and-hold on As Shot and a pop-up menu of White Balance presets appears. Here, you can choose the same white balance presets (seen here on the left) you could have chosen in your camera. If you shot in JPEG mode, you only get one preset, Auto (seen here on the right), because your white balance choice was already embedded in the file by your camera. You can still change the white balance for JPEG images, but you'll have to use the next two methods instead. *Note:* If your list looks different than mine here on the left, it's because you're using a different make/model of camera. The WB pop-up menu is based on which camera brand you shot with.

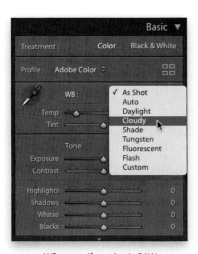
WB presets if you shot in RAW

WB presets if you shot in JPEG

Continued

Step Three:

In our photo in Step One, the overall tone is really blue, so it definitely needs a white balance adjustment. (*Note:* If you want to follow along using this same image, you're welcome to download it from the book's companion webpage, mentioned in the book's introduction.) I usually start by choosing Auto from the White Balance pop-up menu to see how that looks (as you can see here, it's much better all around. In person, her skin has a warmer tone, but the Auto preset is actually a little too warm [yellow]). Go ahead and try out the next three presets, but spoiler alert: Daylight will be a bit warmer, with Cloudy and Shade being progressively even warmer. So, I'd choose Cloudy or Shade (just so you can see how much warmer that will make her skin tone, as well as the whole photo for that matter). You can skip Tungsten and Fluorescent—they're going to be way crazy blue (in fact, it was Fluorescent that we accidentally had our white balance set to from the beginning). By the way, the last preset isn't really a preset at all—Custom just means you're going to set the white balance manually instead of using a preset.

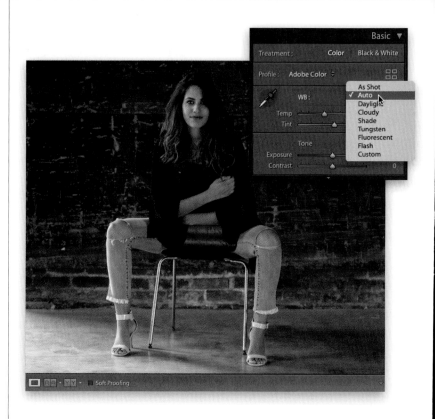

Step Four:

If you go through the WB presets and one looks right to you (or if you shot in JPEG, so your only choice was Auto, and it didn't look right), then we move on to Method #2, which is to choose the WB preset that is the closest to being right (in this case, for me, it was Auto), then drag the Temp and Tint sliders (found right below the pop-up menu) to tweak the color more to your liking. Take a look at those two sliders. Without me even explaining how they work, if I wanted more blue in this photo, which way would I drag the Temp slider? Right—those color bars behind the sliders are a huge help. In this case, I think her skin is too yellow, so I dragged the Temp slider away from the yellow side and more toward blue, looking at the image while I dragged. I didn't have to drag it very far and now it looks pretty good overall.

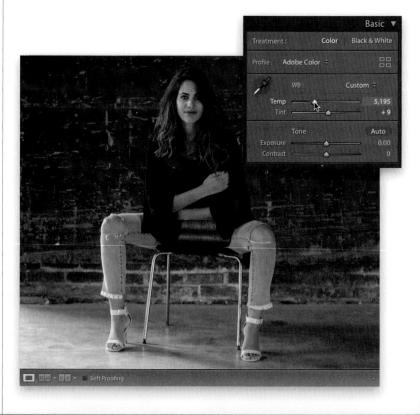

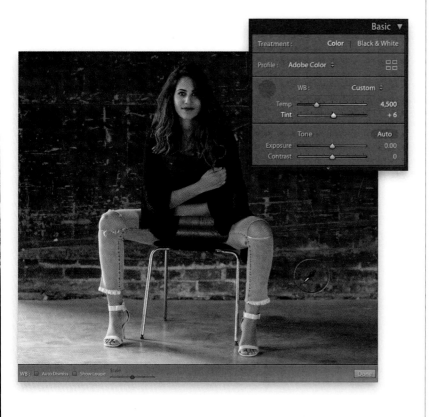

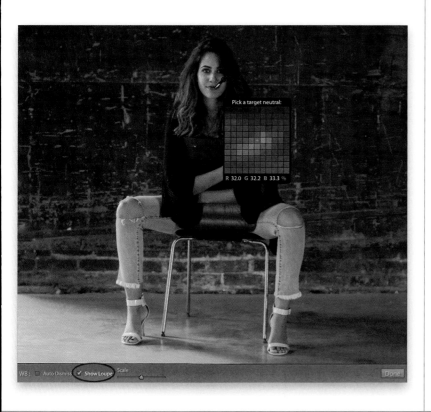

Step Five:

Method #3 is my favorite way to set white balance and is the one I use most of the time. Instead of using a preset or the sliders, I use the White Balance Selector tool (it's that huge eyedropper on the top-left side of the white balance section, or you can just press **W** on your keyboard to get it). It couldn't be easier to use—you simply take the tool and click on an area in your image that should be a light-to-medium gray. Not white (that's for setting the white balance for video cameras)—gray! If there's no gray in the photo, look for an area that's kind of a neutral color, like a tan, ivory, taupe, or beige. Boom. Done. Now, the nice thing about this tool is this: if you don't like how the white balance looks where you clicked, just click somewhere else until it looks good to you. So, let's give it a try—go back to the WB preset pop-up menu, choose As Shot, so it looks blue again, then get the White Balance Selector tool and click it on an area that is supposed to be either gray or neutral (the floor or the lighter areas of that background should do).

Step Six:

What happens if you click in the wrong spot? Trust me, you'll know (see how the whole image turned green here?). If that happens (and it will), don't sweat it—just click somewhere else, including trying a place you wouldn't think would give you an accurate white balance. Now, you see that grid that follows your eyedropper around? We simply call that the "useless annoying grid." Theoretically, it's supposed to help you find a neutral color by showing you the pixels under the location of your cursor, along with the RGB values, and if you to get all three of those numbers to match up (it happened once, in a sci-fi movie), that would be a truly neutral color. I only recommend using this grid to people I don't really like. It kind of evens the score. Anyway, to turn it off, turn off the Show Loupe checkbox (shown circled here in red) down in the toolbar.

Continued

Step Seven:

This is more of a tip than a step, but it's super-helpful. When you're using the White Balance Selector tool, look over at the Navigator panel at the top of the left side Panels area. As you hover the White Balance Selector tool over different parts of your photo, it gives you a live preview of what the white balance would look like if you clicked there (as shown here, where I'm hovering over her leg and the preview shows a very yellowish white balance. If I clicked on that spot, that's what I would get). This can save you lots of clicks and lots of time when trying to find a white balance that looks good to you—move your cursor around the image, and when the preview looks good, just click. When you're done, click the Done button down in the toolbar, or click the tool back where you got it from over in the Basic panel.

TIP: Dismiss the White Balance Selector Tool

In the toolbar, there's an Auto Dismiss checkbox. With this turned on, after you click the White Balance Selector tool once, it automatically returns to its home in the Basic panel.

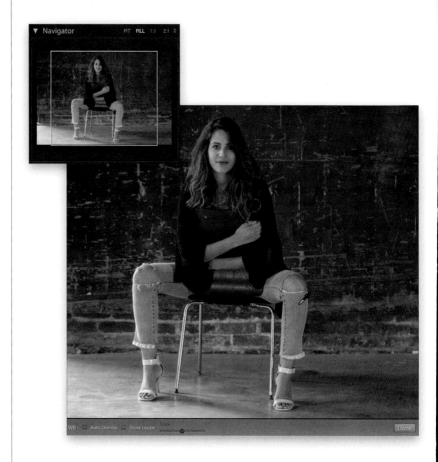

Step Eight:

Here's a before/after using the White Balance Selector tool method.

TIP: For Creative White Balance, Use the Temp/Tint Sliders

Here we learned how to get an accurate white balance because our subject is a person and we want their skin tone to look normal. However, there are times, like when we're doing landscape photos, when we might want to get creative and choose a white balance that makes the image look awesome, rather than accurate. In those cases, I drag the Temp and Tint sliders until I see something I like.

The fact that you can shoot tethered directly from your camera, straight into Lightroom, is one of my favorite features in Lightroom, but when I learned the trick of having the correct white balance applied automatically, as the images first come into Lightroom, it just put me over the top. So much so that I was able to include a free, perforated, tear-out 18% gray card in the back of this book, so you can do the exact same thing (without having to go out and buy a gray card. A big thanks to my publisher, Peachpit Press, for letting me include this). You are going to love it!

Setting Your White Balance Live While Shooting Tethered

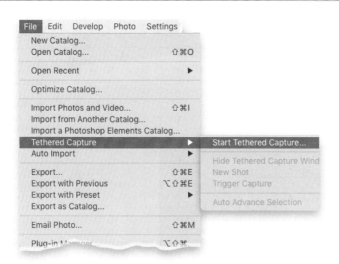

Step One:
Start by connecting your camera to your computer (or laptop) using a USB cable, then go under Lightroom's File menu, under Tethered Capture, and choose **Start Tethered Capture** (as shown here). This brings up the Tethered Capture Settings dialog, where you choose your preferences for how the images will be handled as they're imported into Lightroom (see Chapter 3 for more details on this dialog and what to put in where).

Step Two:
Once you get your lighting set up the way you want it (or if you're shooting in natural light), place your subject into position, then go to the back of this book, and tear out the perforated 18% gray card. Hand the gray card to your subject and ask them to hold it while you take a test shot (if you're shooting a product instead, just lean the gray card on the product, or somewhere right near it in the same light). Now, take your test shot with the gray card clearly visible in the shot (as shown here).

Continued

Step Three:

When the photo with the gray card appears in Lightroom, get the White Balance Selector tool **(W)** from the top of the Develop module's Basic panel, and click it once on the gray card in the photo (as shown here). That's it—your white balance is now properly set for this photo. Now, we're going to take that white balance setting and use it to automatically fix the rest of the photos as they're imported.

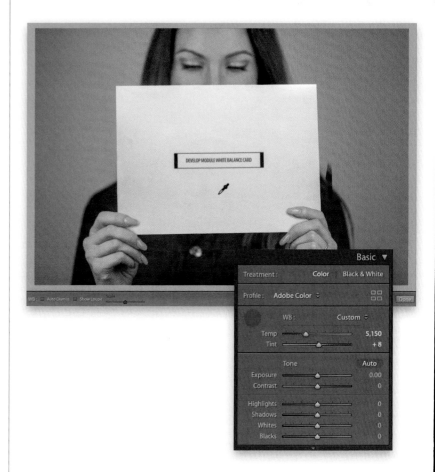

Step Four:

Go to the Tethered Capture window (press **Command-T [PC: Ctrl-T]** if it's no longer visible) and on the right side, from the Develop Settings pop-up menu, choose **Same as Previous**. That's it—now you can take the gray card out of the scene (or get it back from your subject, who's probably tired of holding it by now), and you can go back to shooting. As the next photos you shoot come into Lightroom, they will have that custom white balance you set in the first image applied to the rest of them automatically. So, now, not only will you see the proper white balance for the rest of the shoot, that's just another thing you don't have to mess with in post-production afterward. Again, a big thanks to my publisher, Peachpit Press, for allowing me to include this gray card in the book for you.

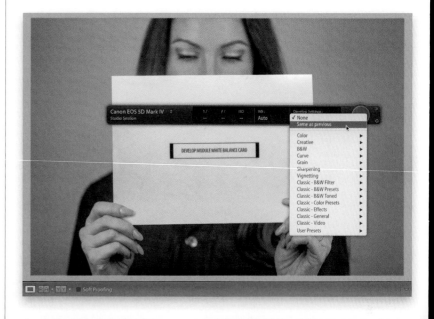

In the white balance project, I showed a before and after, but I didn't get a chance to show you how I did that. I love the way Lightroom handles the whole before and after process because it gives you a lot of flexibility to see these the way you want to see them. Here's how:

Seeing a Before and After

Step One:
If you're working in the Develop module and want to see your image before you started tweaking it (the "before" image), just press the **\ (backslash) key** on your keyboard. You'll see the word "Before" appear in the upper-right corner of your image (as seen here). This is probably the Before view I use the most in my own workflow. To return to your After image, press the \ key again (it doesn't say "After;" the Before just goes away).

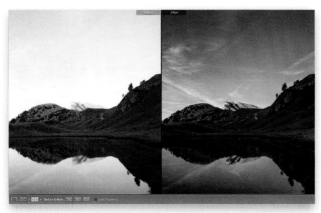

Step Two:
To see a side-by-side Before and After view, with the before on the left and the after on the right (as seen here), press the letter **Y** on your keyboard. Press Y again to return to the normal view. There are some other before/after options, but to access those, you'll need to make sure the toolbar beneath the Preview area is visible (as seen here). If it's not, press the letter **T**.

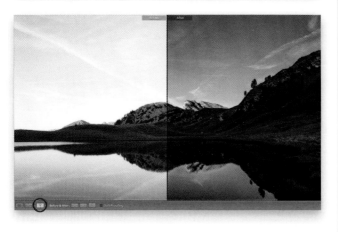

Step Three:
If you prefer a different before/after layout, like a split-screen view, where your image is split down the center with the left half in the Before view and the right half in the After, click the Before and After Views button (circled here in red) once in the toolbar. Click it again for a top/bottom split-screen before and after. The three buttons to the right of Before & After do this: the first one copies the Before image's settings to the After image, the second one copies the After's settings to the Before, and the third just swaps the Before/After settings. To return to normal view, press the letter **D** on your keyboard.

Want to Copy a Particular Look? Reference View Can Help

If you have an image you've processed in Lightroom (maybe last year or even five years ago), and you want to match that look on a current photo you're editing, Reference view lets you put them side by side, so you can see the original (the reference photo) while you edit your current photo to match it. This also works great for nailing the look of an image you saw online—download it, use it as your reference image, and work on matching that same look.

Step One:

In this case, I want my Reference photo to be a shot of Venice's Grand Canal near sunset, and I want to apply its look to a shot I took earlier of that same cathedral across the canal. I want them both to have the same look, but I can't just copy-and-paste the settings because my Grand Canal photo is a flattened JPEG I edited in Photoshop. But, I'm able to put it up as my Reference photo, while I tweak the other image on the right, and I can see my edits live on the Active image as I'm tweaking. To enter this view, in the Develop module's toolbar, click the Reference view button (the second button from the left, shown circled here in red, or press **Shift-R**). Your Reference photo will be displayed on the left (you'll see the word "Reference" at the top right), and the photo you're actively editing will be displayed on the right as the "Active" image.

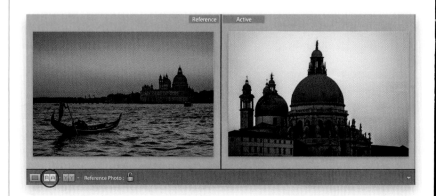

Step Two:

Now you can make your edits right along-side the Reference photo. Here, I made the Active image much warmer, dragging the Temp and Tint sliders way over to the right. I pulled the Exposure back to –0.75, and the Highlights back to –100, and brought up the Contrast a bit, as well. I didn't "nail" it, but I got in the ballpark, thanks to having the Reference photo right there. (*Note:* In this case, I'm using one of my own photos, but I've also used this Reference view feature to help figure out the look applied to a photo I downloaded from the web).

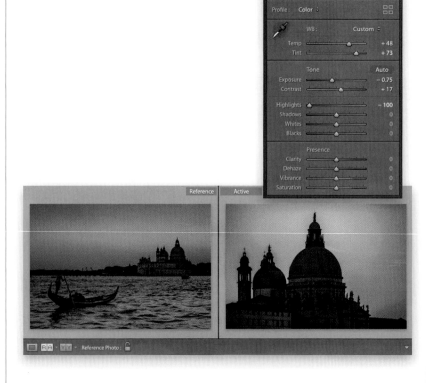

Adobe finally made this feature pretty awesome. We used to joke the old Auto Tone feature was simply the "overexpose by two stops" button. It was fairly useless, but now Adobe went and put some serious math and muscle behind the Auto Tone button (it uses Sensei, Adobe's artificial intelligence and machine learning platform, previously known as Skynet), and now it's actually pretty darn good (and at the very least, a decent starting place).

Auto Tone (It's Finally Actually Really Kinda Pretty Good)

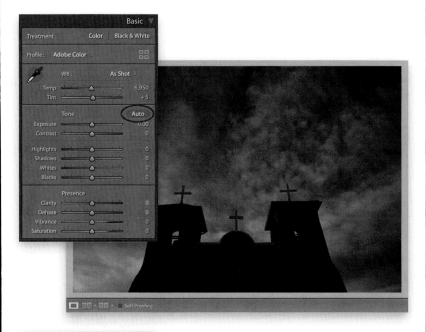

Step One:

Auto Tone is a one-click fix (or at least, a good starting place) and the worse your photo looks at the start, the better job it seems to do. It uses this new AI and machine learning, called "Adobe Sensei," and by golly, it ain't bad! Here's an under-exposed, dull, flat-looking original RAW image. Click the Auto button once (it's in the Basic panel, in the Tone section, just to the right of the word "Tone"), and Lightroom quickly analyzes the image and applies what it thinks is the proper correction for this photo. It only moves the sliders it thinks are needed to make the image look decent (the obvious ones, like Exposure, Contrast, Shadows, and the other stuff in the Tone section of the Basic panel, but it'll also adjust Vibrance and Saturation. At this point, though, it does not adjust the Clarity amount).

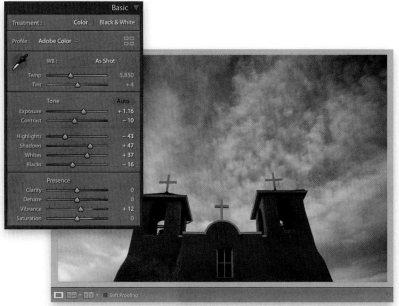

Step Two:

Just one click and look at how much better the image looks. Compare the slider settings now versus the previous step. Also, I find that if you apply Auto Tone and it looks a little funky, it's because sometimes it applies too much of the Shadows slider and lowers the Contrast too much. So, just lower the Shadows amount a bit, and increase the Contrast amount a bit, and then see how that looks (but, again, only do this if the Auto Tone results look funky). By the way, if you don't like the results from the Auto Tone button, no harm done, just press **Command-Z (PC: Ctrl-Z)** to undo the auto toning.

Expanding Your Tonal Range by Setting Your White and Black Points

Back in the days before Lightroom, when we just used Photoshop for toning our images, we started the process in Levels by dragging the whites over as bright as we could get them without clipping the highlights. Then, we'd drag the blacks over as dark as we could get them, without them turning solid black. It was called "setting our white and black points," and doing this actually expanded the tonal range of our photos. Now, not only can we do this same thing in Lightroom, we can have Lightroom do it for us automatically (you just have to know the secret handshake).

Step One:

Here's the original image and you can see it looks pretty flat. I use the technique you're about to learn (which expands the image's tonal range) on pretty much every image, but this is another technique where the worse the original looks, the more dramatic the results. There are two ways to do it: Lightroom can do this for you by expanding the amount of whites in the image as bright as they can get without damaging your highlights, and increasing the amount of blacks, so the dark areas are nearly solid black, but it stops short so you still have some detail. Yup, it'll do all that automatically. Or, you can do it yourself (I never do it the manual way—I always let Lightroom set it for me).

Step Two:

Here's how to have Lightroom automatically set your white and black points, expanding your tonal range, near the start of your editing process (it's so simple): Just press-and-hold the Shift key, then double-click directly on the word "Whites," or on its slider knob in the Basic panel. That sets your white point. Now, Shift-double-click on the word "Blacks" (as shown here in the inset), or on its slider knob, and it automatically sets your black point. That's it. It's that easy, and that's how I do it in my own workflow (but I add one extra thing, which you'll learn after the next page). By the way, if you Shift-double-click on either one and it barely moves or doesn't move at all, that means your original capture already pretty much has its tonal range expanded.

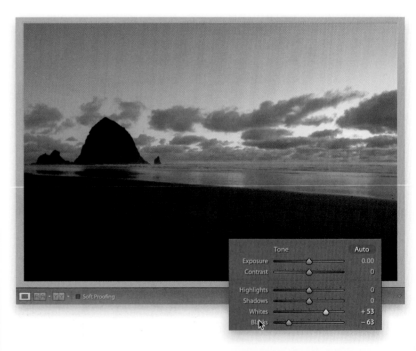

Step Three:

If, instead, you want to do this process manually, you'll want to make sure you don't "clip" any of your highlights (making them so bright you lose data in the brightest areas of your image, or so dark that parts of the image turn solid black and thus have no detail). Luckily, Lightroom can warn you using an onscreen clipping warning. Here's how: Press-and-hold the Option (PC: Alt) key before you drag the Whites slider. This turns the screen solid black (as seen here, at top). As you drag to the right, any areas that start to clip will become visible. If you see red, blue, or yellow, it means you're clipping in just that individual channel (not as big a worry). However, if you see solid white areas, you're clipping in all three channels, and you've gone too far. So, pull it back to the left until those white areas go away. Now, do the same thing with the Blacks slider: press-and-hold the Option key as you drag to the left, and stop when you see black areas appear, then pull back to the right (as seen here, below, where I backed off, so I'm only really clipping in the blues. I can live with that little bit of clipping).

Step Four:

Here's a before and after where I used the automatic "Shift-double-click the Whites/Shift-double-click the Blacks" method to expand the image's tonal range. There's still work to be done (including what I do on the next page in conjunction with this), which will give me my overall exposure. So, what you're seeing here is not the final product—that's just a double-click on two different words. Not bad for a couple of double-clicks, though.

Controlling Overall Brightness (Exposure)

The Exposure slider controls the overall brightness of your image. If you look at the histogram (at the top of the right side Panels area) as you drag the Exposure slider (or heck, just hover your cursor over the Exposure slider itself, then glance up at the histogram), you'll see a light-gray shaded area that covers the center 1/3 (if not more) of the entire histogram. It controls the midtones, but really more than that because it also controls the lower highlights and upper shadows, too, all by itself. If you drag it all the way to the left, it will turn your image almost solid black—to the right, almost solid white.

Step One:

Here's our image, and you can see it's way overexposed (there are no lights here, except for those inside the elevator car and the natural light coming in from above—it looks dark and futuristic inside this "cone," in the City of Arts and Sciences complex in Valencia, Spain). To lower the overall brightness of an image, I reach for the Exposure slider in the Basic panel. This is one powerful slider, and as I mentioned above, it covers a wide range of midtones, lower highlights, and upper shadow areas. So, when I need something a little brighter or darker overall, this is the slider I reach for.

TIP: Get a Larger Working Space

Since the controls we're going to use for editing our image are in the right side Panels area, let's close the left side Panels area, so our image appears much larger onscreen. Just press **F7** on your keyboard, or click on the little, gray, left-facing triangle on the far-left center edge to collapse it and tuck it out of sight.

Step Two:

To darken the overall brightness of the image, drag the Exposure slider to the left until the exposure looks good to you. Here, I dragged it to the left quite a bit (down to –1.35, so it was nearly a stop-and-a-half overexposed). While I do grab this slider to make the overall image brighter or darker, I think you get better results if you use it in conjunction with setting the white and black points (see the next page).

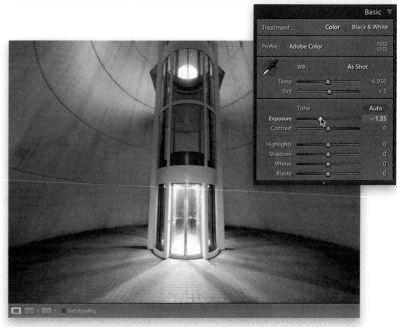

In my own daily workflow, I combine setting the Whites slider, the Blacks slider, and the Exposure slider to give me my overall exposure, and I think the results are far better. I start by setting the white and black points (well, I let Lightroom do this for me automatically; see page 144) to expand my tonal range, and then if the image still looks too dark or too bright, I only have to tweak the Exposure amount a little bit, dragging it left (if I think the overall image is still too bright) or right to brighten it.

My Power Trio: Combining Whites + Blacks + Exposure

Step One:
I'm using the same image we used on the previous page, and I did the same thing here that I did there—I saw the image was overexposed (too bright), so I dragged the Exposure slider to the left until the exposure looked right to me (as seen here in the After photo). So, now the baseline exposure is correct, but we can make this image look better (and this is what I do in my own workflow) if instead of grabbing the Exposure slider first, we use it after we have Lightroom set the Whites and Blacks sliders for us (again, see page 144). That way, those sliders expand the tonal range first, then we can make the final adjustment with the Exposure slider, tweaking it to be darker or lighter with just a small move. I think the result looks much better overall doing it this way.

Step Two:
Here, I used my "Power Trio" technique by first Shift-double-clicking on Whites, and then Shift-double-clicking on Blacks. Then, I took a look at how the overall brightness of the image looked. I felt it needed to be a bit darker overall, so I dragged the Exposure slider to the left. The difference will look more subtle here in a printed version of a screen capture, but when you try it yourself (try it on one of your images, or download this same one), you'll see quite a difference. (By the way, the name "Power Trio" is actually used to describe rock bands that only have drums, bass, and one guitar [no second rhythm guitar or keyboards]. Think bands like ZZ Top, Rush, or Motörhead.)

Adding Contrast (Important Stuff!)

I host a live weekly photography show called *The Grid* (it's now in its seventh year), and once a month, we invite our viewers to submit images for a blind photo critique (we don't mention the photographer's name on the air, so we can give honest critiques without embarrassing anyone). So, what's the #1 most common post-processing issue we see? Flat-looking photos. That's a shame because it's fixed so easily, and with just one slider.

Step One:

Here's our flat, lifeless image. Before we actually apply any contrast (which makes the brightest parts of the image brighter and the darkest parts darker), here's why contrast is so important: when you add contrast it (a) makes the colors more vibrant, (b) expands the tonal range, and (c) makes the image appear sharper and crisper. That's a lot for just one slider, but that's how powerful it is (in my opinion, perhaps the most underrated slider in Lightroom). Now, for those of you coming from a much earlier version of Lightroom, the Contrast slider used to have so little effect that we really didn't use it at all—we had to use the Tone Curve to create a decent amount of contrast. But, Adobe fixed the math behind it back in Lightroom 4, and now it's awesome.

Step Two:

Here, all I did was drag the Contrast slider to the right, and look at the difference. It now has all the things I mentioned above: the colors are more vibrant, the tonal range is greater, and the whole image looks sharper and snappier. This is such an important tweak, especially if you shoot in RAW mode, which turns off any contrast settings in your camera (the ones that are applied when you shoot in JPEG mode), so your RAW images look less contrasty right out of the camera. Adding that missing contrast back in is pretty important, and it's just one slider. By the way, I never drag it to the left to reduce contrast—I only drag it to the right to increase it.

One of the things we worry about most while shooting is making sure that we don't clip off important highlight detail. It's why most cameras have a built-in highlight warning feature, because if the brightest highlights get too bright, they literally clip off, leaving no pixels, no detail, no nuthin'. If you were to print the image, there wouldn't even be any ink on those areas. If you didn't catch the problem in-camera, no worries, we can usually recover those clipped highlights right in Lightroom.

Dealing With Highlight Problems (Clipping)

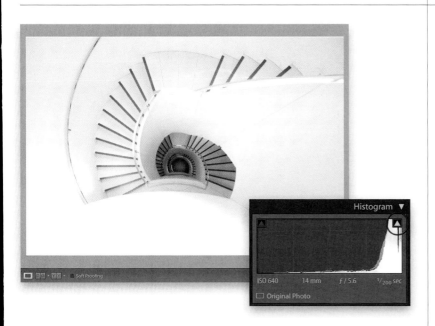

Step One:

Here's a shot of one of the spiral staircases in the wonderful Tate Britain museum in London. Not only is the staircase fairly white, but I overexposed the image a bit when I shot it. That doesn't necessarily mean we have clipping (see the intro above for what clipping means), but Lightroom will warn us if we do. Take a look at the triangle up in the top-right corner of the histogram (seen here). That triangle is normally gray, which means everything's okay—no clipping. If you see a color inside that triangle (red, yellow, or blue), that mean the highlights are clipping in just that color channel, which isn't the end of the world. However, if you see that triangle filled with white, then it's clipping the highlights in all your channels, and you'll need to deal with it if it's an area where there's supposed to be detail.

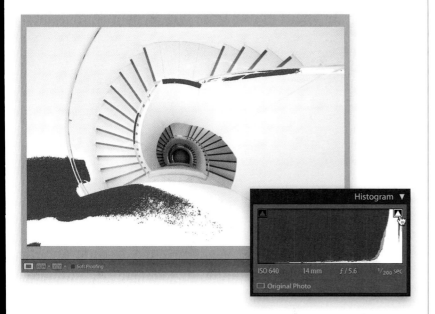

Step Two:

Okay, now we know we have a highlight clipping problem somewhere in our image, but exactly where? To find out, go up to that white triangle and click directly on it (or press the letter **J** on your keyboard). Now, any areas that are clipping in the highlights will appear in bright red (as seen here, where big parts of the stairs and railings are clipping badly). Those areas will have *no* detail whatsoever (no pixels, no nuthin') if we don't do something about it.

Continued

Step Three:

Technically, you could just drag the Exposure slider over to the left until all those red clipped warning areas go away (as shown here), but that will affect the overall exposure of the image, making the entire image underexposed (and this case, a bit dingy, too). It's like you fixed one problem, but then created another. That's why the Highlights slider is so awesome—it lets you leave the exposure right where it is and it addresses those super-bright clipped areas itself because it just affects the highlights and not the entire exposure.

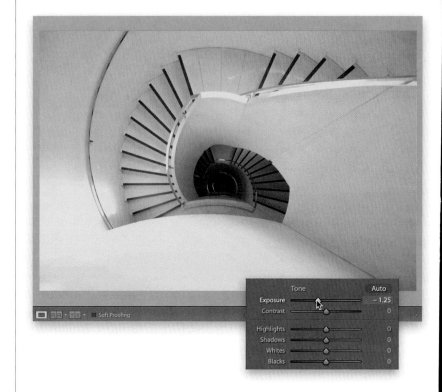

Step Four:

Let's put the Highlights slider to work. Just drag it to the left until you see the red onscreen clipping warning go away (as shown here). The warning is still turned on, but dragging the Highlights slider to the left fixed the clipping problem and brought back the missing detail, so now there are no areas that are clipping.

TIP: This Rocks for Landscapes

The next time you have a blah sky in a landscape or travel shot, drag the Highlights slider all the way to the left to –100. It usually does wonders with skies and clouds, bringing back lots of detail and definition. I use this trick fairly often.

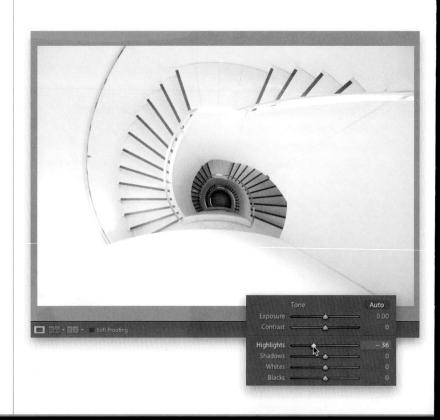

Why do we take so many backlit photos? It's because our eyes are so darn amazing and adjust for such huge differences in tonal range automatically. So, our subject could be standing there totally backlit, but our eyes automatically adjust for it and they look fine to us. The problem is: even the best camera sensors today don't have nearly the range of our eyes, so even though, when we look through our viewfinder, it looks fine to us, when we press the shutter button, the sensor can't handle that much range and we wind up with a backlit photo. Luckily for us, help is just one slider away.

Fixing Backlit Photos and Opening Up Dark Areas

Step One:
Here's the original image and you can see the subject is backlit. While our eyes do an amazing job of adjusting for scenes like this with such a wide range of tones, as soon as we press the shutter button and take the shot, we wind up with a backlit image where our subject is in the shadows (like you see here). As good as today's cameras are (and they are the most amazing they've ever been), they still can't compete with the incredible tonal range of what our eyes can see. So, don't feel bad if you create some backlit shots like this, especially since you're about to learn how easy it is to fix them.

Step Two:
Go to the Shadows slider, drag it to the right, and as you do, just the shadow areas of your photo are affected. As you can see here, the Shadows slider does an amazing job of opening up those shadows and bringing out detail in the image that was just hidden in the shadows. *Note:* Sometimes, if you really have to drag this slider way over to the right, the image can start to look a little flat. If that happens, just increase the Contrast amount (dragging to the right), until the contrast comes back into the photo. You won't have to do this very often, but at least when it happens, you'll know to add that contrast right back in to balance things out.

Clarity: Lightroom's Detail Enhancer

If you're looking for the nerdy technical explanation, the Clarity slider adjusts the amount of midtone contrast, but since that's of little help (well, I guess it is to nerds), then here's how I look at it: I drag this slider to the right when I want to enhance any texture or detail in my image. When you apply a lot of Clarity, it almost looks like you've sharpened the image (but, be careful, you can over-apply Clarity—if you start to see halos around objects in your image or your clouds have drop shadows, that's a warning sign you've gone too far).

Step One:

Which kinds of shots work best with Clarity? Usually anything with wood (from churches to old country barns), landscape shots (because they generally have so much detail), cityscapes (buildings love clarity, so does anything glass or metal), or basically anything with lots of intricate detail (even an old man's craggy face looks great with some Clarity). Here's our original image and there's lots of detail we can enhance—everything from the wood grain in the pews to the ornate adornments throughout the tiny chapel. *Note:* I don't add Clarity to photos where you wouldn't want to accentuate detail or texture (like a portrait of a woman, or a mother and baby, or just a newborn).

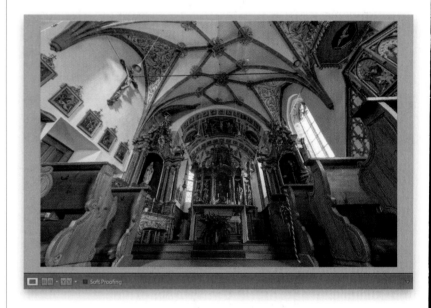

Step Two:

To add more punch and bring out the texture and detail in our image here, drag the Clarity slider quite a bit to the right. Here, I dragged it to +74, so you can really see the effect. Look at the added detail in the wood and the altar. If you start seeing a black glow appear on the edges of objects, you know you've dragged too far. If that happens, just back it off a bit until the glow goes away.

Note: The Clarity slider does have one side effect—it can affect the brightness of the photo; sometimes making it look darker, and other times making parts look too bright. That's easily fixed with the Exposure slider, but I just wanted you to keep an eye out in case that happens.

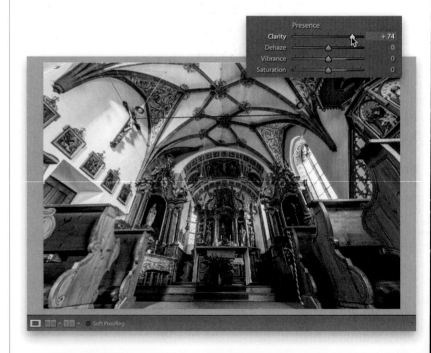

Photos that have rich, vibrant colors definitely have their appeal (that's why professional landscape photographers back in the film days got hooked on Fuji Velvia film and its trademark saturated color). Lightroom has a Saturation slider for increasing your photo's color saturation, but the problem is it increases all the colors in your photo equally, and…well…let's just say it's not awesome (and that's being kind). That's why I love Lightroom's Vibrance slider (a great name for it would have been "Smart Saturation"). It lets you boost colors without trashing your photo, and it does it in a very smart way.

Making Your Colors More Vibrant

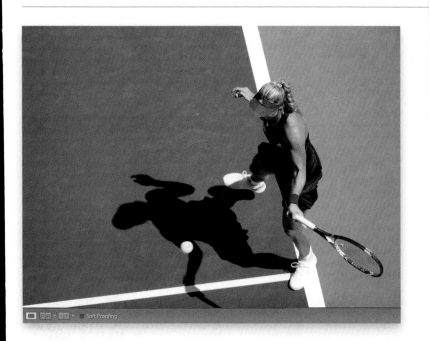

Step One:
In the Presence section (at the bottom of the Basic panel) are two controls that affect the color saturation—one is brilliant; one is…well…crappy. There, I said it. It's crappy. I only use the Saturation slider to reduce color (desaturating), never to boost it because the results are pretty awful (it's a very coarse adjustment where every color in your image gets saturated at the same intensity). This is why I use Vibrance instead—it boosts the vibrance of any dull colors in the image quite a bit. If there are already saturated colors in the image, it tries not to boost them very much at all. Lastly, if your photo has people in it, it uses a special mathematical algorithm to avoid affecting flesh tones, so your people don't look sunburned or weird.

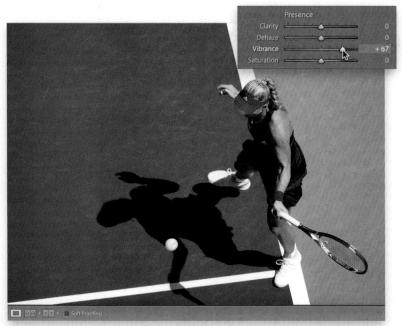

Step Two:
Here's a perfect example. Take a look at our tennis player back in Step One. She's wearing a vibrant red visor and red tennis outfit, but the blue service court areas and the green back court behind the baseline are kind of washed out in the direct sun. If I drag the Vibrance slider over to +67 (like I did here), you can see how much it affected the dull blue and green areas—they're now nice and vibrant. But look at her hat and outfit—they've only been boosted a little because they were already pretty vibrant. Most importantly, compare her skin tone in both image—it's only boosted the tiniest amount because Vibrance protects skin tones wonderfully. It truly is "smart saturation."

Removing Haze

Lightroom's Dehaze feature is so awesome it has its own fan base because it does that good of a job at removing haze, fog, etc. (Bonus tip: If you drag the slider to the left, it actually adds fog or haze, so there's that.) It's actually just another form of contrast, but it's a form that loves to cut through haze, so I'm all for it. Here's how it works:

Step One:
Here's our original image, taken in the canals of Phoenix, Arizona (just wanted to see if you're paying attention). It was a foggy morning, but I kept shooting because I knew Dehaze would bail me out.

Step Two:
In the Presence section of the Basic panel, you'll now find the Dehaze slider (it used to be in the Effects panel, which seemed like a weird place for this slider to live—it needed be here in the Basic panel, along with Clarity, Vibrance, and Saturation, so this was a good move). Anyway, drag the Dehaze slider over to the right and the haze literally just goes away (as shown here).

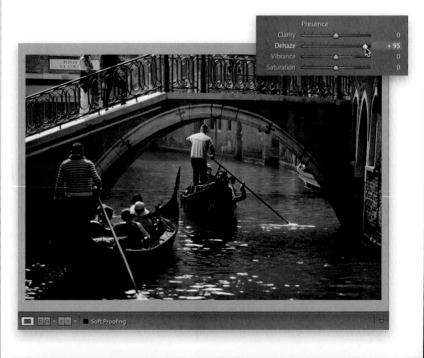

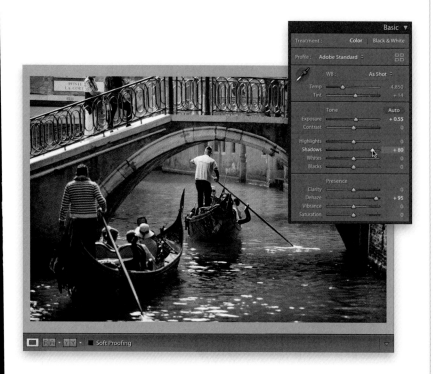

Step Three:

I don't know if you noticed in that last step, but when I dragged that Dehaze slider way over to the right, while it did get rid of the haze, it also made the image a bit darker. That's because Dehaze is a form of contrast, so the darker areas in the image got quite a bit darker. This is why you often have to increase the Exposure slider a bit, and maybe the Shadows slider quite a bit, too (which is what I did here), after applying a heavy dose of Dehaze. Just something to keep in mind. Also, if you have even the slightest amount of vignetting (darkening in the corners) from your lens, cranking Dehaze up will exaggerate it quite a bit, so get rid of any vignetting problems first (we'll look at how to do this in Chapter 9).

Step Four:

Here's a before/after of our image, and you can see what a huge difference it made (but, again, I did increase the Exposure and Shadows amounts afterward, so the image didn't look too dark). Another thing to keep an eye out for when using a high Dehaze setting is that it can introduce a bluish tint into your image. If that happens, you might have to back off the Vibrance slider a bit (to a negative number) to counteract that.

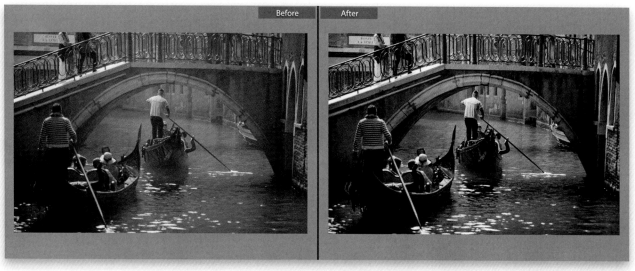

Before | After

Continued

Step Five:

Let's take a look at another image for something else you might run into and a great fix for it. In this case, I tweaked the image (doing the standard stuff: Exposure, Contrast, Clarity, etc.), and I added a decent amount of Dehaze. It actually worked pretty well to get rid of most of the haze in the foreground and middle ground, but the area where the bridge is and behind that is still kind of hazy. If I crank up the Dehaze slider much more, everything will turn blue, and the corners will darken, and it'll start going from bad to worse. That's why it's so awesome to be able to apply Dehaze with the Adjustment Brush. By doing it this way, I can paint over those areas in the back that need an extra amount of Dehaze, without affecting the sky or making everything turn blue.

Step Six:

Click on the Adjustment Brush **(K)** in the toolbar at the top of the right side Panels area, and increase the Dehaze amount by quite a bit (remember, with this brush, you pick an amount, paint, and then go back and choose the right amount. So, don't worry if the amount you choose at this point is the right amount because you'll tweak it after you paint). You can also increase either the Exposure or Shadows, or both (that's what I did here), since Dehaze tends to darken the areas you paint over. Next, take the brush and paint over the bridge, and the surrounding buildings, and they're now nice and crisp. You'd never guess the original image was the one you see on the left on the next page (that was before I made the Exposure, Contrast, etc., tweaks and increased the Dehaze setting). By the way, after I applied Dehaze the first time, I had to lower the Vibrance amount a little to keep the image from looking too blue. I also dragged the white balance Temp slider a little toward yellow to help offset the blue.

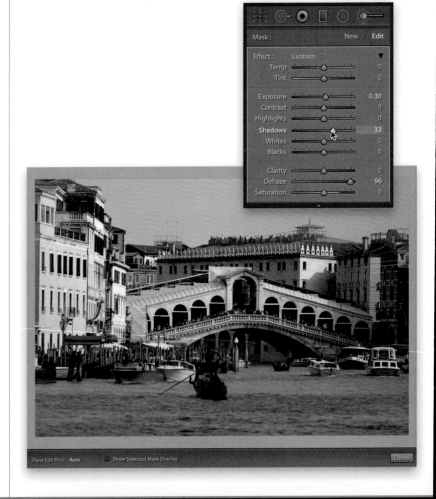

Before After

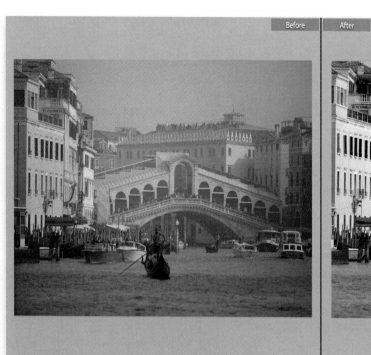

Automatically Matching Exposures

If you've run into a situation where you have some images where the exposure or overall tone is off, Lightroom can usually fix it for you, pretty much automatically. This is great if you're shooting landscapes and the exposure changes on you as the light changes, or if you're shooting a portrait and your exposure changes as you're taking the shots, or about any time where you want a consistent tone and exposure across a set of images.

Step One:

Take a look at this set of images, taken with natural light. The first one is too bright, the second one's too dark, the third looks about right (well, to me anyway), the fourth and fifth look underexposed, etc. So the exposure for these images is kind of all over the place. One brighter, three darker, and one looks okay. Click on the image that has overall exposure you want (to make it the "most selected" image), then press-and-hold the Command (PC: Ctrl) key and click on the other images to select them, as well. Now, press **D** to jump to the Develop module.

Step Two:

Go under the Settings menu and choose **Match Total Exposures** (as shown here). That's it. There are no settings. There's no dialog. No window. It just does its thing. Press **G** to jump back to the Grid view and compare these images to the ones in Step One, and you can see that they all have a consistent exposure now. This works pretty darn well in most cases, which makes it pretty darn handy.

Now that you've learned all that, I wanted to share the order in which I use all those Basic panel sliders (and yes, I pretty much do the same thing every time, in the same order). While there are still things yet to learn, including local adjustments and special effects and lots of other fun stuff, this is the fundamental image editing I do, and it's often the only editing I do to my image (it just depends on the image). Almost everything else I apply to an image (special effects, or looks) will happen after I'm done with this phase here. I hope you find this helpful.

Putting It All Together (Here's the Order I Use for My Own Editing)

1) I choose my RAW Profile
Adobe Color is pretty good, but if I decide I want more pop, I usually go with Landscape or Vivid as my starting place.

2) I set my white balance
If your color isn't right…it's wrong. I use the White Balance Selector tool most of the time.

3) I have Lightroom automatically set my white and black points
I expand my overall tonal range by Shift-double-clicking on the word "Whites," then on the word "Blacks."

4) I tweak the overall brightness
After setting the white and black points, if I feel the image is too dark or too bright, I drag the Exposure slider a bit, until it looks right.

5) I add contrast and clarity
I always add contrast. As for clarity, I only use it if I want to enhance detail.

6) If I have highlight clipping or detail lost in shadows, I fix it now
This is when I would fix any clipping problems or open up the shadows (dragging the Shadows slider to the right) to reveal hidden detail. This is also when I would use Dehaze if there was a haze or fog issue.

7) Boost colors
Between setting my whites and blacks, and adding contrast, my color is usually pretty vibrant, but if for some reason I think it needs more, I increase the Vibrance amount.

Using the Library Module's Quick Develop Panel

There's a version of the Develop module's Basic panel right within the Library module, called the Quick Develop panel. The idea is that you can make some quick, simple edits right there in the Library module, without having to jump over to the Develop module. The problem is, the Quick Develop panel stinks. Okay, it doesn't necessarily stink, it's just hard to use because there are no sliders—there are buttons you click instead that move in set increments (which makes it frustrating to get just the right amount)—but for a quick edit, it's okay (you can see I'm biting my tongue here, right?).

Step One:

The Quick Develop panel (shown here) is found in the Library module, under the Histogram panel, at the top of the right side Panels area. Although it doesn't have the White Balance Selector tool, it has pretty much the same controls as the Develop module's Basic panel (like Highlights, Shadows, Clarity, etc.; if you don't see all the controls, click on the triangle to the right of the Auto Tone button). Also, if you press-and-hold the Option (PC: Alt) key, the Clarity and Vibrance controls change into the Sharpening and Saturation controls (as seen on the right. *Note:* The Dehaze slider from Develop didn't make it over to Quick Develop yet—hopefully, one day soon). If you click a single-arrow button, it moves that control a little. If you click a double-arrow button, it moves it a lot. For example, if you click the single-right-arrow for Exposure, it increases the Exposure amount by 1/3 of a stop. Click the double-right-arrow and it increases it by a full stop.

Step Two:

One way I use Quick Develop is to quickly see if an image (or a set of images) is worth working on, but without actually doing a full edit in the Develop module. For example, these sunrise images all looked a bit too yellow to me, so to quickly see how they would look with some blue added, I selected them, went to Temperature, and clicked once on the single-left-arrow to move it toward blue. For a bigger jump toward blue, I could have clicked on the double-left-arrow to move it more.

Top-left image: original Contrast

Top-right image: original Contrast

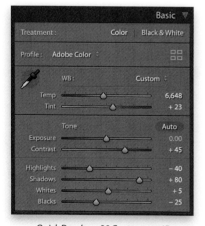

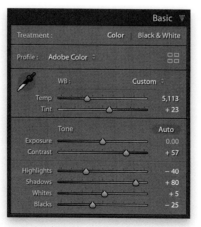

Quick Develop +30 Contrast = +45

Quick Develop +30 Contrast = +57

Step Three:

Another way I use Quick Develop is for comparing changes I'm making to one image to other similar images. For example, here I deselected all the images except for the top-left one. Then, I clicked on the double-right-arrow next to Temperature to make this one image much more yellow (as seen here), which contrasts the other images that I added blue into earlier, and I can see how doing this change compares to the rest.

TIP: Finer Increments in Quick Develop

You can adjust in smaller increments when clicking a single-arrow button. For example, if you Shift-click on the Exposure single-right-arrow, it moves up 1/6 of a stop, instead of a 1/3 of a stop (so, instead of moving +33, it moves just +17 for each Shift-click).

Step Four:

Yet another way to take advantage of Quick Develop is to use it for relative changes. Let's say I had adjusted these images in the Develop module. They look good, but I think they could use more contrast. I had already increased the Contrast to +15 for the first image, the second to +27, the third to +12, and the fourth to +20. If I changed the first one to +30, then used either Sync or Auto Sync, all four images would change their Contrast to +30. Well, that's not what I wanted. I wanted them all to keep the amount of contrast I had originally chosen for each, but add that +30 on top (making the first image's Contrast setting now +45, the second's +57, and so on). I want a relative change added to their current Contrast settings, not absolute where they all change to the same number. Quick Develop lets me do that. I selected the images (in this case, just the top two) and clicked the Contrast double-right-arrow to increase it by +20, then I clicked the single-right-arrow twice to add +10, for a total of +30. This didn't change both images to +30; it added +30 to their current Contrast amounts (as seen here)

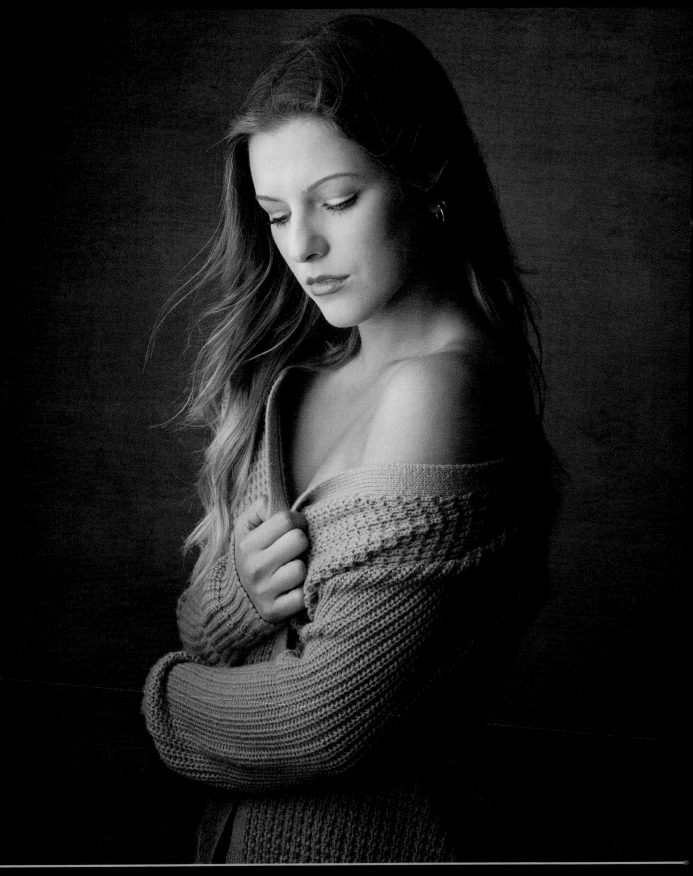

PAINTING WITH LIGHT
the adjustment brush & other toolbox tools

This chapter is about working with Lightroom's Adjustment Brush and other tools, but you know and I know, what we all really want to talk about is drones, which is great if you do drone photography because then this chapter could be about painting with light on your fabulous drone images. But, I'm just using drones here as an analogy to explain a wider concept, so let's not get hung up on the whole drone thing. Hey, did I mention I got the DJI Mavic Air drone? It's pretty slick, and when you fold in the propellers, it's literally the size of a Coca-Cola can. Anyway, the reason I'm bringing up drones is this: every place has its own drone laws, and they vary from country to country. For example, I went to a country in the Middle East with my buddy Dave, but at Customs in their airport, we learned that drones are forbidden in that country, and they confiscated Dave's Mavic Pro. Luckily, he was able to retrieve it upon leaving the country, after he paid a "storage fee." That's where

this book differs, in that I let you move freely from chapter to chapter without a fee, unlike the Federal Aviation Administration (FAA) here in the US, which currently requires you to register your drone with them and pay a $5 registration fee. So, this got me to thinking: perhaps, before you read this chapter, you should submit a small registration fee, like I dunno, maybe $3? That way, I could officially register you to read a chapter like this, which contains information that is worth considerably more than $3. Now, I know what you're thinking: "But Scott, I bought and paid for this book." Well, I bought and paid for my drone, yet I still had to pay a fee to fly it. You see, just buying a book (or a drone) establishes ownership, but that does not constitute usage and thus, according to several made-up laws, a registration fee should be levied, and that's the story of how I became a junior senator representing Florida's 14th Congressional District. #sendyourfeetome

Everything we've done so far affects the entire image—if you drag the Exposure slider, it changes the brightness for the entire image (it's a "global adjustment"). But, what if you want to adjust one particular area of your image (a "local" adjustment)? Then, our primary tool is the Adjustment Brush, which lets you "paint with light" just where you want it. In the darkroom days, this was called "dodging and burning," which simply means brightening (dodging) some areas and darkening (burning) others. This is way bigger than it sounds (and you can do more with this brush than just brightening and darkening).

Adjusting Individual Areas (Dodging & Burning)

Step One:
Here's the original image, taken in Marrakesh, Morocco. The top center and the light are too bright and the side rooms and the center fountain are too dark. This is where the Adjustment Brush, which lets you "paint with light," totally rocks. I usually get the basic overall exposure decent, and then I use the brush on areas that are too bright or too dark. To help you understand how it works: it's a quick, three-step process where (1) you drag a slider to a random amount (brighter or darker), (2) you paint over the area you want to adjust, and (3) you go back to that slider and dial in the right amount of adjustment. It sounds weird (you're kind of flying blind at first, right?), but it works.

Step Two:
Click on the Adjustment Brush (in the toolbox above the Basic panel or press the letter **K**) to bring up its sliders (it's pretty much the same sliders, in the same order, as the Basic panel). First, reset all the sliders to zero by double-clicking directly on the word "Effect" (circled here), then let's work on brightening the left side of the image. The goal is to balance the light in the image, so drag the Exposure slider to the right a bit (the amount doesn't matter right now because you'll choose the right amount after you paint), then paint over that room and the tile in the archway, but not the top of the arch. When you're done, drag the Exposure slider to where it looks good to you (here, I set it to 1.49). Compare this area on the left here, with the original in Step One.

Step Three:

Now let's brighten the archway above the tile on the left. I want to balance the light here, so it's more like the archway on the right side of the image (there's that balancing thing I was talking about. I zoomed in tight here, so you can see the area we're working on more clearly). If I paint with the brush as is (it's set to 1.49), it will be way too bright. To paint in a new area, and be able to use a new, lower exposure setting, we need to tell Lightroom we want to paint someplace new, so click on New (shown circled here) at the top of the panel. Now, we can lower the Exposure amount (I lowered it to 0.72), paint over the top of the archway, and then adjust the Exposure amount without affecting the area where we just painted. You'll also notice that there's now a circle with a black dot on that arch. That's called an "Edit Pin," and it represents the area we just painted over. You'll see a white Edit Pin where we started when we first painted over the room. So, now, your image has two Edit Pins. If you wanted to go back and adjust what you did to the room on the left, you'd click on that white Edit Pin (it would turn into a black dot like this one, letting you know that pin is now active), and it remembers the original Exposure setting.

TIP: Changing Brush Size

Press the **Left Bracket key** to make the brush smaller or the **Right Bracket key** to make it larger.

Step Four:

If you want to see the area a particular pin affects, just hover your cursor over the pin and that area appears in a red tint (as seen here, where I hovered over the pin for the room on the left).

TIP: Leaving This Red Tint On

If you want this red tint (known as the mask overlay) left on, you can either turn on the Show Selected Mask Overlay checkbox in the toolbar beneath the Preview area, or press the letter **O**.

Continued

Step Five:

If you're wondering how I brightened that arch without "going outside the lines" and spilling my brightening onto the wall, I used an awesome feature called Auto Mask. When you turn Auto Mask on (near the bottom of the panel), it senses where the edges of things are and keeps you from accidentally painting over onto other areas. The trick is knowing how it works: You see that little + (plus sign) in the center of the brush (circled here)? That determines what gets affected as you paint, so any area that + travels over gets painted. It's okay if the outside edge of brush strays outside the area (as mine does here), as long as that + in the center doesn't stray over the edge. Keep that + inside the arch and you won't paint over the wall.

TIP: Making Your Brush Faster

Leaving the Auto Mask feature on slows the brush down quite a bit because it's doing math as you paint with it, so I only turn it on when I get near the edge of something I don't want to spill over (press the letter **A** to toggle it on/off).

Step Six:

Now let's work on darkening that center ceiling area with the windows. Click on New (since we're going to be working on a new area), double-click on Effect to reset all the sliders to zero, then drag the Exposure slider way over to the left, so it darkens when we paint, and then paint over the entire center ceiling area. When you're done painting, adjust the Exposure amount (I set mine to –0.67). Now, you're going to unlock more of the brush's power—you can use more than just one slider at a time. The windows in that area could use their highlights pulled back, and the whole area needs more contrast, so drag the Highlights slider to the left, crank up the Contrast, and for even more contrast, crank up the Whites and drag the Blacks to the left (as seen here). Now that ceiling's looking pretty good.

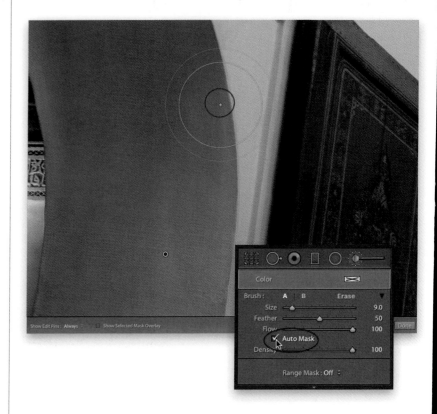

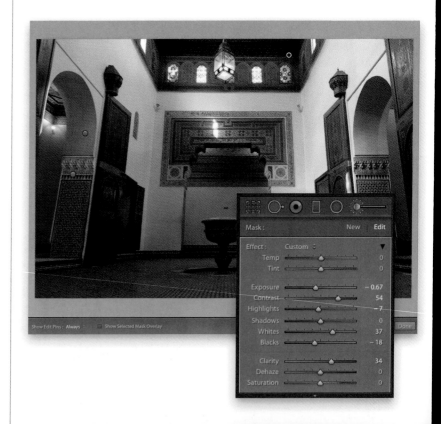

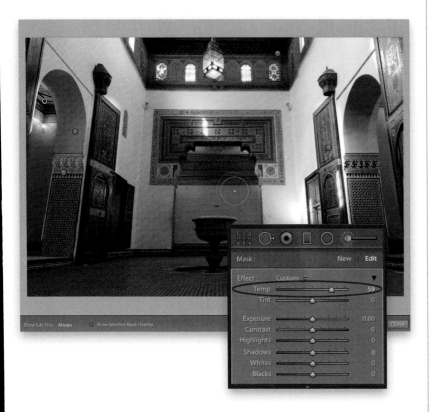

Step Seven:

We've been painting with light (exposure) and contrast, now let's paint with color. Yes, you can paint white balance, so let's warm up both of those side rooms, the hallway right in the center of the image (don't forget to turn on Auto Mask, so you don't spill over and paint on the fountain in the middle), and even the ceiling up top. You do that by clicking on New, double-clicking on Effect to reset the sliders to zero, and then dragging the white balance Temp slider way over to the right, toward yellow. Now, start painting (as shown here, where I'm painting over that hallway wall in the center, with Auto Mask on when I got near that fountain). Click New again, add a bunch of contrast and some clarity, bump up the exposure, and then let's paint over the doors themselves to bring out their detail and dimension.

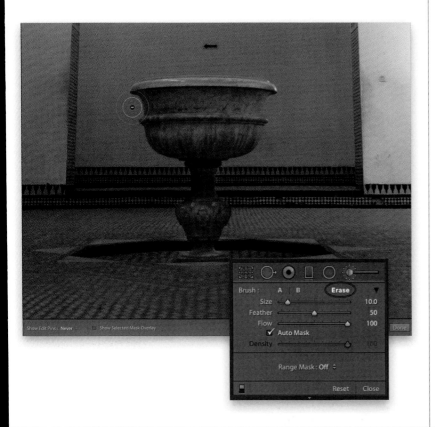

Step Eight:

The fountain in the center still looks pretty dark, so let's brighten it up. You know the routine by now: click on New, double-click on Effect, increase Exposure, paint, and then adjust the slider to the proper amount. I turned on Auto Mask as I painted, but it isn't 100% all the time—sometimes, depending on the tone and definition of an edge, you still wind up spilling over (which I did on the top left of the fountain here). So, I pressed-and-held the **Option (PC: Alt) key**, to temporarily switch to the Erase brush, and I painted over the spill to erase it (note how the plus sign changes into a minus sign when you switch to the Erase brush).

TIP: How to Delete an Edit Pin

If you want to remove a pin from an area, just click on it and hit Delete (PC: Backspace).

Continued

Step Nine:

That floor is looking kind of dingy and could use just a bit of brightening. You know what to do. Ahhh, that looks better. Now, click on the Edit Pin for the doors you painted over (if you're not sure which pin that is, hover briefly over each pin and the area it affects will appear in red. Once you find the pin for the doors, click on it), and those settings automatically reappear in the panel. Let's use those same settings to paint over the tile pattern above the center doorway to bring out its detail (as shown here).

TIP: Seeing If You Missed a Spot

Click on an Edit Pin, then press the letter **O** on your keyboard to turn on the red mask over that area. If you missed a spot, that area won't appear in red, so just paint over it and it should turn red. When it's all red, you know you haven't missed any spots.

Step 10:

This last step is optional, but since a lot of photographers are adding "light hits" (not an official name; it's just what I call it), I thought I would include this. Doing this adds a large "hit" of light over highlight areas, and even areas where there aren't natural highlights, to make it look like little swatches of light are somehow falling down into your image (maybe through the windows?). Click on New and reset your sliders. Then, set your Exposure amount to 1.00, make your brush size really large, and make sure Auto Mask is turned off, then simply click the brush once in highlight areas (or wherever you want a hit of light to appear—I hovered my cursor over the pin, here, so you can see all the places I clicked with that huge brush). It's definitely a special effect, but it can be a nice finishing effect if done right.

Step 11:

Here, you can see the light hits without the red mask overlay (compare it to the image shown in Step Nine). Before we wrap up our project, two quick things: (1) You have some handy Brush options (along with the Erase brush) in the bottom section of the Adjustment Brush panel. You can choose the Brush Size (using a slider), the amount of Feather (how soft the edges are—I usually keep mine set at 50), and the Flow (whether it paints a solid stroke at 100% opacity or whether you want it to build up as you paint; I leave mine at 100). (2) You actually have two brushes to choose from: "A" (your regular brush) and "B," an alternate brush, and you can choose the settings for each. I usually give my "A" brush (my main brush) a soft edge (with a high Feather amount) and give my "B" brush a hard edge (by lowering the Feather amount to 0, as seen here). So, if I run into a situation where I'm painting along a wall, or other area where a soft edge looks weird, I can toggle over to my "B" brush using the \ **(backslash) key** on my keyboard.

TIP: Moving an Edit Pin

To move a pin, just click-and-drag it where you want it.

Five More Things You Should Know About Lightroom's Adjustment Brush

There are a few other things you need to know that will help you get more comfortable with the Adjustment Brush, and once you learn these (along with the rest of the stuff in this chapter), you'll find yourself making fewer trips over to Photoshop, because you can do so much right here in Lightroom.

#1: You have a choice of how Lightroom displays the Edit Pins, and you make that choice from the Show Edit Pins pop-up menu down in the toolbar beneath the Preview area (as shown here). Choosing Auto means when you move your cursor outside the image area, the pins are hidden. Always means they're always visible, and Never means you never see them. Selected means you only see the currently active pin.

#2: To see your image without the edits you've made with the Adjustment Brush, click the little switch at the bottom left of the panel (circled below in red).

#3: If you press the letter **O**, the red mask overlay stays onscreen, so you can easily see, and fix, areas you've missed.

#4: If you click on the little down-facing triangle to the far right of the Effect pop-up menu, it hides the Effect sliders, and instead gives you an Amount slider (as shown here) that provides a single, overall control over all the changes you make to the currently active Edit Pin.

#5: Below the Auto Mask checkbox is the Density slider, which kind of simulates the way Photoshop's Airbrush feature works, but honestly, the effect is so subtle when painting on a mask, that I don't ever change it from its default setting of 100.

Fixing problems that only appear in certain parts of your image is where the Adjustment Brush comes up big, because you can paint away the problems in these areas. Things like white balance problems when, for example, part of your image is in daylight and part is in the shade. Or painting away noise that just appears in the shadow areas, leaving the rest of the photo untouched (and saving it from the blurring that comes with noise reduction). Incredibly handy.

Selectively Fixing White Balance, Dark Shadows, and Noise Issues

Step One:
Let's start with painting white balance. Take a look at the image here, where the subject is lit, but the background is in the shade. Because I shot this in Auto White Balance on my camera, the background has a fairly strong blue tint to it (pretty typical when part of your image winds up in shade. I face this a lot shooting sports, when part of the field is in shade in late afternoon games and part is in daylight). This is where the ability to paint white balance in just certain areas is incredibly helpful, so press the letter **K** to get the Adjustment Brush.

Step Two:
Double-click directly on the word "Effect" to reset all the sliders to zero. Then, drag the Temp slider over to the right a bit (toward yellow) and start painting over the background. As you do, the yellow white balance you're painting neutralizes the blue in the background (as seen here). Because you have to guess your starting point, the original amount of Temp I used (31) wasn't enough, so I increased the Temp amount to 73 and that looked better. Painting with white balance like this is a huge help. Next, let's paint away noise the same way.

Continued

Step Three:

Here we have an image that is severely backlit from the window. If you look at the before image on the left, you can't even see any detail around the window—it's all just a silhouette. However, when you crank up the Shadows slider and the Exposure slider enough to where the image is properly exposed (I also lowered the Highlights slider a lot to bring some detail back in the area outside the window), you see all the noise big time. Noise usually hides in the shadows, and sometimes when you drastically open up those shadow areas (like we did here), any noise that was in the image is now magnified. So, the window looks great, but the window pane, the shutters, and the area below the window are full of red, green, and blue noise dots that we need to deal with.

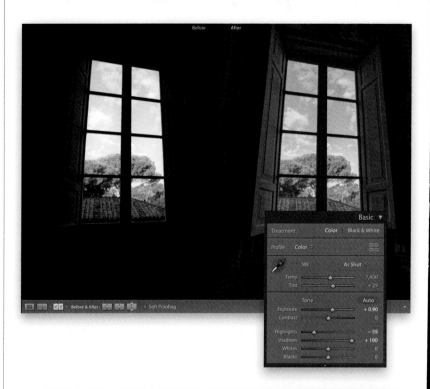

Step Four:

So, why don't we just use Lightroom's regular Noise Reduction controls in the Detail panel? It's because that affects the entire image equally—when it reduces noise, it also softens the entire image. Here, by using the Adjustment Brush, we can reduce the noise only in the areas I mentioned and leave the rest of the photo (the brighter areas that don't show much noise) sharp and untouched. By doing it this way, we only make those areas a little soft and not the entire image. To do this, get the Adjustment Brush, and then double-click on the word "Effect" to reset all the sliders to zero. Now, drag the Noise slider all the way to the right, and then paint over those areas to reduce the noise there. How far are you supposed to drag that Noise slider? The idea is to find that sweet spot where it's not too noisy and it's not too blurry. Also, don't forget, all the other sliders here still work, so you could darken just those areas a little, while you're applying noise reduction, which would help to hide the noise, too. Here, I also increased the Sharpness slider to 26.

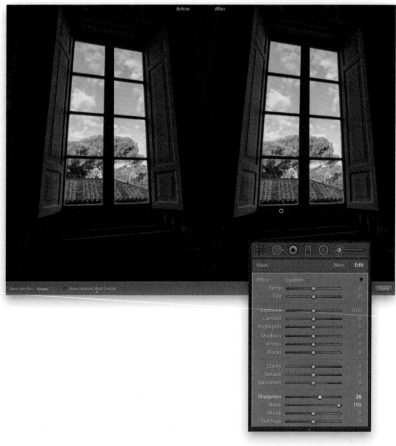

When it comes to detailed retouching, I generally jump over to Adobe Photoshop, but if you just need to do a quick retouch, it's amazing how many things you can do right here in Lightroom using the Adjustment Brush and the Spot Removal tool, with its healing power. Here's a quick retouch using just those two tools:

Retouching Portraits

Step One:
Here are the things we're going to retouch in this image: (1) remove any major blemishes and wrinkles, (2) soften her skin, (3) brighten the whites of her eyes, (4) add contrast to her eyes and sharpen them, and (5) add some highlights to her hair. Although we're seeing the full image here, for retouching, it's best to zoom in quite a bit. So, go ahead and zoom in nice and tight to start the next step. By the way, I thought her skin looked a little too bright in the original image, so here I reduced the Highlights to −15 (just so you know).

Step Two:
Here, I've zoomed in to a 1:2 view, so we can really see what we're doing (just select this zoom ratio from the pop-up menu at the top right of the Navigator panel, at the top of the left side Panels area). Click on the Spot Removal tool (in the toolbox near the top of the right side Panels area, or just press the letter **Q**). This tool works with just a single click, but you don't want to retouch any more than is necessary, so make the brush Size of the tool a little bit larger than the blemish you're going to remove. Move your brush cursor over the blemish and then just click once. A second circle will appear, showing you where it sampled a clean skin texture. Of course, it's not always 100% right, and if for some reason it chose a bad area of skin to sample from, just click on that second circle, drag it to a clean patch, and it will update your blemish removal. Go ahead and remove any blemishes now using this tool (as shown here).

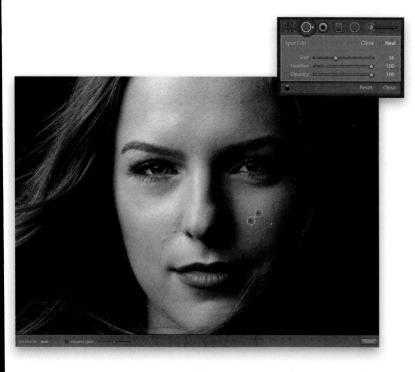

Continued

Step Three:

Now, let's remove some wrinkles under her eyes. Zoom in tighter (this is a 1:1 view), then take the same Spot Removal tool we've been using (make sure it's set to Heal) and paint a stroke over the wrinkles under her eye on the right (as shown here). The area you've painted over turns white (as seen here), so you can see the area you're affecting.

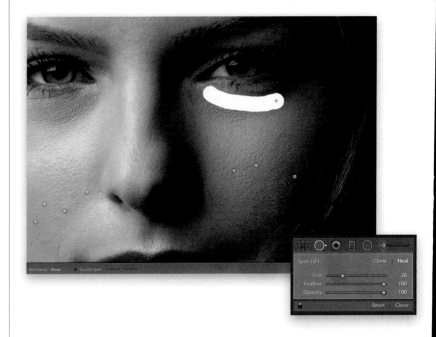

Step Four:

Lightroom analyzes the area and picks a spot somewhere else in the image to use to repair those wrinkles. It usually picks something nearby, but in this case it chose an area across the bridge of her nose, which, of course, created a bad retouch. Luckily, if you don't like where Lightroom chose to sample from, you can simply have it sample somewhere else by clicking on that second outline (the thinner one of the two) and dragging it somewhere on her face where you think the texture and tone will match better (here, I moved it right up under the original area where the wrinkles were, as shown in the overlay). Also, don't forget to remove the wrinkles beneath the other eye (it's easier to forget than you'd think). *Note:* If our subject is at an age where fully removing the wrinkles is unrealistic, we need to "reduce" the wrinkles instead, so we would decrease the Opacity amount to lower the strength of the removal, bringing back some of the original wrinkles.

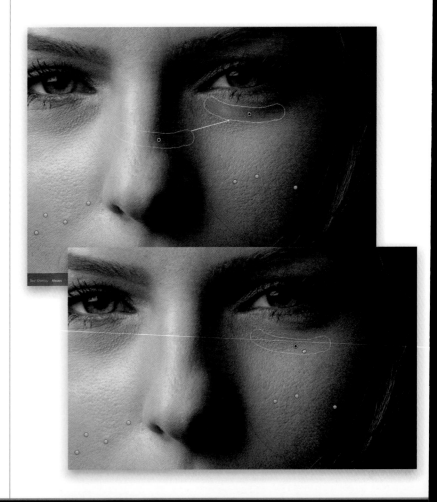

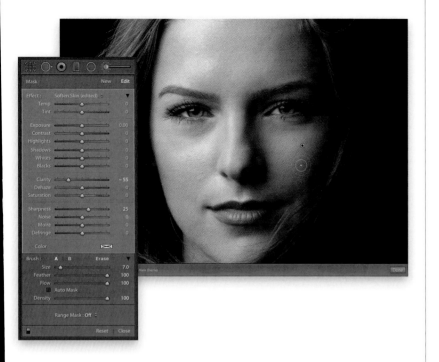

Step Five:

Now that the blemishes and wrinkles are removed (I also removed some stray hairs), let's do some skin softening. Switch to the Adjustment Brush (also in the toolbox near the top of the right side Panels area, or just press the letter **K**), then choose **Soften Skin** from the Effect pop-up menu. Now, paint over her face, but be careful to avoid any areas that you don't want softened, like her eyelashes, eyebrows, lips, nostrils, hair, the edges of her face, and so on. This softens the skin by giving you a negative Clarity setting (it's set at –100). Here, I've only painted over the right side of her face, so you can see the difference. This is quite a lot of softening, so once you're done, back off the Clarity amount so you can still see skin detail (I raised my amount to –55).

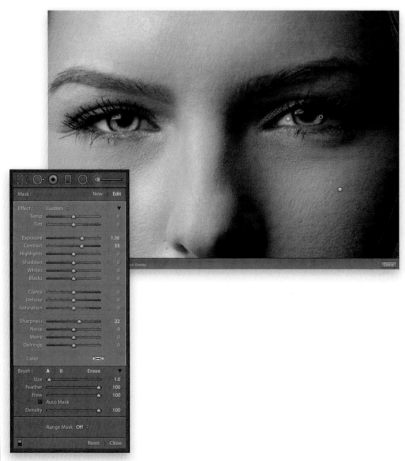

Step Six:

Next, let's work on her eyes, and we'll start by making the whites brighter. First, click the New button in the top right of the panel, then double-click on the word "Effect" to reset all the sliders to zero. Now, drag the Exposure slider to the right a little bit (here, I dragged it over to 0.50) and paint over the whites of her eyes. If you accidentally paint outside the whites, just press-and-hold the **Option (PC: Alt) key** to switch to the Erase brush and erase away any spillover. Do the same for the other eye and, when you're done, adjust the Exposure slider, as needed, to where the whitening looks natural. Next, let's brighten her irises. Click the New button, and increase the Exposure amount to 1.36 and paint over both irises. Then, to add some contrast, increase the Contrast slider to 33. Lastly, to make those eyes really nice and sharp, increase the Sharpness slider to 22, so the irises get brighter, more contrasty, and sharper, all at the same time.

Continued

Step Seven:

Now, click the New button once again, and let's brighten the highlights in her hair. Start by resetting your sliders to zero, then drag the Exposure slider to the right a little bit (I dragged mine to 0.35), and then paint over the highlight areas to bring them out. Lastly, one of the retouches I get asked the most to do by subjects is to slim them up a bit. I don't think our subject here needs it at all, but if you're asked, here's how it's done: Go to the Transform panel (in the right side Panels area), and in the Transform section, drag the Aspect slider to the right (as seen here at the bottom). As you do, it compresses (narrows) the photo, giving you an instant slimming effect. The farther to the right you drag, the more your subject gets slimmed (here, I dragged to +25). A before/after is shown below.

TIP: Keep from Seeing Too Many Pins

To see just the currently selected Edit Pin, choose **Selected** from the Show Edit Pins pop-up menu in the Preview area toolbar.

The After photo has clearer and smoother skin (plus the highlights have been reduced a little bit); the eyes are brighter, have more contrast, and are sharper; we've enhanced the highlights in her hair; and we've slimmed her face a bit

The Graduated Filter (which is actually a tool) lets you recreate the look of a traditional neutral density gradient filter (these are glass or plastic filters that are dark on the top and then graduate down to fully transparent). They are popular with landscape photographers because you're either going to get a perfectly exposed foreground or a perfectly exposed sky, but not both. However, the Lightroom version actually has some big advantages over using a real neutral density gradient filter.

Richer Skies Using the Graduated Filter

Step One:
Start by clicking on the Graduated Filter tool in the toolbox (it's the second icon to the left of the Adjustment Brush, or press **M**), near the top of the right side Panels area. When you click on it, a set of options pops down that are similar to the effects options of the Adjustment Brush (shown here). Here, we're going to replicate the look of a traditional neutral density gradient filter and darken the sky. Start by choosing **Exposure** from the Effect pop-up menu and then drag the Exposure slider to the left to –1.65 (as shown here). Just like with the Adjustment Brush, at this point, we're just kind of guessing how dark we're going to want our gradient, but we can darken or lighten it later.

Step Two:
Press-and-hold the Shift key (to keep your gradient straight as you drag), click on the top center of your image, and drag straight down until you reach around the middle of the photo (the horizon line). You can see the darkening effect it has on the sky, and the photo already looks more balanced. You might need to stop dragging the gradient before it reaches the horizon line, if it starts to darken your properly exposed foreground, but here, I was able to drag quite a bit lower than the horizon line (it just depends on the photo). In this case, just lowering the exposure didn't do all that much for our sky (as seen here), and this is one area where Lightroom's feature is better than the real filter—we can do more than just darken the exposure.

Continued

Step Three:

Since lowering the Exposure amount didn't make my sky look great (though, honestly, that's usually enough), the next thing I do is add some blue by simply dragging the Temp slider to the left toward blue. What a huge difference that makes! You can also add in some contrast and bring out the clouds by increasing the Whites. That's stuff you could never do with the real filter. Also, here, you can see that I pulled the gradient down so far that it started to darken the mountain just a bit (the Edit Pin shows where the center of your gradient is—you can drag it up/down to reposition). On the next page, I'll show you how to deal with situations like that (and, in the next technique, I'll show you an even better trick), but before we get to all that, just a couple of quick things: (1) To delete your gradient, click on the Edit Pin and press the Delete (PC: Backspace) key. (2) If you don't press-and-hold the Shift key while you drag out your gradient, you can rotate it as you drag (in case you need to).

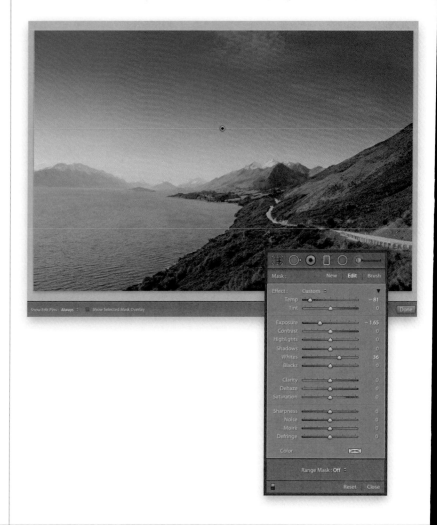

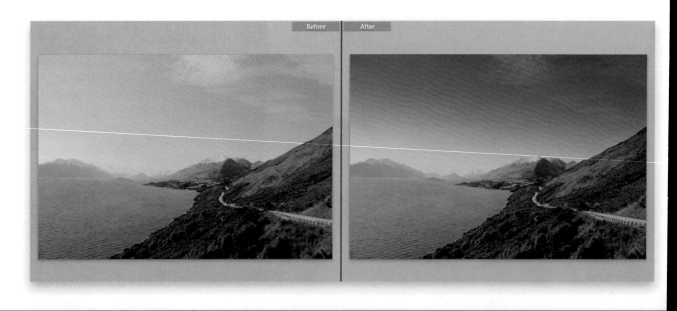

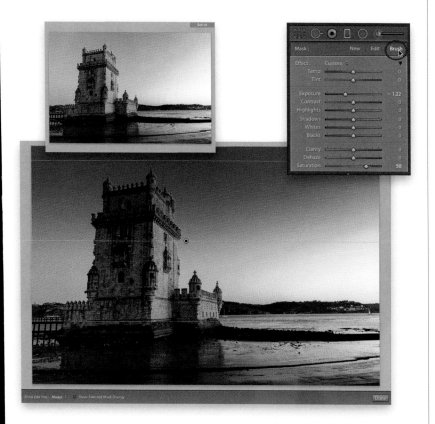

Step Four:
You're going to run into times where the Graduated Filter covers part of the image you don't want affected, like in this case, where we do want to darken and saturate the sky and graduate down to transparent, but it also darkens and saturates Lisbon's Belem Tower at the same time, which we don't want. Luckily, you can edit that gradient and basically erase the filter just over that tower area. While the Graduated Filter pin is selected, in the Mask section right below the toolbox, click on Brush, as shown here.

Step Five:
Now, scroll down to the bottom of the panel, just below the sliders, click on Erase, and start painting over the tower, and as you do, it removes the darkening and saturation from the areas you're painting over (as seen here). All the same rules apply as you're painting with this brush that apply to the regular Adjustment Brush (you can press the letter **O** to see the mask as you paint, you can change the amount of feathering on the brush, etc.). Also, you can use this brush to add to a mask, instead of just removing like we did here—don't click on Erase, and then you're adding to the mask. Now, if you want an even easier way to do this, instead of using a brush, check out the next technique.

Making Tricky Adjustments Easily Using Color and Luminance Masking

You just learned the technique for adding a gradient to the sky to darken it and make it richer and bluer, and you also learned the somewhat painstaking way to paint away areas from that mask that you didn't want darkened or made bluer. While you were carefully painting, you might have wondered, "There has got to be a better way, right?" Ah yes, my friend, there is, but it's better than that because there are actually two ways—using a Color or a Luminance Range Mask—and I have to say they are pretty darn awesome.

Step One:
Here's the original image (the tower of the Koutoubia Mosque in Marrakesh, Morocco), and you can see the sky is just screaming for us to use the Graduated Filter tool **(M)** to make it darker and richer, and then have it fade to transparent (see the previous technique if you're not sure what I'm talking about).

Step Two:
Here, I've applied the Graduated Filter, dragging it from the top down to the bottom, and sure enough it gave us a nice, rich, blue sky as it graduates down to transparent. To get that look, of course, I lowered the Exposure slider quite a bit, but I also dragged the Temp slider a little over toward the blue side to add a lot more blue to the sky, I adjusted the Whites and Blacks, and I cranked up the Contrast and Saturation quite a bit, as well. Now comes the problem: while it did an awesome job on the sky, it also darkened the tower on both sides, as well as the clouds in the sky. As I mentioned in the intro above, we could reach for the Brush tool and carefully paint over these areas, but it's gonna be tricky. Luckily, we have something way faster and better we can use instead.

Step Three:
While you still have the Graduated Filter active, scroll all the way to the bottom of its panel and you'll see "Range Mask: Off." There are two different types of Range Masks: Color (which lets us choose which color we want to apply the Graduated filter to) and Luminance (which lets us remove the effect of the Graduated Filter from the darker parts of the image, or the lighter parts, by just dragging a slider). Here, we're going to start by using the Color Range Mask, so click directly on the word "Off," and then choose **Color** from the pop-up menu (as shown here).

Step Four:
Once you choose Color, the Color Range Selector tool (the eyedropper) appears with an Amount slider below it (as seen in the step above). The way this works is really amazingly simple: take the eyedropper and simply click it on the color you want the Graduated Filter applied to (in this case, it's that blue color, so click once in a blue area of the sky), and it instantly masks the tower away (as seen here). If clicking once didn't do the trick (you have lots of different shades of blue in your image), you can add more eyedroppers in different areas of the image by pressing-and-holding the Shift key, clicking once in those areas, and it adds them to what is included in that Graduated Filter adjustment. You can add up to four eyedroppers (as I've done here).

TIP: Click-and-Drag Over Colors
Maybe even more helpful, you can take the eyedropper and click-and-drag out a rectangle over an area to automatically include all the colors in that area.

Continued

Step Five:

If you want to see the mask that's created by the Color Range Mask, press-and-hold the Option (PC: Alt) key, then click on the Amount slider and you'll see a preview of it (as shown here). By the way, dragging the Amount slider to the left includes more areas of colors to be masked away (the dark areas) and dragging to the right masks away fewer colors (press-and-hold the Option key, then drag it back and forth, and you'll instantly see what it does). If you look at the image here at the bottom, you'll see I included a Before/After of the mask, so you can really see what's happening. In the Before image, you can see the mask it applied as a simple gradient—the white areas are affected by all those sliders you moved, and as it moves down to gray, those areas get less of the effect. When it gets down to solid black at the bottom of the image, those black areas are masked out and don't get the effect at all. So, white areas get the full effect, gray partial, and black none. Now look at the mask preview on the After image—the areas in solid black are not affected by the gradient (so the tower doesn't get that darkening or blue over it), and the gray areas, like the clouds, are only partially affected. The white areas (where the blue in the sky is) are the only areas really getting the full effect. Pretty amazing, right?!

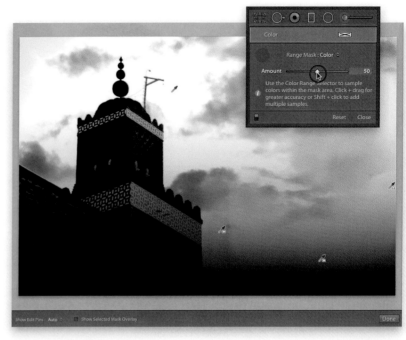

How the mask normally looks when the Graduated Filter is applied evenly across the image

After one click on the blue sky, it masks out non-blue areas, like the tower and clouds

Step Six:

Here's a before/after from the point where we added the gradient. The Before image on the left shows how it looks right after you drag the Gradient Filter from top to bottom. The After image on the right is after clicking the eyedropper on the blue part of the sky, which masked out the tower and clouds for a much more realistic look.

How it looks right after you drag the Graduated Filter

How it looks after you add the Color Range Mask by clicking in the blue sky. The tower and the clouds are masked out from the effect

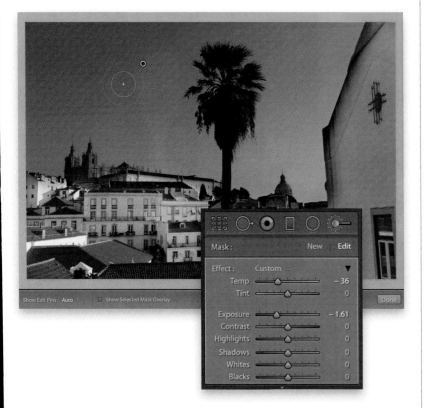

Step Seven:

Two things: (1) The Range Mask isn't just available with the Graduated Filter; it's also available with the Adjustment Brush and the Radial Filter, as well. (2) We haven't used the Luminance Range Mask yet, so let's do that, but we'll use the Adjustment Brush this time, just because we can. We're going to use a different photo (this one from Lisbon). The sky is really washed out, and painting a darker sky between those palm fronds to darken the sky would be really, really tricky and take a ton of time. We'll start by getting the Adjustment Brush **(K)**, darkening the Exposure, and dragging the Temp slider way over toward blue (I took it to –36 here), then just painting over the whole sky—paint right over the palm tree, and if you spill onto the building on the right and skyline below, don't sweat it. No Auto Mask necessary—just paint right over it all.

Step Eight:

Now, go to the bottom of the Adjustment Brush's panel and choose **Luminance** from the Range Mask pop-up menu. This masks away areas based on their darkness or brightness, rather than color. There are two "nubs" on the Range slider: Drag the left one to the right and the darker parts of the image—the palm and the buildings—get masked out of your brush strokes over the sky. To see the mask it created, press-and-hold the Option (PC: Alt) key, click on the Range slider, and it shows the mask (as seen here). Dragging the right nub to the left would subtract any lighter areas from the mask, but in this case, we don't really have any. The Smoothness slider controls how smooth the transition is between the areas that are masked and the effect. Dragging to the right makes the transition smooth; dragging to the left makes it more abrupt and harsh. I added a final before/after on the next page, so you can see how well it masked away that palm and how natural the sky looks behind it.

Continued

Before painting over the sky

*After painting with the Adjustment Brush
and adding a Luminance Mask*

This feature was designed so you could create an edge-darkening vignette without your subject being right in the center—if you use the Post-Crop Vignetting effect in the Effects panel, it darkens the outside edges all the way around your image equally. That's all well and good, but that's not what I use this filter for. I use this filter to create a soft spotlight effect right where I want it in 10 seconds flat, and it's awesome!

Spotlight Effects (and Off-Center Vignettes) Using the Radial Filter

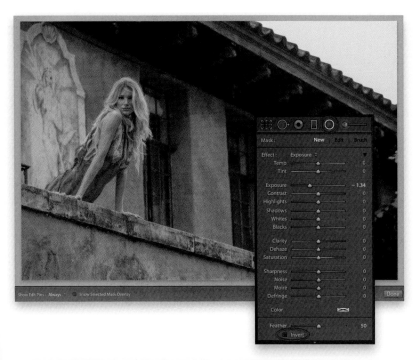

Step One:
The viewer's eye is drawn to the brightest part of the image first, but unfortunately, in this shot, the lighting is fairly even because of the overcast skies, so our subject blends in to her surroundings more than we'd like. We're going to use the Radial Filter tool to re-light the scene and focus the viewer's attention on our subject by adding a subtle spotlight effect. So, click on the Radial Filter tool in the toolbox near the top of the right side Panels area (it's shown circled here in red; or press **Shift-M**). This tool creates an oval or a circle, and you get to decide what happens inside or outside this shape. To get the spotlight effect, I do two things: (1) I lower the Exposure slider quite a bit (in this case to –1.34), and (2) I make sure the Invert checkbox (near the bottom of the panel) is turned off, so the darkening happens outside the oval.

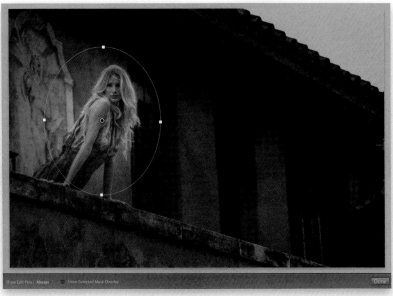

Step Two:
Click-and-drag out the tool over the area where you want the spotlight, and of course, in this case, I would want it over our subject. If, after you drag it out, it's not in the exact spot you want it, just click inside the oval and drag it wherever you want. *Note:* If you need to create a perfect circle using the Radial Filter tool, press-and-hold the Shift key and it constrains the shape to a circle. Also, if you press-and-hold the Command (PC: Ctrl) key and double-click anywhere in your image, it creates an oval as large as it possibly can (you'd use this when you want to create one that affects nearly the entire image, maybe for an overall vignette effect).

Continued

Step Three:

Now that our spotlight is in place, there are lots of things we can do to edit it. For example, if you want to stretch the pool of light out a bit (so it covers all of her), just grab one of the four points around the oval and drag outward. To rotate the spotlight (like I did here), just move your cursor outside the oval and it will change into a two-headed arrow. You can then click-and-drag in the direction you want to rotate your oval. By the way, the transition between the brighter area and the darker area is nice and smooth because the edges of the oval have been feathered (softened) to create that smooth transition (the Feather amount is set to 50, by default. If you want a harder or more abrupt transition, just lower the amount using the Feather slider at the bottom of the panel. Here, I ended up increasing it to 100).

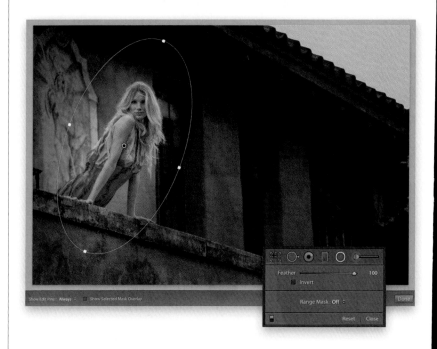

TIP: Removing Ovals

If you want to remove an oval you've created, click on it and then just hit the Delete (PC: Backspace) key.

Step Four:

Let's say you'd like to add another spotlight, a really small one, right over her face. First, to add another spotlight with the same settings, Right-click anywhere inside your oval and choose **Duplicate** (as shown here). That puts another oval right on top of your current one, so the image now looks really dark outside that oval, but you're going to change two things: (1) You're going to make the duplicate really small (slightly larger than her face), and then you're going to click on that center pin and drag it up over her face. It still doesn't look right (well, it does if you're going for a Hollywood Noir effect), because now just her face is lit, and everything else is really dark. So, (2) go to the bottom of the panel, and turn on the Invert checkbox (as seen here; her face will turn really dark), and then drag the Exposure slider over to the right to brighten rather than darken (I took it to 0.42). Now everything looks right.

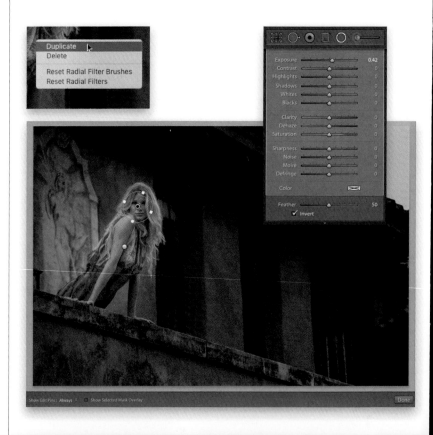

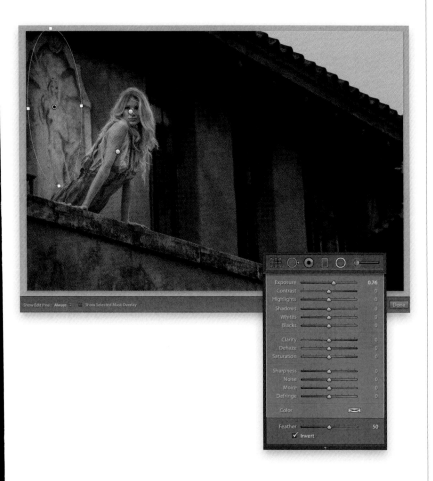

Step Five:

You can add yet another little spotlight oval using this trick: Let's say we want another one that's inverted (the center of the oval gets affected), so we can put just a little light on that bas-relief piece behind her and to the left. Press-and-hold **Command-Option (PC: Ctrl-Alt)**, and click-and-drag the center of the second small oval on her face and a third oval appears (it's a duplicate of your second one). Drag it to the left, position it over the illustration, shape it so it fits nicely over the bas-relief, and raise the Exposure amount, but not so much that it competes brightness-wise with our subject. Here, I raised it to 0.76. A before/after is shown below. By the way, all these settings I'm using here, I'm choosing by just eyeing it—every photo is different. It's a judgement call, but don't worry, since you made the decision to buy this book, I have great faith in your judgement. :)

TIP: Swapping to the Inside/Outside

Pressing the **' (apostrophe) key** turns the Invert Mask checkbox on/off, swapping the effect to the inside/outside.

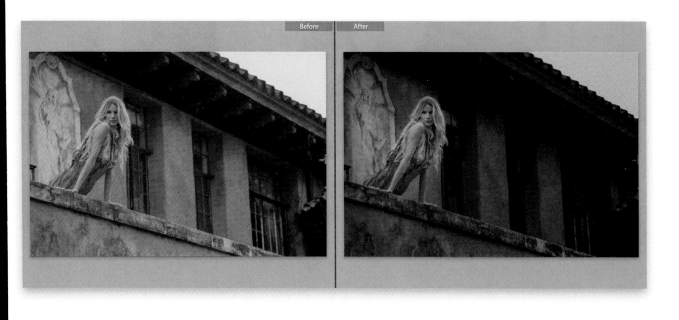

SPECIAL EFFECTS
making stuff look…well…special!

Here's a little known fact: did you know that the Academy of Motion Picture Arts and Sciences (the folks who give out the annual Academy Awards) originally created the Special Effects Oscar category as a way to honor the work done by photographers using Lightroom's Effects panel? Okay, well that's not 100% true. Actually, it's not even 1% true, but if you ever looked in Lightroom's Effects panel and saw that not only are there just two effects in there (Grain and Post-Crop Vignetting), you'd have to ask yourself, are those even effects? Really, is the bar so low for what's allowed into that panel that the simple act of adding noise to your photo is worthy of 50% of an entire panel? I would expect to see some kick butt stuff in that panel, so I figure that Adobe's Lightroom engineers, brilliant as they are, just weren't particularly awesome at putting features in the right spots. I thought it was

one of those left brain/right brain things, but a friend at Adobe, who works closely with the Lightroom team, revealed to me how it's really decided: it's the work of paid lobbyists. I know, it's hard to imagine, but it's a well-known fact out in San Jose, where Adobe is based. Here's how it works: when Lightroom's engineers come into work in the morning, in the lobby of Adobe HQ are small groups of people yelling out where they think certain features should be placed, and they hold up free samples of everything from cans of Monster Energy drink to *Star Wars* action figures (apparently, it was a Boba Fett action figure that shot little missiles and an off-color 12" wampa that got an engineer to move Dehaze to the Basic panel). If I was there with an original Jawa figure with fabric cape, I'll bet I could get the Exposure slider moved to the Split Toning panel. Just sayin'.

Applying Filter-Like "Looks" Using Creative Profiles

Back in Chapter 5, we looked at applying camera profiles to your RAW images. Well, buried in the menu where Adobe put those RAW profiles they also included a bunch of creative profiles for applying more special-effect-style "looks," but using these isn't just limited to RAW photos—you can add them to JPEGs, TIFFs, whatever. These creative profiles have a huge advantage over presets, because presets just move your Develop module sliders to a "pre-set" location (like somebody stepped in and processed the photo for you). However, the profiles don't mess with your sliders—they're their own separate thing, more like special effect filters, so you can still edit your image any way you want after you apply a profile.

Step One:
Here's our original image (remember, the creative profiles don't need a RAW image, you can use them on JPEGs, TIFFs, and PSDs, as well). In the Develop module, at the top of the Basic panel, choose **Browse** from the Profile menu (as shown here), or click the icon with the four little boxes to the right of it. This brings up the Profile Browser with rows of thumbnails (seen in Step Two). There are four sets of creative profiles (behind the scenes, these looks are based on Color Lookup Tables; just throwin' that in for you techie folks). They are: (1) Artistic, (2) B&W (which I cover in this chapter on page 232), (3) Modern, and (4) Vintage.

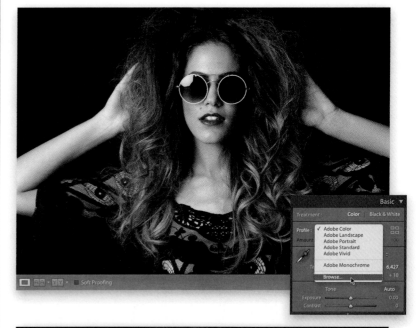

Step Two:
Two important things to know about the Profile Browser: (1) each thumbnail displays your image with its look applied to it, so you're getting a mini-preview just by looking at the thumbnails, but even better (2) you can audition these looks right on your full-size image by simply hovering your cursor over a thumbnail. So, you can really see whether this is a look you like before committing to it (of course, nothing in Lightroom is really very committed because if you did click on a particular profile and decided you didn't like it after all, you'd just press **Command-Z [Ctrl-Z]** to undo it). Here, I applied the Artistic 08 creative profile.

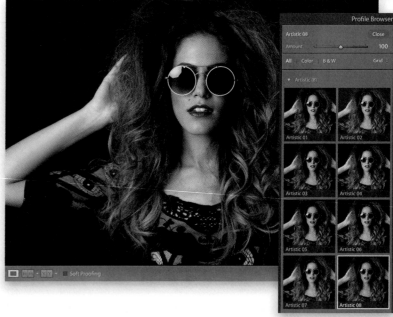

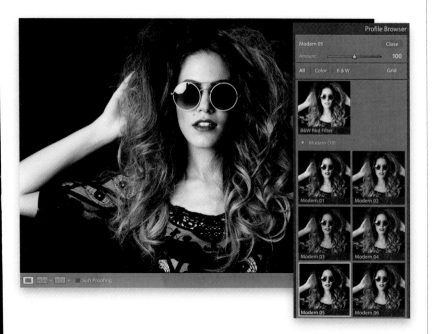

Step Three:
Let's take this a step further. Scroll down to the Modern profiles, and click on one you like (here, I chose Modern 05, which has kind of a nice desaturated-type look). I actually really like this profile (it's one of my personal favorites out of the whole bunch). You can also see one of the B&W thumbnails at the top of the browser, here (this list of thumbnails scrolls up/down, but the controls at the top, including the all-important Close button, which you click after you're done applying your profile, stay static). By the way, you can add any one or more of these creative profiles to the Favorites section at the top by moving your cursor over a thumbnail, and then clicking on the star icon in the top-right corner.

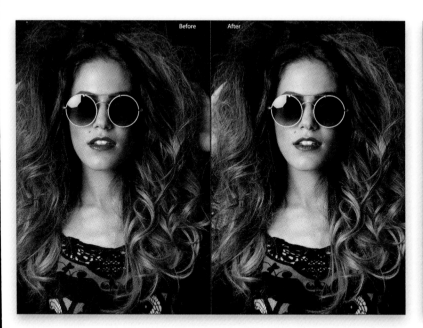

Step Four:
I like the profile I applied in Step Three, but I wish it wasn't quite so desaturated. Luckily, there's an Amount slider for these creative profiles (unlike with presets) at the top of the Profile Browser, so I can drag this slider to the left, which backs off the intensity, and I can dial in just the right amount (here, I dragged it down to 59; compare it with the full amount in Step Three). This works for any creative profile (there isn't an Amount slider for the RAW profiles), and not only can you back off the amount, if you want a more intense effect, then you can drag the slider to the right.

Virtual Copies—The "No Risk" Way to Experiment

Let's say you added a vignette to a bridal shot. Well, what if you wanted to see a version in black and white, and a version with a color tint, and a really contrasty version, and then maybe a version that was cropped differently? Well, what might keep you from doing that is having to duplicate a high-resolution file each time you wanted to try a different look, because it would eat up hard drive space and RAM like nobody's business. But luckily, you can create virtual copies, which don't take up space and allow you to try different looks without the overhead.

Step One:

You create a virtual copy by just Right-clicking on the original photo and then choosing **Create Virtual Copy** from the pop-up menu (as shown here), or using the keyboard shortcut **Command-'** (apostrophe; **PC: Ctrl-'**). These virtual copies look and act the same as your original photo, and you can edit them just as you would your original, but here's the difference: it's not a real file, it's just a set of instructions, so it doesn't add any real file size. That way, you can have as many of these virtual copies as you want, and experiment to your heart's content without filling up your hard disk.

Step Two:

When you create a virtual copy, you'll know which version is the copy because the virtual copies have a curled page icon in the lower-left corner of the image thumbnail (circled in red here) in both Grid view and in the Filmstrip. So now, go ahead and tweak this virtual copy in the Develop module any way you want (here, I increased the Exposure, Contrast, Shadows, Clarity, and Vibrance), and when you return to Grid view, you'll see the original and the edited virtual copy (as seen here).

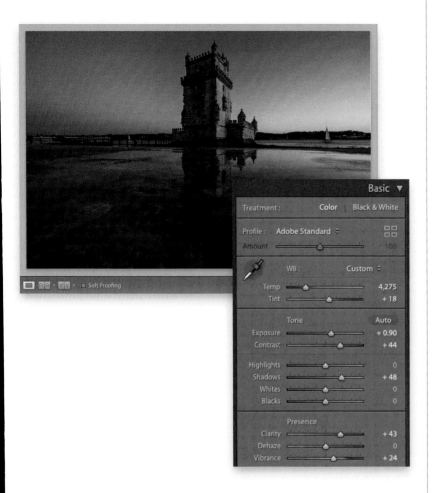

Step Three:
Now you can experiment away with multiple virtual copies of your original photo, at no risk to that original or your hard drive space. So, click on your first virtual copy, then press Command-' (PC: Ctrl-') to make another virtual copy (that's right—you can make virtual copies of your virtual copy), and then head over to the Develop module, and make some adjustments (here, I made changes to the White Balance, adding more blue and magenta to get this look. I also increased the Exposure, Contrast, Shadows, Clarity, and Vibrance). Now, make some more copies to experiment with (I made a few more copies and tried a few other looks). *Note:* When you make a copy, you can hit the Reset button at the bottom of the right side Panels area to return the virtual copy to its original unedited look. Also, you don't have to jump back to Grid view each time to make a virtual copy—that keyboard shortcut works in the Develop module, too.

Step Four:
Now, if you want to compare all your experimental versions side by side, go back to Grid view, select your original photo and all the virtual copies, then press the letter **N** on your keyboard to enter Survey view (as shown here). If there's a version you really like, of course you can just leave it alone, and then delete the other virtual copies you don't like. (*Note:* To delete a virtual copy, click on it and press the Delete [PC: Backspace] key, and then click Remove in the dialog that appears.) If you choose to take this virtual copy over to Photoshop or export it as a JPEG or TIFF, at that point, Lightroom creates a real copy using the settings you applied to the virtual copy.

Changing Individual Colors

Anytime you have just one color you want to adjust in an image (for example, let's say you want all the reds to be redder, or the blue in the sky to be bluer, or you want to change a color altogether), one place to do that would be in the HSL panel (HSL stands for Hue, Saturation, Luminance). This panel is incredible handy (I use it fairly often) and luckily, because it has a TAT (Targeted Adjustment tool), using it is really easy. Here's how this works:

Step One:
When you want to adjust an area of color, scroll down to the HSL panel in the right side Panels area (by the way, those words in the panel header, HSL/Color, are not just names, they're buttons, and if you click on either of them, the controls for that panel will appear). Go ahead and click on HSL (since this is where we'll be working first), and four buttons appear in the panel: Hue, Saturation, Luminance, and All. The Hue panel lets you change an existing color to a different color by using the sliders. Just so you can see what it does, click-and-drag the Red slider all the way to the left and the Orange slider to –71, and you'll see it changes the red roof to magenta.

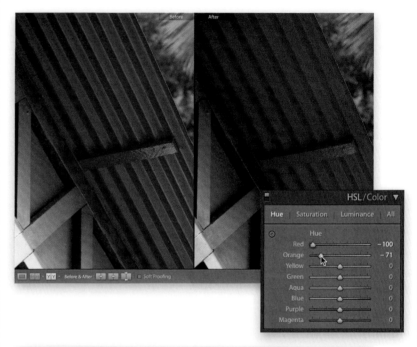

Step Two:
If you dragged the Red slider all the way to the right, and left the Orange slider at –71, it would change the color of the red roof to more of an orangeish color. This is a perfect task for the Hue sliders of the HSL panel. Now, what if you wanted to make the orange color more orange, but you've pushed the sliders just about as far as they can go? Well, you'd start by clicking on the word "Saturation" at the top of the panel.

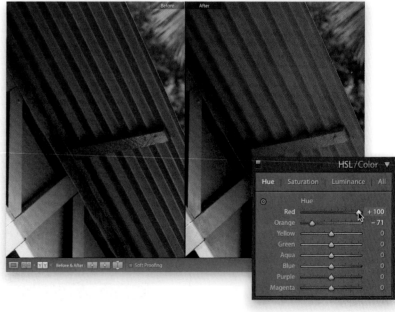

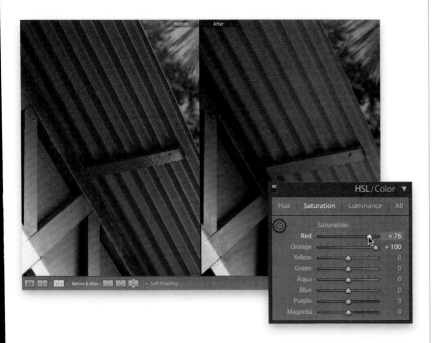

Step Three:

Now, these eight sliders control just the saturation of colors in your image. Drag the Orange slider way over to the right, and the Red not quite as far, and the orange in the roof becomes more vibrant (as seen here). If you know exactly which color you want to affect, you can just drag the sliders. But if you're not sure exactly which colors make up the area you want to adjust, then you can use the TAT (the Targeted Adjustment tool in the top-left corner of the panel). So, if you had a blue sky and wanted to make it more vibrant, you'd click on the TAT, then click it on the sky, and drag it upward to make it bluer (downward to make it less blue). And it wouldn't just move the Blue slider, but would increase the Aqua Saturation amount, as well. You probably wouldn't have realized that there was any aqua in that blue sky, and this is exactly why this tool is so handy here. In fact, I rarely use the HSL panel without using the TAT!

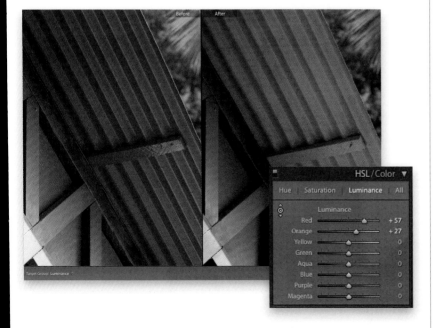

Step Four:

To change the brightness of the colors, click on Luminance at the top of the panel. To brighten the orange color of the roof, take the TAT and click-and-drag straight upward on it, and its color gets brighter (the Luminance for both Red and Orange increased). Two last things: Clicking the All button (at the top of the panel) puts all three panels in one scrolling list and the Color panel breaks them all into sets of three for each color—a layout more like Photoshop's Hue/Saturation. But, regardless of which layout you choose, they all work the same way. A before/after is shown here, after we changed and brightened the color of the roof.

How to Add Vignette Effects

An edge vignette effect (where you darken all the edges around your image to focus the attention on the center of the photo) is one of those effects you either love or that drives you crazy (I, for one, love 'em). Here we're going to look at how to apply a simple vignette, one where you crop the photo and the vignette still appears (called a "post-crop" vignette), and how to use the other vignetting options.

Step One:

To add an edge vignette effect, go to the right side Panels area and scroll down to the Lens Corrections panel (the reason it's in the Lens Corrections panel is this: some particular lenses darken the corners of your photo, even when you don't want them to. In that case, it's a problem, and you'd go to the Lens Corrections panel to fix a lens problem, right? There, you would brighten the corners using the controls in this panel. So, basically, a little edge darkening is bad, but if you add a lot intentionally, then it's cool. Hey, I don't make the rules—I just pass them on). Here's the original image without any vignetting (by the way, we'll talk about how to get rid of "bad vignetting" in Chapter 8—the chapter on how to fix problems).

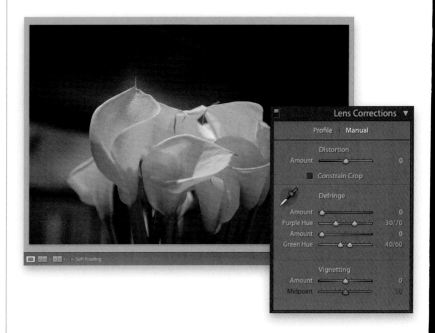

Step Two:

We'll start with regular full-image vignetting, so click on Manual at the top of the panel, then drag the Vignetting Amount slider all the way to the left. This slider controls how dark the edges of your photo are going to get (the further to the left you drag, the darker they get). The Midpoint slider controls how far in the dark edges get to the center of your photo. So, try dragging it over quite a bit, too (as I have here), and it kind of creates a nice, soft spotlight effect, where the edges are dark, your subject looks nicely lit, and your eye is drawn right where you want it to look.

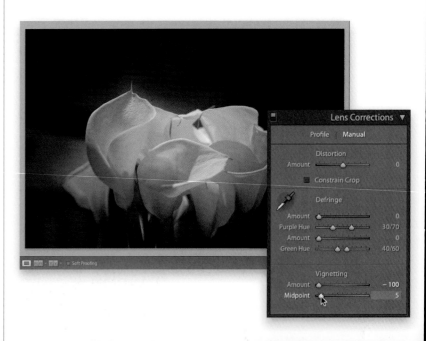

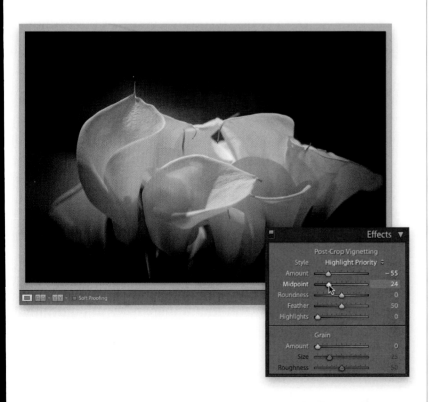

Step Three:

Now, this works just fine, until you wind up having to crop the photo, because cropping will crop away the edge vignette. To get around that problem, Adobe added a control called "Post-Crop Vignetting," which lets you add vignetting effects after you've cropped. I'm cropping that same photo in tight here, and now most of the edge vignetting I added earlier will be cropped away. So, scroll down to the Effects panel, and at the top, you'll see Post-Crop Vignetting. Before we try that, reset your Vignetting Amount slider (in the Lens Corrections panel) to 0 (zero), so we don't add the post-crop vignetting on top of the little bit of original vignetting still in our photo.

Step Four:

Before we get to the sliders, let's talk about the Style pop-up menu. You have three choices: (1) Highlight Priority, (2) Color Priority, and (3) Paint Overlay (though the only one that really looks good is Highlight Priority, so it's the only one I ever use). Highlight Priority is more like what you get with the regular vignette. The edges get darker, but the color may shift a bit, and I'm totally okay with the edges looking more saturated. This choice gets its name from the fact that it tries to keep as much of the highlights intact, so if you have some bright areas around the edges, it'll try to make sure they stay bright. I made the edges pretty darn dark here—darker than I would make mine, but I wanted you to really see the effect on the cropped image (just for example purposes). The Color Priority style is more concerned with keeping your color accurate around the edges, so the edges do get a bit darker, but the colors don't get more saturated, and it's not as dark (or nice) as the Highlight Priority style. Finally, Paint Overlay gives you the look we had back in Lightroom 2 for post-crop vignetting, which just painted the edges dark gray (yeech!).

Continued

Step Five:

The next two sliders were added to give you more control to make your vignettes look more realistic. For example, the Roundness setting controls how round the vignette is. Just so you know exactly what this does, try this: leave the Roundness set at 0, but then drag the Feather amount (which we'll talk about in a moment) all the way to the left. You see how it creates a very defined oval shape? Of course, you wouldn't really use this look (well, I hope not), but it does help in understanding exactly what this slider does. Well, the Roundness setting controls how round that oval gets (drag the slider back and forth a couple of times and you'll instantly get it). Okay, reset it to zero (and stop playing with that slider). ;-)

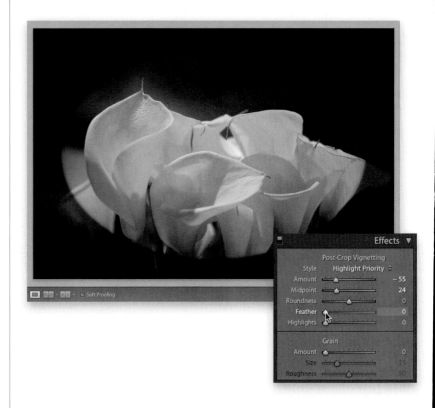

Step Six:

The Feather slider controls the amount of softness of the oval's edge, so dragging this slider to the right makes the vignette softer and more natural looking. Here, I clicked-and-dragged the Feather amount to 57, and you can see how it softened the edges of the hard oval you saw in the previous step. So, in short, the farther you drag, the softer the edges of the oval get. The bottom slider, Highlights, helps you to maintain highlights in the edge areas you're darkening with your vignette. The farther to the right you drag it, the more the highlights are protected. The Highlights slider is only available if your Style is set to either Highlight Priority or Color Priority (but you're not going to set it to Color Priority, because it looks kind of yucky, right?). So there ya have it—how to add an edge vignette to focus the viewer's attention on the center of your image by darkening the edges all the way around.

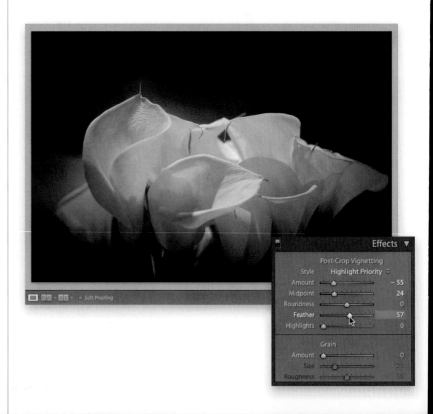

There's a Photoshop effect that started making the rounds a couple years ago, and now it's one of the hottest and most requested looks out there—you see it everywhere from big magazine covers to websites to celebrity portraits to album covers. Anyway, you can get pretty darn close to that look right within Lightroom itself. Now, before I show you the effect, I have to tell you, this is one of those effects that you'll either absolutely love (and you'll wind up over-using it), or you'll hate it with a passion that knows no bounds. There's no in-between.

Getting That Trendy High-Contrast Look

Step One:
Before we apply this effect, I have a disclaimer: this effect doesn't look good on every photo. It looks best on photos that have lots of detail and texture, so it looks great on city shots, landscapes, industrial shots, and even people (especially guys)—anything you want to be gritty and texture-y (if that's even a word). So, you're usually not going to apply this effect to anything you want to look soft and/or glamorous. Here's a shot with lots of detail and that has lots of texture. It's just screaming for this type of treatment.

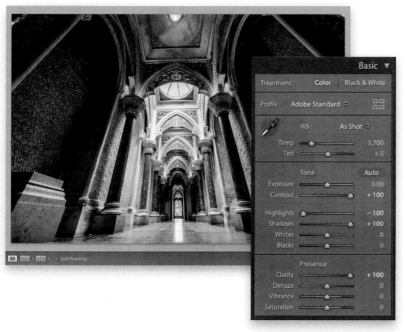

Step Two:
You're going to really crank up four sliders in the Develop module's Basic panel: (1) drag the Contrast slider all the way over to +100, (2) drag the Highlights slider all the way to –100, (3) drag the Shadows slider all the way to +100 (that opens up the shadows), and (4) drag the Clarity slider all the way to the right to +100. Now, the whole image has that high-contrast look already, but we're not done yet.

Continued

Step Three:

At this point, depending on the photo you applied this effect to, you might have to drag the Exposure slider to the right a bit if the entire image is too dark (that can happen when you set the Contrast at +100). Or, if the photo looks washed out a bit (from cranking the Shadows slider to +100), then you might need to drag the Blacks slider to the left to bring back the color saturation and overall balance. Here, I ended up decreasing the Exposure to –0.20 and the Blacks to –23. Outside of those potential tweaks, the next step is to desaturate the photo a little bit by dragging the Vibrance slider to the left (here, I dragged it over to –25). This desaturation is a trademark of this "look," which kind of gives the feel of an HDR image without combining multiple exposures.

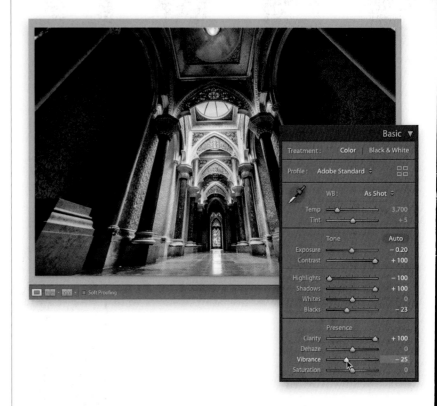

Step Four:

The final step is to add an edge vignette to darken the edges of your photo, and put the focus on your subject. So, go to the Lens Corrections panel (in the right side Panels area), click on Manual at the top, and drag the Vignetting Amount slider to the left (making the edges really dark). Then drag the Midpoint slider pretty far to the left, as well (the Midpoint slider controls how far the darkened edges extend in toward the middle of your photo. The farther you drag this slider to the left, the farther in they go). This made the whole photo look a little too dark, so I had to go back to the Basic panel and increase the Exposure amount a little bit (to +0.10) to bring back the original brightness before the vignette. I included a few befores and afters on the next page just to give you an idea of how it affects different images. Hey, don't forget to save this as a preset (see page 208), so you don't have to do this manually every time you want to apply this look.

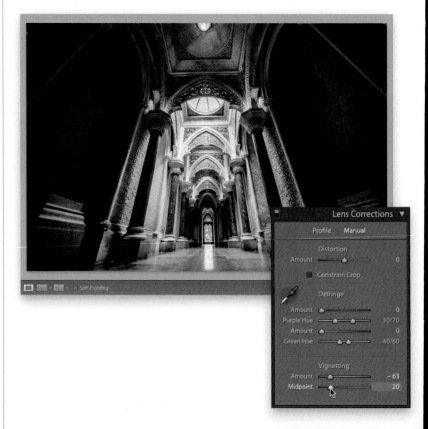

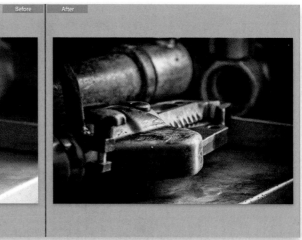

Creating Black-and-White Images

There are two methods for converting your images from color to black and white, and I'll start with the method that has been in Lightroom from the start. But, the newer method (definitely my preferred method) gives you more choices, live previews, and, I think, a far better result. Plus, once you've made the conversion, you can use the same techniques you learned in Chapters 5 and 6 to really fine-tune your conversion.

Step One:
Here's our original color image (taken in Banff, Canada), and I thought it would make a good candidate for converting to black and white (not every color image makes a good black-and-white, no matter how good the conversion technique). Before we do the conversion, take a look in the right side Panels area, and you'll see a panel called "HSL/Color." Keep an eye on that panel. Now, at the very top of the Basic panel, in the Treatment section, click on Black & White (as shown here).

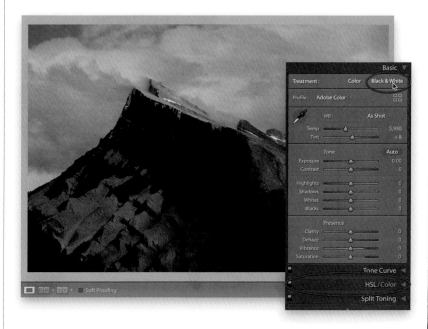

Step Two:
Now look at the HSL/Color panel, again. It's no longer visible—it has been replaced by the B&W panel (seen in the inset here), and Lightroom has applied its Adobe Monochrome profile. If you click on the Auto button at the bottom of the panel, it applies an Auto mix (as seen here). Since "it's less than awesome," I don't use it, but instead do it manually. Each of the sliders in this panel affects the underlying tones represented by that color slider. For example, drag the Blues slider back and forth and you'll see how it affects the sky. What these sliders do is brighten or darken parts of your image, and if you just drag each one back and forth a few times, you'll get what they do and how each affects your black-and-white image.

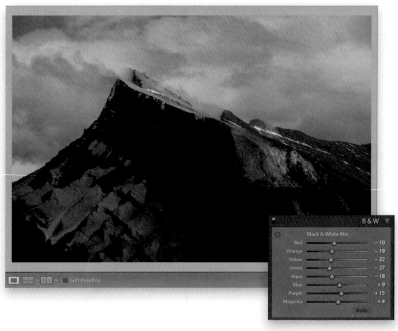

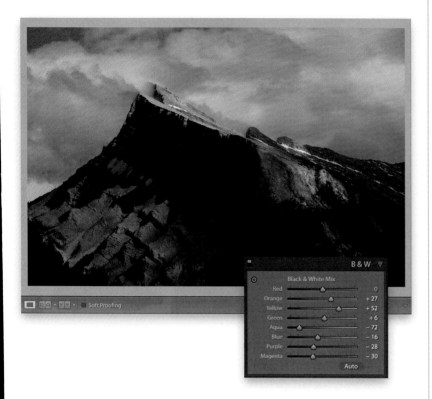

Step Three:

That's what I did here—I double-clicked on Black & White Mix at the top of the panel to remove the Auto mix, then I dragged each slider back and forth a few times to see how each affects the image. The Red slider and the Magenta slider didn't affect this particular image at all, but most of the other sliders did, so I dragged each one, evaluated how it looked to me, and if I liked what a particular slider did, I left it there. This alone won't make a great black-and-white, but it's good to know this is here if you want to tweak a particular part of your image later. What I'm saying here is that I wouldn't use this feature at this stage of the game, but later (when we do our conversion using the better method) we can come back here if we need some part of the photo to be brighter, and we can't think of an easier or faster way to do it.

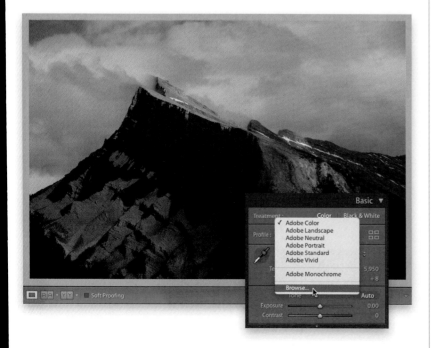

Step Four:

Okay, hit the Reset button at the bottom of the right side Panels area and let's try the other method. Go to the top of the Basic panel, and from the Profile pop-up menu, choose **Browse** (as shown here). We're going to use a profile to convert to black and white, and we're going to have a lot of choices as to how this conversion happens, and how the final image winds up looking.

Continued

Step Five:

When you choose Browse, it brings up the Profile Browser you see here. Scroll down to the B&W profiles. The awesome thing about these B&W profiles is that they're not presets—they don't move any sliders—so when find one you like and apply it, you can still tweak the resulting image to your heart's content. It shows you a preview of what each B&W profile looks like right on the thumbnail themselves. To find which one looks best to you, just hover your cursor over each thumbnail and you'll get a live preview right on your image. Here, I moved my cursor over each of the thumbnails to find out which one looked best on this particular image, and, for me, it was B&W 07. So, that's what you're seeing here. Just one click.

TIP: Would This Make a
Good B&W Image?

If you're looking through your images and wonder if a particular one would make a good black-and-white, just press the letter **V** on your keyboard and it makes the image black and white, and you'll see whether there's potential there or not. If it doesn't look good, press V again to return to the full-color image.

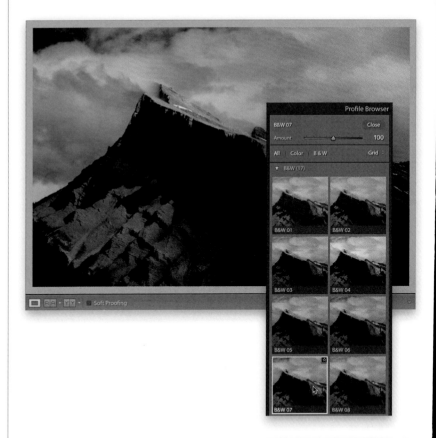

Step Six:

One of the best things about these profiles (besides the fact that they don't move any sliders when you use them) is that you can control their amounts—if you apply one and the effect is too intense, you can use the Amount slider at the top of the panel to back off the intensity. Or, if you like what you see, you can intensify the profile's effect, so that's what I did here, where I increased the Amount by dragging the slider to the right to 152.

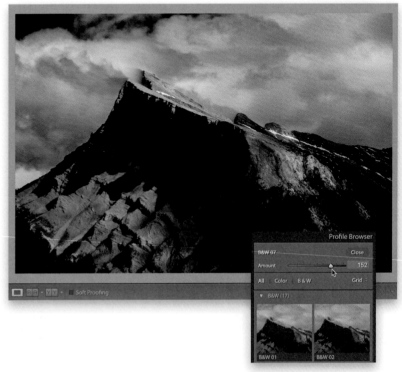

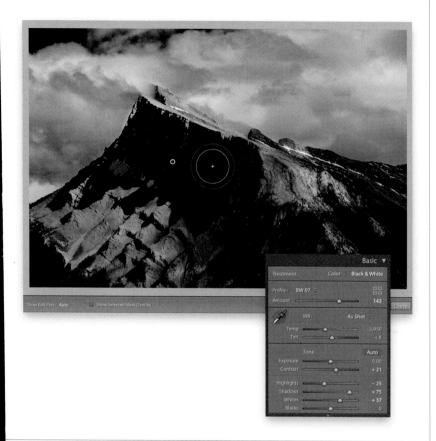

Step Seven:

Since the B&W profiles don't move any sliders, you're free to use them to tweak your image. That's what I did here, adding a little more Contrast, backing off the Highlights a bit, and opening up the Shadows and the Whites. After all that, I still felt the top side of the mountain was a bit dark, so I switched to the Adjustment Brush **(K)**, increased the Exposure amount to 0.71, and painted over just that area to brighten it. Or, rather than using the Adjustment Brush, you could go to the B&W panel and tweak individual color sliders (like we did in Step Three). Lastly, I went to the Detail panel and sharpened the living daylights out of it (which I always do with black-and-white images) by setting the Amount to 90 and the Radius to 1.1.

TIP: Add Some Noise!

If you want a more film-like look, go to the Effects panel, under Grain, and increase the Amount to add a film-grain look. The further you drag this slider to the right, the grainier it gets.

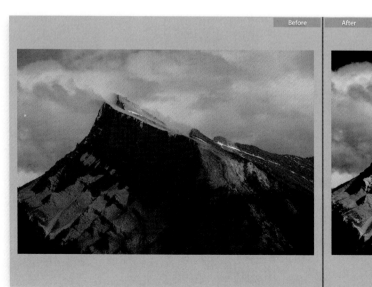

The auto conversion to black and white

After applying a B&W profile, then cranking up the amount, and making Basic panel, Adjustment Brush, and Detail panel tweaks

Making Great Duotones

This is such a simple technique, but it's so effective. I learned this trick years ago from my buddy and Adobe Worldwide Evangelist, Terry White, who learned it from another photographer who works for Adobe, and now I'm passing it on to you. Of all the methods I've used to create duotones over the years, this is definitely the easiest, but crazy enough, it's also the best.

Step One:

Although the actual duotone is created in the Split Toning panel (in the right side Panels area), you should convert the photo to black and white first. (I say "should" because you can apply a duotone effect on top of your color photo, but…well… yeech!) So, go to the Profile Browser, by clicking on the icon with the four squares in the top right of the Basic panel, and scroll down to the B&W profiles—see page 202 for more on these, but for now, just find one that looks good to you as a starting point (I chose B&W 01 here), and then click the Close button in the top right of the browser.

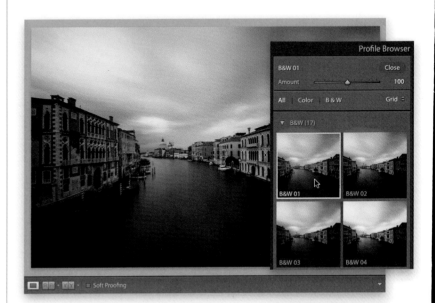

Step Two:

The trick to creating duotones is actually incredibly simple: you only add the color tint in the shadows, and you leave the highlights untouched. So, go to the Split Toning panel, in the right side Panels area, and start by dragging the Shadows Saturation slider to around 25, so you can see some of the tint color (as soon as you start dragging the Saturation slider, the tint appears, but, by default, the hue is a reddish color). Now, drag the Shadows Hue slider over to 35 to get more of a traditional duotone look (I usually pick a hue from 32 to 41, somewhere in there. While you're there, lower the Shadows Saturation to 20, as shown here). That's it.

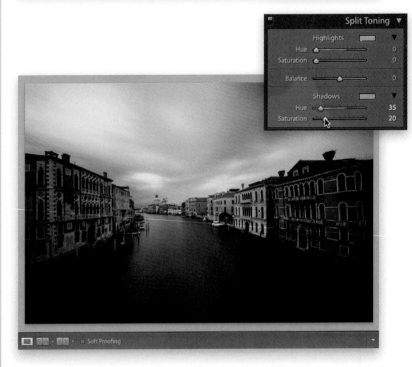

TIP: Reset Your Settings

If you want to start over, press-and-hold the Option (PC: Alt) key, and the word "Shadows" in the Split Toning panel changes to "Reset Shadows." Click on it to reset the settings to their defaults.

This matte finish look has become really popular in the last couple of years and luckily, it's pretty easy to pull off. It's just a simple Curves move (and even if you've never used Curves before, you'll be able to do this).

Creating a Matte Look

Step One:

In the Develop module, go down to the Tone Curve panel (if your Tone Curve doesn't look like this one, and instead has sliders under it, click on the little curve icon in the bottom-right corner of the panel to switch to the curve you see here). You're going to add two control points to the diagonal line by just clicking right on that line. So, add one about 1/4 of the way up from the bottom-left corner (you can see the point I added here) and one 1/4 of the way down from the top-right corner (where my cursor is in the image shown here). If you mess up and add a point you didn't mean to, Right-click on it and choose **Delete Control Point**. Adding those two control points locks down most of the curve, so we can adjust the deep shadows and highlights without messing with the rest of the tones of the image. That's the hard part, the rest is easy.

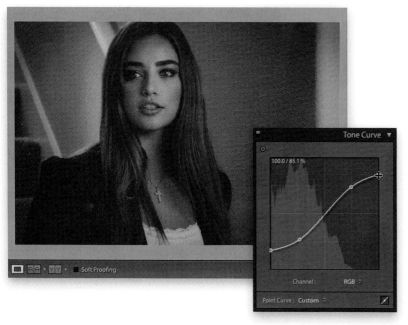

Step Two:

Now, go to the very bottom-left corner, click on that control point, and drag straight up, right along the left edge. Then, do the same thing with the control point up in the very top-right corner, except drag it down a bit along the right edge (as shown here). That's it—you've got the matte look, and now you can rule Instagram like a boss!

Using One-Click Presets (and Making Your Own!)

Lightroom comes with a number of built-in Develop module presets that you can apply to any photo with just one click. These are found in the Presets panel over in the left side Panels area, where you'll find 15 different collections of presets: 14 built-in collections put there by Adobe and a User Presets collection (that one's empty for now, because this is where you store the ones you create on your own). These are huge time savers, so take just minute or two and learn how to put them to use (and how to create your own).

Step One:

We'll start by looking at how to use the built-in presets, then we'll create one of our own, and apply it in two different places. First, let's look at the built-in presets by going to the Presets panel (found in the left side Panels area). There are 14 built-in Lightroom collections (and a User Presets collection, where you can save and store your own presets. If you imported any presets, as I have, you'll also have an Imported Presets collection). When you look inside each collection, you'll see that Adobe named these built-in presets by starting each name with the type of preset it is (for example, within the Classic - Effects presets, you'll find Grain. That's the type of preset, then it says, "Light," "Medium," or "Heavy").

TIP: Renaming Presets

To rename any preset you created (a user preset), just Right-click on the preset and choose **Rename** from the pop-up menu.

Step Two:

You can see a preview of how any of these presets will look, even before you apply them, by simply hovering your cursor over the presets in the Presets panel. A preview will appear above the Presets panel in the Navigator panel (as shown here, where I'm hovering over a Classic - Color preset called Cross Process 3, and you can see a preview of how that color effect would look applied to my photo, up in the Navigator panel, at the top of the left side Panels area).

Step Three:

To actually apply one of these presets, all you have to do is click on it. In the example shown here, I went to the Classic - B&W Filter presets and clicked on the Green Filter preset to create this black-and-white conversion. I could be done right there with one click, but the nice thing is if you want to tweak things after the preset has been applied, you can just grab the sliders in the Basic panel and go to town!

Step Four:

For example, here I increased the Contrast to +44, and I lowered the Highlights a bit more than the preset had (to –98), so I could darken the background a bit. I opened up the Shadows a bit to +10, so you could see more detail in the dark parts of her hair, and I backed off the Clarity amount to +16 to keep the image from looking so "crunchy." Also, once you've applied a preset, you can apply more presets and those changes are added right on top of your current settings, as long as the new preset you chose doesn't use the same settings as the one you just applied. So, if you applied a preset that set the Exposure, White Balance, and Highlights, but didn't use vignetting, if you then chose a preset that just uses vignetting, it adds this on top of your current preset. Otherwise, if the new preset uses Exposure, White Balance, or Highlights, it just moves those sliders to new settings, so it might cancel the look of the original preset. For example, after I applied the Green Filter preset, and tweaked the settings I mentioned above, I went to the Classic - Effects presets collection and applied the preset called "Vignette 1" (as shown here) to add a dark edge effect. The Green Filter didn't have a vignette, so it added it on top.

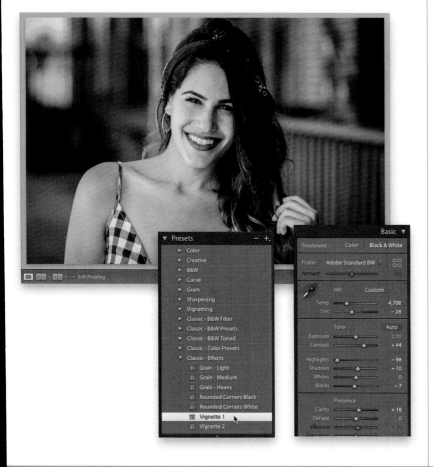

Continued

Step Five:

Now, of course you can use any built-in preset as a starting place to build your own preset, but here's how build your own custom preset from scratch: Click the Reset button at the bottom of the right side Panels area to reset our photo to how it looked when we started. Now we'll create a look that's kind of like the popular Instagram filter, Clarendon. Choose the Adobe Portrait profile from the Profile pop-up menu, then increase the Exposure amount to +0.62 to brighten things up, bring the Highlights down to –37, and the Shadows up to +11 to open the dark areas a bit. Set the Whites way up to +69, the Blacks to –58, and Vibrance to +7 to add a little more punch to the color. That's it for the Basic panel tweaks.

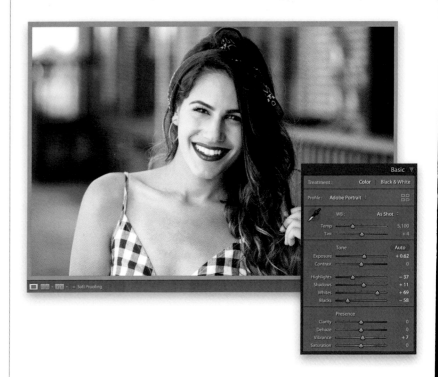

Step Six:

Now, go the Split Toning panel. In the Highlights section, set the Hue to 59 (for an amber tone) and Saturation to 11, so there's not too much of it. In the Shadows section, set the Hue to 177 (kind of a greenish shade) and the Saturation to 10. The Balance slider in the middle lets you choose the balance between the Highlights Hue and the Shadows Hue. Drag the Balance to –83, so the image is learning toward the greens in the shadows. Okay, we have our Instagram Clarendon-like look. Now, let's save it as a preset so we can apply this same look to other photos in just one click.

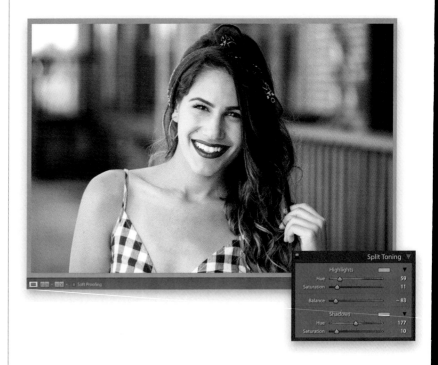

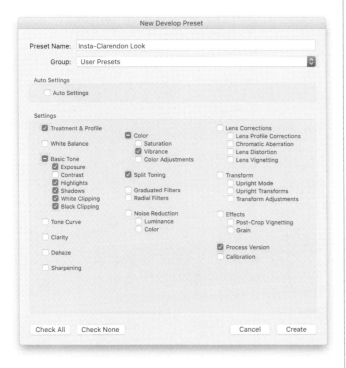

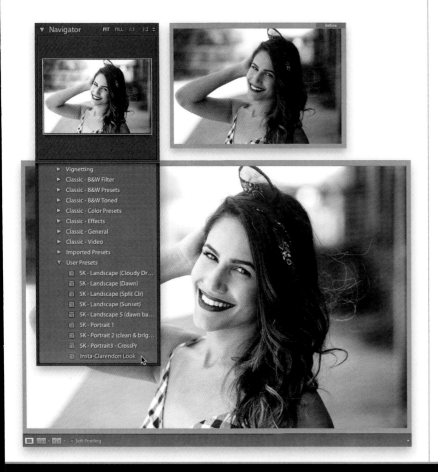

Step Seven:

In the Presets panel, click on the + (plus sign) button on the right side of the panel header and choose **Create Preset** to bring up the New Develop Preset dialog (shown here). Give your new preset a name (I named mine "Insta-Clarendon Look"), click the Check None button at the bottom of the dialog (to turn off all the checkboxes), then turn on the checkboxes beside all the settings you edited (as seen here). Now, click the Create button to save all the edits you just made as your own custom preset, which will appear under the User Presets collection in the Presets panel.

Note: To delete a user preset, just click on the preset, then click on the – (minus sign) button, which will appear to the left of the + button on the right side of the Presets panel header.

Step Eight:

Now click on a different photo in the Filmstrip, then hover your cursor over your new preset. Look up at the Navigator panel, and you'll see a preview of the preset (as seen here). Seeing these instant live previews is a huge time saver, because you'll know in a split second whether your photo will look good with the preset applied or not, before you actually apply it. Click on it to apply it.

TIP: Updating a User Preset

If you tweak a user preset and want to update it with the new settings, Right-click on your preset and choose **Update with Current Settings** from the pop-up menu.

Continued

Step Nine:

If you're going to apply a particular preset (either a built-in one or one you created) to a bunch of images you're importing, you can actually have that preset applied to your images as they're imported, so when they appear, they already have your preset applied. You do this right within the Import window. Just go to the Apply During Import panel (seen here), where you'd choose which preset you want from the Develop Settings pop-up menu (as shown here, where I chose that Insta-Clarendon Look preset we just created), and now that preset is automatically applied to each photo as it's imported. There's one more place you can apply these Develop presets, and that's in the Saved Preset pop-up menu, at the top of the Quick Develop panel, in the Library module (see more about the Quick Develop panel in Chapter 5).

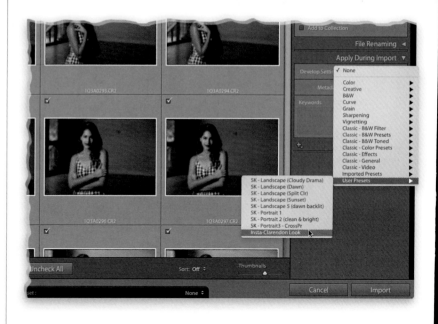

TIP: Importing Presets

There are lots of places online where you can download free Develop module presets (like from this book's companion website and my LightroomKillerTips .com site). Once they're downloaded, go to the Presets panel, click the on + (plus sign) button on the right side of the panel header, choose **Import Preset(s)**, and navigate your way to the preset(s) you just downloaded. You can also just Right-click directly on User Presets, and choose **Import** from the pop-up menu (as seen here). Locate the preset(s) you download-ed and click the Import button, and it will now appear in your User Presets.

Sun flare effects are really popular right now, and thankfully, they're pretty darn easy to do. Plus, there are two ways you can pull this off. I'll go with my favorite method first, and I'm adding the second method as a tip, since it uses the same settings—just a different tool.

Sun Flare Effect

Step One:
Here's our original image, and if you look at her hair and the backlighting from the sun, you can already see which side you're going to need to put your sun flare on.

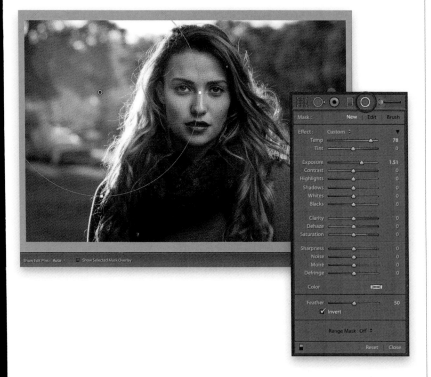

Step Two:
Get the Radial Filter tool in the toolbox near the top of the right side Panels area (it's shown circled here; or press **Shift-M**), but before you click-and-drag it out, drag the Temp slider way over to the yellow side (here, I dragged it over to 78). Now, crank up the Exposure (it is the sun, ya know, and in this case, I dragged it over to the right to 1.51, so basically adding a stop-and-a-half exposure). Then, click-and-drag it out over her shoulder on the left (as seen here). Notice the position of the oval here—I'm intentionally letting it spill a little over onto the side of her face.

Continued

Step Three:

Next, we're going to add some negative Clarity to soften our sunbeam, so drag the Clarity slider way over to the left (here, I dragged it over to –78). It's a little dark, so let's also increase the Exposure to brighten it up (I increased it to 2.93). To better position the flare, click on the little black edit pin and drag it up and to the left a bit (as shown here).

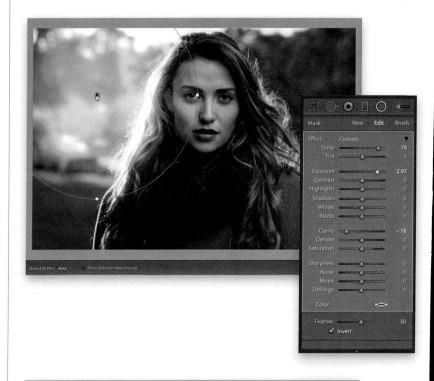

Step Four:

To make the effect look more realistic, you're going to need to somewhat match up the color of the rest of the image with the very warm color you just added with this sun flare. So, go to the Basic panel and drag the Temp slider over to the right a bit, so the sun flare blends in. To finish things off, back off the Contrast a bit (one of the rare times I add negative contrast, but in this case, with the sun bursting in, it helps "sell" the look by lowering the contrast of the rest of the image). A before and after is shown below.

TIP: Optional Second Method

Another way to get a similar effect is to use the Adjustment Brush **(K)** with a really large brush size. Same settings as with the Radial Filter tool—just one or two clicks in the same spot with the brush, and you're there.

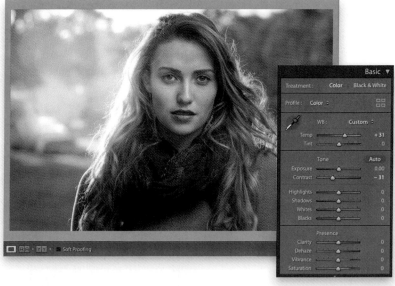

The hot look in fashion right now is to add a cross-process effect, and there are a couple of different ways to do this. We'll start with the easy version, and at least uncork the advanced version, which uses Curves.

Cross-Processing Fashion Look

Step One:
These cross-processing effects are usually applied to color images using the Split Toning panel, like we use when creating a duotone look (see page 206), but unlike the duotone, you're going to choose one hue for the highlights and a different hue for the shadows here.

TIP: See a Tint Color Preview
To make it easier to see which color tint you're choosing, press-and-hold the Option (PC: Alt) key, drag the Hue slider, and it will give you a temporary preview of your color tint as if you bumped up the Saturation amount to 100%.

Step Two:
Here, I set the Highlights Hue to 57 and the Shadows Hue to 232. I then set the Shadows Saturation slider to 56 and the Highlights Saturation slider to 51 (a little bit higher than usual, just to add more color). That's all there is to it (I told you this was easy). By the way, the Balance slider (found between the Highlights and Shadows sections) lets you balance the color mix—dragging to the right tips the balance toward the Highlights color and dragging left tips the balance more toward the color in the shadows. You can also choose colors from the color swatches to the right of the words Highlights and Shadows—clicking on either swatch brings up a color picker, and along the top are some common split-tone highlight colors. To close the color picker, click on the X in the upper-left.

Continued

Step Three:

The other method for creating cross-processing looks is to tweak the individual Red, Green, and Blue color channels using the Tone Curve panel (found in the right side Panels area). To pick an individual channel to edit, click on the Channel pop-up menu and choose the channel you want to edit (in our example, the Red channel). Our original image is shown here, and to apply this particular cross-processing effect (you can use this curve to create any color combination you want), you can leave the Red channel alone. Choose Green from the channel pop-up menu (shown bottom middle) and add a point to the curve by clicking once 1/4 of the way up from the bottom of the diagonal line, and then drag it diagonally up to increase the amount of green in the shadows. Add another point 1/4 of the way down from the top and pull it down just a tiny bit. Now, go to the Blue channel and drag the bottom-left corner point straight upward along the left edge a little bit (as shown) to add some blue into the lower midtones. Then, drag the top-right corner point down along the right side (as shown here) to add some blue. Add a point 1/4 of the way down from the top of the curve, and then drag it down just a little, which adds some yellows to the highlights. Finally, add another point 1/4 of the way from the bottom and drag that one up a bit.

Step Four:

Now you have blues, greens, and yellows. If you think the image looks too contrasty or doesn't have enough contrast, go to the Basic panel and adjust the Contrast slider until it looks right to you.

Lightroom's panoramic feature (which stitches multiple frames into one very wide, or very tall, shot) is one of the best out there, and one of the coolest things about it (besides how fast it is, and the great options it has) is that the final panoramic image it creates is still a RAW image. What?!! I know. Crazy, right, but that's how it works (well, that's how it works if you started with RAW images anyway).

Creating Panoramas

Step One:
Start by selecting the images you want combined into a panorama (or pano, for short) in the Library module. Then, go under the Photo menu, under Photo Merge, and choose **Panorama** (as seen here) or just press **Control-M (PC: Ctrl-M)**.

TIP: Overlap 20% or So In-Camera
For Lightroom to successfully stitch together your shots into one single image, when you're taking your pano photos, be sure to overlap each frame by at least 20%. It helps Lightroom determine which frames go together and keeps you from having gaps. Well, it really wouldn't have gaps, it just wouldn't successfully stitch it together—you'd get a warning.

Step Two:
This brings up the Panorama Merge Preview dialog (shown here). It has three Projection choices for creating your pano, but it automatically chooses which one it thinks is best. Personally, I only use Spherical, and according to Adobe, it works best for wide panos. If you shoot architectural panos, where you'd want to keep the lines that are supposed to be straight, straight, Adobe recommends the Perspective projection. Lastly, the Cylindrical projection is a cross between the two, as it's supposed to work better for panos that are really wide, but still need straight vertical lines. All that being said, I still just use Spherical all the time.

Continued

Step Three:

Take a look back at that preview in Step Two. See all that white space around it that needs to be cropped off? Well, you could always crop that away later in Lightroom, but you have two solid options here in this dialog: The first is to have it automatically crop away any of the white gaps around the edges of your image. Just turn on the Auto Crop checkbox (as shown here), and it crops the image tight so none of those white areas are visible. The downside of Auto Crop is cropping this tight makes your pano less tall and less wide. Depending on the photo, that might not be a problem, but it might crop off the tops of mountains or the tops of buildings, etc. The good news is: if you turn it on and you don't like what you see in the preview, you can just toggle it right back off. But, there is a better option.

TIP: This Pano Dialog Is Resizable

You can resize it to whatever size and dimensions you like by just clicking-and-dragging its edges. Since panos are usually wide images, I drag mine out as wide as it can fit onscreen.

Step Four:

Now, behold the wonder that is Boundary Warp. This is my "go-to" option for panos (I use it every time) and simply dragging the slider all the way to the right does as close to magic as you're going to see in Lightroom—it just moves the pano around somehow to fill in those open gaps and yet, when it's done, it doesn't look funky, it looks fantastic! I'm not sure why it's a slider and not a checkbox because I do a lot of panos, and I've never not wanted it at 100% (drag it back to 90% or 80% and you'll see what I mean). Either way, it's pretty darn awesome and I use it on every pano I stitch (I have some comparisons for you on the next page).

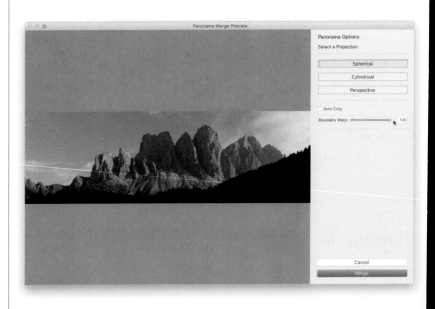

Note that the resulting pano file is a DNG image

Step Five:

Just for visual comparison purposes, take a look at the three images here. The top image is the original pano as-is; the middle shot is with the Auto Crop checkbox turned on and the white gaps around the edges trimmed away; and the bottom image is the same pano, but with the Boundary Warp slider dragged all the way over to 100%. There is no answer that is wrong here—you can choose whichever one you want, including making no choice at all and cropping it later in Lightroom or taking it over to Photoshop to use Content-Aware Fill to fill in those gaps. Totally your call.

TIP: If It Can't Find a Lens Profile

If you see a warning icon and it says Lightroom is "Unable to match a lens profile automatically," it'll still make the pano—the results just won't be quite as good. To fix this, click the Cancel button, make sure your pano photos are still selected, then go to the Lens Corrections panel (in the Develop module's right side Panels area) and turn on the Enable Profile Corrections checkbox in the Profile tab. Next, choose your lens make/model from the pop-up menus, then go back and try your pano again, and all should be good.

Step Six:

Now, click the Merge button and it will render the final high-res version of your pano (it renders in the background, but you'll see a progress bar in the upper-left corner of Lightroom). When it's finished, your final stitched pano appears as a DNG file in the same collection as the images you used to create the pano (provided, of course, that the images were in a collection when you started. If not, it'll appear in the same folder, but usually at the bottom of the folder), and you can tweak this pano like you would any other image.

Adding Beams of Light

This effect makes use of the fact that Lightroom has two brushes, and you can make each of the brushes a different size and switch between the two. We use that to create a transition between a small brush and a large brush, and the feathering keeps the transitions smooth. Super-easy to do, and on the right image, it's really effective.

Step One:

Here's the original RAW image we want to add light beams to. If you're thinking, "Scott…that's a pretty lame photo," well, I would have to agree, but it does have one thing going for it: the sun is peeking through the trees. But, I'm with you on the lameness of this shot, which is why in the next step we're at least going to try to take it from lame to not quite as lame.

Step Two:

The first thing we need to do is to warm up the image (color-wise), so in the Basic panel, drag the Temp slider way over to yellow. That's a start. Now let's make it a little bit brighter (maybe 1/4 of a stop or so) by increasing the Exposure to +0.25 and the Contrast to +56. Then, drag the Highlights back quite a bit, so the sun isn't so bright (it's going to get brighter when you add the beams)—I took it over to –60. Now, the woods still look pretty dark, so drag the Shadows slider all the way over to +100. I also dragged the Whites all the way down to –100 because it's really bright where the sun is coming through. Finally, crank up the Clarity to +24 to bring out the detail, and then crank up the Vibrance to +27 to bring out more color, and well…it's still not an awesome photo, but it does look better.

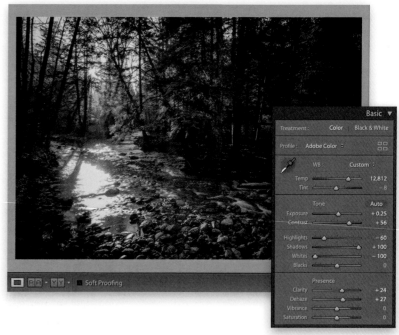

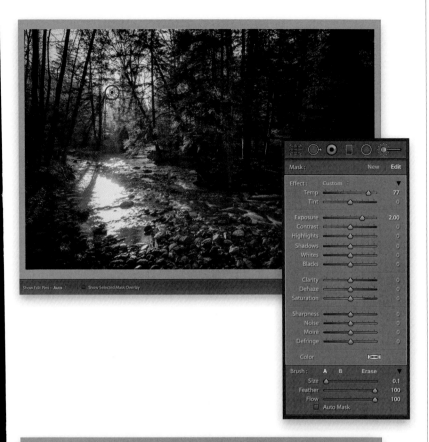

Step Three:

Now, to create our beams, get the Adjustment Brush **(K)** from the toolbox near the top of the right side Panels area, then drag the Temp slider over to 77 (so it paints a very yellow stroke) and crank up the Exposure to around 2.00. At the bottom of the panel, we have two brushes we can use marked "A" and "B." Click on the A brush, set the Feather amount to 100 (to make the edges of your brush soft), and then set the Flow amount to 100 (so we get a consistent amount of the effect we're going to apply). Now, set your Brush size really small at 0.1 (yes, that is one tiny brush), then take that brush and click once right on the sun. It's so small, you won't actually see anything, but you should see a little black edit pin appear in the spot where you clicked (as shown circled here in red).

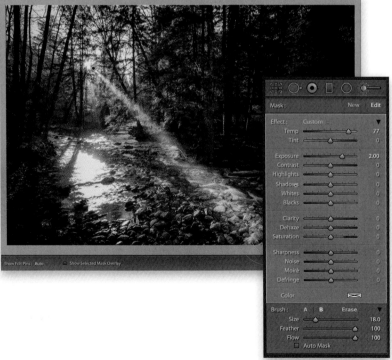

Step Four:

Now click on the B brush and, again, make sure the Feather and Flow are set at 100, but set this brush at a much larger size (here, I set it to 18.0). Remember, you've already clicked once, right on the sun, right? Now that you have the B brush, move to the bottom of the image, press-and-hold the Shift key (holding the Shift key makes it draw a straight line between where you first clicked on the sun and where you'll click at the bottom of the image), and click once with that larger brush. It will draw a straight line between the two spots, starting at that small size and growing until it reaches the size of the larger brush click at the bottom of the screen. That's how you create a beam, but there's something we can do (on the next page) to make the process of adding more beams a little quicker.

Continued

Step Five:

We're going to continue the process of adding more beams, but to speed things up, instead of going to the bottom of the Adjustment Brush panel every time we need to switch brushes, we're going to use a keyboard shortcut to make the process much faster and easier. Here's what you do: With the A brush selected, click once on the sun, then press the **/ (forward slash) key** to switch to the B brush, press-and-hold the Shift key and click at the bottom of the screen, but to the right or left of your original beam. Each time you press the forward slash key, it toggles between the A and B brushes. So, hit the forward slash key to toggle to the A brush, click once on the sun, press it again to switch to B, press-and-hold the Shift key, and click again somewhere else along the bottom, hit forward slash to return to A, and do it all again, with your beam ending some-where else, until your image looks like the one you see here.

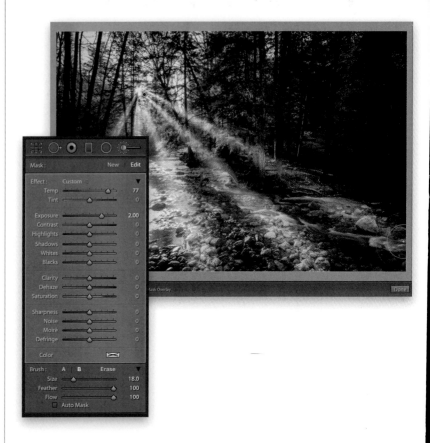

Step Six:

All of these beams of light you have added are represented by the same edit pin you created the first time you clicked the brush on the sun. This is really handy because you'll probably need to lower the intensity of those beams, so they blend in better with the rest of the image and look more realistic. To do that, simply go to the Expo-sure slider (you're still in the Adjustment Brush panel, by the way), and back it off some. You were painting at 2.00 (plus 2 stops), so drag it back to the left a bit until it looks like they blend in better (in our case, I lowered the Exposure to 1.04, so I dropped the brightness of my beams by nearly a full stop).

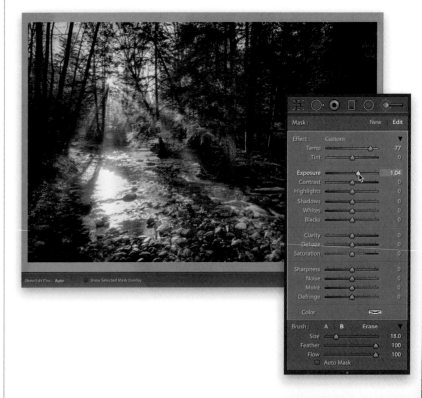

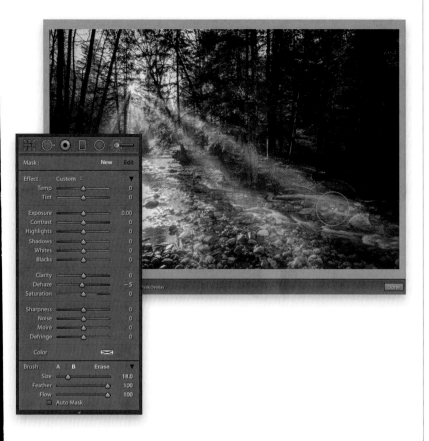

Step Seven:

This is an optional step, but depending on the image, this can add a nice bit of realism, as we add a little haze or fog around our beams. Here's how: First, click on the New button near the top-right corner of the panel, then double-click on the word "Effect" to reset all your Adjustment Brush sliders to zero. Go down to the Dehaze slider and drag it just a little bit to the left (here, I dragged it to –5), and then take a large brush and paint over the area where the beams are, and it adds a foggy haze around the beams (as seen here). Again, it's a totally optional step, but I wanted to give you the option.

TIP: Creating Softer Beams

If you think your beams need to be a little bit softer, drag the Adjustment Brush's Clarity slider over to the left a bit, and you'll see the beams soften.

Step Eight:

Here are a few more examples using the exact same technique, but with the color of the beam varied (which you do by changing the white balance). In the slot canyon shot at the top left, I moved the white balance Temp slider more toward blue to create a whiter beam, but without turning white. In the shot at the Valley of Fire on the top right, I lowered the Temp slider (dragging it to the left), so the beams weren't so yellow, and I lowered the Exposure amount quite a bit. In the concert shot, I made the A brush a lot bigger (I set A to 20 and B to 35), and I changed the white balance of the beam.

Creating
HDR Images

Lightroom lets you take a series of shots that were bracketed in-camera and combine them into a single 32-bit HDR image. But, don't worry—it doesn't create that "Harry Potter on acid" style of HDR. In fact, the merged HDR will look a lot like the normal exposure, but the tonal range is expanded to the extent that you can now do things like opening up the shadows big time without getting a ton of noise. Plus, the final HDR image is a DNG image, so you can edit it like any other RAW image (but with more headroom and tonal depth).

Step One:

Select your bracketed shots in the Library module. Here, I have three bracketed shots (the regular exposure, one shot that is two stops *underexposed*, and one shot that is two stops *overexposed*), but according to Adobe's own engineers, Lightroom doesn't need more than just two frames to do its thing—the one that's two stops under and the one that's two stops over. So, here I selected just those two shots. Now, go under the Photo menu, under Photo Merge, and choose **HDR** (as shown here; or just press **Control-H [PC: Ctrl-H]**).

Step Two:

This brings up the HDR Merge Preview dialog (seen here), and in a few moments, a preview of your HDR image will appear. (*Note:* This dialog is resizable—just click-and-drag the edges to resize it.) Near the top right, the Auto Settings checkbox is on by default (it's the same as Auto Tone from the Basic panel, which I don't generally use on my regular images, but with HDR images, it actually works surprisingly well, so I leave it on). Depending on the image, it can have more detail or it might look brighter in the shadow areas, but it won't look a whole lot different (with Lightroom's brand of HDR, you don't really see the benefits until you "tone" the image in the Develop module).

TIP: Faster HDR Processing

To skip this dialog and have it create your HDR in the background (using whatever settings you used on your last HDR image), just press-and-hold the Shift key as you choose HDR from the Photo menu.

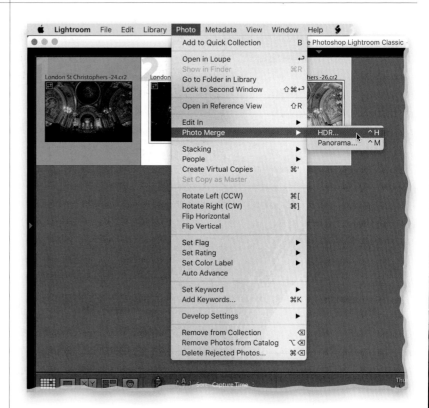

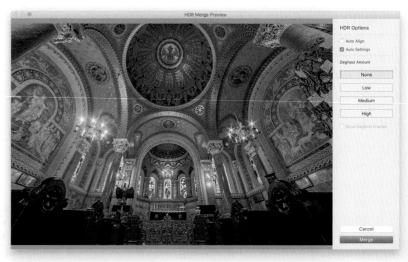

Step Three:
We'll skip the Auto Align checkbox for now because we'll talk about that on the next page. So, for now, just click the Merge button, and it will create your single HDR image, which will appear right next to your individual frames in your collection, as seen here (if you're working in folders, you might have to scroll to the bottom of the folder to find this HDR.dng image). By the way, by just looking at the thumbnails, you can see how your HDR image takes the best from those two images to create an image with more depth.

Step Four:
Now you can tweak your HDR image just like you would any other regular RAW image (yes, the resulting HDR image Lightroom creates is a RAW image). Here, Auto Tone has already been applied (so don't be surprised if you see that some of the sliders have already been moved), but I increased the Contrast and Clarity (as shown here), and I actually decreased the Vibrance a bit because I thought the overall color was a bit too punchy—I wanted more of a gold color than yellow. Anyway, the point is you can tweak it like you would any other image, however, on the next page you'll learn one of the big advantages of creating an HDR image.

Continued

Step Five:

Lightroom's big HDR secret is that with the added tonal range that comes with merging your images to HDR, you can really open up the shadow areas and bring out detail, without getting a bunch of noise. For example, take a look at the normal single-frame image here on the left. When you open up those shadows, you get a ton of noise—it's raining noise in that single image. Now, look at the HDR image on the right, where I opened up the shadows big time. Where's the noise? Exactly! That's one of the big secrets and one of the best reasons to create HDR images like this. The added tonal range rocks!

Step Six:

We're switching images here to discuss the Auto Align checkbox in the HDR Merge Preview dialog. What this helps with (mostly) are shots you hand-held while bracketing—if the alignment is off a little (or a lot), it'll fix that automatically. For example, take a look at the hand-held, bracketed shot of this camel on the left (I know, I know, it only has one hump, so technically it's not a camel, it's a dromedary). You can see it almost has an outline of a second "camel-like animal" along the edges. That's because I hand-held it. Turn on the Auto Align checkbox and now look at the image on the right. It automatically aligns the images for you, and it usually does a pretty amazing job. Of course, if you shot your HDR on a tripod, it doesn't need to align anything, so you can skip the Auto Align checkbox, and it'll process faster. The Deghost Amount feature is different than the Auto Align feature in that Auto Align helps align things if you moved your camera a little when you took the photos. Deghost helps if something was actually moving in your shot (like someone walking in your frame, who now appears like a fully- or semi-transparent ghost, but it doesn't look cool, it looks like a mistake).

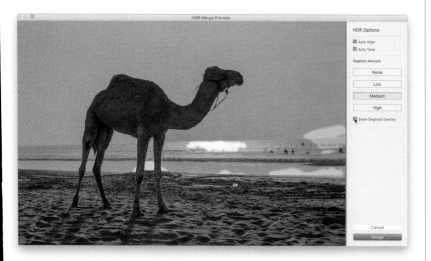

Step Seven:

By default, Deghost Amount is turned off (only turn it on if you have visible ghosting). To turn it on, click either Low (for mild deghosting), Medium (for more), or High (if there's a lot of ghosting in the image), and it does a pretty amazing job of basically pulling a non-moving area from one of the bracketed exposures and seamlessly displaying it, rather than the ghosted movement. I always start with the Low amount and only move up to Medium or High if the ghosting is still visible. If you want to see the areas that are being deghosted in your image, you can turn on the Show Deghost Overlay checkbox, and after a few seconds (it has to rebuild a new preview), the areas that are being deghosted will appear in red (as seen here, where I chose Medium).

Step Eight:

Jumping back to our original HDR, I thought I would show you the normal, single image (the one shown here at the top. Note how dark the pews are, and you saw what happens if I increase the shadows in those pews), and the HDR image (shown below). No noise, but a great range of tones.

TIP: Seeing the Expanded Range for Yourself

If you really want to see how much your range has been expanded with an HDR image, go to the Exposure slider and drag it all the way to the right. Notice it didn't stop at +5.00? Now, it goes to +10.00 and −10.00 (if you drag it to the left) stops. You can go from absolutely solid black to absolutely solid white.

Making Streets Look Wet

This is a trick I've been using for a while to make streets look wet in my travel photos, and what I love about it is that it's so simple (you just use two sliders) and yet it's amazingly effective (especially on cobblestone streets, where it looks especially good, but also on just regular ol' asphalt streets, too).

Step One:
In the Develop module, go ahead and make any regular tweaks to the image in the Basic panel (I Shift-double-clicked on the Whites slider and the Blacks slider to have Lightroom automatically set the white and black points. I also decreased the Shadows a bit to bring out detail in the bridge). None of these adjustments have anything to do with the effect you're about to learn, but I thought you might at least want to know what the basic edits I applied to prep the photo were.

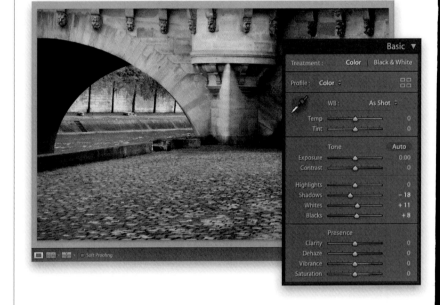

Step Two:
Click on the Adjustment Brush tool **(K)** up in the toolbox and then double-click on the word "Effect" to zero out all the sliders. You've got just two sliders to adjust here: (1) Drag the Contrast slider to 100, then drag the Clarity slider to 100, as well. That's it—that's the recipe. Now, paint over the surface you want to appear wet (here, I'm painting over the street in the foreground). As you paint, the area looks wet and appears to add reflections like an actual wet street.

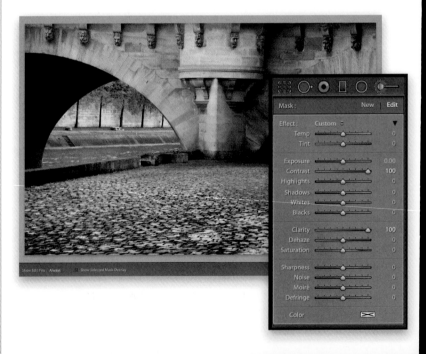

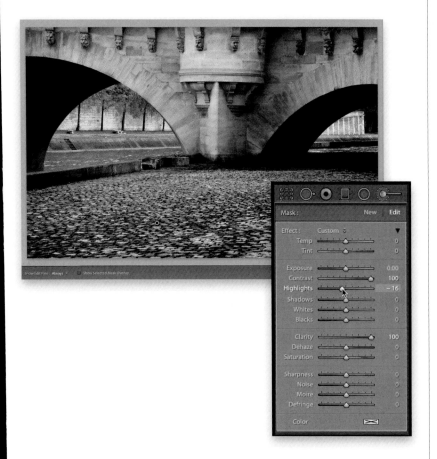

Step Three:
If you paint over the street and it doesn't look "wet" enough, click the New button at the top-left corner of the Adjustment Brush panel and start painting over the same area, but start in a different part of the street (that way, you're stacking this second pass of the look over the first coat of "wet"). By the way, if for any reason the street looks too bright from applying that much Clarity, just lower either the Exposure slider or Highlights slider a little bit for each pin, so it looks to have about the same brightness overall (here, I lowered the Highlights slider to –16. I tried lowering Exposure, as well, but lowering just the Highlights looked better to me).

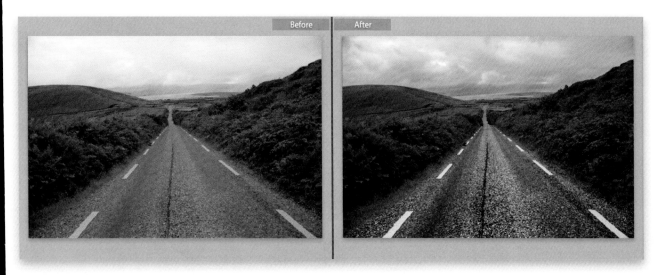

Step Four:
This technique looks particularly great on cobblestone streets, but it also works for most regular paved streets. I did a before/after here, so you can see an example. Okay, that's it. Instant wet streets.

PROBLEM PHOTOS
dealing with common image problems

Problem photos. We all wind up dealing with them, and while we create some of these issues ourselves, a lot of them are created by our cameras, and we're left to pick up the pieces. Well, I have some advice for you that, if you follow to the letter, not only will help you deal with these types of issues, but will change the way you, and your friends, think about them. Now, you have to have an open mind because this requires a little out-of-the box thinking. So, don't just jump to conclusions before you hear the whole thing because you'll just dismiss it and we'll all lose. Here's the thing: to deal with these types of issues, you're going to have to become an image psychiatrist. Stop snickering, this is important stuff. You're going to need to really analyze each image, and really talk it through, to get to the root of these problems. The first and most important step, before you start any of this is to look and find a very small couch online—one just big enough for a memory card. (You can find these on eBay, Esty, or even Amazon sometimes, but they come from Japan, so while the shipping will only be slightly more, the wait time can often be 4 to 6 weeks.) Now, I know your first thought is, "Oh, this should be easy. I'll just pick up the Barbie Pink Passport 3-Story Townhouse from Amazon." Trust me, it doesn't work (I've tried it. The seats are made of plastic and the card just slides off onto the floor, and then nobody's talking to anybody). You need, at the very least, the KidKraft Shimmer Mansion Dollhouse because they use real wood (not this plastic rubbish Mattel tries to pass off as a couch). Once you get your couch and memory card set up, the first question you should ask is, "Tell me about your sensor."

Fixing Backlit Photos

I think the reason we take so many backlit photos is that our eyes capture such an incredible tonal range, instantly adjusting for things like backlighting, so when we're standing there, our subject doesn't look dark at all. However, our camera's sensor captures only a fraction of the tonal range of what our eyes see. Luckily, as we learned in Chapter 5, Lightroom's Shadows slider was born to fix situations just like this, but there is an extra step you need to know to make it look right.

Step One:

Here's our backlit subject (you can see the sun is behind her on the left, here). While I was standing there, even though she was backlit, to my eyes she looked properly exposed. When I held my DSLR up and looked through the viewfinder, it looked the same, but then this is what my camera's sensor came up with—my subject is nearly a silhouette. This we can deal with.

TIP: Watch Out for Noise

If an image has noise in it, it's usually in the shadow areas, so if you do open the shadows a lot, any noise gets amplified. Keep an eye out for it as you drag that Shadows slider. If things get really noisy in those shadow areas, you might need to get the Adjustment Brush **(K)**, drag the Noise slider to the right, and paint over just that shadow area to keep that noise in check.

Step Two:

In the Develop module, go to the Basic panel and drag the Shadows slider over to the right until your subject's face starts to look balanced with the rest of the light in the image (I dragged it to +80). Don't make it too bright or it'll start to look unnatural. Another thing to look out for, and it's happening in this case, is if you have to drag that Shadows slider pretty far to the right, the photo can start looking washed out (like this one does here). But, we'll fix that with just one simple move.

Step Three:

One way to get rid of that washed-out look is to drag the Contrast slider over to the right a bit (I dragged it to +46, here) until that washed-out look is gone. If you don't like how that looks (it usually does the trick, but depending on the image, hey, ya never know), then set Contrast back to zero and simply push a little bit of blacks into the image by dragging the Blacks slider to the left just a little bit. One of those two methods should do the trick to keep the image from looking washed out after opening up those shadow areas.

Step Four:

Here, I used Lightroom's Before/After view (press **Y**) to show what a big difference this technique (dragging the Shadows slider, then bringing back the contrast) can make.

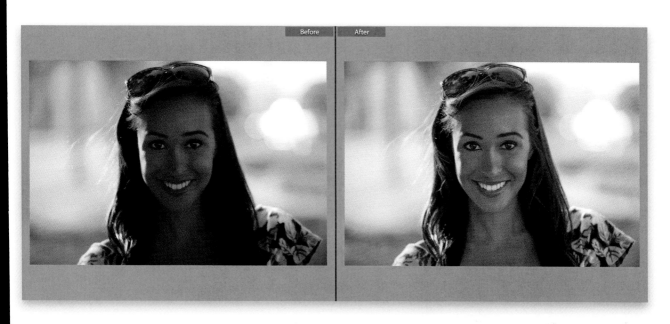

Reducing Noise

If you wind up shooting at a high ISO or in very low light, chances are your image is going to have some noise—either luminance noise (a visible graininess throughout the photo, particularly in shadow areas) or color noise (those annoying red, green, and blue spots). Lightroom can handle them both, but an added advantage is that it can apply this noise reduction while the image is still in its 16-bit RAW state (most commercial plug-ins can only work once the image has been converted to a regular 8-bit image).

Step One:

To reduce the noise in a "noisy" image like this (it was shot at 800 ISO, but it was way underexposed, so I had to open up the shadows a ton and that's where noise lives), go to the Develop module's Detail panel, to the Noise Reduction section. You see that little warning icon in the top-left corner of the panel? That's letting you know that to really see the changes you make to the image using any of the sliders in this panel, you need to zoom in to at least the full size (1:1) view. If you look at the image in Step Two, I zoomed in even tighter (to 3:1), and now you can really see the noise that's in the tile on the floor, and on the wall.

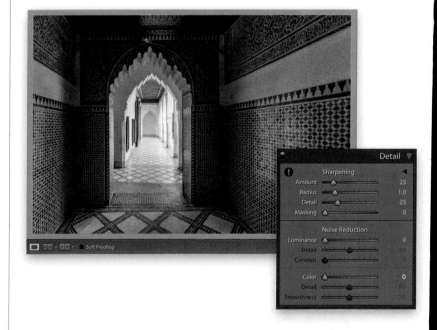

Step Two:

I usually start by reducing the color noise, simply because it's so distracting (if you shoot in RAW, it automatically applies some color noise reduction). So, start by dragging the Color slider to 0, and then slowly drag it to the right. As soon as the color in the specks goes away, stop, because once it's gone, it doesn't get "more gone" (it just gets blurrier). Here, I stopped at 24. If you feel you lost detail in the process, drag the Detail slider to the right to help it protect color details in edge areas. If you keep this setting really low, you avoid adding colors speckles, but you might get some color bleeding (like they're glowing a bit). Dragging the Smoothness slider to the right softens the color speckles, but I don't mess with this slider because I haven't seen an instance where it didn't make the image look blurry and worse.

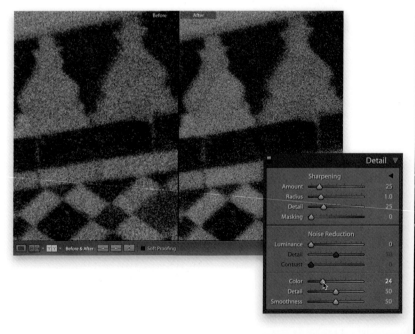

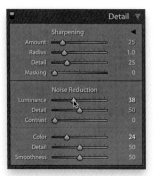

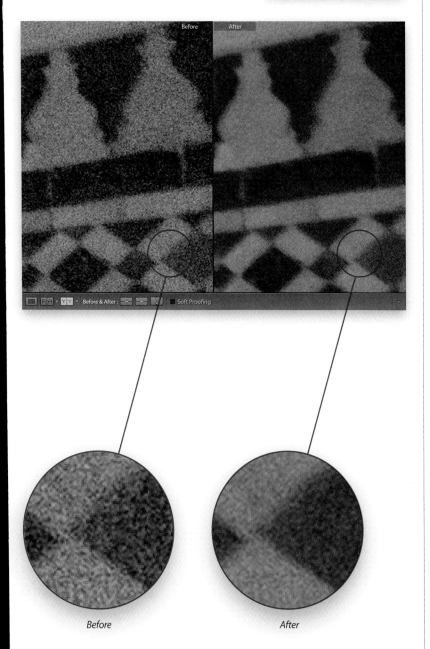

Before

After

Step Three:

Once the color noise has been dealt with, your image now just looks grainy, which is a different kind of noise (luminance noise). So, drag the Luminance slider to the right until the noise is greatly reduced (here, I dragged it over to 38). I gotta tell you, this baby works wonders all by itself, but you have additional control with the other two sliders beneath it. The "catch" is this: your image can look clean, or it can have lots of sharp detail, but it's kinda tricky to have both. The Detail slider (in Adobe speak, the "luminance noise threshold") really helps with seriously blurry images. So, if you think your image looks a little blurry now, drag the Detail slider to the right—just know this may make your image a little more noisy. If, instead, you want a cleaner-looking image, drag the Detail slider to the left—just know that you'll now be sacrificing a little detail to get that smooth, clean look (there's always a trade-off, right?). If you feel you've lost contrast in this process, drag the Contrast slider to the right, but know that it might create some blotchy-looking areas. Again, it's a trade-off and ultimately, you'll decide if using it helps or hurts your particular image.

Continued

Step Four:

Another method for removing noise when you have it in just a particular area, like in the sky or one dark area you opened up, is to "paint" noise reduction using the Adjustment Brush **(K)**. In the Adjustment Brush's panel, you'll see "Noise." Drag this slider to the right a bit, then paint over an area in an image, and it helps to reduce noise where you painted. It's not awesome (as you might expect), and it tends to make those areas blurry to hide the noise, but on some particular images, it works great and only blurs the areas where you paint and not the entire image, like normal Noise Reduction in the Detail panel tends to do. Remember, you can apply the Detail panel's Noise Reduction first, then paint noise reduction over just really bad areas.

Lightroom keeps track of every edit you make to your photo and it displays them as a running list, in the order they were applied, in the Develop module's History panel. So if you want to go back and undo any step, and return your photo to how it looked at any stage during your editing session, you can do that with just one click. Now, unfortunately, you can't just pull out one single step and leave the rest, but you can jump back in time to undo any mistake, and then pick up from that point with new changes. Here's how it's done:

Undoing Anything (or Everything!)

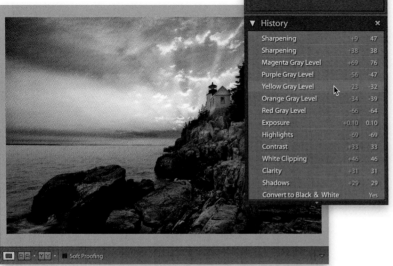

Step One:
Before we look at the History panel, I just wanted to mention that you can undo anything by pressing **Command-Z (PC: Ctrl-Z)**. Each time you press it, it undoes another step, so you can keep pressing it and pressing it until you get back to the very first edit you ever made to the photo in Lightroom, so it's possible you won't need the History panel at all (just so you know). If you want to see a list of all your edits to a particular photo, click on the photo, then go to the History panel in the left side Panels area (shown here). The most recent changes appear at the top. (*Note:* A separate history list is kept for each individual photo.)

Step Two:
If you hover your cursor over one of the history states, the small Navigator panel preview (which appears at the top of the left side Panels area) shows what your photo looked like at that point in history. Here, I'm hovering my cursor over the point a few steps back where I had converted this photo to black and white, but since then I changed my mind and switched back to color.

Continued

Step Three:

If you actually want to jump back to what your photo looked like at a particular stage, then instead of hovering over the state, you'd click once on it and your photo reverts to that state (as shown here). By the way, if you use the keyboard shortcut for your undos (instead of using the History panel), the edit you're undoing is displayed in very large letters over your photo. This is handy because you can see what you're undoing, without having to keep the History panel open all the time.

TIP: Undos Last Forever

Photoshop's History panel only lets you have 20 undos, and if you close the file, they go away. However, in Lightroom, every single change you make to your photo inside Lightroom is tracked and when you change images, or close Lightroom, your unlimited undos are saved. So even if you come back to that photo a year later, you'll always be able to undo what you did.

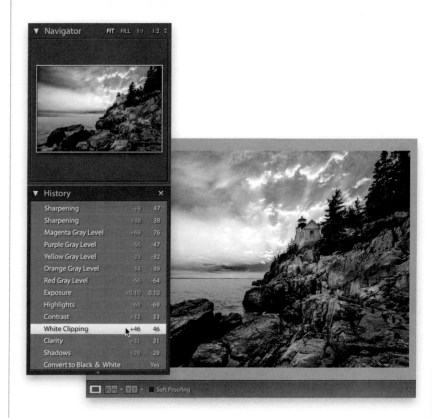

Step Four:

If you come to a point where you really like what you see and you want the option of quickly jumping back to that point, go to the Snapshots panel (right above the History panel) and click on the + (plus sign) button on the right side of the panel header. The New Snapshot dialog appears (seen here, on right) where you can give it a name that makes sense to you (I named mine "Duotone with Vignette," so I'd know that if I clicked on that snapshot, that's what I'd get—a duotone with a vignette). Click Create and that moment in time is saved to the Snapshots panel (as seen here). By the way, you don't have to actually click on a previous step in the History panel to save it as a snapshot. Instead, you can just Right-click on any step and choose **Create Snapshot** from the pop-up menu. Pretty handy.

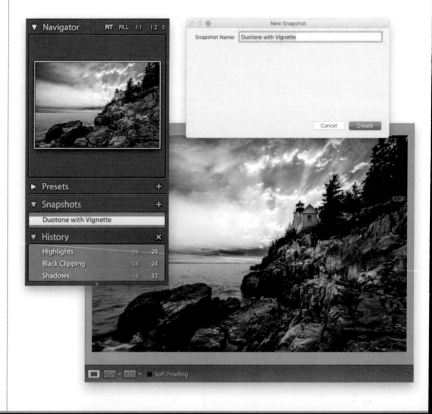

When I first used the cropping feature in Lightroom, I thought it was weird and awkward—probably because I was so used to the Crop tool in older versions of Photoshop—but once I got used to it, I realized that it's probably the best cropping feature I've ever seen. This might throw you for a loop at first, but if you try it with an open mind, I think you'll wind up falling in love with it. If you try it and don't like it, make sure you read Step Six for how to crop more like you used to in Photoshop (but don't forget that whole "open mind" thing).

Cropping Photos

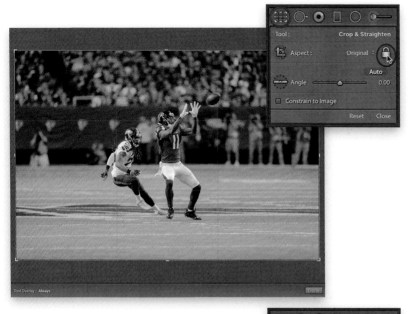

Step One:

Here's the original photo. The action happened down field a bit, and even though I was shooting a 400mm lens, the action is still pretty far away. So, we need to crop in tight because the shot isn't about all the empty space—the shot is about the receiver catching the ball. Go to the Develop module and click on the Crop Overlay tool (circled here in red) in the toolbox above the Basic panel, and the Crop & Straighten options will pop down below it. This puts a "rule of thirds" grid overlay on your image (to help with cropping composition), and you'll see four cropping corner handles. To lock your aspect ratio (so your crop is constrained to your photo's original proportion), or unlock it if you want a non-constrained freeform crop, click on the lock icon near the top right of the panel (as shown here).

Step Two:

To crop the photo, grab a corner handle and drag inward to resize your Crop Overlay border. Here, I grabbed the bottom-right corner handle and dragged diagonally inward. But, it's still not tight enough.

Continued

Step Three:

Now let's crop in tight on the action (you did download this photo, right? The URL for the downloads is in the book's introduction). Just grab the top-left corner and drag it diagonally inward for a nice, tight crop (as seen here). If you need to reposition the photo inside the cropping border, just click-and-hold inside the Crop Overlay border. Your cursor will change into the "grabber hand" (shown here), and now you can drag it where you want it.

TIP: Hiding the Grid

If you want to hide the rule-of-thirds grid that appears over your Crop Overlay border, press **Command-Shift-H (PC: Ctrl-Shift-H)**. Or, you can have it only appear when you're actually moving the crop border itself, by choosing **Auto** from the Tool Overlay pop-up menu in the toolbar beneath the Preview area. Also, there's not just a rule of thirds grid, there are other grids—just press the letter **O** to toggle through the different ones.

Step Four:

When the crop looks good to you, press the letter **R** on your keyboard to lock it in, remove the Crop Overlay border, and show the final cropped version of the photo (as seen here). But there are two other choices for cropping we haven't looked at yet.

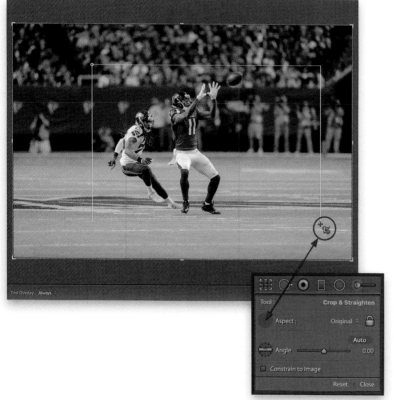

Step Five:

If you know you want a particular size ratio for your image, you can do that from the Aspect pop-up menu in the Crop & Straighten options. Go ahead and click the Reset button, below the right side Panels area, so we return to our original image, and then click on the Crop Overlay tool, again. Click on the Aspect pop-up menu at the top-right side of the Crop & Straighten options, and a list of preset sizes appears (seen here). Choose **8.5x11** from the pop-up menu, and you'll see the left and right sides of the Crop Overlay border move in to show the ratio of what an 8.5x11" crop would be. Now you can resize the cropping rectangle and be sure that it will maintain that 8.5x11 aspect ratio.

Step Six:

The other, more "Photoshop-like," way to crop is to click on the Crop Overlay tool, then click on the Crop Frame tool (shown circled here in red) to release it from its home near the top left of the Crop & Straighten options. Now you can just click-and-drag out a cropping border in the size and position you'd like it. Don't let it freak you out that the original cropping border stays in place while you're dragging out your new crop, as seen here—that's just the way it works. Once you've dragged out your cropping border, it works just like before (grab the corner handles to resize, and reposition it by clicking inside the cropping border and dragging. When you're done, press R to lock in your changes). So, which way is the right way to crop? The one you're most comfortable with.

TIP: Canceling Your Crop

If, at any time, you want to cancel your cropping, just click on the Reset button at the bottom-right side of the Crop & Straighten options panel.

Lights Out
Cropping Rocks!

When you crop a photo using the Crop Overlay tool in the Develop module, the area that will get cropped away is automatically dimmed to give you a better idea of how your photo is going to look when you apply the final crop. That's not bad, but if you want the ultimate cropping experience, where you really see what your cropped photo is going to look like, then do your cropping in Lights Out mode. You'll never want to crop any other way.

Step One:

To really appreciate this technique, first take a look at what things look like when we normally crop an image—lots of panels and distractions, and the area we're actually cropping away appears dimmed (but it still appears). Now let's try Lights Out cropping: First, click on the Crop Overlay tool to enter cropping mode. Now press **Shift-Tab** to hide all your panels.

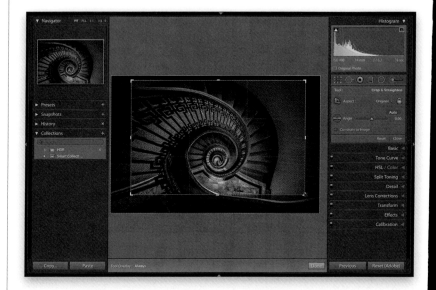

Step Two:

Press the letter **L** twice to enter Lights Out mode, where every distraction is hidden, and your photo is centered on a black background, but your cropping border is still in place. Now, try grabbing a corner handle and dragging inward, then clicking-and-dragging outside your cropping border to rotate it, and watch the difference—you see what your cropped image looks like live as you're dragging the cropping border. It's the ultimate way to crop (it's hard to tell from the static graphic here, so you'll have to try this one for yourself—you'll never go "dim" again!).

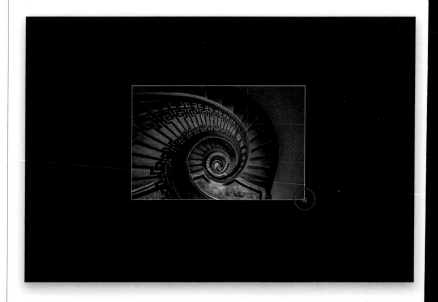

If you've got a crooked photo, Lightroom's got four great ways to straighten it. One of them is pretty precise, two are automatic, and with the last you're pretty much just "eyeing it," but with some photos that's the best you can do.

Straightening Crooked Photos

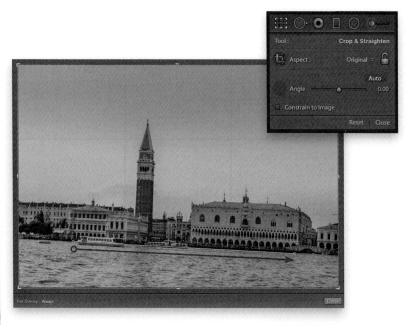

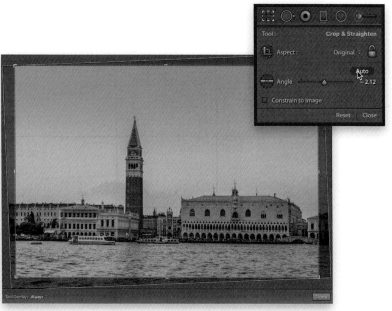

Step One:

Here's a shot with a pretty bad tilted horizon line (probably something to do with all the wine in Venice. Just a theory). The first method is to get the Crop Overlay tool **(R)**, found in the toolbox, right under the histogram in the Develop module's right side Panels area. Click on the Angle tool, found in the Crop & Straighten options (it looks like a level), then click-and-drag it left to right along something that's supposed to be level in the image (as shown here, where I've dragged it from left to right along the banks of the canal—see the red arrow for direction). This works really well (you can even drag it vertically, so I could have dragged it down the tower). However, there is one catch: you have to have something in the photo that's supposed to be level—like a horizon, or a wall, or a window frame, etc.

Step Two:

The second method is often my first choice because it's just one click and it's totally automated. Above the Angle slider is an Auto button—an auto straighten button (hit the Reset button, at the bottom of the panel, to make the image crooked again). Click it and it attempts to straighten the photo automatically, and if it has a pretty clear visible horizon line, or other obvious straight areas, it does a really nice job. Notice that it doesn't complete the process—it just rotates the cropping border to the precise amount it would take to crop the image. If it looks good to you, click the Done button below the bottom-right corner of the Preview area.

Continued

Step Three:

The third method is kind of like the second method. Really, it's exactly like method #2 in that it's a one-click button to level your image. Go to the Transform panel (in the right side Panels area), and in the Upright section at the top, click the Level button (as shown here), and it auto straightens the photo. Truth be told, the Auto button in the Crop Overlay tool's panel is just a shortcut for the Upright Level feature. Still, I thought you should know about it, just in case you're working in the Transform panel, so you don't leave it and go to the Crop Overlay tool's panel just to straighten your image.

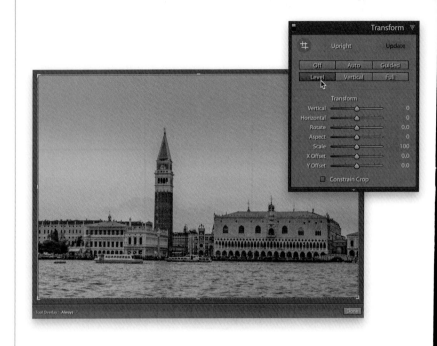

Step Four:

Hit the Reset button (at the bottom of the right side Panels area) to reset the image to where it's crooked again, and we'll try the fourth method, better known as "eyeing it." Now, you could get the Crop Overlay tool, again, and when you move your cursor outside the cropping border (onto the gray background), it changes into a two-headed arrow. Just click-and-drag up/down to rotate your image until it looks straight. However, I prefer to go to the Transform panel, where you'll find a Rotate slider. In this case, drag that slider to the left and it rotates the image counterclockwise. Just stop dragging when it looks straight (as I did here). While this creates those white triangle-shaped gaps around your image, you can have Lightroom automatically crop those away by turning on the Constrain Crop checkbox (as shown here), which will crop away those gaps for you.

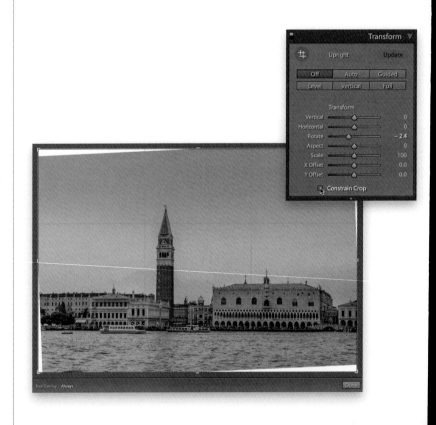

This tool is actually pretty well named—it's great for removing spots or the occasional power line or distracting soda bottle in the background on the beach. However, don't confuse it with Photoshop's awesome Healing Brush. I've used the Healing Brush. The Healing Brush was a friend of mine. Spot Removal tool: you are no Healing Brush (but, it's all we've got, so let's at least learn how to use it).

Removing Stuff with the Spot Removal Tool

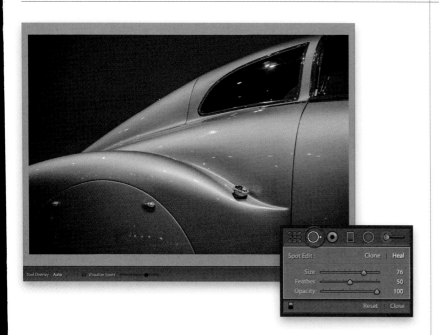

Step One:

Here's the image we want to retouch, which was taken inside a museum exhibit of beautiful, exotic old cars. Since it's indoors, you can see all the lights in the ceiling reflected on the car, so our goal is to remove at least the most obvious white spots. Click on the Spot Removal tool (shown circled here in red) in the toolbox near the top of the right side Panels area, or just press **Q**, and make the brush a little bigger than the spot you want to remove (you can change brush size by using the **Left and Right Bracket keys** on your keyboard—they're just to the right of the letter P).

Step Two:

Zoom in, so you can see the white spots better, and then just click once over one of those spots and it's gone (as seen here, where I clicked once on a spot on the left side). When you do this, you'll see two outlined areas: (1) the one with the slightly thicker outline is showing the area where you clicked, and (2) the other one (the thinner one) is showing you the area that the Spot Removal tool sampled to make that repair. (*Note:* If you make a mistake, just hit the Delete [PC: Backspace] key to remove your repair). Usually, this sample area is pretty close to the area you're trying to fix, but sometimes (for reasons I can't begin to understand) it decides to sample somewhere totally weird (like in the middle of one of the windows). When that happens (notice I didn't say "if"), there are two things we can do about it.

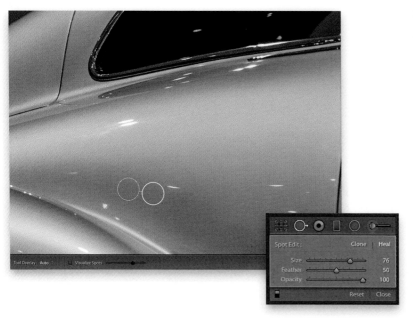

Continued

Step Three:

The first method is to press the **/ (Forward Slash) key** on your keyboard (named after the lead guitarist for Guns N' Roses). Each you time you press it, Lightroom picks a different area to sample from, and usually its second or third choice is a pretty decent one. That's the automatic way—letting Lightroom choose the new sample spot for you. The second method is the manual way: just click inside the sample circle and drag it to a different area yourself (as seen here, where I dragged it down and over to the right). Notice the little line with an arrow pointing to where you clicked to do your repair. Once you drag the sample circle over to a new area, let go of your mouse button and it does the repair. *Note:* If parts of the repair look see-through, go to the Spot Removal panel (near the top of the right side Panels area) and drag the Feather amount to the left (making the edges of the brush harder). Sometimes that will do the trick. So, those are your choices for fixing a bad repair: press the Forward Slash key or drag the second circle to a better location.

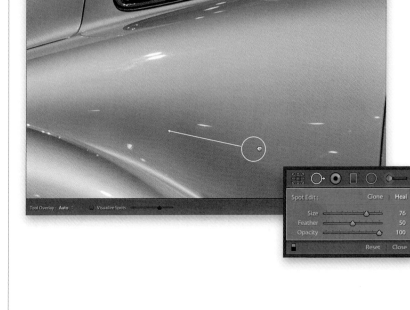

Step Four:

If you want to speed up the process and paint over either a line, or in our case, more than just one reflection spot, you can "paint" a stroke with the Spot Removal tool—just click-and-drag it right over the spots you want to remove. As you paint, the area you're painting over turns white (as shown here), but that's just so you can see where you painted. When you release your mouse button, after just a second or two, it chooses a sample area and removes your spot(s). Once again, it shows an outlined area where it sampled from and if your repair doesn't look good, use the two techniques you just learned in Step Three to find a better area to sample from for a more realistic repair.

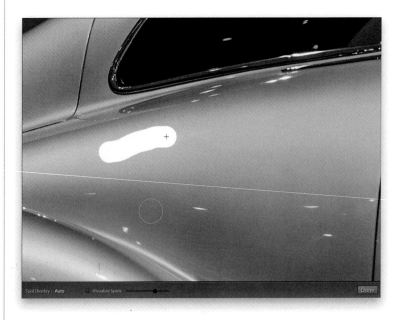

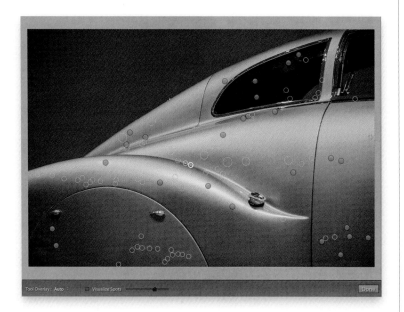

Step Five:

So, that's the process (and yes, it can take awhile, like an old person at a 50-item salad bar, who feels they need a tiny bit of all 50 items. But I digress). You navigate around your image, clicking once on small spots with a brush a little larger than the spot you want to remove, and for larger spots or for groups of spots, you'll paint a stroke by clicking-and-dragging the tool over the area you want to repair. Before long, your image will have circles and strokes all over it, because while the tool is active, you can switch to any previous removal you did by just clicking on an edit pin, and then you can drag a circle, or delete it, and try again.

Step Six:

Here's a before/after, with most of the spots removed (I didn't get every single one because…well…it's kind of a pain in the butt, and I have this book to write, and well…I got most of the big stuff anyway).

Finding Spots and Specks the Easy Way

There is nothing worse than printing a nice big image, and then seeing all sorts of sensor dust, spots, and specks in your image. If you shoot landscapes or travel shots, it is so hard to see these spots in a blue or grayish sky, and if you shoot in a studio on seamless paper, it's just as bad (maybe worse). I guess I should say, it used to be bad—now it's absolutely a breeze thanks to a feature added back in Lightroom 5 that makes every little spot and speck really stand out so you can remove them fast!

Step One:
Here's an image from Lake Tahoe, Nevada, and you can see a few spots and specks in the sky pretty clearly—I see around eight dust or sensor spots. But it's the spots that you can't see clearly at this size, or against this flat sky, that "Getcha!" Of course, you eventually do see them—like after you've printed the image on expensive paper, or when a client asks, "Are these spots supposed to be there?"

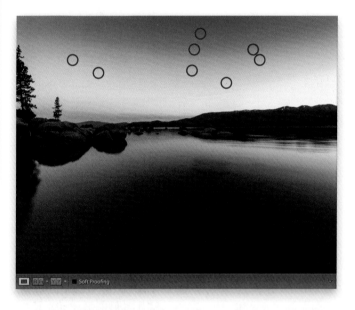

Step Two:
To find any spots, specks, dust, or junk in your image, click on the Spot Removal tool (**Q**; it's shown here circled in red) in the toolbox near the top of the right side Panels area. Down in the toolbar, directly below the main Preview area, is a Visualize Spots checkbox (also circled here). Turn this checkbox on and you get an inverted view of your image, where you can instantly see some more spots now.

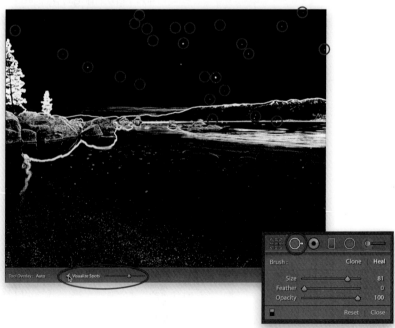

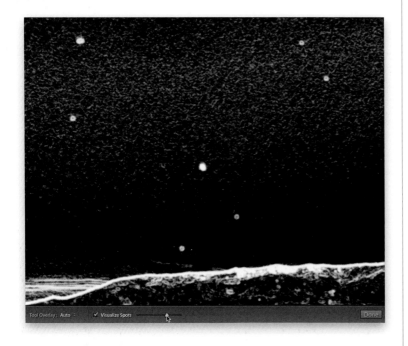

Step Three:

I zoomed in a bit here, so you can see the spots better, but another reason why they stand out so amazingly is because I increased the Visualize Spots threshold level (drag the Visualize Spots slider to the right, and now if there are any spots, specks, dust, etc., still hiding, you'll see them in an instant). I drag this slider to the right until I find that point where the spots stand out, but without the threshold overwhelming everything by bringing out what, if you drag too far, looks like snow or noise.

TIP: Click-and-Drag a Brush Size

When using the Spot Removal tool, you can press-and-hold Command-Option (PC: Ctrl-Alt) and click-and-drag out a selection around your spot (start by clicking just to the upper left of the spot, then drag across the spot at a 45° angle). As you do, it lays down a starting point and then your circle drags right over the spot.

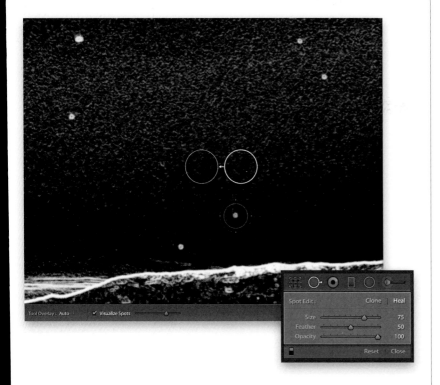

Step Four:

Now that the spots are so easily visible, you can take the Spot Removal tool and just click it once, right over each spot, to remove them (as shown here). Use the Size slider or the **Left and Right Bracket keys** to make the tool a little larger than the spot you want to remove. When you're done, turn the Visualize Spots checkbox off and make sure the Spot Removal tool sampled from matching areas. If you see a spot where it didn't, just click on that circle to make it active, then click inside the sampling circle and drag it to a matching area.

Continued

Step Five:

Often, it's dust on your camera's sensor that creates these annoying spots and they'll be in the exact same position in every shot from that shoot. If that's the case, then once you've removed all the spots, make sure the photo you fixed is still selected in the Filmstrip, and select all the similar photos from that shoot, then click the Sync button at the bottom of the right side Panels area. This brings up the Synchronize Settings dialog, shown here. First, click the Check None button, so everything it would sync from your photo is unchecked. Then, turn on the checkboxes for Process Version and Spot Removal (shown here), and click the Synchronize button.

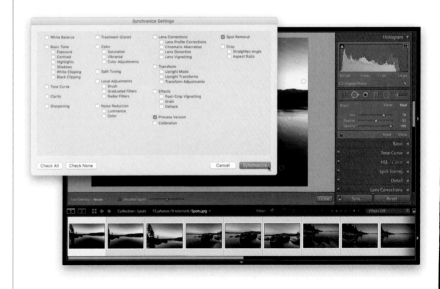

Step Six:

Now, it applies that same spot removal you did to the first photo to all these other selected photos—all at once (as you can see it did here). To see these fixes applied, click on the Spot Removal tool again. I also recommend you take a quick look at the fixed photos, because depending on the subject of your other shots, the fixes could look more obvious than on the photo you just fixed. If you see a photo with a spot repair problem, just click on that particular circle, hit the **Delete (PC: Backspace) key** on your keyboard to remove it, then use the Spot Removal tool to redo that one spot repair manually.

TIP: When to Use Clone

There are two choices for how this tool fixes your spots—Clone or Heal. The only reason to ever switch it to Clone is if the spot you're trying to remove is on or near the edge of an object in your image, or near the edge of the image itself. In these cases, Heal often smudges the image.

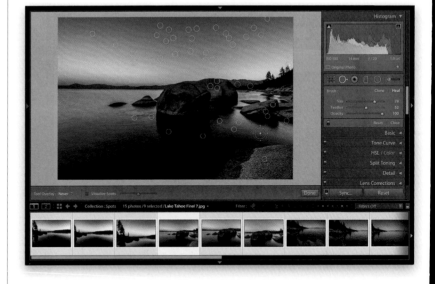

If you wind up with red eye in your photos (point-and-shoots are notorious red-eye generators thanks to the flash being mounted so close to the lens), Lightroom can easily get rid of it. This is really handy because it saves you from having to jump over to Photoshop just to remove red eye from a photo of your neighbor's six-year-old crawling through a giant hamster tube at Chuck E. Cheese. Here's how it works:

Removing Red Eye

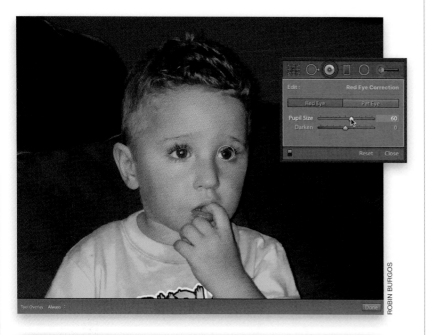

ROBIN BURGOS

Step One:
Go to the Develop module and click on the Red Eye Correction tool, found in the toolbox right under the Histogram panel (its icon looks like an eye, and it's circled here in red). Click the tool in the center of one of the red eyes and drag down, and when you release the mouse button, it removes the red eye. If it doesn't fully remove all the red, you can expand how far out it removes it by going to the Red Eye Correction tool's options (they appear in the panel once you've released the mouse button), and dragging the Pupil Size slider to the right (as shown here) or clicking-and-dragging the edge of the circle itself (it allows you to reshape it, as well). If you need to move the correction, click-and-drag inside the circle.

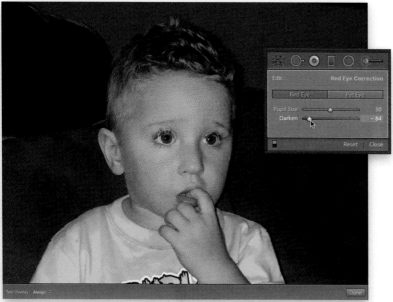

Step Two:
Now do the same thing to the other eye (the first eye you did stays selected, but it's "less selected" than your new eye selection—if that makes any sense). As soon as you click, this eye is fixed, too. If the repair makes it look too gray, you can make the eye look darker by dragging the Darken slider to the left (as shown here). The nice thing is that these sliders (Pupil Size and Darken) are live, so as you drag, you see the results right there onscreen—you don't have to drag a slider and then reapply the tool to see how it looks. If you make a mistake and want to start over, just click the Reset button at the bottom right of the tool's options.

Automatically Fixing Lens Distortion Problems

Ever shoot some buildings downtown and they look like they're leaning back? Or maybe the top of a building looks wider than the bottom, or a doorway or just a whole image seems like it's "bulging" out. All these types of lens distortion problems are really pretty common (especially if you use wide-angle lenses), but luckily for us, fixing them is usually just a one- or two- (maybe three-, seldom four-, rarely five-, but I once did six-) click fix.

Step One:

Open an image that has a lens distortion problem. This one has a bunch—from the building bulging outward to it being squashed on its right side. We can fix some of these problems with one click by going to the Lens Corrections panel and turning on the Enable Profile Corrections check-box (which we'll do in the next step). Doing this searches Lightroom's built-in database of lens fixes and applies the matching one to remove the outward bowing, along with any edge vignetting (darkening) in the corners. If it can't find a lens profile, you'll have to help it out by choosing your lens make and model from the Lens Profile pop-up menus, and then it does the rest. What if you don't see your exact lens there? Just pick a close match.

Step Two:

So, in the Develop module, go to the Lens Corrections panel, in the right side Panels area, turn on that Enable Profile Correc-tions checkbox, and it applies the lens profile (if it can find one). Although the building is still squashed on its right side, the bulging is now gone (look at how the columns are straight now and no longer curved). Even if this didn't fix anything, it's important to turn this checkbox on because it helps the next corrections work better. Also, there are two Amount sliders in this panel for fine-tuning the profile corrections, and while they're kind of subtle, they can definitely make a differ-ence—drag them back and forth once or twice and you'll get a feel for how they affect your image.

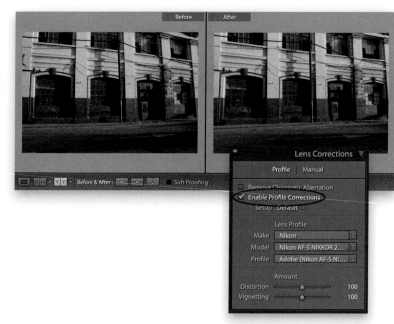

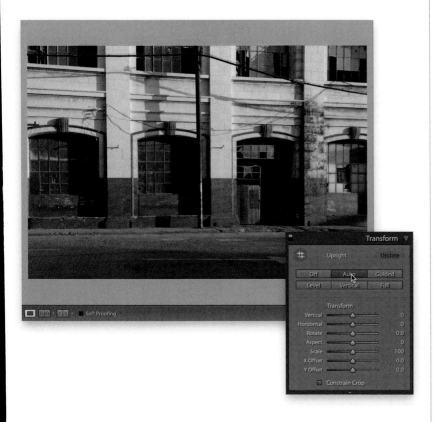

Step Three:

This step is a big one, and your results with it will be improved because you turned on that lens profile in Step Two. There's a correction feature called "Upright," and what it does is helps make buildings that are learning back look more "upright" (it's fairly well-named). You'll find this Upright feature near the top of the Transform panel (in the right side Panels area). In this panel, you'll see six different buttons, but 99.9% of the time I just click the Auto button (as shown here) because it gives the most natural and most balanced correction (some of the others over-correct, and while they'll get things like the vertical lines in buildings perfectly straight, they often do so at the expense of the overall image—it's that whole "the cure is worse than the illness" thing). So, click the Auto button, and as you'll see, it does a fairly good job of balancing the image (its right side is no longer squashed, but it's still pinched just a little bit to that side).

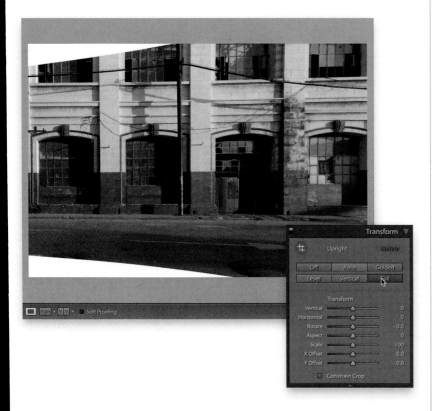

Step Four:

If we click on the Full button, in this particular case, it does a pretty darn good job of straightening out that far-right end—it's no longer pinched. But, to do that, it definitely leaves white gaps at the bottom and top left side. There is a Constrain Crop checkbox at the bottom of this panel and turning that on will automatically crop the image tight, so those white areas will be completely cropped away. In this case, it will leave your image looking more like a long, thin pano, so you might want to consider a "Plan B" (which would make a great name for a gourmet burger joint in Hartford, Connecticut, but of course, I'm just speculating. Try their mini-cheeseburgers. They're insane!).

Continued

Step Five:

Plan B is to get the Crop Overlay tool **(R)** and crop away parts of the white areas, but not all of it, as seen here (the darker areas outside the cropping border will be cropped away). In the next step, we might be able to lessen the amount we have to crop away, but for now, go ahead and crop the image like you see here. By the way, there are two other Upright buttons we haven't discussed yet (we'll look at Guided in the next technique): Vertical straightens the vertical lines in your photo, but it often leaves gaps that are much worse than what you see here. It's very legalistic, as it only considers that one aspect of your photo—not how the final overall image looks. So, this is probably the Upright button I use the least. If you click the Level button, it usually does a great job with the simple act of straightening a crooked photo. So, if that's all your image needs, then click on Level. But, we must move on, because we're still trying to limit our white triangles in the left corners.

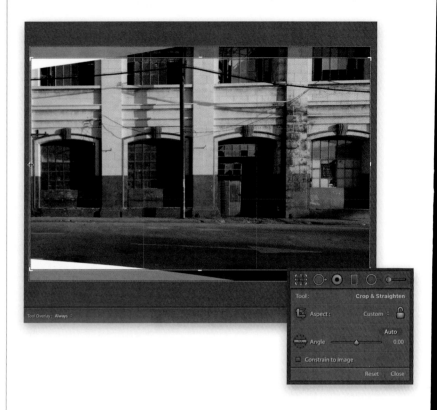

Step Six:

The building is still a bit "wonky" and not perfectly flat (now the left side looks a little squashed). You can fix this by going down to the Transform sliders and dragging the Horizontal slider a tiny bit to the left, until the building really looks flat (as shown here). Once you do that, look how little the white triangles in the corners are now. The Horizontal slider controls the side-to-side angle of the image (drag it back and fourth once or twice, and you'll see exactly what it does). The Vertical slider is for manually fixing buildings that are leaning backward (drag it back and forth once or twice and you'll see what I mean). If you use either of these sliders, and the image looks too thin or two wide when you're done, you can bring it back to a normal width by dragging the Aspect slider.

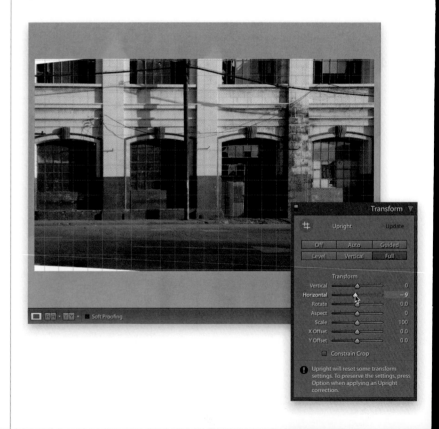

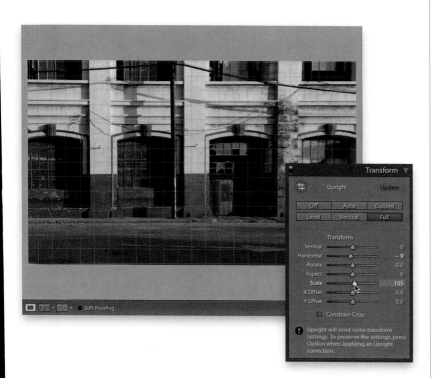

Step Seven:
To finish filling in those white corners, drag the Scale slider to the right until the image grows in size to fill them. You don't want to scale it up too much or you'll start to see pixelization (a loss of quality) and softnesss, so just move this slider a little if you can.

Step Eight:
Here's a before/after view with Lightroom doing most of the work. We (a) turned on the lens profile; (b) clicked the Upright Full button (which is pretty rare, as it's normally the Auto button—go figure); (c) dragged the Horizontal slider to make the building flatter; and lastly, (d) we used the Scale slider to zoom in on the image a bit to cover those white corners. That's not that much to fix a mess like we started with.

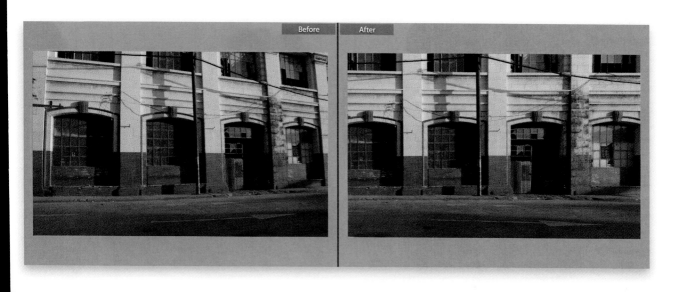

Fixing Lens Problems Yourself Using Guided Upright

If I have a shot where buildings or walls are leaning back, and using the automated Upright feature doesn't get the job done, this is my next stop: the "do-it-yourself" version of Upright, called "Guided Upright." You drag out lines along walls or areas that should be straight, and it takes over from there. You can draw up to four lines and reposition them once they're in place, and the image will update live.

Step One:

Here's an image with a serious case of "lean back," courtesy of a super-wide-angle lens and bad camera technique (shhh, don't mention that last part too loud). If the Auto Upright method we looked at in the previous technique didn't do the job for you, then it's time to help Lightroom out by using Guided Upright, where you tell it what's supposed to be straight and it straightens it out for you. Go to the Transform panel (in the right side Panels area) and click on the Guided button (as seen here). When you move your cursor out over the image, it changes into a crosshair. Now, click-and-drag that along an object in your image that's supposed to be vertically straight (like I did here with the column on the far right). At this point, with just one guide, the image looks the same, but that's about to change. By the way, you can reposition your guide by clicking-and-dragging it (as shown here).

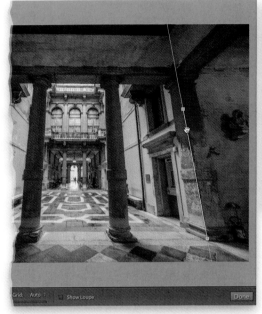

Step Two:

Drag another guide out along something else in the image that's supposed to be straight. Here, I placed another guide along the edge of the column on the far left, and those walls now become straight. You'll see white triangle-shaped gaps in the bottom corners (we'll deal with them later), but for now, just take a moment to enjoy how straight those walls are. Ahhh- hhh…those are some straight walls. But, look at the ceiling and the roof. There's still a little work to do, but luckily, we still have two horizontal guides left to help us with those.

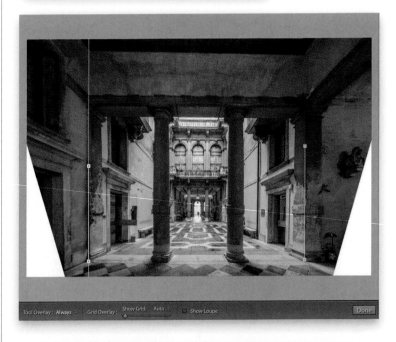

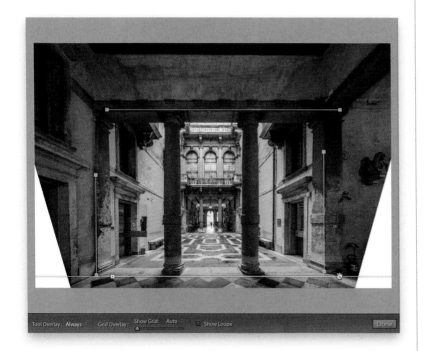

Step Three:

Now, you can click-and-drag out a horizontal guide along either the ceiling or the floor. In this case, I tried adding one along the ceiling, right above the columns, and one along the floor below the columns (as seen here). When you add that third guide, it adjusts the image as soon as you add it—same with the fourth guide. This is great because you can see if it looks good, and if it doesn't, you can press **Command-Z (PC: Ctrl-Z)** to Undo adding that guide, try a new location, and it will update live as you add it. Here, you can see all four guides in place, and the image looks pretty straight overall.

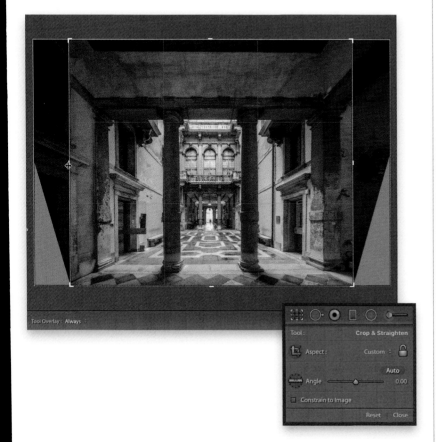

Step Four:

We still have to deal with those white triangle gaps in the corners, but we have two choices: (1) Of course, we could jump over to Photoshop (see Chapter 10 for more on doing this) and use the Magic Wand tool (**Shift-W**; while pressing-and-holding the Shift key the whole time) to select both of those areas. Then, go under the Select menu, under Modify, and choose **Expand** to expand those selected areas by 4 pixels (and click OK). Go under the Edit menu, choose Fill, and for Contents, choose **Content-Aware Fill**, and let it take a crack at filling in the gaps (it works fairly well in this case). Or, (2) we could crop them away using Lightroom's Crop Overlay tool **(R)**, which is what I did here. Be sure to unlock the Lock icon (in the top right of the Crop & Straighten options), so you can drag in the sides until those white gaps will be cropped off, and then hit **Return (PC: Enter)** to lock in the final crop. A before/after is on the next page, and you can see the difference this made.

Continued

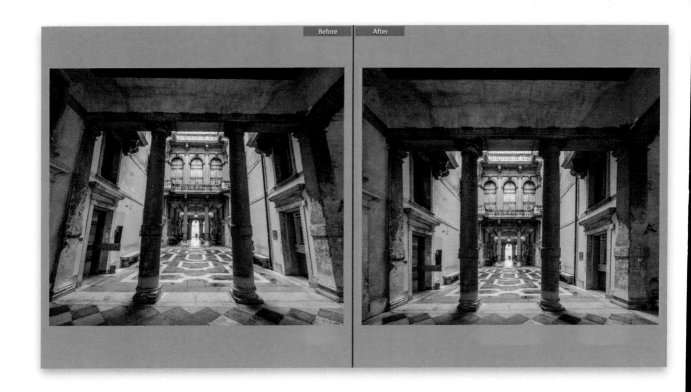

Vignetting is a lens problem that causes the corners of your photo to appear darker than the rest of the photo. This problem is usually more pronounced when you're using a wide-angle lens, but can also be caused by a whole host of other lens issues. Now, this darkening in the corners is not to be confused with adding a post-crop edge vignette effect all the way around your image (not just the corners), which is something we sometimes intentionally add to focus attention away from the edges (I covered adding edge vignette effects in Chapter 7).

Fixing Edge Vignetting

Step One:
In the photo shown here, you can see how the corner areas look darkened and shadowed. This is the bad vignetting that I mentioned above, and is considered a lens problem because it's caused by the lens you were using when you took the shot. Vignetting like this can happen in expensive lenses and cheaper lenses (it's just often more pronounced in chapter lenses).

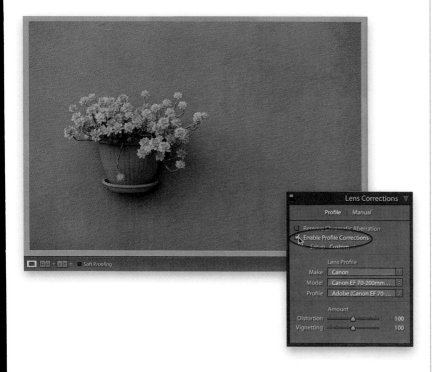

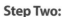

Step Two:
Our first line of defense is to go to the Lens Corrections panel in the Develop module's right side Panels area, click on Profile at the top of the panel, and then turn on the Enable Profile Corrections checkbox (as shown here). This applies a fix from Lightroom's built-in database of lens corrections, and it tries to automatically remove the edge vignetting, based on the make and model of the lens you used (it learns all this from the EXIF data embedded in your image). You can see here it did a decent job. It didn't get it all, but it seems to have gotten most of it (but, we'll tweak these results in a moment). If, for some reason, it wasn't able to find a profile for your lens (the pop-up menus in the Lens Profile section are set to none or appear blank), just choose your lens make/model from the pop-up menus.

Continued

Step Three:

Once you apply this Lens Profile correction, if enough of the vignetting didn't go away, you can fine-tune the results in the Amount section (at the bottom of the panel), using the Vignetting slider. Here, I had to drag it all the way over to 200 until nearly all of the vignetting was gone. There's still a tiny bit, and if that bugs you like it does me, it might be time to pull out "the big guns" and do this manually.

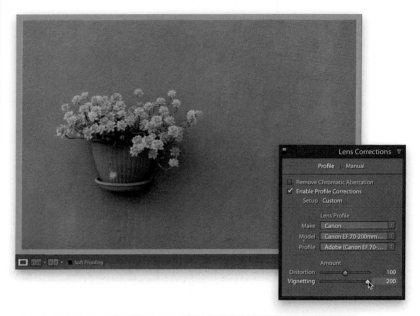

Step Four:

Click on Manual at the top of the panel, and you'll see a Vignetting section at the bottom. There are two sliders here: the first slider controls the amount of brightening in the edge areas, and the second slider lets you adjust how far in toward the center of your photo the corners will be brightened. In this photo, the edge vignetting is pretty much contained in the corners and doesn't spread too far into the center of the photo. So, start by slowly clicking-and-dragging the Amount slider to the right, and as you do, keep an eye on the corners of your image. As you drag, the corners get brighter, and your job is to stop when the brightness of the corners matches the rest of the photo (as seen here). In this case, the leftover vignetting is really right up in the corners, but my brightening with the Amount slider is starting to brighten farther into the image than just the corners. So, to keep the brightening to just the ends of the corners, drag the Midpoint slider over to the right until your brightening is just affecting what's up in the very tips of the corners (as I did here). The before/after on the next page shows just how much edge vignetting there really was and how much better it looks after you deal with it.

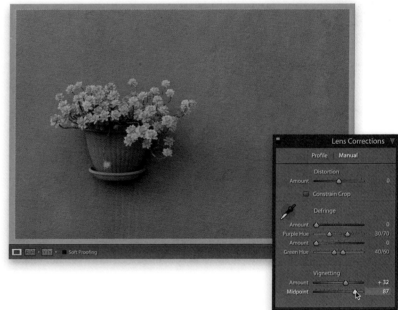

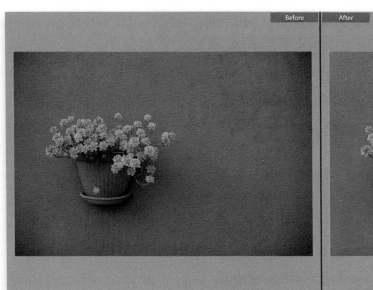
Before

After

Sharpening Your Photos

What you see in Lightroom's Detail panel (where Adobe hides the Sharpening controls) depends on which file format you shoot with in your camera. If you shoot in JPEG, your camera applies sharpening in-camera already, so when you come to the Detail panel, your Sharpening Amount will be set to zero. However, if you shoot RAW, the sharpening in your camera is turned off, and by default, Lightroom applies a small amount of capture sharpening. But, it's barely enough sharpening to be noticeable, so it's important to add our own.

Step One:

To sharpen your image, go to the Detail panel in the Develop module, and you'll see four Sharpening sliders. If you shot in RAW, you'll see that a default Sharpening Amount of 25 has already been applied, since your camera turns off internal sharpening when you shoot in RAW. There's a name for sharpening applied with an amount of 25: it's called "barely perceptible to the human eye" (weird thing: dogs can see a slight difference). Anyway, it's at least a starting point. If you shot in JPEG, sharpening was already applied in-camera, so by default, Lightroom sets the Amount at zero (as seen in the bottom inset here) and no sharpening is applied.

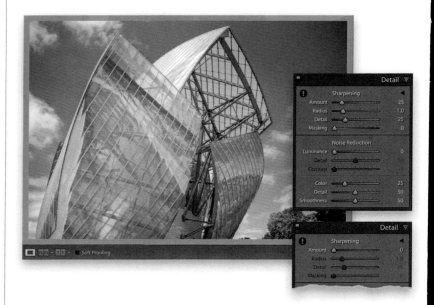

Step Two:

At the top of the panel, there's a little preview area that zooms in tight on one small area of the image (if you don't see this preview window, click on the black left-facing triangle to the right of Sharpening at the top of the panel). If you move your cursor over the preview, it changes to the grabber hand, so you can click-and-drag to move around. You can also click the little icon in the upper-left corner of the panel (shown circled here), then move your cursor out over your image, and that area will now appear zoomed, in the preview window (to keep the preview on that area, just click on the area in the main image). To turn this off, click that icon again. If you want to zoom in even tighter, you can Right-click inside the preview window, and choose a 2:1 view from the pop-up menu (shown here).

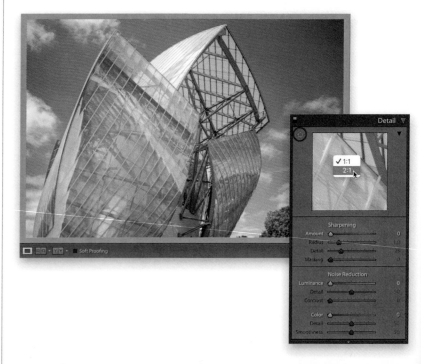

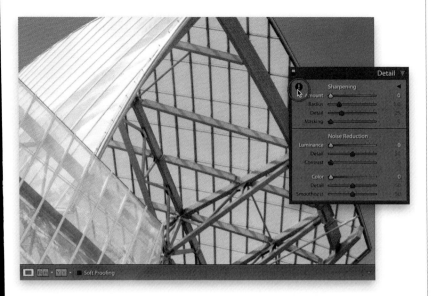

Step Three:
Just for the record, I bailed on using that tiny preview window years ago—it's just about useless—so, I hide it from view by clicking on the down-facing triangle doohickey to its right. Just so ya know, if you do hide that preview window, you'll see a warning symbol in the top left (shown circled here in red) letting you know that to really see the results of your sharpening, you need to at least be at a 100% full-size view. Luckily, that warning sign is more than a warning—if you click directly on it, it will zoom your image to a 1:1 full-size view for you (as seen here).

Step Four:
The Amount slider does just what you'd expect—it controls the amount of sharpening applied to your photo. Here, I increased it to 130, which is more than I'd normally apply (I'm usually in the 50 to 70 range), but I wanted you to really see the difference here. The Radius slider determines how many pixels out from the edge the sharpening will affect, and I generally leave this set at 1.0, but if I really need some mega-sharpening, I'll bump it up to 1.1 or 1.2. You have to be careful bumping this up because you can start to get a white line or hard-edged halo around the edges of objects, so I usually crank the Amount rather than increase the Radius. Also, I never change the Detail slider. It's designed to keep you from having those halos, and if you increase its amount, it removes your halo protection and gives you crunchier, more haloey (if that's even a word) sharpening, so I leave it as-is.

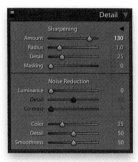

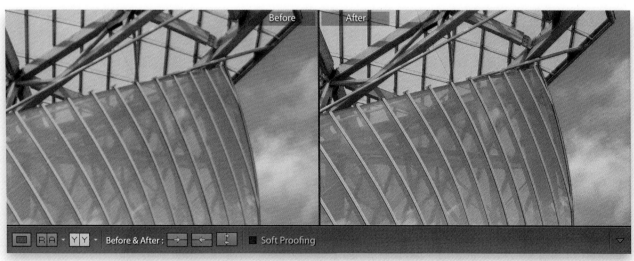

Continued

Step Five:

The last sharpening slider, Masking, is to me the most amazing one of all, because what it lets you do is control exactly where the sharpening is applied. For example, some of the toughest things to sharpen are things that are supposed to be soft, like a child's skin, or a woman's skin in a portrait, because sharpening accentuates texture, which is exactly what you don't want. But, at the same time, you need detail areas to be sharp—like their eyes, hair, eyebrows, lips, clothes, etc. Well, this Masking slider lets you do just that—it kind of masks away the skin areas, so it's mostly the detail areas that get sharpened. To show how this works, we're going to switch to a portrait.

TIP: Toggling Off the Sharpening

If you want to temporarily toggle off the changes you've made in the Detail panel, just click on the little switch on the far left of the Detail panel's header.

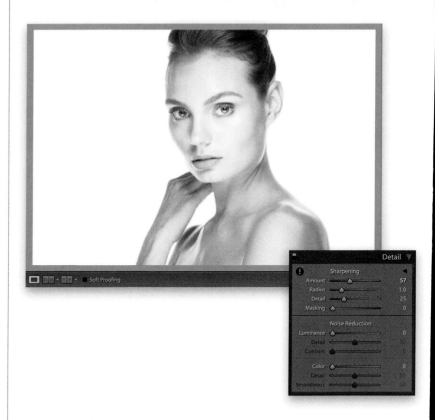

Step Six:

First, press-and-hold the Option (PC: Alt) key and then click-and-hold on the Masking slider, and your image will turn solid white (as shown here). What this solid white image is telling you is that the sharpening is being applied evenly to every part of the image, so basically, everything's getting sharpened.

Step Seven:
As you click-and-drag the Masking slider to the right, parts of your photo will start to turn black, and those black areas are now not getting sharpened, which is our goal. At first, you'll see little speckles of black, but the farther you drag that slider, the more non-edge areas will become black—as seen here, where I've dragged the Masking slider over to 70, which pretty much has the skin areas in all black (so they're not being sharpened), but the detail edge areas, like the eyes, lips, hair, nostrils, and outline, are being fully sharpened (which are the areas still appearing in white). So, in reality, those soft skin areas are being automatically masked away for you, which is really pretty darn slick if you ask me.

Step Eight:
When you release the Option (PC: Alt) key, you see the effects of the sharpening, and here you can see the detail areas are nice and crisp, but it's as if her skin was never sharpened (in fact, I was able to crank up the Amount after the masking). Now, just a reminder: I only use this Masking slider when the subject is supposed to be of a softer nature, where we don't want to exaggerate texture.

TIP: Sharpening a Smart Preview
If you apply sharpening (or noise reduction) to a low-res smart preview of an image, the amount you apply might look just right. But, when you reconnect your hard drive, and it links to the original high-res file, that amount of sharpening (or noise reduction) will actually have much less of an effect. So, you might want to leave the sharpening (and noise reduction) for when you're working on the original file.

Fixing Chromatic Aberrations (a.k.a. That Annoying Color Fringe)

Have you ever seen an image that has either a purple or green color halo or fringe around the edges of things in the image? If you haven't, you're probably just not looking because these color fringes (called "chromatic aberrations") show up fairly often (it's a lens problem), and you can actually exacerbate them (how's that for a $10 word) by applying a lot of contrast or clarity. But, I wouldn't stop applying either one because Lightroom has a very effective way to fix this.

Step One:
Here's the original image, and at the Fit in Window size, you can't tell there's any chromatic aberrations at all, but when you zoom in, you'll find them instantly. They were easily visible at a 1:1 full-size view, but in the next step, I zoomed in even tighter (to an 8:1 view) on the building on the left, so you can really see what's going on.

Step Two:
You can see here that it almost looks like someone traced the left edge of the black space between the windows with a thin yellow/greenish marker, the right edge with a pale purple marker, and along the diagonal part of the reflection on the window with a blue marker.

Step Three:
Let's get rid of these by first going to the Develop module's Lens Corrections panel, clicking on Profile at the top, and then turning on the Remove Chromatic Aberration checkbox (as shown here). A lot of the time, just turning on this checkbox is enough to fix the problem (it sure was with this image—take a look here, and in the before/after below, and you'll see the yellow/greenish, purple, and blue edge fringe is all gone). Just one checkbox. How easy is that? Now, what do you do if that doesn't work? Well, you go on to Step Four, that's what ya do.

Step Four:
Click on Manual at the top of the panel (just to the right of Profile), and in the Defringe section, drag the purple Amount slider to the right a little to remove the purple fringe manually—just drag it until the purple line goes away. If it reduces it, but doesn't fully get rid of it, you might have to help it choose the right hue to neutralize it by dragging the Purple Hue sliders around a bit. Do the same thing with the Green Hue and the green Amount sliders until the green fringe is gone. Now, if you're not sure which slider to drag (or moving the sliders doesn't seem to do much), then let Lightroom set them for you. Just click on the Fringe Color Selector tool (the eyedropper in the top left of the Defringe section, shown circled here in red), zoom in really tight, and click it once directly on the color that is fringing. Now, the sliders will move automatically right where they need to, to remove that color fringe.

Basic Camera Calibration in Lightroom

Some cameras seem to put their own color signature on your photos, and if yours is one of those, you might notice that all your photos seem a little red, or have a slight green tint in the shadows, etc. Even if your camera produces accurate color, you still might want to tweak how Lightroom interprets the color of your RAW images. The process for doing a full, accurate camera calibration is kinda complex and well beyond the scope of this book, but I did want to show you what the Calibration panel is used for, and give you a resource to take things to the next level.

Step One:

Before we start, I don't want you to think that camera calibration is something everybody must do. In fact, I imagine most people will never even try a basic calibration, because they don't notice a big enough consistent color problem to worry about it (and that's a good thing. However, in every crowd there's always one, right?). So, here's a quick project on the very basics of how the Calibration panel works: Open a photo, then go to the Develop module's Calibration panel, found at the very bottom of the right side Panels area, (see, if Adobe thought you'd use this a lot, it would be near the top, right?).

Step Two:

The topmost slider is for adjusting any tint that your camera might be adding to the shadow areas of your photos. If it did add a tint, it's normally green or magenta—look at the color bar that appears inside the Tint slider itself. By looking at the color bar, you'll know which way to drag (for example, here I'm dragging the Tint slider away from magenta, toward green, to reduce any reddish color cast in the shadow areas, but the change in this particular photo is so subtle I didn't even see a change).

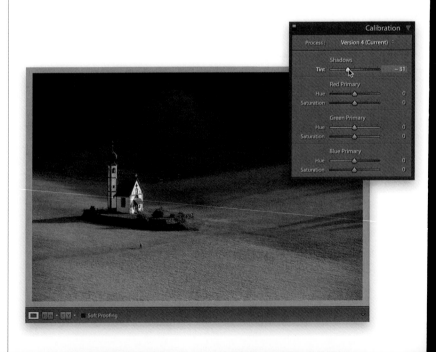

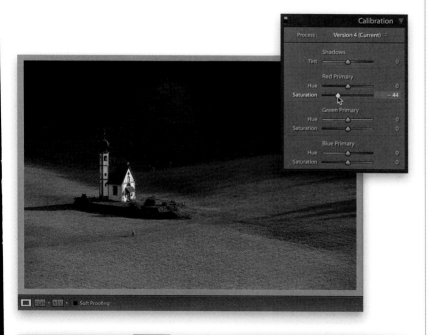

Step Three:

If your color problems don't seem to be in the shadows, then you'll use the Red, Green, and Blue Primary sliders to adjust the Hue and Saturation (the sliders that appear below each color). Let's say your camera produces photos that have a bit of a red cast to them. You'd drag the Red Primary Hue slider away from red, and if you needed to reduce the overall saturation of red in your photo, you'd drag the Red Primary Saturation slider to the left until the color looked neutral (by neutral, I mean the grays should look really gray, not reddish gray).

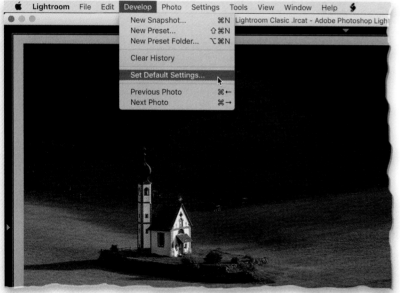

Step Four:

Once you get the color dialed in the way you want, you've tested this new color calibration on a few different images from that same camera, and you feel you've neutralized the color bias from your camera with the current Calibration sliders, then you can save a whole lot of time by designating these settings as the new default settings for that particular camera. That way, it will automatically recognize images from that camera and apply your new calibration settings for you. How cool is that? Here's how to set that up: First, make sure you haven't adjusted any settings but those in the Calibration panel (or they'll be baked into your new default settings for that camera). Then, go under the Develop menu and choose **Set Default Settings** (as shown here, above). This brings up the dialog you see here asking if you want to update your default settings for images from this particular camera (it notes the make, model, and possibly the file format, right in the dialog). If you do, click Update to Current Settings (and, obviously, this is also where you go to return to Adobe's default settings, if you ever change your mind and want to go back). That's all there is to it.

EXPORTING
saving JPEGs, TIFFs, and more

"Do we really need an entire chapter on exporting our JPEGs?" Well, I can't say that you personally need a whole chapter, but I know for certain that my publisher does, because in their words, "We prepaid for these pages." You see (prepare yourself, as I reveal some serious book publishing industry secrets that you neither want to know or will ever have any use for as long as we both shall live, so help me God).... Anyway, because paper costs are so ridiculous these days (it's not like this stuff grows on trees), when they sign a book author to a deal, the publisher is exposing themselves to the risk of paper costs rising significantly between the time they sign the author and the time the book is actually published—often a year or more. So, to protect themselves from these rising costs, they invite new authors to their offices (in my case, in San Francisco). After a light snack and some coffee, they took me to Neiman Marcus in Union Square. It's a very high-end store, and we were just looking around, but then they started pushing me to shoplift some small items. Of course, I resisted, but they kept pushing. They said, "It's okay, everybody out here does it." So, at first, I just took a belt, and then a small bottle of cologne, but they kept telling me that if I wanted to be a successful author, I needed to be bolder. They were putting a lot of pressure on me, and next thing you know, I'm shoving a Maurizio Braschi sable coat under my shirt and I'm sprinting for the door like Usain Bolt. Anyway, apparently my publisher videotaped the whole thing, and they told me that if the price of paper rises before I'm done with the book, they're turning the video over to the police. Well, luckily for me, the paper costs somehow dropped by 1.4% by pub date; I filled the pages in this Exporting chapter with random Springsteen lyrics I copied from the web, and I made enough selling that coat on eBay to pay for a bus ticket home. Overall, it was a petty good trip. Did I mention I got a new belt? And, that I'm (of course) totally making this up?

Saving Your Photos as JPEGs

Since there is no Save command for Lightroom (like there is in Photoshop), one of the questions I get asked most is, "How do you save a photo as a JPEG?" Well, in Lightroom, you don't save it as a JPEG, you export it as a JPEG (or a TIFF, or a DNG, or a Photoshop PSD). It's a simple process, and Lightroom has added some automation features that can kick in once your photo is exported.

Step One:

You start by selecting which photo(s) you want to export as a JPEG (or a TIFF, PSD, or DNG). You can do this in either the Library module's Grid view or down in the Film-strip in any other module by Command-clicking (PC: Ctrl-clicking) on all the photos you want to export (as shown here).

Step Two:

If you're in the Library module, click on the Export button at the bottom of the left side Panels area (circled here in red). If you're in a different module and using the Filmstrip to select your photos for export, then use the keyboard shortcut **Command-Shift-E (PC: Ctrl-Shift-E)**. Whichever method you choose, it brings up the Export dialog (shown in the next step).

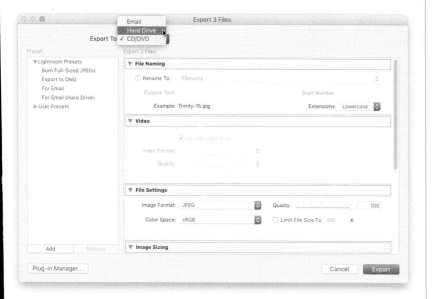

Step Three:
Along the left side of the Export dialog, Adobe put some Export presets, which are basically designed to keep you from having to fill out this entire dialog every time from scratch. It comes with a few presets from Adobe, but the real power of this is when you create your own (those will appear under the User Presets header). The built-in Lightroom Presets are at least a good starting place to build your own, so for now, click on Burn Full-Sized JPEGs and it fills in some typical settings someone might use to export their photos as JPEGs and burn them to a disc. However, we'll customize these settings so our files are exported where and how we want them, then we'll save our custom settings as a preset, so we don't have to go through all this every time. If, instead of burning these images to disc, you just want to save these JPEGs in a folder on your hard drive, go to the top of the dialog, and from the Export To pop-up menu, choose **Hard Drive**, as shown here.

Step Four:
Let's start at the top of the dialog: First, you need to tell Lightroom where to save these files in the Export Location section. If you click on the Export To pop-up menu (as shown here, at top), it brings up a list of likely places you might choose to save your files. The third choice (Choose Folder Later) is great if you're making presets, because it lets you choose the folder as you go. If you want to choose a folder that's not in this list, choose Specific Folder, then click the Choose button to navigate to the folder you want. You also have the option of saving them into a separate subfolder, like I did here, at the bottom. So, now my images will appear in a folder named "Trinity Church" on my desktop. If these are RAW files and you want the exported JPEGs added into Lightroom, turn on the Add to This Catalog checkbox.

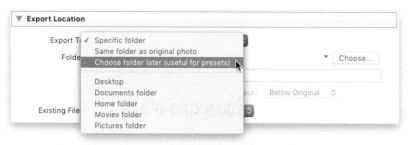

Choose where to save your exported images from the Export To pop-up menu

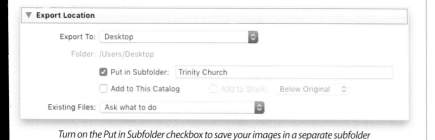

Turn on the Put in Subfolder checkbox to save your images in a separate subfolder

Continued

Step Five:

The next section down, File Naming, is like the file naming feature you learned about back in the Importing chapter. If you don't want to rename the files you're exporting, but want to keep their current names, leave the Rename To checkbox turned off, or turn it on and choose File-name from the pop-up menu. If you do want to rename the files, choose one of the built-in templates, or if you created a custom file naming template (we learned this back in Chapter 3), it will appear in this list, too. In our example, I chose Custom Name – Sequence (which automatically adds a sequential number, starting at 1, to the end of my custom name). Then, I simply named these shots "Trinity Church," so the photos will wind up being named Trinity Church-1, Trinity Church-2, and so on. There's also a pop-up menu for choosing whether the file extension appears in all uppercase (.JPG) or lowercase (.jpg).

Step Six:

Let's say you're exporting an entire collection of images, and inside that collection are some video clips that were shot with your DSLR. If you want them included in your export, in the Video section, turn on the Include Video Files checkbox (shown here). Below that checkbox, you'll choose the video format (H.264 is really compressed, and is for playing on a mobile device; DPX is usually for visual effects). Next, choose your video quality: Max will keep the quality as close to your original video as possible, and High is still good, but may be slower. Choose Medium if you're going to post it to the web, or if you're planning to view it on a high-end tablet. Choose Low for viewing on all other mobile devices. You can see the differences between your format and quality choices by watching the Target size and speed listed to the right of the Quality pop-up menu. Of course, if you don't have any videos chosen when you export, this section will be grayed out.

You can skip the Image Sizing section altogether, unless you need to make the image you're saving smaller than its original size

Step Seven:
Under File Settings, you choose which file format to save your photos in from the Image Format pop-up menu (since we chose the Burn Full-Sized JPEGs preset, JPEG is already chosen here, but you could choose TIFF, PSD, DNG, or if you have RAW files, you could choose Original to export the original RAW photo). Since we're saving as a JPEG, there's a Quality slider (the higher the quality, the larger the file size), and I generally choose a Quality setting of 80, which I think gives a good balance between quality and file size. If I'm sending these files to someone without Photoshop, I choose sRGB as my color space. If you chose a PSD, TIFF, or DNG format, their options will appear (you get to choose things like the color space, bit depth, and compression settings).

Step Eight:
By default, Lightroom assumes that you want to export your photos at their full size. If you want to make them smaller, in the Image Sizing section, turn on the Resize to Fit checkbox, then type in the Width, Height, and Resolution you want. Or you can choose to resize by pixel dimensions, the long edge of your image, the short edge of your image, the number of megapixels in your image, or a percentage from the top pop-up menu.

Continued

Step Nine:

Also, if these images are for printing in another application, or will be posted on the web, you can add sharpening by turning on the Sharpen For checkbox in the Output Sharpening section. This applies the right amount of sharpening based on whether they're going to be seen only onscreen (in which case, you'll choose Screen) or printed (in which case, you'll choose the type of paper they'll be printed on—glossy or matte). For inkjet printing, I usually choose High for the Amount, which onscreen looks like it's too much sharpening, but on paper looks just right (for the web, I choose Standard).

You can add Output Sharpening for wherever these images will be viewed, either onscreen (on the web or in a slide show), or on a print

Step 10:

In the Metadata section, you start by choosing what metadata you want to be exported with your images: everything, everything but your Camera Raw data, everything but your camera and Camera Raw data (this hides all your exposure settings, your camera's serial numbers, and other stuff your clients probably don't need to know), just your copyright and contact info (if you're including your copyright, you probably want to include a way for people to contact you if they want to use your photo), or just your copyright. If you choose All Metadata, All Except Camera Raw Info, or All Except Camera & Camera Raw Info, you can still have Lightroom remove any Person keywords by turning on the Remove Person Info checkbox or any GPS data by turning on the Remove Location Info checkbox.

The next section down lets you add a visible watermark to the images you're exporting (watermarking is covered in detail in the next project), and to add your watermark to each image you're exporting, turn on the Watermark checkbox, then choose a simple copyright or your saved watermark from the pop-up menu.

Step 11:
The final section, Post-Processing, is where you decide what happens after the files are exported from Lightroom. If you choose Do Nothing (from the After Export pop-up menu), they just get saved into that folder you chose back in the beginning. If you choose Open in Adobe Photoshop, they'll automatically be opened in Photoshop after they're exported. You can also choose to open them in another application or in a Lightroom plug-in. Go to Export Actions Folder Now opens the folder where Lightroom stores your export actions. So, if you want to run a batch action from Photoshop, you could create a droplet and place it in this folder. That droplet would then show up in the After Export pop-up menu, and choosing it would open Photoshop and run your batch action on all the photos you were exporting from Lightroom. (*Note:* I show you how to create a batch action in Chapter 11.)

Step 12:
Now that you've customized things the way you want, let's save these settings as your own custom preset. That way, the next time you want to export a JPEG, you don't have to go through these steps again. Now, there are some changes I would suggest that will make your preset more effective. For example, if you saved this as a preset right now, when you use it to export other photos as JPEGs, they'll be saved in that same Trinity Church folder. Instead, this is where it's a good idea to select **Choose Folder Later** (in the Export Location section, as shown here), like we discussed back in Step Four.

Continued

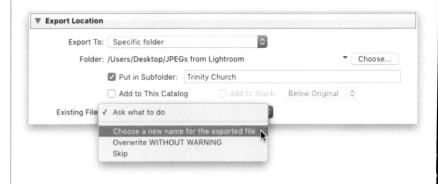

Step 13:

If you know you always want your exported JPEGs saved in a specific folder, then in the Export Location section, click the Choose button, and choose that folder. Now, what happens if you go to export a photo as a JPEG into that folder, and there's already a photo with the same name in it (maybe from a previous export)? Should Lightroom just automatically overwrite this existing file with the new one you're exporting now, or do you want to give this new file a different name, so it doesn't delete the file already in that folder? You get to choose how Lightroom handles this problem using the Existing Files pop-up menu (shown here). I pick **Choose a New Name for the Exported File** (as shown here). That way, I don't accidentally overwrite a file I meant to keep. By the way, when you choose Skip, if it sees a file already in that folder with the same name, it doesn't export the JPEG image—instead, it just skips it.

TIP: Rename Files When Using a Preset

Before you export your photos, make sure you give your files a new custom name, or the shots from your football game will be named Trinity Church-1.jpg, Trinity Church-2.jpg, and so on.

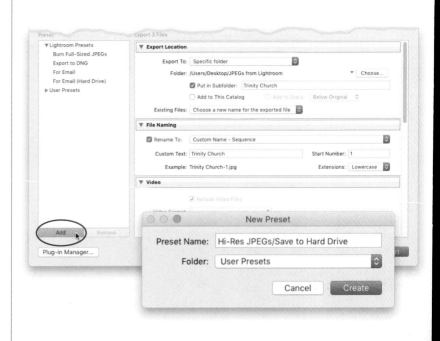

Step 14:

Now you can save your custom settings as a preset: click the Add button at the bottom-left corner of the dialog (shown circled here in red), and then give your new preset a name (in this case, I used Hi-Res JPEGs/Save to Hard Drive. That name lets me know exactly what I'm exporting and where they're going).

Step 15:
Once you click the Create button, your preset is added to the Preset section (on the left side of the dialog, under User Presets), and from now on you're just one click away from exporting JPEGs your way. If you decide you want to make a change to your preset (as I did in this case, where I changed the Color Space to ProPhoto RGB, and I turned the Watermark checkbox off), you can update it with your current settings by Right-clicking on your preset, and from the pop-up menu that appears, choosing **Update with Current Settings** (as shown here).

While you're here, you might want to create a second custom preset—one for exporting JPEGs for use in online web galleries. To do that, you might lower the Image Sizing Resolution setting to 72 ppi, set your sharpening to Screen, set Amount to Standard, set the Metadata to Copyright & Contact Info Only, and you might want to turn the Watermark checkbox back on to help prevent misuse of your images. Then, you'd click the Add button to create a new preset named something like Export JPEG for Web.

Step 16:
Now that you've created your own presets, you can save time and skip the whole Export dialog thing altogether by just selecting the photos you want to export, then going under Lightroom's File menu, under **Export with Preset**, and choosing the export preset you want (in this example, I'm choosing the Export JPEG for Web preset). When you choose it this way, it just goes and exports the photos with no further input from you. Sweet!

Adding a Watermark to Your Images

If your images are going on the web, there's not much to keep folks from taking your images and using them in their own projects (sadly, it happens every day). One way to help limit unauthorized use of your images is to put a visible watermark on them. That way, if someone rips them off, it'll be pretty obvious to everyone that they've stolen someone else's work. Also, beyond protecting your images, many photographers are using a visible watermark as branding and marketing for their studio. Here's how to set yours up:

Step One:

To create your watermark, press **Command-Shift-E (PC: Ctrl-Shift-E)** to bring up the Export dialog, then scroll down to the Watermarking section, turn on the Watermark checkbox, and choose **Edit Watermarks** from the pop-up menu (as shown here). *Note:* I'm covering watermarking here in the Export chapter, because you can add your watermark when you're exporting your images as JPEGs, TIFFs, etc., but you can also add these watermarks when you print an image (in the Print module), or put it in a web gallery (in the Web module).

Step Two:

This brings up the Watermark Editor (seen here), and this is where you either (a) create a simple text watermark, or (b) import a graphic to use as your watermark (maybe your studio's logo, or some custom watermark layout you've created in Photoshop). You choose either Text or Graphic up in the top-right corner (shown circled here in red). By default, it displays the name from your user profile on your computer, so that's why it shows my copyright down in the text field at the bottom of the dialog. The text is also positioned right up against the bottom and left borders of your image, but luckily you can have it offset from the corners (I'll show you how in Step Four). We'll start by customizing our text.

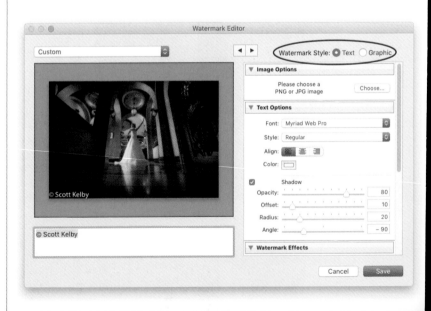

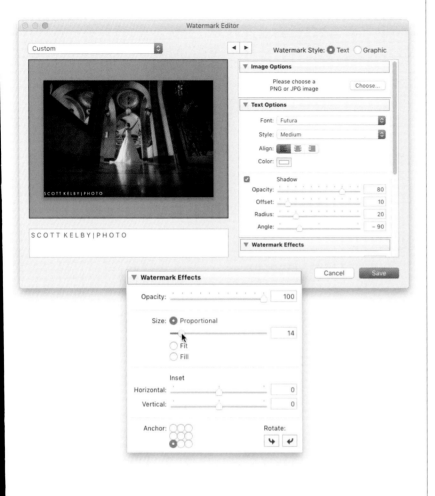

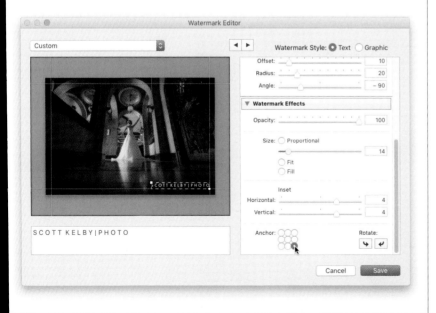

Step Three:

Type in the name of your studio in the text field at the bottom left, then choose your font in the Text Options section on the right side of the dialog. In this case, I chose Futura Medium. (By the way, the little line that separates SCOTT KELBY from PHOTO is called a "pipe," and you create one by pressing Shift-Backslash.) Also, to put some space between the letters, I pressed the Spacebar after each one. You also can choose the text alignment (left justified, centered, or right justified) here, and you can click on the Color swatch to choose a font color. To change the size of your type, scroll down to the Watermark Effects section, where you'll find a Size slider (seen here) and radio buttons to Fit your watermark to the full width of your image, or Fill it at full size. You can also move your cursor over the type on the image preview and corner handles appear—click-and-drag outward to scale the text up, and inward to shrink it down.

Step Four:

You get to choose the position of your watermark in the Watermark Effects section. At the bottom of the section, you'll see an Anchor grid, which shows where you can position your watermark. To move it to the bottom-right corner, click the bottom-right anchor point (as shown here). To move it to the center of your image, click the center anchor point, and so on. To the right of that are two Rotate buttons if you want to switch to a vertical watermark. Also, back in Step Two, I mentioned there's a way to offset your text from the sides of your image— just drag the Horizontal and Vertical Inset sliders (right above the Anchor grid). When you move them, little positioning guides will appear in the preview window, so you can easily see where your text will be positioned. Lastly, the Opacity slider at the top of the section controls how see-through your watermark will be.

Continued

Step Five:

If your watermark is going over a lighter background, you can add a drop shadow using the Shadow controls in the Text Options section. The Opacity slider controls how dark the shadow will be. The Offset is how far from the text your shadow will appear (the farther you drag to the right, the farther away the shadow will be). The Radius is Adobe's secret code name for softness, so the higher you set the Radius, the softer your shadow will become. The Angle slider is for choosing where the shadow appears, so the default setting of –90 puts the shadow down and to the right. A setting of 145 puts it up and to the left, and so on. Just drag it, and you'll instantly see how it affects the position of your shadow. The best way to see if the shadow really looks better or not is to toggle the Shadow checkbox on/off a couple of times.

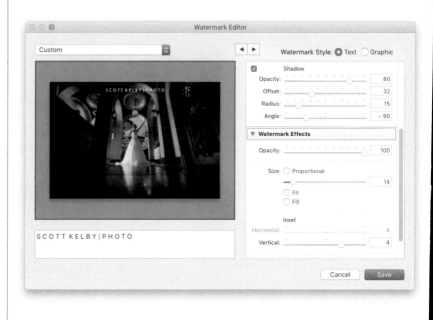

Step Six:

Now let's work with a graphic watermark, like your studio's logo. The Watermark Editor supports graphic images in either JPEG or PNG format, so make sure your logo is in one of those two formats. Scroll back up to the Image Options section, and where it says Please Choose a PNG or JPEG Image, click the Choose button, find your logo graphic, then click Choose, and your graphic appears (unfortunately, the white background behind the logo is visible, but we'll deal with that in the next step). It pretty much uses the same controls as when using text—go to the Watermark Effects section and drag the Opacity slider to the left to make your graphic see-through, and use the Size slider to change the size of your logo. The Inset sliders let you move your logo off the edges, and the Anchor grid lets you position the graphic in different locations on your image. The Text Options and Shadow controls are grayed out, since you're working with a graphic.

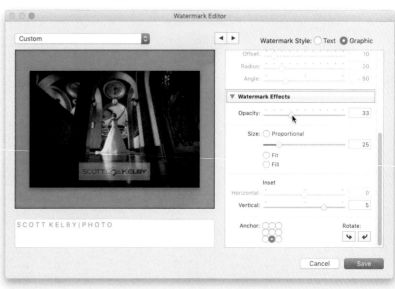

In Photoshop, this logo has a white Background layer, so a white background will appear behind your logo when you bring it into Lightroom's Watermark Editor

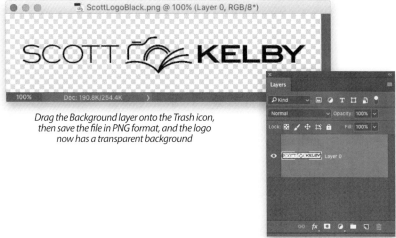

Drag the Background layer onto the Trash icon, then save the file in PNG format, and the logo now has a transparent background

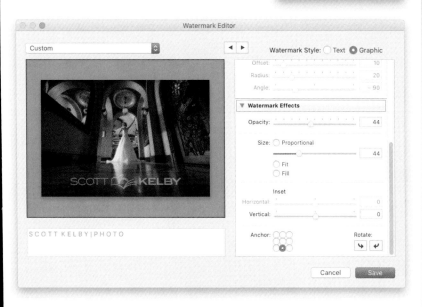

Step Seven:

To make that white background transparent, you have to open the layered file of your logo in Adobe Photoshop and do two things: (1) Delete the Background layer by dragging it onto the Trash icon at the bottom of the Layers panel, leaving just your graphics (and text) on their own transparent layers. Then, (2) save the Photoshop document in PNG format. This saves a separate file, and the file appears flattened, but the background behind your logo will be transparent (as shown here at the bottom).

Step Eight:

Now choose this new PNG logo file (in the Image Options section of the Watermark Editor), and when you import it, it appears over your image without the white background (as seen here, where I used a white logo instead). You can now resize, reposition, and change the opacity of your logo graphic in the Watermark Effects section. Once you get it set up the way you want it, you should save it as a watermark preset (so you can use it again, and you can apply it from the Print and Web modules). You do that by clicking the Save button in the bottom right or choosing **Save Current Settings as New Preset** from the pop-up menu in the top-left corner of the dialog. Now your watermark is always just one click away.

Emailing Photos from Lightroom

Back in Lightroom 3 (and earlier versions), if you wanted to email images from Lightroom, it was…well…it was a workaround. You had to jump through a lot of hoops (creating aliases/shortcuts to your email program, and placing those inside one of Lightroom's folders, and on and on). It kinda worked, but it was kinda clunky. Luckily, now, it's built right in, and it couldn't be easier.

Step One:

In Grid view, Command-click (PC: Ctrl-click) on the images you want to email. Now, go under the File menu and choose **Email Photos** (as shown here) to bring up Lightroom's email dialog (shown in the next step).

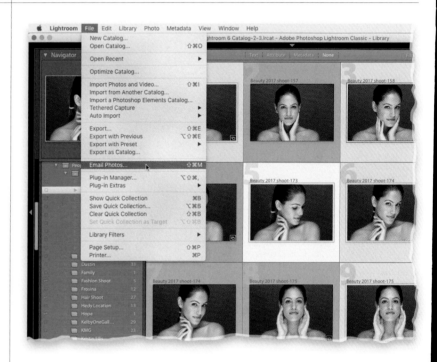

Step Two:

Here's where you enter the email address of the person you want to email the images to and type in the subject line of your email, and it chooses your default email application (but you can choose a different email application if you like from the From pop-up menu). You'll also see the thumbnails of the images you just selected in Lightroom's Grid view.

TIP: What If Your Email App Isn't Listed?

Then, from the From pop-up menu, choose **Go to Email Account Manager**. There, click the Add button (in the bottom left) and when the New Account dialog appears, choose your email provider from the Service Provider pop-up menu (you'll see AOL, Gmail, Hotmail, etc.). If yours isn't listed there, then choose Other, and you'll have to add the server settings yourself. Now, add your email address and password in the Credential Settings section (it will verify that it's correct), and your email server will be added to your From pop-up menu.

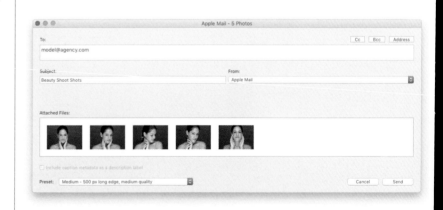

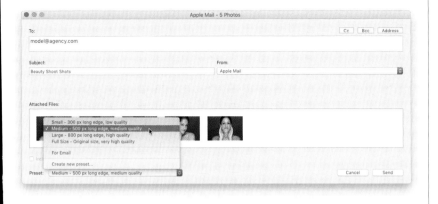

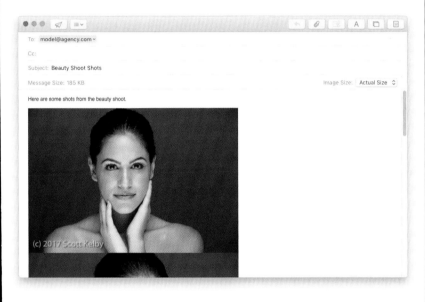

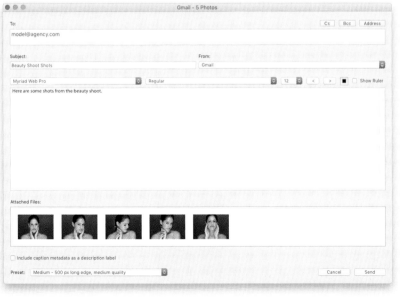

Step Three:

You also get to choose the physical size of the images you're emailing (after all, if you attach enough of them at their full size, chances are your email will bounce back for being too large). There are four built-in size presets you can choose from the pop-up menu in the bottom-left corner of the dialog (as shown here), where you choose both the size and quality. If you've created any presets for emailing, those will appear here, too, or to create one now, choose Create New Preset at the bottom of the menu, and it brings up the standard Export dialog. Enter the settings you want, save it as a preset (click the + [plus sign] button in the bottom-left corner of the Export dialog), and now that preset will appear in your email Preset pop-up menu.

Step Four:

If you're using an email app, when you click the Send button, it launches your email program, fills in all the info you entered in the Lightroom email dialog (address, subject, and so on), and then it attaches your images at the size and quality you selected, so type your message and hit the Send button in your email program, and off it goes. If you're using webmail, once you choose it in the From pop-up menu, the dialog changes to include a message area (seen here at the bottom). Type your message and click the Send button.

TIP: Using the Two Email Presets

Adobe included two email presets in Lightroom's Export dialog: one that brings up the regular email dialog you just learned about (called "For Email"), and the other simply saves your images to your hard drive for you to email later (manually). To save the images for emailing later, go under the File menu, under Export with Preset, and choose **For Email (Hard Drive)**. You'll choose which folder you want to save your images into, and then it just saves them as JPEGs at a small size (640x640 pixels at a quality setting of 50).

Exporting Your Original RAW Photo

So far, everything we've done in this chapter is based on us tweaking our photo in Lightroom and then exporting it as a JPEG, TIFF, etc. But what if you want to export the original RAW photo? Here's how it's done, and you'll have the option to include the keywords and metadata you added in Lightroom—or not.

Step One:

First, click on the RAW photo you want to export from Lightroom. When you export an original RAW photo, the changes you applied to it in Lightroom (including keywords, metadata, and even changes you made in the Develop module) are saved to a separate file called an XMP side-car file, since you can't embed metadata directly into the RAW file itself (we talked about this in Chapter 3), so you need to treat the RAW file and its XMP sidecar file as a team. Now press **Command-Shift-E (PC: Ctrl-Shift-E)** to bring up the Export dialog (shown here). Click on Burn Full-Sized JPEGs just to get some basic settings. From the Export To pop-up menu up top, choose **Hard Drive**, then, in the Export Location section, choose where you want this original RAW file saved to (I chose my desktop). In the File Settings section, from the Image Format pop-up menu, choose **Original** (shown circled here in red). When you choose to export the original RAW file, most of your other choices are grayed out.

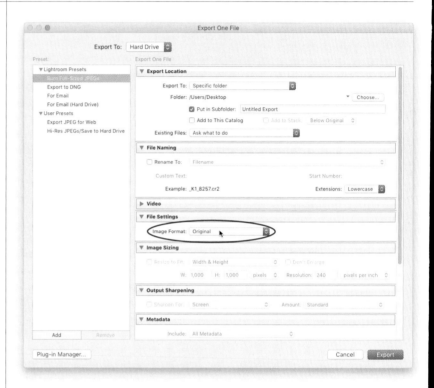

TIP: Saving Your RAW Photo as a DNG

From the Image Format pop-up menu, choose **DNG** to bring up the DNG options. Embed Fast Load Data affects how fast the preview appears in the Develop module (it adds a little size to your file). Use Lossy Compression does to RAW images what JPEG compression does to other images—it tosses some info to give you files that are around 75% smaller in size (good for archiving the images the client didn't pick, but you don't want to delete).

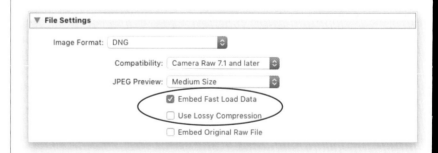

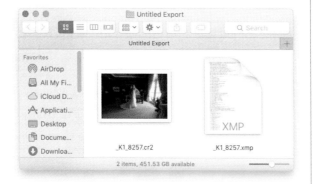

Step Two:

Now click Export, and since there's no processing to be done, in just a few seconds your file appears on your desktop (or wherever you chose to save it)—you'll see your file and its XMP sidecar (with the same exact name, but XMP as its file extension) in a folder (as seen here, on my desktop). As long as these two stay together, other programs that support XMP sidecar files (like Adobe Bridge and Adobe Camera Raw, for example) will use that metadata, so your photo will have all the changes you applied to it. If you send this file to someone (or burn it to disc), make sure you include both files. If you decide you want the file to not include your edits, just don't include the XMP file with it.

Here's the image with contrast, highlights, shadows, clarity, and white balance adjustments, and a split toning effect added, when you include the XMP sidecar file

Here's the original image, without contrast, highlights, shadows, clarity, and white balance adjustments, and no split toning effect added, when you don't include the XMP sidecar file

Step Three:

If you export the original RAW file and send it to someone with Photoshop, when they double-click on it, it will open in Camera Raw, and if you provided the XMP file, they'll see all the edits you made in Lightroom, as seen in the top image shown here, where the contrast, highlights, shadows, clarity, and white balance were adjusted, and a split toning effect was added. The bottom image shown here is what they'll see in Camera Raw when you don't include the XMP file—it's the untouched original file with none of the changes I made in Lightroom.

Step Five:

Now select the photos that you'd like to publish to Flickr, and drag-and-drop them onto the Flickr Photostream in the Publish Services panel (you'll see Photostream appear right underneath Flickr, as seen here). Once you've dragged them into this collection (yup, it's a collection), click directly on Photostream and you'll see that the images you just dragged there are waiting to be published (they're not actually published to Flickr until you click the Publish button at the bottom of the left side Panels area or the top right of the center Preview area). What's nice about this is it lets you gather up as many photos, from as many different collections as you'd like, and then publish them all at once with just one click. But for our example here, we'll assume that you just want to publish these five images.

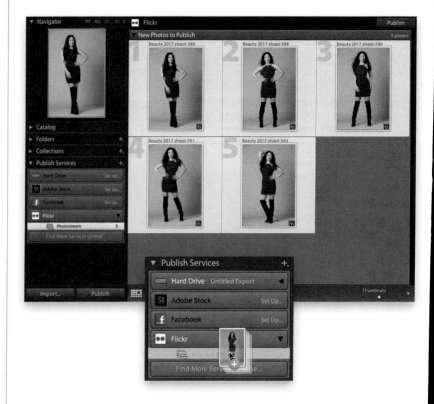

Step Six:

Click the Publish button now, and a split-screen appears in the Preview area, with the five New Photos to Publish appearing in the section on top first. One by one, they'll move down to the Published Photos section below (here, three of the five images have been published). Once all your photos have been published, the New Photos to Publish section disappears, because there are no photos waiting to be published. (By the way, while your photos are being published, a small status bar will appear in the top-left corner of Lightroom to let you know how things are moving along.)

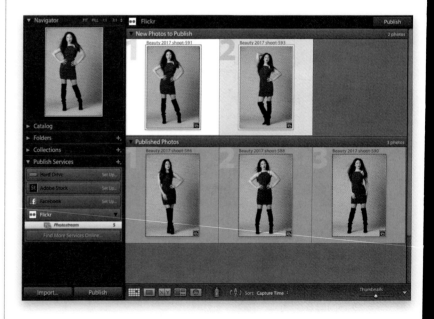

Step Seven:

Switch to your web browser, go to your Flickr Photostream page, and you'll see your images have now been published there (as seen here). Now, you can take things a step further, because the comments that people post online about your published photos can be synced back to Lightroom, so you can read them right there in the Comments panel (in the right side Panels area). For example, on the Flickr website itself, I clicked on the second image and added a comment in the field below it. I wrote: "The watermark needs to be moved to the bottom."

Step Eight:

To see the comments in Lightroom, go to the Publish Services panel, click on your Flickr Photostream, and it displays your published photos. Then, Right-click on your Photostream and choose **Publish Now** from the pop-up menu, and it goes and checks your Flickr account to see if any comments have been added, and downloads them into Lightroom. Now, click on a photo, and then look in the Comments panel (at the bottom of the right side Panels area), and any comments that were added to that image in Flickr will appear there. Also, it displays how many people have tagged that published photo as one of their favorites on Flickr.

Continued

Step Nine:

Okay, so far so good, but what if you make a change to one of those published photos in Lightroom? Here's what to do (and here's where this Publish Services thing works so well): First, click on the Flickr Photostream to display the photos you've already published to Flickr, then click on the photo you want to edit, and press **D** to jump over to the Develop module. In this case, I just made some adjustments in the Basic panel. Now that our edits are done, it's time to get this edited version of the photo back up to our Flickr photostream.

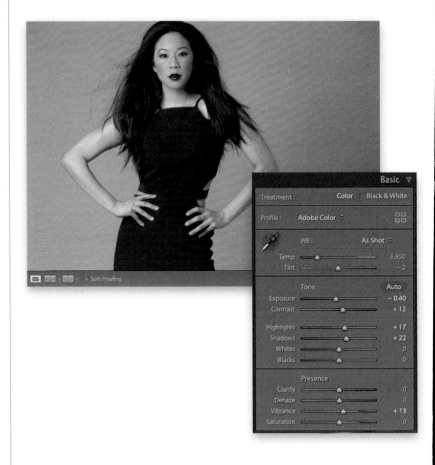

Step 10:

Go back to the Library module, to the Publish Services panel, and click on your Photostream, and you'll see a split screen again, but this time it's showing your edited photo up top waiting to be republished. Click the Publish button and it updates the image on Flickr, so your most recent changes are reflected there. Of course, once you do this, the Modified Photos to Re-Publish section goes away, because now all your photos are republished. Okay, so that's the Flickr Publish Services, and now that you've learned how that works, setting up your hard drive for drag-and-drop publishing is a cinch, so we'll do that next.

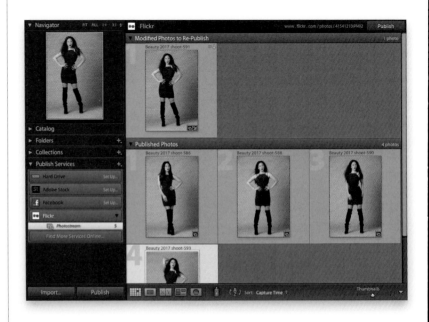

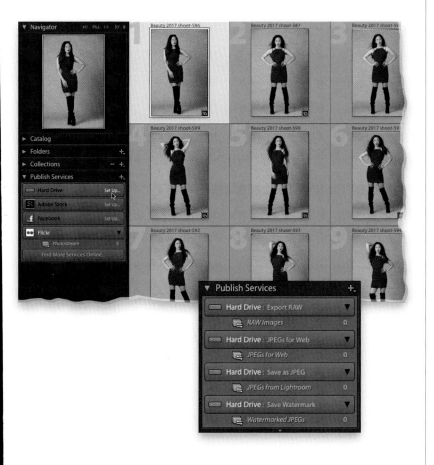

Step 11:
Start by clicking on the Set Up button next to Hard Drive in the Publish Services panel. We'll configure this one so it saves any files we drag onto it as high-resolution JPEGs to your hard drive (so think of this as a drag-and-drop shortcut to make JPEGs, rather than having to go through the whole Export dialog). Give this publish service a name now—call this one "Save as JPEG"—then fill out the rest just like you would for exporting a high-res JPEG to your hard disk (like we did back on page 272). When you click Save, it replaces Set Up with the name of your service (in this case, now it reads: "Hard Drive: Save as JPEG," so you know at a glance that it's going to save images you drag-and-drop on it to your hard drive as JPEGs). You can add as many of these as you'd like by Right-clicking next to Hard Drive and choosing **Create Another Publish Service via "Hard Drive."** That way, you can have some that export your images as originals, or some for emailing, or…well…you get the idea (look at the Publish Services panel here where I created a few extra setups, just so you can see what they'd look like).

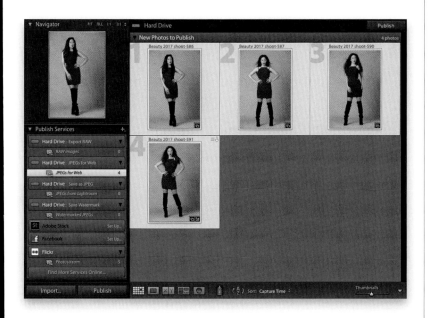

Step 12:
Now that you've got at least one configured, let's put it to work. In the Library module, go ahead and select four RAW files you want saved as JPEGs (they don't have to be RAW files—they can already be JPEGs that you just want exported from Lightroom), and drag-and-drop those selected photos onto your Hard Drive: Save as JPEG publish service. From here, it's pretty much the same as you just learned with Flickr—the images appear in a New Photos to Publish section until you click the Publish button, then it writes them as JPEGs into whichever folder you chose when you set this publish service up.

LR WITH PHOTOSHOP
how and when to use Photoshop

It's important to know that, even as powerful as Lightroom Classic is today, there are times when you're going to need to jump over to Photoshop to accomplish what you need to do. However, a little historical perspective will help you better understand when and why you need to make this jump: You see, Lightroom 1.0 came out 11+ years ago, which is actually longer than it sounds when you realize that Lightroom was around before even the iPhone. If you were using Lightroom back then and your cell phone rang, it was some weird Motorola or Nokia flip phone, with an awful little monochrome screen that looked like it was from a 1960s Soviet Soyuz mission. There were no apps on your phone, no games, heck, there was no Twitter (if you mentioned "Twitter" to someone, they assumed you were referring to the sound a bird makes). So, if you wound up in a doctor's office, or the DMV, or any type of waiting room, you didn't just pick up your phone and start watching videos or posting on social media. Nope, you just sat there, staring at the wall, sobbing, as you quietly prayed for the sweet angel of death to come and mercifully end your excruciating boredom. Sorry, I got off track. Where was I? Oh, yeah, using Photoshop. Well, back then, Lightroom had very few features and a lot of the sliders weren't actually attached to anything. Adobe, of course, knew all this and held a secret meeting in the vast catacombs beneath their San Jose headquarters, attended by leaders of the World Bank and the Ordo Templi Orientis, where it was decided to make Lightroom work with Photoshop so seamlessly that users wouldn't notice important stuff was missing. Well, the plan worked and, in fact, they'd still be getting away with it to this very day if it weren't for those meddling kids! Well, them and the Illuminati.

Choosing How Your Files Are Sent to Photoshop

When you take a photo from Lightroom over to Photoshop for editing, by default, Lightroom makes a copy of the file (in TIFF format), embeds it with the ProPhoto RGB color profile, sets the bit depth to 16 bits, and sets the resolution to 240 ppi. But if you want something different, you can choose how you'd like your files sent over to Photoshop—you can choose to send them as PSDs (that's how I send mine) or TIFFs, and you can choose their bit depth (8 or 16 bits) and which color profile you want embedded when your image leaves Lightroom.

Step One:

Press **Command-, (comma; PC: Ctrl-,)** to bring up Lightroom's preferences, and click on the External Editing tab up top (seen here). If you have Photoshop on your computer, it chooses it as your External Editor, so in the top section, choose the file format you want for photos that get sent to Photoshop (I set mine to PSD, because the files are much smaller than TIFFs), then from the Color Space pop-up menu, choose your file's color space (Adobe recommends ProPhoto RGB. If you keep it at that, I'd change Photoshop's color space to ProPhoto RGB, as well—whatever you choose, just use the same color space in Photoshop). Adobe also recommends choosing a 16-bit depth for the best results (although, I personally use an 8-bit depth most of the time). You also get to choose the resolution (I leave mine set at the default of 240 ppi). If you want to use a second program to edit your photos, you can choose that in the Additional External Editor section.

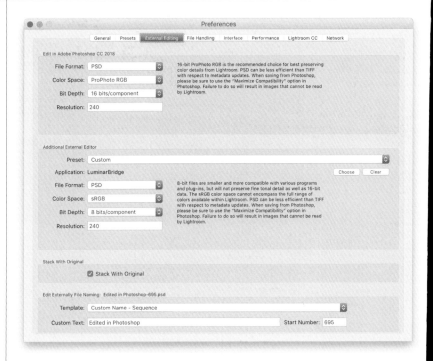

Step Two:

Next, there's a Stack With Original checkbox. I recommend leaving this on, because it puts the edited copy of your image right beside your original file (more on this in the next project), so it's easy to find when you return to Lightroom. Lastly, you can choose the name applied to photos sent over to Photoshop. You choose this from the Edit Externally File Naming section at the bottom of the dialog, and you have pretty much the same naming choices as you do in the regular Import window.

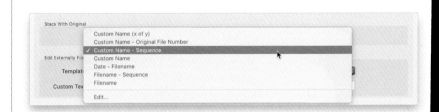

While Lightroom is great for so many everyday editing things, it doesn't do heavy special effects or major photo retouching; there are no layers, no filters, and its type controls are very limited, and it doesn't do many of the bazillion (yes, bazillion) things that Photoshop does. So, there will be times during your workflow where you'll need to jump over to Photoshop to do some "Photoshop stuff" and then jump back to Lightroom for printing or presenting. Luckily, these two applications were designed to work together from the start.

How to Jump Over to Photoshop, and How to Jump Back

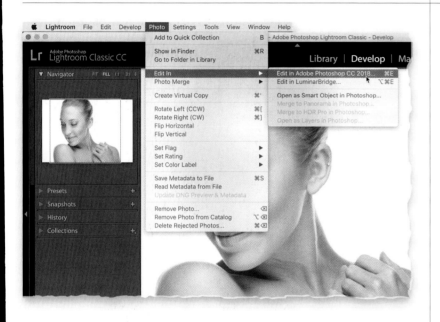

20-Second Tutorial:

To take the image you're working on over to Photoshop, go under the Photo menu, under Edit In, and choose **Edit in Adobe Photoshop** (as shown here), or just press **Command-E (PC: Ctrl-E)**, and Lightroom sends a copy of your image over to Photoshop. Do anything you want to it in Photoshop and then simply save the image, close the window, and it comes right back to Lightroom. However, if you want to follow along with the project here, I'll take you through the process (plus, you'll get to learn a few Photoshop things along the way). Here's our original image in Lightroom.

Step One:

Now, press Command-E (PC: Ctrl-E) to open the image in Photoshop. If you took the shot in RAW, it just "loans" Photoshop a copy of the image and opens it. However, if you shot in JPEG or TIFF mode, this brings up the Edit Photo with Adobe Photoshop dialog, where you choose (1) to have a copy of your original photo sent to Photoshop, with all the changes and edits you made in Lightroom applied to it, (2) to have Lightroom make a copy of your original untouched photo and send that to Photoshop, or (3) to edit your original JPEG or TIFF in Photoshop without any of the changes you've made thus far in Lightroom. Since we're working with a JPEG here, we'll choose the first option, and work on a copy that has our Lightroom adjustments.

Continued

Step Two:

Here's a copy of our image open in Photoshop CC. We're going to create a blend of two images, kind of a multiple exposure effect with one image blending into the shape of the other (it's a pretty popular effect right now seen in web ads, site banners, etc.). Start by getting the Quick Selection tool from the Toolbar (**W**; it's shown circled here in red). Now, you can either have Photoshop select your subject for you by clicking on the Select Subject button up in the Options Bar (also circled here; this feature works amazingly well), or you can paint over her yourself. Either way will put a selection border around your subject (as seen here). If you decide to paint the selection, you might have to zoom in tight, by pressing **Command-+ (plus sign; PC: Ctrl-+)**, and shrink the size of the brush down (press the **Left Bracket key** on your keyboard to make the brush smaller, or the **Right Bracket key** to make it larger) to help paint in every little area. This tool does a great job in making selections, so it shouldn't take long at all. By the way, to zoom back out, double-click the Hand tool near the bottom of the Toolbar.

Step Three:

Once she's fully selected, press **Command-J (PC: Ctrl-J)** to put a copy of just the subject up on her own separate layer above the Background layer. In the image you see here, I went to the Layers panel and hid the Background layer (the one with the solid white background around her) by clicking on the eye icon to the left of the layer's thumbnail. I did that so you could see that this new layer is just her without the white background. The gray/white checkerboard you now see behind her represents the transparent areas of this layer, so you can see it's just her, on her own separate layer. Having her on her own separate layer like this, without a background behind her, is a key part of this technique.

Step Four:

Now let's open the image we're going to blend with her—it's a shot of the New York City skyline taken from the Top of the Rock observation deck. In Lightroom, click on the image, then press Command-E (PC: Ctrl-E) to open this image in Photoshop, as well. See that tab near the top of the window (the one that says "nyc skyline .jpg")? If you have this Photoshop preference turned on, you can click on these tabs to switch from one image document to another. With this skyline image now open, press **Command-A (PC: Ctrl-A)** to put a selection around the entire image, and then we'll do a simple copy/paste onto our headshot photo document. So, press **Command-C (PC: Ctrl-C)** to copy it, click the BeautyHeadshot1.jpg tab to switch to that image, then press **Command-V (PC: Ctrl-V)** to paste this image on top of your headshot image. It will appear on its own separate layer, so now you'll have three layers: (1) Background is your original image; (2) Layer 1 is that selection of just her on a transparent background; and (3) Layer 2, at the top, is the skyline image.

Step Five:

We need to put a selection back around our subject, and there's a keyboard short-cut that will do that: press-and-hold the Command (PC: Ctrl) key, then click once directly on the image thumbnail for Layer 1 in the Layers panel. When you do this, it puts a selection around your subject (the same selection you made earlier). Now, with that selection in place, make sure the top layer is still active (Layer 2—the skyline shot), then go down to the bottom of the Layers panel and click on the Add Layer Mask icon (it's the third icon from the left, circled here in red). When you do that, it masks the skyline photo into the shape of your subject (as seen here), and the selection automatically deselects itself (so don't be concerned that you don't see it in place any more).

Continued

Step Six:

To blend the skyline in with your subject on the layer below it, you're going to change the layer blend mode of this skyline layer. Layer blend modes determine how the layer you're currently on interacts with the layers below it. When it's set to its default setting—Normal—it doesn't interact, it just covers whatever's on the layer below, so if you change the blend mode, it'll blend. There are 27 different blend modes, and depending on the image, they always look different. So, what I do is press **Shift-+ (plus sign)** again and again, and it toggles through all the different blend modes. Your job? Simply stop at the one that looks good to you. In this case, I used the **Overlay** blend mode, but others I liked were Soft Light, Hard Light, Pin Light, and Subtract (choose whichever one you like best).

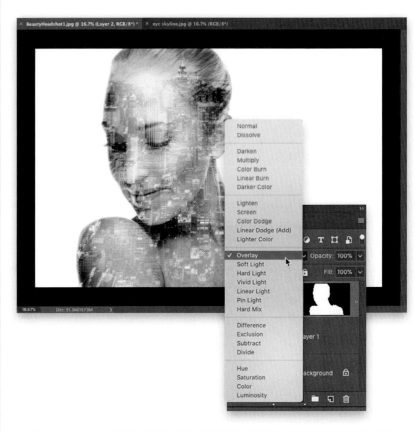

Step Seven:

Now we're going to bring back some of our original image, but we still need that lower layer (so the city layer has something to mix with). What we'll do is make a copy of the layer of her with the transparent background, and drag that copy layer to the top of the layer stack. So, in the Layers panel, click on Layer 1 (her with the transparent background), then press Command-J (PC: Ctrl-J), which makes a duplicate of the layer, but this duplicate appears below the skyline, so you can't see that you've done anything. Just click on that layer and drag it up to the top of the layer stack, and at this point, it will look like when we started (as seen here).

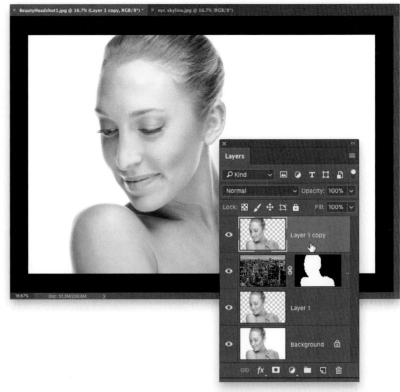

Your copy layer is hidden
behind a black layer mask

Choose a large, soft-edged brush
from the Brush Picker up in the
Options Bar, then drag the
brush Size slider to 1800 px

Lower the Opacity to 50%
up in the Options Bar

Step Eight:

Now you're going to hide this copy layer on top behind a black layer mask, so we can reveal just the parts we want. Press-and-hold the Option (PC: Alt) key and click on the Add Layer Mask icon (the same one you clicked on earlier, at the bottom of the Layers panel). This hides your copy layer behind a black layer mask, so you can't see it at all. It's still there—it's just hidden. Now, go to the Toolbar and get the Brush tool (or just press the letter **B**), then go up to the Brush Picker in the Options Bar, choose a large, soft-edged brush (as shown on the right), and drag the brush Size slider to 1800 pixels. Now, lower the Opacity of the brush to 50% (you also do this up in the Options Bar).

Step Nine:

Look at the bottom of the Toolbar and make sure your Foreground color is set to white (if it's not, press the letter **X** on your keyboard until the white color swatch appears in the front). Then, take the brush and paint over the parts of the image where you want to reveal the original (as I did here where I painted over the left side of her face), and because you're using a soft-edged brush, it blends smoothly. There's still some skyline coming through her face here, but if you want less skyline and more of her face visible, paint over that part of her face again (since you're painting with your brush at 50% Opacity, it builds up as you paint over the same area).

Continued

Step 10:

We're done tweaking the image here in Photoshop, so at this point, you can choose to flatten the image (by choosing **Flatten Image** from the Layers panel's flyout menu), which removes all the layers and leaves you with a single-layer image, like we normally have in Lightroom, or you can keep all the layers intact and send them over to Lightroom (more on this choice on the next page). But, no matter which you choose to do (flattening the image or not), what you do next is the same: just press **Command-S (PC: Ctrl-S)** to Save the changes, then press **Command-W (PC: Ctrl-W)** to Close the image window. Save and close. That's it. Now when you go back to Lightroom, and look in your headshot image collection, you'll find your edited image right beside your original image (as shown here). If you're using folders instead of collections, you'll find this edited image at the end of the images in the folder.

Step 11:

Now that the image is back in Lightroom, you can treat it like any other image, so let's convert it to black and white, and then finish things off by adding a little film grain (I often add grain to black-and-white photos to give them more of a traditional B&W film look). Of course, you can use any of the sliders or profiles in the Develop module, but for now let's just go to the Presets panel in the left side Panels area, and under the B&W presets, click on B&W High Contrast. Then, in that same panel, go down to the Grain presets and choose Medium to apply the film grain effect. So, to recap: press **Command-E (PC: Ctrl-E)** to take your selected image over to Photoshop, do all the tweaking you want there, and when you're done, simply save and close and your edited image appears in Lightroom. Be sure to read the next technique, though, because it's something you'll want to know about saving a layered file back to Lightroom.

If you take an image over to Photoshop, and you add a bunch of layers, and then you just "save and close," like I've been saying, what happens to those layers? They actually stay intact, even though, in Lightroom, you only see the single image (as if you had flattened the image). The trick is how to reopen the layered image in Photoshop and still have the layers intact.

Keeping Your Photoshop Layers Intact

Step One:

If you have an image with multiple layers (like we did in the previous project), and you save and close the document without flattening it, in Lightroom, you'll just see a flattened version of the image, but the layers are actually still there (you just can't see them because Lightroom doesn't have a layers feature). If you want to see the layers, or work with them, you have to go back to Photoshop. *However*, to do that, when you click on the layered image in Lightroom and press **Command-E (PC: Ctrl-E)** to open it in Photoshop, when the dialog appears asking you if you want to edit a copy with your Lightroom changes, you must choose Edit Original (as seen here).

Step Two:

When you choose Edit Original (and by the way, this is the *only* time we ever choose Edit Original in the Edit Photo with Adobe Photoshop dialog), when the image opens in Photoshop, all the layers are back. If you don't choose Edit Original in that dialog, it sends Photoshop a flattened version of the image. So, if you open a file you know has layers, but you don't see them in Photoshop, you know you chose the wrong option in that dialog.

Adding Photoshop Automation to Your Lightroom Workflow

If there's a "finishing move" you like to do in Photoshop (after you're done tweaking the image in Lightroom), you can add some automation to the process, so once your photos are exported, Photoshop launches, applies your move, and then resaves the file. It's based on you creating an action in Photoshop (an action is a recording of something you've done in Photoshop, and once you've recorded it, Photoshop can repeat that process as many times as you'd like, really, really, fast). Here's how to create an action, and then hook that directly into Lightroom:

Step One:
We start this process in Photoshop, so go ahead and press **Command-E (PC: Ctrl-E)** to open an image in Photoshop (don't forget, you can follow along with the same photo I'm using here, if you like, by downloading it from the site I gave you back in the book's introduction). What we're going to do here is create a Photoshop action that adds a nice, simple matte border around the image, then a simple black frame around the outside, and then it puts your nameplate under the image (it looks better than it sounds). Once we create this action, you'll be able apply a frame with a matte around your image automatically when you export your final image as a JPEG (or TIFF or whatever) from Lightroom.

Step Two:
To create an action, go under the Window menu and choose **Actions** to make the Actions panel visible. Click on the Create New Action icon at the bottom of the panel (it looks just like the Create a New Layer icon in the Layers panel and is circled here), which brings up the New Action dialog (shown here). Go ahead and give your action a name (I named mine "Add Frame") and click the Record button (notice the button doesn't say OK or Save, it says Record, because it's now recording your steps).

Step Three:

We're going to need to get this photo off the Background layer and put it on its own separate layer. To do that, press **Command-A (PC: Ctrl-A)** to put a selection around the entire image (as seen here), then press **Command-Shift-J (PC: Ctrl-Shift-J)** to "cut" the image off the Background layer and put it on its own layer (as seen in the Layers panel here—you can see the image is now on Layer 1 and the Background layer is empty).

Step Four:

Now we're going to add some white space around the image by going under the Image menu and choosing **Canvas Size** (or you can use the shortcut **Command-Option-C [PC: Ctrl-Alt-C]**). When the Canvas Size dialog appears, at the bottom, choose **White** from the Canvas Extension Color pop-up menu, then turn on the Relative checkbox in the middle (that lets us specify how much space we want to add, without having to do any math, by adding it to the current dimensions). For the Width, add 4 inches, and for the Height, add 6 inches, so we'll add more space below the image than on the sides. Click OK to add this space. Now press **V** to switch to the Move tool, and click-and-drag your image up a bit on the canvas (press-and-hold the Shift key to keep it centered), so it's about an inch or so higher than center (as shown here). That leaves us room to add our nameplate in just a minute.

Continued

Step Five:

We need to get the selection back around our image, so go to the Layers panel, press-and-hold the Command (PC: Ctrl) key, and click directly on the layer thumbnail for Layer 1 (your Paris image, in this case), which puts a section around the image. You're going to make that selection around 1/2" larger all the way around your image (this is what we're going to use to create our matte), so go under the Select menu and choose **Transform Selection** to switch your selection into a transformation border. Now, click-and-drag the center handles on each side out about 1/2" from the image (as shown here). It should be about equal distance on all sides (you could technically measure out the sides by making the Rulers visible by pressing **Command-R [PC: Ctrl-R]**, but I honestly just "eye" it). When it looks like what you see here, press **Return (PC: Enter)** to lock in the selection's resizing.

Step Six:

We're going to fill this selected area with white, but we need this matte to appear below our image (not covering it), so click on the Create a New Layer icon at the bottom of the Layers panel (it's the second icon from the right). When this new blank layer appears in the Layers panel, click-and-drag it below your Paris image layer. Your selection will still be in place, so press **D**, then **X**, to set your Foreground color to white, then press **Option-Delete (PC: Alt-Backspace)** to fill your matte selection with white. Deselect by pressing **Command-D (PC: Ctrl-D)**. To create the matte effect, at the bottom of the Layers panel, click on the Add a Layer Style (fx) icon, and choose **Inner Glow** to bring up the Inner Glow options in the Layer Style dialog (seen here). Set your Blend Mode to **Normal**, your Opacity to 26%, and then click on the color swatch and choose black as your glow color. Next, set your Size to 19 pixels, click OK, and it adds a thin shadow inside your white box, which looks like a cut matte.

Step Seven:

Now that our matte is done, we're going to add a thin, black frame border around the outside of the image area. In the Layers panel, click on the Background layer and press Command-A (PC: Ctrl-A) to put a selection around the entire Background layer (as seen here). We'll need to add another blank layer, so click on the Create a New Layer icon at the bottom of the Layers panel to add this new layer directly above the Background layer (as seen here in the Layers panel).

Step Eight:

To add a stroke around the outside of the image, go under the Edit menu and choose **Stroke** to bring up the Stroke dialog (seen here). We want the stroke to appear inside that selected area, so choose Inside for Location, enter 100px for the Width (it's a high-res image, so it won't be nearly as thick as it sounds), then make sure your Color is set to black, and click OK, and it adds a thin black frame to the outside of your image (as seen here). Press Commad-D (PC: Ctrl-D) to Deselect.

Continued

Step Nine:

Now let's add that nameplate below our image. Get the Horizontal Type tool **(T)**, click below your image, and type in your name or the name of your studio. In our example here, I typed in my name, and then I added a "pipe" (a vertical separator line) by pressing **Shift-Backslash**, then "Photography." I typed this nameplate in all caps using the font Gil Sans Light at 24 points. It still needs to be centered, and we need to lower the opacity a bit, so it's gray instead of black and doesn't compete with the image, but that's what Step 10 is for.

Step 10:

To center your text under the image, click on the Move tool in the Toolbar, then in the Layers panel, Command-click (PC: Ctrl-click) on the Background layer, so both the text layer and Background layer are selected. Now, to center your text, go up to the Options Bar and click the Align Horizontal Centers button (shown circled here in red). Then, click on the Type layer in the Layers panel, and in the top-right corner of the panel, lower the Opacity of this layer to 50%, which gives it a gray color, rather than black, and helps it to recede. Now, let's save and close the file by pressing **Command-S (PC: Ctrl-S)**, and then **Command-W (PC: Ctrl-W)**.

Step 11:

You may have forgotten by now, but we've been recording this process the whole time (remember that action we created a while back? Well, it has been recording our steps all along). So, go back to the Actions panel and click on the Stop icon at the bottom of the panel (as shown here). What you've recorded is an action that will apply the effect, then save the file, and then close that file. Now, I generally like to test my action at this point to make sure I recorded it correctly, so head back to Lightroom, click on a different photo, press Command-E (PC: Ctrl-E) to bring that photo over to Photoshop, then in the Actions panel, click on the Add Frame action and click the Play icon at the bottom of the panel. It should apply the effect very, very quickly, then it will save and close the document and send it back to Lightroom. If it looks good, we can move on to the final step.

Step 12:

We're now going to turn that action into what's called a "droplet," and we can use this droplet inside of Lightroom. When you drop an image onto a droplet, it automatically launches Photoshop, opens that photo, and runs the action you turned into a droplet (in our case, it would automatically run the frame action). Then it saves and closes the photo automatically, because you recorded those two steps as part of the action. Pretty sweet. So, to make a droplet, go under Photoshop's File menu, under Automate, and choose **Create Droplet** (as shown here).

Continued

Step 13:

This brings up the Create Droplet dialog (shown here). At the top left of the dialog, click the Choose button, choose your desktop as the destination for saving your droplet, and then name your droplet "Add Frame." Now, in the Play section of this dialog, make sure to choose **Add Frame** (that's what we named our action earlier) from the Action pop-up menu (as seen here). That's it—you can ignore the rest of the dialog, and just click OK in the top-right corner. If you look on your computer's desktop, you'll see an icon that is a large arrow, and the arrow is aiming at the name of the droplet (as seen here at the bottom).

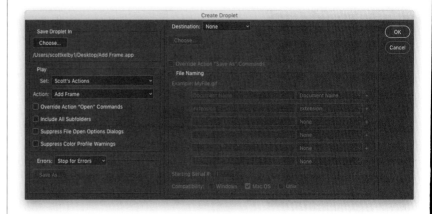

Step 14:

Now that we've built our Add Frame droplet in Photoshop, we're going to add that droplet to our Lightroom workflow using a feature called "Export Actions," which are things that happen after you export an image. To become an Export Action, you have to place this droplet in the folder where Lightroom stores its Export Actions. Luckily, Lightroom can bring this folder right to you. Go back to Lightroom, and under the File menu, choose **Export**. When the Export dialog appears, go down to the Post-Processing section, and from the After Export pop-up menu, choose **Go to Export Actions Folder Now** (as shown here). This brings up the folder on your computer where Lightroom stores Export Actions (shown at the top). All you have to do is drag that droplet you saved earlier on your desktop into this folder, and then simply close the folder—it's now an Export Action in Lightroom.

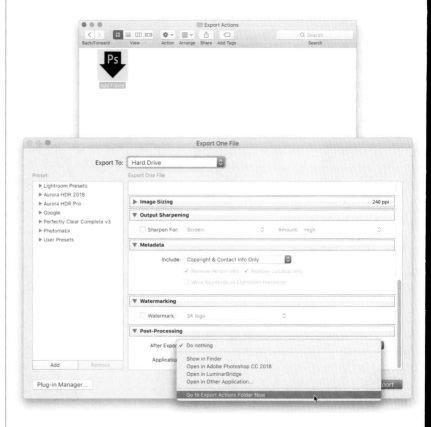

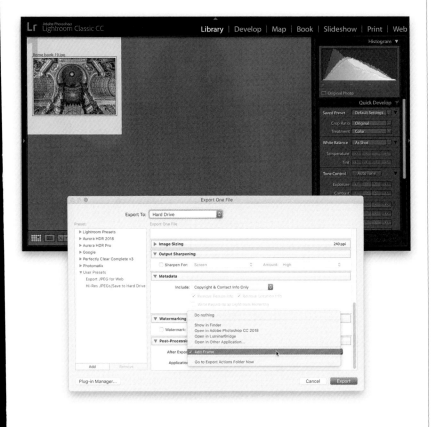

Step 15:

Okay, let's put it to work: In Lightroom's Grid view, select the photo (or photos) you want to have that effect applied to, then press **Command-Shift-E (PC: Ctrl-Shift-E)** to bring back the Export dialog. In the Preset section on the left, click on the right-facing triangle to the left of User Presets, and then click on the Export JPEG for Web preset we created in Chapter 9 (if you didn't create that one, go ahead and do it now). In the Export Location section, click on the Choose button and select the destination folder for your saved JPEG(s) (if you want to change it). Then, in the File Naming section, you can give your photo(s) a new name (if you'd like). Now, in the Post-Processing section at the bottom, from the After Export pop-up menu, you'll see **Add Frame** (your droplet) has been added as a choice, so choose it (as shown here).

Step 16:

When you click Export, your photo(s) will be saved as a JPEG, then Photoshop will automatically launch, open your photo(s), apply your Add Frame action, then save and close the photo(s). Pretty slick stuff! Here's that image we just selected in Light-room after having Photoshop run the Add Frame action when we exported it. I love it when a plan comes together.

PHOTO BOOKS
creating beautiful books with your images

It's pretty amazing that today, using Lightroom's Book module, anyone can make a beautiful, hardcover coffee table book, complete with a fancy glossy dust jacket like you see at the bookstore. You don't need the permission of a publisher, or the approval of a bunch of snooty editors. That's right—you are in total control and can have a glorious coffee table book of your own sitting on your coffee table in about four days, and at the same time, have it available for sale in Blurb's online bookstore. So, when other photographers see your coffee table book, and coyly ask, "So, do you sell these? Can people buy them?" Of course, they stand there smirking as they're expecting you to say, "Well, not really," but instead you'll chuckle and say, "Why of course they're for sale," as you casually whip out a card and hand them the pre-printed web address where they can buy your book, as you coyly remark, "They're quite expensive, but I can get you a discount code if you need one." Then, you just pause, not saying anything, just smiling and letting it hang there in the air for a moment, marinating slowly, as their smirk vanishes and is replaced with a look of shame and jealousy, as though a crashing wave of disgrace has washed over them, leaving the unmistakable stench of a loser so strong not even Irish Spring body wash can remove it. Yes, this is the moment you've been waiting for—a chance to even the score with that aloof ex-vice president of your local camera club—and it would all be so perfect if it were not for the fact that nobody will actually see your coffee table book, let alone your coffee table, because people no longer visit people's homes because they're all at home on Facebook, viewing your images 3" wide on the non-color calibrated screen of a factory reconditioned Samsung Galaxy Tab S2 tablet. Sigh. This sounded so much better in my head.

Before You Make Your First Book

Here are just a couple of quick things you'll want to know before you actually build your first book, including what kind of books, sizes, and covers are available through Adobe's partner in book building, Blurb (www.blurb.com):

Step One:

When you jump over to the Book module (up in the taskbar, or just press **Command-Option-4 [PC: Ctrl-Alt-4]**), a Book menu appears up top, and if you go under that menu, at the bottom of it, you'll find **Book Preferences**. Go ahead and choose that before we get rollin' here. Okay, let's start at the top: Just like in the Print, Slideshow, or Web modules, in the Book module, you get to choose whether the default setting for your frames is Zoom to Fill or Zoom to Fit (I leave it set at Zoom to Fill, simply because it usually looks better, but you can choose whichever you like best).

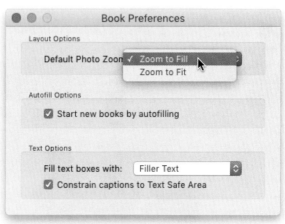

Step Two:

When we build our book project together (after these two pages), you'll have the option of having Lightroom automatically fill all the pages of your book with the photos you've chosen to be in the book (so you don't have to drag-and-drop them into the book one by one). With this preference turned on, as soon as you go to the Book module, it flows your Filmstrip photos into the photo frames on each page and—boom—you've got a book (of course, you can rearrange any pages or swap out photos after the fact, but it's a good starting place).

Step Three:

In the final section, there's a preference to help you visually see where you can add text. Some of the layouts have areas where you can put text, and it's easy to see in the thumbnail, but once you apply it to your actual page, unless there's some text already in place (Filler Text), then you wouldn't know there was a text box there at all. So, choosing Filler Text acts as a reminder (but don't worry—it's just for looks. It doesn't actually print until you erase it and start typing your own text, so you don't have to worry about it showing up in your final book—just like you don't have to worry about guides printing in your final book). Besides Filler Text, if you actually added captions or titles (in the Metadata panel fields in the Library module), you can choose to have Lightroom pull that text instead (which will definitely save you some time). Lastly, Constrain Captions to Text Safe Area just means it will keep your captions from extending into areas where it might get cut off, or extend into the page gutter between pages.

Step Four:

Before you turn the page and we start building a book together, I thought I'd show you the different sizes and types of books you can order directly from Lightroom through Blurb (an online photo book lab that's very popular with photographers, and Adobe's printing partner for Lightroom):

There are five different sizes: Small Square 7x7", Standard Portrait (tall) 8x10", Standard Landscape (wide) 10x8", Large Landscape 13x11", and Large Square 12x12". There are three different cover choices for each: a Softcover, a Hardcover Image Wrap (shown here, on the left and right), and a Hardcover Dust Jacket (you get to choose the inside flap covers and text if you want it, too!). Okay, let's build our book.

Making Your First Book In Just 10 Minutes

This is kind of my quick start guide on how to build a photo book from scratch. It'll take you more time to pick which photos you think you might want in the book than it will to actually make the book (10 minutes, tops). The rest of the chapter will dig in to individual topics, like adding captions, creating custom layouts, etc., but for now, let's just build a book the fast and easy way. When you see how quick (and fun) this is, you'll be making books from here on out.

Step One:
The first step is pretty simple: make a new collection with the finished photos you think you might want to put in your book. It's okay if there are photos in there that don't wind up in the book, and they don't have to be in order at this point—you just need to start somewhere. So, I always start by creating this collection of final images for my book (here, I created a "Morocco for Photo Book" collection inside my Morocco collection set).

Step Two:
Go to the Book module, and thanks to those Preference settings you selected (on the previous two pages), when you jump to the Book module it automatically takes the images in this collection and puts them on the pages of your book, in the order they appear in the collection. Don't sweat it—we can change the order anytime. In fact, we'll be doing that shortly, but this gives you a starting place. Since you won't be doing anything else in the left side Panels area, close it, so you have more room to work with your pages. Now, the default layout puts one photo on the right page and leaves the left blank, but if you want to put one photo on each page (like I have here), then go down to the Auto Layout panel in the right side Panels area, click on the Clear Layout button, then choose **One Photo Per Page** from the Preset menu. Click the Auto Layout button, and it will automatically fill both pages now.

Step Three:

Before you do anything else, you'll need to go up to the Book Settings panel and choose the book's Size (if you change this later, it kind of messes up your layouts). If this is your first book, I recommend going with a 10x8" (or 8x10"), just to keep the cost down. Once you have this process down, then you might want to splurge on a coffee-table-sized book, like the Large Landscape or Large Square. Most of the books I build are the 10x8" Standard Landscape—they cost less and research has shown that people prefer viewing printed photo books at this "magazine" size. Next, choose your Cover style. The vast majority of books I print are softcover—they're perfect bound, so they have a nice look, and they're the least expensive. If you go with either Hardcover Image Wrap (your image wraps around the front and back hardcover) or Hardcover Dust Jacket (a separately printed glossy wrap goes over your hardcover image wrap), they'll cost more. Lastly, choose your Paper Type. I generally go with Standard or Premium Lustre for everyday books (and for gifts). I only upgrade to their ProLine Pearl Photo (which is really nice paper) when I am doing a large, hardcover coffee-table-sized book (because of the extra cost).

Step Four:

Now, before you start customizing the order and layout of your pages, you'll need to know how to get to the different views for your book. There are three, and you choose them by clicking on the little buttons on the left side of the toolbar, right below the Preview area. For example, click on the second button (shown circled here in red) to zoom in to this two-page spread view (or press **Command-R [PC: Ctrl-R]**; you'll use this view a lot). Click on the first button to see your entire book layout (or press **Command-E [PC: Ctrl-E]**). The third button is a single-page view, but you'll really only use that for spell-checking and proofing your text.

Continued

Step Five:

Okay, the boring stuff is out of the way, so now comes the fun part: laying out your book. Like I mentioned in Step Two, Lightroom will automatically fill the pages of your book with your images, but the order and layout of each individual page is totally up to you from this point on. In our spread, here, both pages have images filling the pages, but if you want to change one of the pages to a different layout, click on the page you want to edit (a yellow border will appear around it letting you know it's selected), then click the little down-facing arrow in the bottom-right corner, and a pop-up menu of pre-designed book page layouts appears (as seen here). Here, I clicked on 1 Photo layouts, and in the scrolling list of thumbnails at the bottom, I clicked on the thumbnail that puts a white border around the image, and it immediately applied it to that page (also seen here). That's all there is to it—if you see a thumbnail layout that looks good to you, click on it.

Step Six:

The default layout that Lightroom gives you puts one photo on each page, but if you want to put multiple photos on a page, you can choose from loads of templates with two, three, or four photos, or from templates with pre-designed multi-photo layouts. In this case, I clicked on 2 Photos (as seen here) to see the thumbnail list of two-photo layouts. I then clicked on a layout with two tall, side-by-side images and that thumbnail was applied. Of course, you have to choose another photo to add to this two-photo layout, so for now it just displays a tall, empty, gray box (these are called photo "cells"). *Note:* If a layout is designed with text blocks, you'll see lines that represent where the text block will appear (but, you don't have to add text if you don't want, even if the thumbnail has an area to add text).

Step Seven:

From this point on, it's a "drag-and-drop" world, which makes the rest of this process really easy. To add another photo to this two-photo layout, just make the Filmstrip visible along the bottom, click on a thumbnail, and drag-and-drop it right into that second tall, gray box, and that image now appears in that cell (as seen here). If you wanted to swap the left and right photos, again, it's just a drag-and-drop—click on the left photo and drag it over to the right photo cell, let go, and they swap. *Note:* Take a look back at the tall image on the left in Step Six. Notice how it's kind of off-center in the frame? You can reposition your image within any photo cell by simply clicking-and-dragging it left or right (as I did here where I centered the image). Also, when you click on an image, a Zoom slider appears above it, so you can zoom in/out (if you zoom in too tight, you may not have enough resolution to print the image, and if that happens, you'll see a warning in the upper-right of the photo).

TIP: Adding More Pages

You can always add more pages to your photo book by going to the Page panel (in the right side Panels area) and clicking the Add Page button.

Step Eight:

Now, it's not just dragging-and-dropping within the same page. Like I said, it's a drag-and-drop world at this point. Click-and-drag the image on the left page over onto the tall right photo cell, and the two swap (notice the image that was on the far left is now over on the right page, on the right side—they've swapped).

TIP: Removing a Photo

To remove a photo from a cell, click on it and hit the **Delete (PC: Backspace) key**. It doesn't delete it from your collection, so you can still find it down in your Filmstrip and drop it onto another a page.

Continued

Step Nine:

One of my favorite layouts is a two-page spread, and I include a decent amount of them in every book I create for two reasons: (1) they have a big impact in the book, stretching across both pages like that; and (2) it seems like almost any photo looks great as a two-page spread.

Note: By default, every spread has two pages, right? Well, when you choose one photo to stretch across two pages, that extra photo doesn't just disappear—a new page is created. If you apply a two-page spread to an image on a right page, it adds a new blank page where it used to be, and a new two-page spread is created with your image. You'll have to choose a new image to fill the blank page. If you apply a two-page spread to an image on a left page, it adds a new page to make the two-page spread, and then it takes the page on the right and it moves it to the next page in your book, so now the rest of your layouts are off by one page. Your choices now are: (a) click on the page after your two-page spread, add another page, and drop in another photo, or (b) delete the page that used to be your right page, and that fixes the problem. Your call.

Step 10:

Besides dragging-and-dropping images, you can also drag-and-drop individual pages. Just click on a page to select it, then drag-and-drop it where you want it— even if it breaks up a spread (as I'm doing here, where I dragged the left page in the bottom-left corner and split the two pages in the row above it. The thin yellow line shows where this page will appear when you release the mouse button). You can swap left and right pages the same way. Lastly, if you want to move a full spread, click on the left page to select it, then Command-click (PC: Ctrl-click) on the right page to select them both (as seen here, at the bottom) and drag them where you want them to appear in your book.

Step 11:

Once you have your layouts all in place, your front and back covers designed (see page 339), and the pages in the order you want them (and you've checked any text for typos—there's nothing more embarrassing than receiving your printed book and finding a horrendous typo. I know a guy this happened to and he was crushed. Okay, it was me. I was crushed. Learn from my mistake. See what I did there?). Anyway, once everything looks good to you, click the Send Book to Blurb button at the bottom of the right side Panels area (shown circled here in red). You don't have to worry about resolution issues (outside of what I mentioned in Step Seven), or color space issues, or any of that stuff—Lightroom takes care of all of that, packs it up, and gets it ready for upload to Blurb.

Step 12:

When you click that Send Book to Blurb button, it brings up the Purchase Book dialog you see here. Near the top it shows the specs of your book (including style, paper, number of pages, and price). Below that are fields for the book's title, subtitle, and author (this is helpful since you'll have the opportunity to sell this book publicly on Blurb's website, should you decide to make it available for purchase). If you don't have a Blurb account, you'll be asked to create one (they need your payment info, where to ship the book, etc.), so you'll do that next, and once you're finished, Lightroom compiles everything, uploads it (it doesn't take as long as you'd think), and then in a few days, your book arrives, followed by a reasonable amount of oohing and aahing. That's the process—it's surprisingly straightforward. If you want to dig in more to some of the details, well…that's what the rest of this chapter is all about.

Using Auto Layout to Automate Your Layout Process

In my quick start project, when we switched to the Book module, Lightroom took the images in our collection and arranged them on pages for us, right? That feature is called Auto Layout, but the default layouts are pretty simplistic—one photo, edge-to-edge, on every page, or every right page. Snooze. That's what you'd expect to get doing a photo book at Walgreens. Luckily, we can create and save our own auto layouts, to our specs, which makes a much more interesting-looking book in just one click.

Step One:

If you already have a layout in place, let's go ahead and start from scratch, so we can use the Auto Layout feature. In the Book module, go to the Auto Layout panel, near the top of the right side Panels area, and click the Clear Layout button (as shown here, at the top). There are a set of default presets, and if you click-and-hold on the Preset pop-up menu, you'll see 'em. But, we already know they're pretty lame, so instead, choose **Edit Auto Layout Preset** (as shown here), so we can create our own presets using our own settings.

Step Two:

When you choose that, the Auto Layout Preset Editor appears (seen here). It's split into two parts: the Left Pages and the Right Pages. On the left side, the pop-up menu is set to Same as Right Side or Blank (depending on which preset was originally chosen in the pop-up menu), so whatever you choose for your right side pages (on the right side of the dialog), the same will happen for the left side pages, or they will just be blank. Instead, choose **Fixed Layout** from that pop-up menu. That way, we can choose what appears on our left and right pages separately.

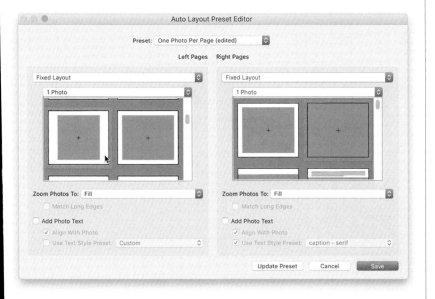

Step Three:
Let's set up a preset to make the left page images square and the right page images full page. Here's what you do: In the Left Pages section, after choosing Fixed Layout from the pop-up menu at the top, choose **1 Photo** from the pop-up menu below that. Now, scroll down to the square image page layout and click on it (as shown here), then just leave the right side at Fixed Layout, with one, full-page photo.

TIP: Hide Info Overlay
By default, info about your book appears in the top left of the Preview area (size, page count, and price). If you'd rather not see this information (it's pretty distracting), then just go under the View menu and choose **Show Info Overlay** (or press the **I** key) to turn it off.

Zoom Photos To: Fit

Zoom Photos To: Fill

Step Four:
There's another option you need to know about with these custom layout presets: you get to choose how your image appears, once you click-and-drag it into place, using the Zoom Photos To pop-up menus below the layout thumbnails. If you choose Fit, it scales your image down to fit inside the frame. So, if you choose Fit with a square layout like we chose, the image will fit fully inside the square (like the image shown here on the top left), but because it fits fully inside that square cell, your photo won't actually appear square. For that to happen, you'd have to choose Fill (like you see here, on the top right, and what I have selected in the previous step). Luckily, you can always change this after the fact, on a per-page basis, by Right-clicking on a photo and choosing **Zoom Photo To Fill Cell** from the pop-up menu to turn it on or off (as shown here at the bottom).

Right-click on a page to apply Zoom Photo To Fill Cell anytime

Continued

Step Five:

Some other options you can choose from are, for example, if you know you're going to want to add some text to your pages, turn on the Add Photo Text checkbox, and your pages will be ready for you to add text by just clicking in the text field on a page and typing. You can also choose a Text Style preset for things like captions and stuff. Of course, you could just choose a layout that has a text area already built-in, but this is at least another option if you want to use a layout that doesn't already have text. For now, though, let's choose a more interesting left page than just that large square, so from the second pop-up menu, choose **2 Photos**, then scroll down and click on the two horizontal images layout seen here, then choose **Fill** from the Zoom Photos To pop-up menu.

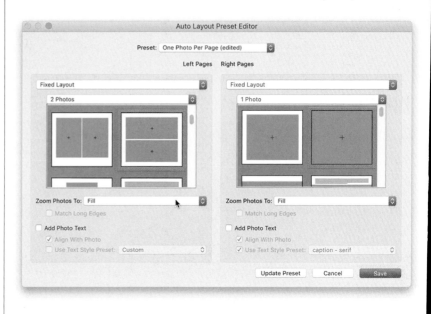

Step Six:

Okay, now lets save this layout (two horizontal photos on the left page and one full-bleed photo on the right) by choosing **Save Current Settings as New Preset** from the Preset pop-up menu up top. This will bring up the New Preset dialog (seen below). I name my presets with a descriptive name, calling out what I chose on the left page and the right page (as seen). Now, click the Create button, then Done, and let's give it a try.

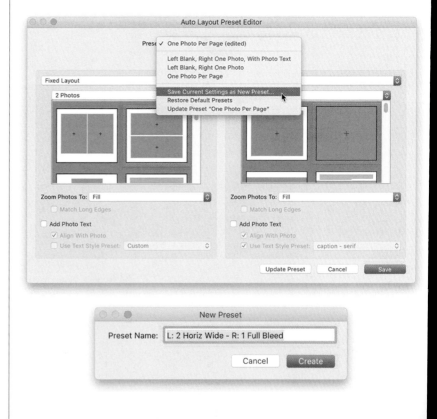

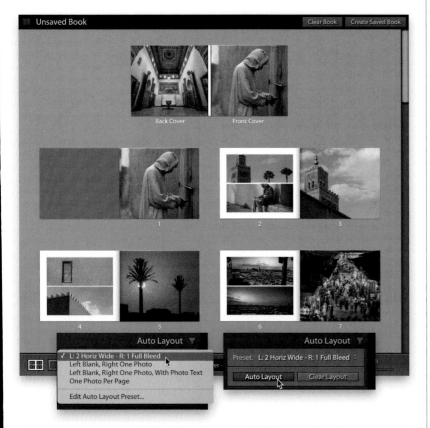

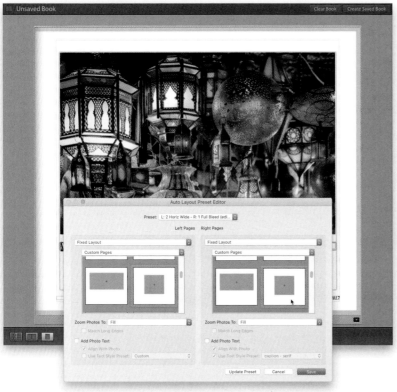

Step Seven:

Go back to the Auto Layout panel, click the Clear Layout button (if you already have a layout in place), and then from the Preset pop-up menu, choose the preset you just created (as shown in the inset below on the left). Now, click the Auto Layout button (shown in the inset below on the right) and it fills those blank pages with the images in your collection, using the preset you created (as seen here). Of course, this is just our starting place—now you can edit any page you'd like by clicking on it, then clicking the black arrow in the bottom-right corner and choosing a different layout. *Note:* Have you noticed that it takes your first photo and makes it the front cover, but then it also puts that same image as the first page (as seen here)? That really gets on my nerves. Not much you can do, except replace it with a different photo, which is what I do, but it still kinda frosts my Wheaties that we have to do that.

Step Eight:

I think the real power of Auto Layout is shown when you've created your own custom pages (see page 326) because you can then create auto layouts with pages you've designed, rather than the ones that come with Lightroom. When you make your presets, you can choose **Custom Pages** from the second pop-up menu (under Fixed Layout), and you'll see thumbnails for all the custom pages you've created, and you can choose any one you'd like. Here, I chose the same small, square, custom page for both the left and right and saved it as a preset. Then, I went to the Auto Layout panel, clicked the Clear Layout button to remove that previous layout we applied in Step Seven, and then I chose this L: Sm square – R: Sm square fine art-looking preset. I think this is the real power. Once you make custom pages, it takes things up a notch.

Making Your Own Custom Pages

As far as book page designs go, we have the pre-designed pages that come with Lightroom, and we can mark the ones we use the most as favorites, so we can get to them easily without digging through tons of thumbnails. But, beyond that, we can also create our own custom pages—pages with our own specs (well, within certain limits)—and have them easily available when we want 'em.

Step One:
To make this easy, start by double-clicking on a book page, then clicking on the little down-facing arrow in the bottom-right corner of the page, and then choosing the 1 Photo full bleed layout (as shown here). This will be what we edit to create our custom page. *Note:* We can only create custom single-photo pages. Sadly, we can't do this with two-, three-, or four-image pages.

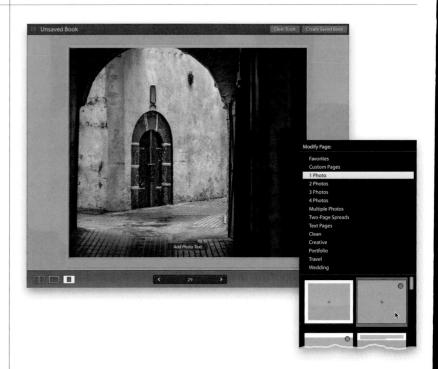

Step Two:
Move your cursor down to the bottom-right corner of the page, and you'll see it turns into a black bar with a two-headed arrow. Click-and-drag diagonally inward on that corner, and the image will scale proportionally (as shown here). If all you're looking for is a smaller-sized image, like what you see here, or even smaller (remember, it scales proportionally), just keep dragging until the size looks good to you, and then you can save that as a custom page. However, I imagine you want to do a bit more than that (and if you do, keep reading).

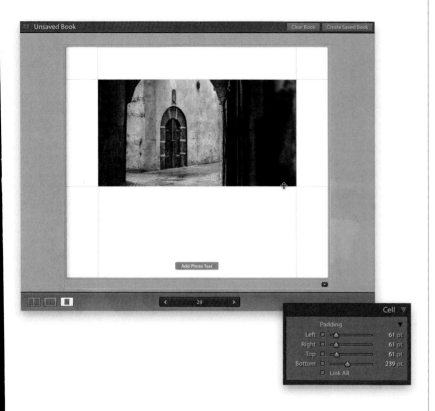

Step Three:

To create pages that aren't proportional, go to the Cell panel in the right side Panels area, and you'll find four Padding sliders that control the amount of white space around your image (they control the size of the cell your image resides within). By default, all four sliders are linked together, so if you drag one of them, they all move, which is why things are always proportional. To unlink these sliders, so you can move them independent of each other, turn off the Link All checkbox (as seen here). Now, you can drag each slider independently (if you want things to be really precise), but now that they're unlinked, I just click on the sides, top, or bottom of the image and drag. Here, I'm dragging upward from the bottom, and only the bottom is moving, so it creates a panorama layout, and any photo I drop onto this page now will instantly look like a pano. I use this one a lot in my books.

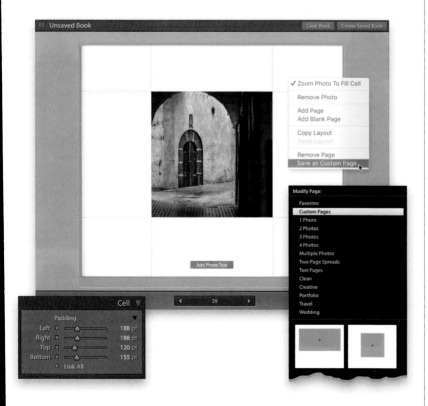

Step Four:

Okay, now that you've got the idea, let's make a small, square custom page, like the one I have here (there's not one nearly this small, or this square in the built-in presets, except for one that has a torn edge border, which I'm not a fan of, but hey, that's just me). Here, I clicked-and-dragged the four sides inward until it made a square, and when I got pretty close to getting it looking perfectly square, that's when I look to the Cell panel to see if my numbers, especially the Left and Right padding, are equal. If not, I just drag their sliders or highlight a field and type in what I think is the right number. When you've got a page looking like you'd like it, Right-click anywhere on the page, and from the pop-up menu that appears, choose **Save as Custom Page** (as shown here). Now this layout can be applied to any page by choosing it from the Modify Page pop-up menu, under Custom Pages (you can see the two custom pages we just created here).

Adding Text and Captions to Your Photo Book

If you've been using Lightroom for a while, you know the text capabilities have been really limited. But, when it came to books, Adobe added their full-featured type engine right into the Book module, so you have a surprising amount of control over how your type looks and where you can put it. Now, if we can only get them to put a copy of the Book module's type feature over into the Slideshow and Print modules (don't get me started).

Step One:

There are two ways to add text to your photo book: (1) Choose a page layout that has a text area already in place, so all you have to do is click in the text box and start typing. Or, (2) you can add a text caption to any page by going to the Text panel (in the right side Panels area) and turning on the Photo Text checkbox (as shown here). Now you'll see a yellow horizontal text box appear across the bottom of your image. To add your caption, just click and start typing.

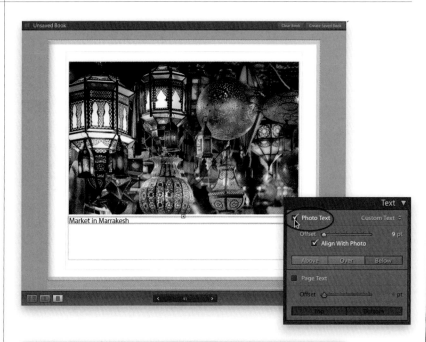

Step Two:

The Align With Photo checkbox keeps your caption aligned with your photo when you add padding to the photo's cell. So, as you shrink your photo within the cell, your caption will shrink within its cell, too. You can tweak exactly how far away your caption is from your photo using the Offset slider—the farther you drag it to the right, the farther away the text moves from your image (as shown here). *Note:* If you want to have Lightroom select a text box for you, go under the Edit menu and choose **Select All Text Cells** (this is handy if you have a page with three photos and three captions, and you want to turn all the captions off—just choose Select All Text Cells and then turn the Photo Text checkbox off to hide them from view).

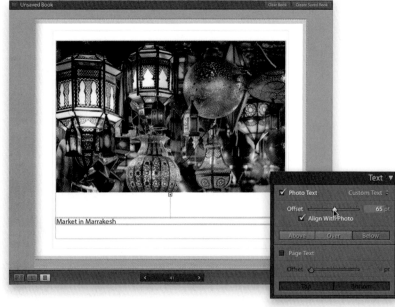

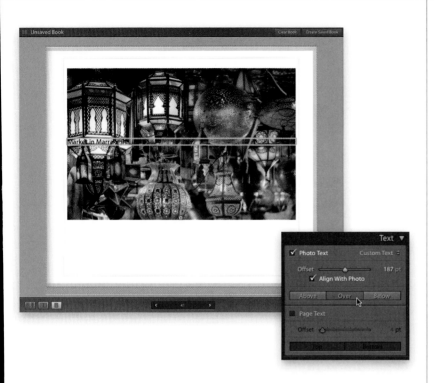

Step Three:
You also have the choice to move your caption above your photo, or to put your caption right over the photo itself (as seen here) using the three buttons below the Offset slider: Above, Over, and Below. Click the Over button and your text box now appears right over the photo, and the Offset slider controls how high your caption appears over it (as you slide it back and forth, you'll see your caption move up and down the photo). *Note:* If you choose to add a caption to a full-page photo layout, the only option you'll have for placement is Over, since there's no white space above or below the photo to fit a caption.

Step Four:
By default, your text is aligned with the left side of your photo, but if you go to the bottom of the next panel down, the Type panel, you'll see alignment buttons—you can choose Align Left, Align Center (as shown here), or Align Right (the fourth choice is Justification, which only comes into play if you're using columns of text). *Note:* If your Type panel doesn't look like this one (you see a lot fewer sliders), then you just need to click on the little black left-facing triangle to the far right of the word "Character" and this expands the panel down to show more options.

Continued

Step Five:

While we're in the Type panel, let's go ahead and highlight our text so we can change the color to white (easier to read over this particular photo) by clicking on the black Character color swatch, and when the Character color picker appears, clicking on the white swatch. Now, click on the Align Left button at the bottom of the Type panel. Look how close the text is to the left edge (it's right on it). If you want to offset that text (scoot it out a little from the edge), there isn't a slider for that. Instead, click off the photo (in that white area around it), then hover your cursor over the left end of the text box and it will change to a two-headed arrow. Now you can click-and-drag your text over to the right a bit (as shown here). *Note:* I have to warn you that getting this two-headed arrow cursor to actually appear may take a few tries. It's, shall we say, "finicky." You can also use it to drag the text box up/down by moving it over the top/bottom of the text box. Again, finicky though.

Step Six:

All the other standard controls that you'd expect for working with type are here (like Size, Opacity, and Leading [the space between two lines of text]), but there are also some more advanced type controls that I didn't expect (like Tracking [the space between all the letters in a word], Kerning [the space between two individual letters], and Baseline [shifting a letter or number above or below the line the text sits on—helpful for writing things like H_2O]). And, of course, you can choose your Font and Style (bold, italic, and so on) from the menus near the top. But, at the top is a very handy thing— Text Style presets, which are already set up using popular fonts and styles. So, if you're working on a travel book and choose Caption – Serif, you get a font style that's appropriate for travel photo books. A nice time saver.

Step Seven:

While we're talking presets: if you tweak your text and like it, you can save the settings as a preset (choose **Save Current Settings as New Preset** from the Text Style Preset pop-up menu). That way, the next time you don't have to start from scratch. If you'd like to add another line of text (besides your caption), go back to the Text panel and turn on Page Text (as shown here). This adds another line of text, lower down the page (you can control how far below the photo it appears using the Offset slider, just like the Photo Text). Of course, you can use the Type panel to choose your font, alignment, and all that stuff just like usual, but remember to high-light your text first.

Step Eight:

If you'd like a more visual approach to your type tweaks (rather than dragging sliders or choosing numbers), then click on the Targeted Adjustment tool (TAT, for short—it's circled in red here). Now you can click-and-drag on your highlighted text to change the Size or Leading. Just move your cursor directly over your text, and click-and-drag up/down to control the space between two lines of text (Leading) or drag left/right to control the Size of your type (that's what I'm doing here). Honestly, I don't find myself using the TAT for Type tasks—it seems easier and faster to just move the sliders, but hey, that's just me. So, that's the scoop on adding captions and text to your photo book. *Note:* If you chose a layout where you can add a lot of text, you can split that text into multiple columns using the Columns slider at the bottom of the Type panel. The Gutter slider controls the amount of space between your columns—dragging to the right increases the amount of space between them.

Adding and Customizing Page Numbers

Another nice Book module feature in Lightroom is automatic page numbering. You have the ability to control the position, the formatting (font, size, etc.), and even which page the numbering starts on (along with how to hide the page numbers on blank pages if you want).

Step One:
To turn on page numbering, go to the Page panel and turn on the Page Numbers checkbox (shown circled here in red). By default, it places page numbers in the bottom-left corner of left pages and the bottom-right of right pages.

Step Two:
You can choose where you'd like them to appear using the pop-up menu to the right of the Page Numbers checkbox. The Top and Bottom options center the page number at the top or bottom of the page (respectively; as shown here, where I moved them to the bottom center). Choosing Side places the page number at the outside center of the page and, obviously, choosing Top Corner will move it to the top corner of the page.

Step Three:

Once your numbers are visible, you can format them (choosing a custom font, size, etc.) by highlighting any page number, then going to the Type panel and choosing how you want them to appear (here, I changed the font to Minion Pro and I lowered the Size to 12 pt).

Step Four:

Besides just customizing their look, you can also choose which page the numbering starts on. For example, if the first page of your photo book is blank (so the images or opening story start on a right page), you can have that right page become page 1 by Right-clicking directly on the page number itself on the right page and, from the pop-up menu that appears, choosing **Start Page Number** (as shown here). Lastly, if you have a blank page(s) in your book (maybe all the left pages), and you don't want it to have a printed page number, just Right-click on the number on the blank page, and from the pop-up menu that appear, choose **Hide Page Number**.

Four Things You'll Want to Know About Layout Templates

There are a few things about making books in Lightroom that aren't really obvious, so I thought I'd put them all together here so you don't have to go digging for them. It's all easy stuff, but since Adobe likes to sneak some features in "under the radar," or give them names that only Stephen Hawking could figure out, I thought this might keep you from reaching for a pistol. Ya know, metaphorically speaking. ;-)

#1: The Advantage of Match Long Edges (and How to Do It Manually)

If you create an Auto Layout preset (see page 322) and choose Zoom Photos to Fit, there's a checkbox for Match Long Edges. With that turned off, if you put a wide photo and a tall photo on the same page, the tall photo will be much larger than the wide photo (as shown here, left). If you turn on Match Long Edges, then it balances the size, even though the two photos have different orientations (as shown here, right). If you didn't use Auto Layout, and you still want that balanced look, just hover your cursor over the corner of the tall image and it changes into a two-headed arrow. Click-and-drag inward to visually shrink the photo until it balances the size.

Match Long Edges off looks way out of balance

Match Long Edges on sizes it down to look more balanced

#2: Saving Your Favorite Layouts

If you see a layout you like and want to use again (without having to remember where to find it), you can save it to your Favorites at the top of the Modify Page pop-up menu by hovering your cursor over it, then clicking on the little circle that looks like a Quick Collection marker (as shown here). If you change your mind, go to your Favorites, and click on the now-gray circle to turn it off. Also, once you've set up some favorites, if you create an Auto Layout preset, one of the page choices in the Editor will be Random From Favorites—it pulls the layout from ones you like. You even get to choose how many photos per page it includes (that way, if you only want 1- or 2-photo favorites, it'll only use those). Cool!

#3: Sorting Pages

You sort pages in Multi-Page View by clicking on the page you want to move to select it, then you click directly on the yellow bar at the bottom where the page number is (as shown here, where I've clicked on page 17), and then you just drag-and-drop that page where you want it in your book. If you want to move a two-page spread, click on the first page to select it, Shift-click on the second page to select it, and then click on either page number area to drag-and-drop the spread to a new location. You can even move groups of pages at once (like pages 10 through 15) by Shift-clicking on those pages to select them, then clicking on any one of the selected pages' yellow bar at the bottom, and dragging them where you want them. By the way, you can swap photos from page to page when you're in the Multi-Page View by just clicking-and-dragging them.

#4: The Front & Back Covers Change If You Choose Dust Jacket

If you choose the Hardcover Dust Jacket cover option for your book, you get to add two extra images on the flaps that fold inside the covers to keep your dust jacket in place (as seen here). You'll only see these side flaps appear if you choose the dust jacket option.

#5: I Know, I Said There Were Only Four, But...

There's one more page you might want to consider in your book: Blurb's logo page, which is the last page in the book. If you let them put their logo at the bottom of the last page, they give you a discount on the price of your book. How much? Well, on this book, the regular price was $46.16 without the logo page. If you turn on the option to allow a logo page (in the Book Settings panel), then the price comes down to $38.99 (that's almost a 20% discount for giving them a logo on a page that was going to be blank anyway. Definitely worth considering).

Customizing Your Backgrounds

By default, all your book pages have white backgrounds, but it doesn't have to be that way. Here are four different ways to colorize or customize your page backgrounds:

Step One:

If you want to change the background color of your page, go to the Background panel and turn on the Background Color checkbox. Choose a new color by clicking on the color swatch to bring up the Background Color picker, and click on any of the preset color swatches at the top, or choose any shade from the gradient bar below. To access all colors, click-and-drag the little horizontal bar on the gradient bar on the far right upward to start revealing the colors.

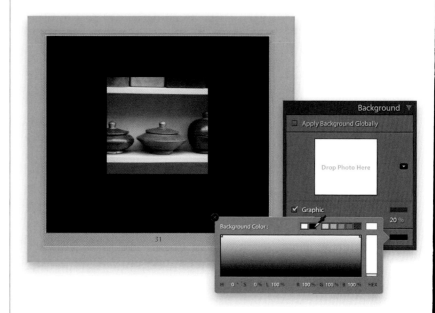

Step Two:

Besides just a solid color for your background, you can also choose from a collection of built-in background graphics, including one for travel with things like maps and page borders, and one for weddings with elegant little page ornaments. To get to these, turn on the Graphic checkbox, then to the right of the square background graphic well in the center of the panel, click the little black button to bring up the Add Background Graphic menu, with a thumbnail list of built-in backgrounds (as seen here). Just click on a category at the top, then scroll down to the graphic you want to use, click on it, and it appears behind your photo (as seen here). You can control how light/dark the graphic is using the Opacity slider and change its color by clicking on the color swatch (more on this in the next step).

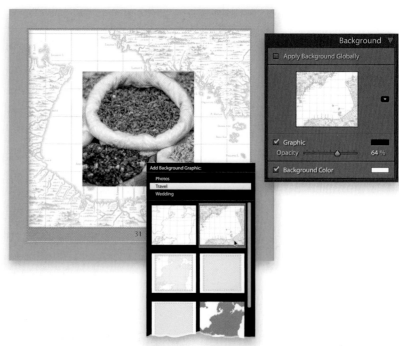

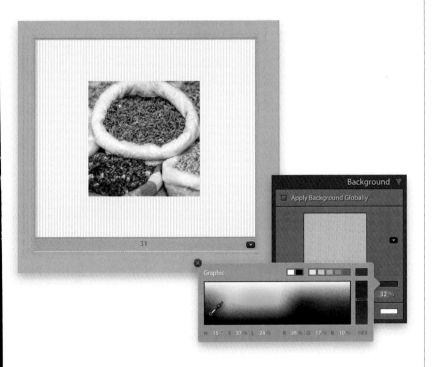

Step Three:

If you want a pattern, rather than a graphic, you can add vertical lines, and better yet, you can choose their color. First, go to the Travel category and choose the lines background from the pop-up menu. Set its Opacity (lightness or darkness), then click on the color swatch to the right of the Graphic checkbox to bring up the Graphic color picker (seen here) and choose any color you'd like for your line pattern (I chose an orange color here, and lowered the Opacity to 32% to make it fade into the background a bit more).

Step Four:

There is one more Background panel option, but before we get to that, look up at the top of the Background panel and you'll find the Apply Background Globally checkbox. Turning this on will repeat your current background throughout the entire book (if that's what you want), and it saves you the time of adding the background manually to every single page (I leave this off, so I can customize my page backgrounds individually). Okay, now on to the last option: using a photo as a background (very popular in wedding albums). In the Filmstrip, find the photo you want to use as a background, drag-and-drop it onto the square background graphic well in the center of the Background panel (as shown here), and that photo becomes your page background. I usually like this background photo to be very light behind my main photo (so it doesn't compete with it), so I lower the Opacity quite a bit—usually to between 10% and 20%. By the way, to remove your background image altogether, Right-click on the background graphic well and choose **Remove Photo**.

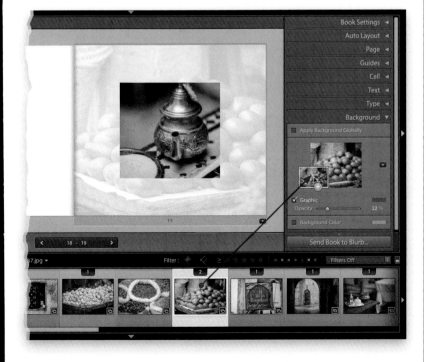

Helping with Layouts and Printing Outside of Blurb

Here are a few more things you'll probably want to know about (well, you actually might not need these at all, but if you do, and you go looking for them, at least they're here, right?):

Page Guides:

If you'd like some visual guides to help you align things, Lightroom's got you covered. You turn on/off these non-printing guides in the Guides panel in the right side Panels area. There are four types of guides: (1) Page Bleed, lets you see the small area on the very outside edge of your page that will be cropped off if you choose to have a photo fill the page. It only crops off around 1/8", so you won't even notice it. (2) The Text Safe Area guide shows the area where you can add text without it getting lost in the gutter between spreads or being too close to the outside edges. (3) The Photo Cells guide is the one that appears when you click on a photo anyway, so I leave that off for sure, and lastly, (4) the Filler Text guide puts dummy text in place for layouts that have text (so you'll see where you can add type).

Saving Your Book as a PDF or JPEG:

You don't have to send your book to Blurb for printing—you can save it as a PDF or JPEG and have it printed wherever you'd like. You choose this in the Book Settings panel at the top of the right side Panels area. From the Book pop-up menu, choose either to print to Blurb, or make a PDF or JPEG (it creates an individual JPEG of each page). If you choose PDF or JPEG, you'll then get to choose the quality of the photos (I set this to 80), the color profile (many photo labs recommend sRGB), the resolution (I set mine to 240 ppi), the sharpening strength, and the type of paper (I use High and Glossy).

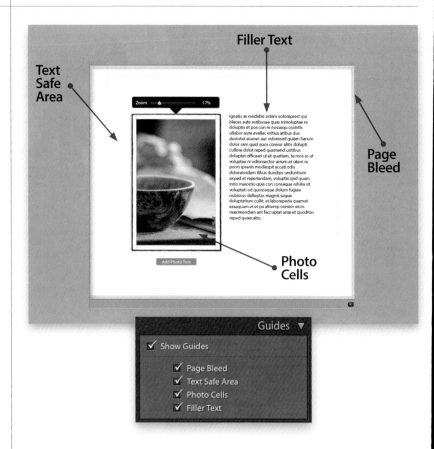

If you want to create your cover text here in Lightroom's Book module, you're in luck, because it's more powerful and flexible than you might think. You can create multiple lines on the cover, different text blocks with different typefaces, and you can even add text to the spine for hardcover wrap layouts.

Creating Cover Text

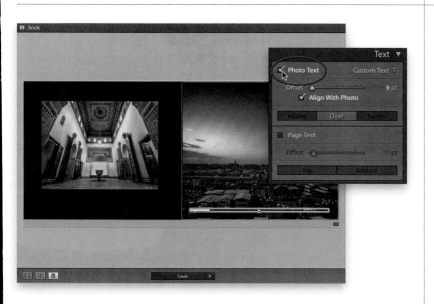

Step One:
Click on the Front Cover page to make it active, and you'll see "Add Photo Text" appear over the bottom center of the image. Click on that and a text block appears at the bottom of your image. Any text you enter in this text block will appear over your image. By the way, if for any reason you don't see the Add Photo Text button, go to the Text panel (in the right side Panels area) and turn on the Photo Text checkbox (as seen circled here) and it will appear. In our case, I typed in "Magical Morocco," but it's hard to see because the default type is small and black (don't worry, we'll change that in a few moments).

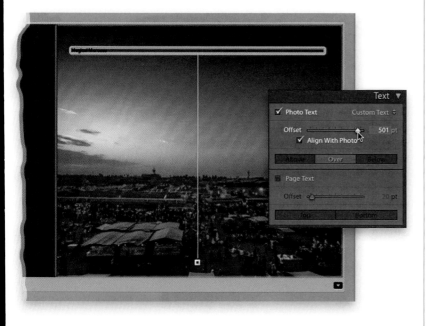

Step Two:
Like I mentioned, by default your text block appears near the bottom of the image, but you can choose how high on the page this text block appears using the Offset slider in the Photo Text section of the Text panel (as shown here). The farther you drag the Offset slider, the farther up that text block moves (as seen here, where I moved it to the top).

Continued

Step Three:

Once you have your text block positioned where you want it, you can control everything from the color of the text to the size, leading (space between two or more lines of type), tracking (the space between all the letters in your text), and even the justification (left, center, right, justified) in the Type panel. This is a pretty darn surprisingly powerful panel, with lots of nice options to make your type look great. We'll start by changing our font and font size. So, click-and-drag over your text to select it, then in the Type panel, choose a font from the first pop-up menu and adjust the Size (I choose P22 Cezanne Pro at 54 points). If you need to change the color of the type, just click on the Character color swatch to bring up the Character color picker and choose a new color there (I changed it to white here).

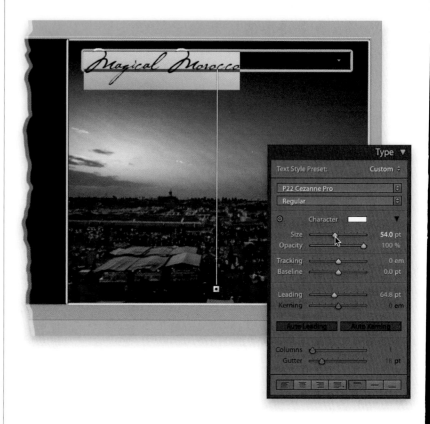

Step Four:

Now, all we have to do is adjust the placement, as needed. Here, I clicked on the Align Center button at the bottom of the panel to move the type in the middle, and then I clicked on the top of the text box and dragged it down a bit.

TIP: Getting a Second Text Block

If you go back to the Text panel and turn on the Page Text checkbox, you can add a second block of text that you can position and style any way you'd like.

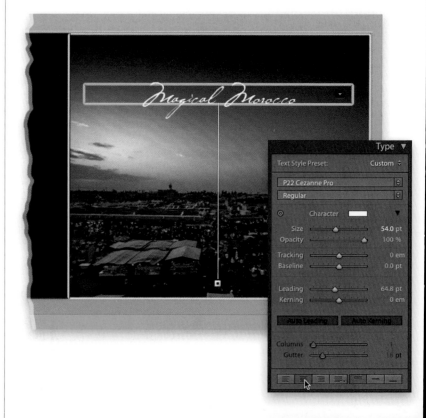

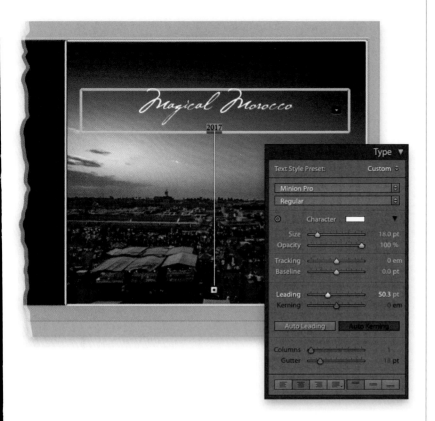

Step Five:

If you want a second line of type in the same text block, just put your cursor after the last letter and hit the Return (PC: Enter) key on your keyboard. The nice thing is this second line can be edited completely separately from the first line, so you can type in your text, select it, then choose a different font (I chose Minion Pro), change the size (I made it 18 points), and you can control the space between the letters using the Tracking slider. I also used the Leading slider to add more space between them (here, I increased it to 50.3). Finally, I clicked on the top of the text box and dragged it down a bit.

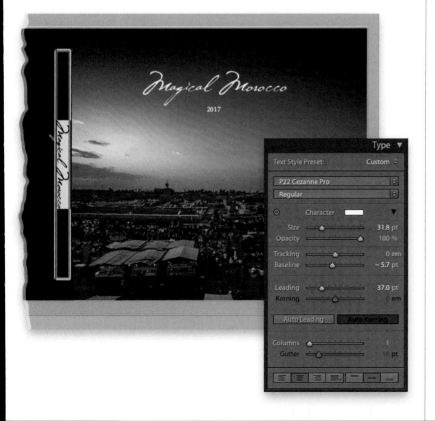

Step Six:

If you're printing a hardcover image wrap book, you also have the option of adding type to the spine. Just move your cursor over the spine (between the front and back cover) and a vertical text block will appear. Click inside it and start typing to add your text sideways down the spine (as seen here). You can edit the font, color, position, etc., just like you would any other text block.

TIP: Choosing a Color for the Spine

Go to the Background panel, turn on the Background Color checkbox, then click on its color swatch and choose a new color. Even better tip: when the Background Color picker appears, click-and-hold your mouse button down anywhere in the picker and, while still holding down the mouse, move the Eyedropper tool out over your cover photo and steal a color.

Custom Template Workaround

If you want a layout for your photo book that is more ambitious than the simple custom page layouts you just learned about, then you can do a pretty slick little workaround (which I learned from Adobe's own Lightroom Evangelist, Julieanne Kost), which is to go to the Print module, design any custom page layout you want (at the same size as your book) with the photos you want, save it as a JPEG file, and import that finished layout into Lightroom as if it was just one photo. It's not actually a template, but it looks like you used one.

Step One:

First, jump over to Lightroom's Print module, and click on the Page Setup button in the lower-left corner. When the Page Setup (PC: Print Setup) dialog appears, from the Paper Size pop-up menu, choose **Manage Custom Sizes** to bring up the dialog you see here (on a PC, click the Properties button, then in the Paper Options section, click the Custom button). You're going to create a new preset size (so you don't have to go through this again). Click the + (plus sign) button (shown circled here in red), and enter 7 in for both Width and Height (PC: Length), for Blurb's Small Square 7x7" book. On a Mac, you'll need to set all your margins (left, top, right, bottom) to 0 in, then click OK twice. Now this template is one click away in the future. While you're here, though, you might want to create presets for all the Blurb sizes (like 10x8", 8x10", 13x10", and 13x13").

Step Two:

Now design any layout you'd like in the Print module. For this layout, I used one of the built-in presets that comes with Lightroom called 4 Wide (found in the Template Browser panel in the left side Panels area). Once the template appeared, I selected the four photos I wanted in this layout, then I turned the Identity Plate checkbox off in the Page panel in the right side Panels area. I only changed two small settings in the Layout panel, so it all fits nicely in the 7x7 square we're using. I set the bottom and top margins to 0.44 in and left the sides at 0.50 in, which gives you the layout you see here (there isn't a layout exactly like this in the Book module's templates).

Step Three:
Although I used a built-in print template here, you can use the Print module's Custom Package feature (found up in the Layout Style panel at the top of the right side Panels area) to start with a blank page and create any type of layout you want (see Chapter 12 for more on this). Okay, once you've got your page set up the way you want it to look here in the Print module, scroll down to the Print Job panel and, where it says Print To, go ahead and choose **JPEG File** (as shown here). Set your Print Sharpening and Media Type to whichever settings you use (again, see Chapter 12 for more on this), then turn on the checkbox for Custom File Dimensions (so it uses the 7x7" custom size you created). Click the Print to File button to save this single 7x7" page as a JPEG file.

Step Four:
Now go to the Library module, and press **Command-Shift-I (PC: Ctrl-Shift-I)** to bring up the Import window. Find that JPEG file you just created and import it into Lightroom. Once it comes in, drag it into the collection you created for your photo book, then jump back to the Book module. Go to the page in your book where you want this 4 Wide image to appear. Right-click on the image on that page and choose **Remove Photo**, so it's just an empty page. From the Modify Page pop-up menu, choose a layout where the photo will fill the entire page, then simply find your 4 Wide image in the Filmstrip and drag it onto this empty page to get the layout you see here. The downside is that it's not a template—it's a fixed page (a flattened JPEG like any other photo). The upside is that you've got a page in your book where you created the layout from scratch exactly the way you wanted it.

PRINTING
unlocking the power of the print

Okay, I'm giving you fair warning. I'm gonna go on a bit of a rant here, because I feel so strongly about making prints. The print is when a photograph is born. What you see on your computer screen isn't real. It's pixels and 1s and 0s trapped behind a thin sheet of glass. You can't touch it, or taste it, or feel it—it's digital. A print is real. But, let's put aside the whole "real" part for now and think about this as saving your images for future generations. Got your photos all backed up on a hard drive? Good! That'll last at least three years, maybe four or five, if you're lucky. If you accidentally knock one over while it's running, or it falls off your desk, it's a goner. It's not just hard drives. You can back up your photos on CDs, DVDs, optical drives—you name it. They all have a short shelf life and it's not "if" they'll die, it's when. But, you know what lasts at least 100 years? Prints. Say what you want about that old shoebox of prints our parents left us; it worked. The fact they made prints and stuck them in a shoe box is the reason why we have any visual history of our early lives at all. Prints live on after we're gone. So, how can you ensure your prints last even longer? It's easy: make a set of prints of your portfolio images, then book a flight to Spitsbergen, a small Norwegian island in the Arctic Svalbard archipelago. Ask for directions to the Svalbard Global Seed Vault, and when you get there, ask for Earl (tell him I sent you) and let him know you want to store your prints there. Your prints will be pretty secure there thanks to the frigid arctic air, six super-thick steel security doors, and the perennially cranky polar bears that roam nearby looking for a handout. Also, it wouldn't hurt if you took Earl a Bacon Swiss Crispy Chicken Fillet Sandwich from Carl's Jr. and a medium Diet Dr. Pepper. He really likes that.

Printing Individual Photos

If you really like everything else in Lightroom, it's the Print module where you'll fall deeply in love. It's really brilliantly designed (I've never worked with any program that had a better, easier, and more functional printing feature than this). The built-in templates make the printing process not only easy, but also fun (plus, they make a great starting point for customizing and saving your own templates).

Step One:

Before you do anything in the Print module, click on the Page Setup button at the bottom left, and choose your paper size (so you won't have to resize your layout once it's all in place). Now, start in the Template Browser (in the left side Panels area) by clicking on the Fine Art Mat template. The layout you see here should appear, displaying the first photo in your current collection (unless you have a photo selected—then it shows that one). There's a Collections panel here, too, so if you want to change collections, you can do so in the left side Panels area. A few lines of info may appear over the top-left corner of your photo. It doesn't actually print on the photo itself, but if you find it distracting, you can turn this off by pressing the letter **I**, or going under the View menu and choosing **Show Info Overlay**.

Step Two:

If you want to print more than one photo using this same template, go down to the Filmstrip and Command-click (PC: Ctrl-click) on the photos you want to print, and it instantly adds as many pages as you need (here, you see just one image, but if you look down in the toolbar, you can see that this is print 1 of 19). There are three layout styles (in the Layout Style panel at the top right), and this first one is called Single Image/Contact Sheet. This works by putting each photo in a cell you can resize. To see this photo's cell, go to the Guides panel and turn on the Show Guides checkbox. Now you can see the page margins (in light gray), and your image cell (outlined in black, as seen here).

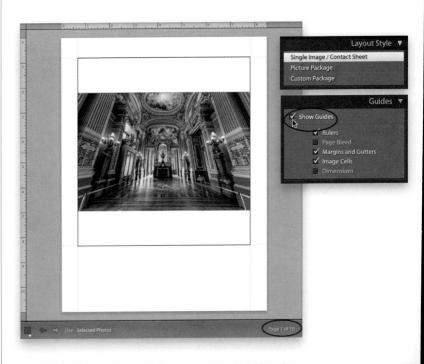

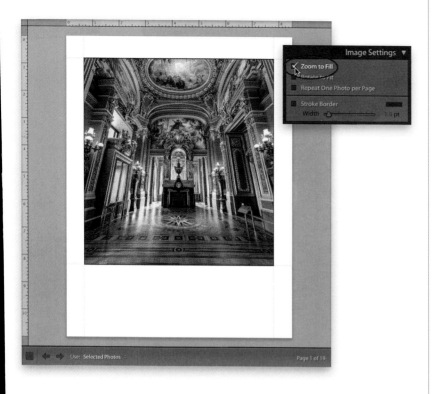

Step Three:

If you look back at the layout in Step Two, did you notice that the image fit the cell side-to-side, but there was a gap on the top and bottom? That's because, by default, it tries to fit your image in that cell so the entire image is visible. If you want to fill the cell with your photo, go to the Image Settings panel and turn on the Zoom to Fill checkbox (as shown here), and now your image fills it up (as seen here). Now, of course, this crops the image a bit, too (well, at least with this layout it did). This Zoom to Fill feature was designed to help you make contact sheets, but as we go through this chapter, I bet you'll totally start to love this little checkbox, because with it you can create some really slick layouts—ones your clients will love. So, even though it does crop the photo a bit, don't dismiss this puppy yet—it's going to get really useful very soon.

Step Four:

Now, let's work on the whole cell concept, because if you "get" this, the rest is easy. First, because your image is inside a cell and you have the Zoom to Fill checkbox turned on, if you change the size of your cell, the size of your photo doesn't change. So, if you make the cell smaller, it crops off part of your image, which is really handy when you're making layouts. To see what I mean, go to the Layout panel, and at the bottom of the panel are the Cell Size sliders. Drag the Height slider to the left (down to 4.41 in), and look at how it starts to shrink the entire image size down right away, until it reaches its original unzoomed width, then the top and bottom of the cell move inward without changing the width further. This kind of gives you a "letter box" view of your image (HD movie buffs will totally get that analogy).

Continued

Step Five:

Now drag the Height slider back to the right, kind of where it was before, then drag the Width slider to the left to shrink the width. This particular photo is wide (in landscape orientation), so while moving the top and bottom of the cell shrank the image, and then the cell, dragging the Width slider like we are here, just shrinks the cell inward (this will all make sense in a minute). See how the left and right sides of your cell have moved in, creating the tall, thin cell you see here? This tall, thin layout is actually kind of cool on some level (well, it's one you don't see every day, right?), but the problem is that the center of the fireplace is on the left side of the frame. We can fix that.

TIP: Print Module Shortcut

When you want to jump over to the Print module, you can use the same keyboard shortcut you do in almost any program that lets you print: it's the standard old **Command-P (PC: Ctrl-P)**.

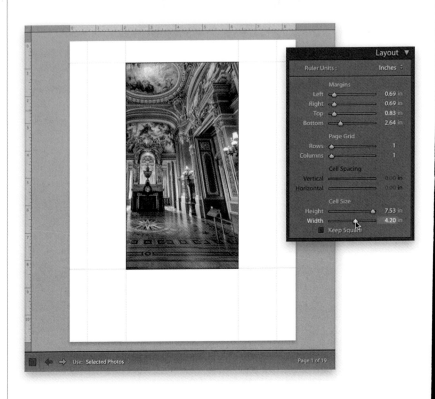

Step Six:

One of my favorite things about using these cell layouts is that you can reposition your image inside the cell. Just move your cursor over the cell, and your cursor turns into the Hand tool. Now, just click-and-drag the image inside the cell to the position you want it. In this case, I just slid the photo over to the right a bit until the middle of the fireplace was in the center.

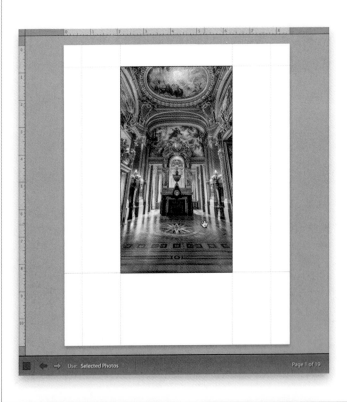

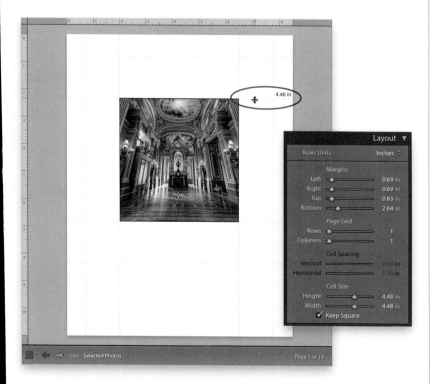

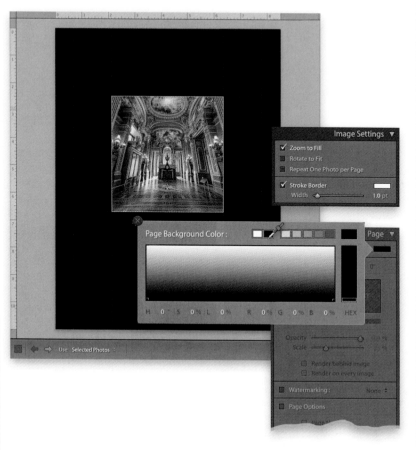

Step Seven:
At the bottom of the Cell Size section is a checkbox called "Keep Square." Go ahead and turn on this checkbox, which sets your Height and Width to the exact same size, and now they move together as one unit (since it's perfectly square). Let's try a different way of resizing the cell: click-and-drag the cell borders themselves, right on the layout in the Preview area. You see those vertical and horizontal lines extending across and up/down the page showing the boundaries of your cell? You can click-and-drag directly on them, so go ahead and give it a try. Here, I'm clicking on the top horizontal guide (shown circled here in red), and dragging outward to enlarge my square cell (and the photo inside it). So, by now you've probably realized that the cell is like a window into your photo.

TIP: Rotating Images
If you have a tall photo in a wide cell (or on a wide page), you can make your photo fill as much of that page as possible by going to the Image Settings panel, and turning on the Rotate to Fit checkbox.

Step Eight:
Let's finish this one off with one of my favorite printing features in Lightroom: the ability to change the color of your page background. To do this, just go to the Page panel, turn on the Page Background Color checkbox, and click the color swatch to the right of it to bring up the Page Background Color picker (seen here). In this case, I'm choosing black, but you can choose any color you'd like (dark gray, blue, red—you name it), then close the color picker. Also, you can put a stroke around your image cell by going up to the Image Settings panel, turning on the checkbox for Stroke Border, then choosing a color (just click on the color swatch), and choosing how thick you want your stroke using the Width slider.

Creating Multi-Photo Contact Sheets

The reason you jumped through all those hoops just to print one photo was because the whole Single Image/Contact Sheet was really designed for you to have quick access to multi-photo layouts and contact sheets, which is where this all gets really fun. We're picking up here, with another set of photos, to show you how easy it is to create really interesting multi-photo layouts that clients just love!

Step One:

Start by clicking on any of the multi-photo templates that come with Lightroom (if you hover your cursor over any of the templates in the Template Browser, a preview of the layout will appear in the Preview panel at the top of the left side Panels area). For example, click on the 2x2 Cells template, and it puts your selected photos in two columns and two rows (as shown here). Here, I selected six photos, and if you look down at the right end of the toolbar, you'll see Lightroom will make two prints, although only one will have four photos—the second print will just have those two leftover photos. The layout you see here doesn't look that good, because they're all horizontal photos in vertical cells, but we can fix that. It would look worse if there were tall photos mixed in.

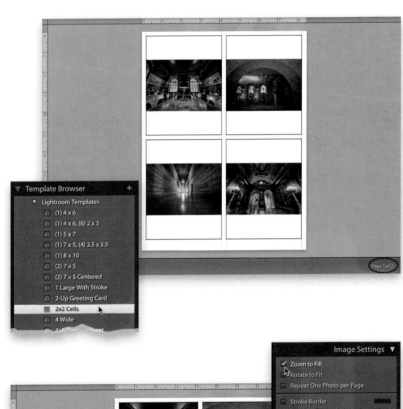

Step Two:

Of course, just printing all your wide photos on a page with wide cells, and then creating a second template with tall cells, would fix that, but an easier way is to go to the Image Settings panel and turn on the Zoom to Fill checkbox (as shown here). This zooms all the images up to fill the cells, so the wide photos zoom in, and how they fill the cells looks uniform (as seen here). Plus, you can reposition the images in their cells by clicking-and-dragging them. However, turning on Zoom to Fill usually crops a tiny bit off of tall shots, and quite a bit off the wide shots, changing the whole look of the photos (luckily, there is a way around this, too).

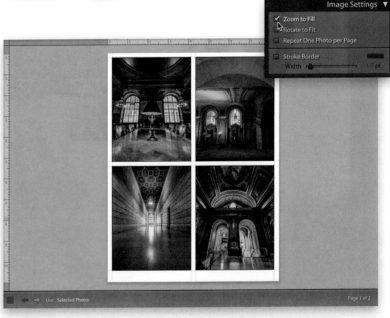

Step Three:

What you need is a way to print tall images and wide images together at nearly full size, without much cropping. The trick is to turn on the Rotate to Fit checkbox (as shown here), which rotates the wide photos so they best fill the tall cells (as seen here, where the wide photos are now turned sideways to fit in the cells as large as possible). When you turn on Rotate to Fit, it applies that to all your pages, so if you have other wide photos on other pages, it will rotate them, as well.

Step Four:

If you want to print the same photo, at the same exact size, multiple times on the same page, then you can go to the Image Settings panel and turn on the checkbox for Repeat One Photo per Page, as shown here. If you want to print the same photo multiple times on the same page, but you want them to be different sizes (like one 5x7" and four wallet-size photos), then turn to page 364 for details on how to set that up.

Continued

Step Five:

If you click on a different multi-photo layout, like the 4x5 Contact Sheet (as shown here), your photos instantly adjust to the new layout. One nice feature of this template is that the names of your images appear directly below each image. If you want to turn this feature off, go to the Page panel and, near the bottom of the panel, turn off the Photo Info checkbox. By the way, when you have this checkbox turned on, you can choose other text to appear under your images from the pop-up menu to the right of the words Photo Info. Here, I turned on the Zoom to Fill checkbox, but of course, that's totally optional—if you don't want your images cropped, then you should leave Zoom to Fill turned off.

Step Six:

So far, we've been using Lightroom's built-in templates, but half the fun of this process is building your own, and it's surprisingly easy, as long as you don't mind having all your cells being the same exact size, which is the limitation of using the Single Image/Contact Sheet type of layout. You can't have one photo that's square, and two that are rectangular. They're either all square or all rectangular, but don't worry, we'll tackle how to create multiple photos at any size you want a little later. For now, we'll use this contact sheet power to create some cool layouts. Start by selecting some photos (eight or nine should be fine), then click on the template called "Maximize Size" (shown here; it's a decent starting place for building your own templates). Since we're going to be adding photos, I turned off the Rotate to Fit checkbox (it's on by default in this template) in the Image Settings panel.

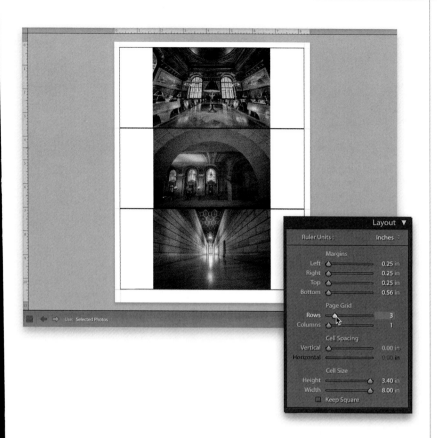

Step Seven:

You create custom multi-photo layouts in the Layout panel. There's a Page Grid section, which is where you pick how many rows and columns you want in your layout, so start by dragging the Rows slider over to 3, while leaving the Columns set at 1, so you get three photos each in their own row (like you see here). You'll notice that the three photos are stacked one on top of another with no space between them. (Note: The black lines you see around the cells are just guides, so you can easily see where the cell borders are. You can get rid of these in the Guides panel by turning off the Image Cells checkbox.)

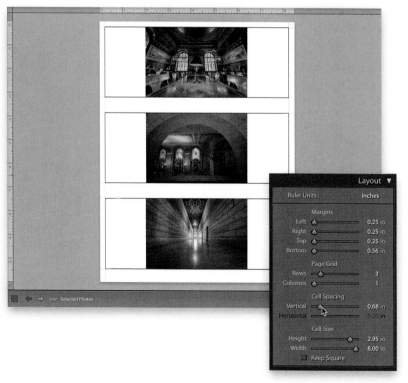

Step Eight:

To create some vertical space between your photos, go to the Cell Spacing section and click-and-drag the Vertical slider to the right (as shown here, where I dragged it over to 0.68 in to put a little more than a half-inch of space between the photos). Now let's take things up a notch.

Continued

Step Nine:

Now go to the Page Grid sliders and increase the Columns to 3, so you have this layout of three columns wide by three rows deep. Of course, since the default setting is to not have any space between photos, the columns of photos don't have any space between them horizontally.

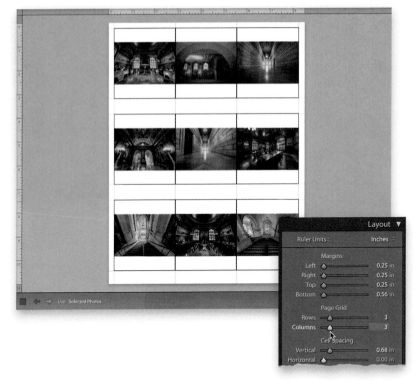

Step 10:

You add space between the photos in columns by going to the Cell Spacing section, and clicking-and-dragging the Horizontal slider to the right (as shown here). Now that you've got space between your columns, take a look at the page margins. There's lots of space at the top and bottom, and just a little bit of space on the sides of the page.

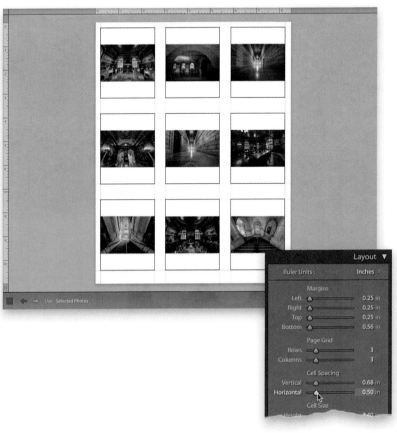

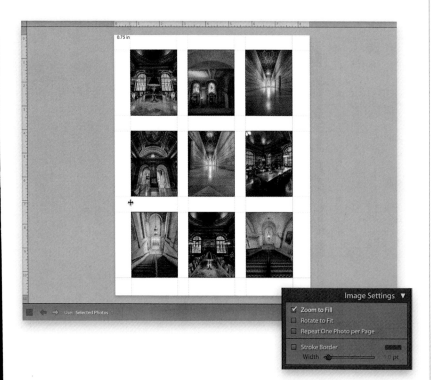

Step 11:

Although you can drag the Margins sliders to adjust the page margins (right there in the Layout panel), you can also just click directly on the margins themselves and drag them (as shown here). Here, I clicked-and-dragged the top, bottom, and side margins in to where they were about a half-inch from the edge of the page. While we're here, let's go back up to the Image Settings panel and turn on the Zoom to Fill checkbox to fill the cells with the images, as seen here (don't forget, you can reposition your images inside those cells by just clicking-and-dragging them).

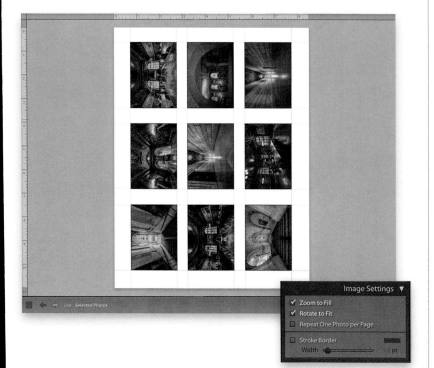

Step 12:

If you want to see the full image (not zoomed in tight), but still have them fill the cells, you could turn on the Rotate to Fit checkbox right there in the Image Settings panel, as well. Now all the photos are turned on their sides, so they fit the full width of each cell as large as possible (as seen here).

Continued

Step 13:

Let's wrap this section up with a few examples of cool layouts you can create using these Contact Sheet style layouts (all based on a borderless 8.5x11" page size, which you can choose by clicking the Page Setup button at the bottom of the left side Panels area). Start by turning on the Zoom to Fill checkbox in the Image Settings panel. Then, go to the Layout panel, under Page Grid, and change the number of Rows to 1 and the number of Columns to 3. Drag the Left, Right, and Top Margins sliders to around 0.75 in, and the Bottom Margins slider to around 2.75 (to leave lots of room for your Identity Plate). Jump down to Cell Spacing and set Horizontal to 0.13. Under Cell Size, for the Height, drag it to around 7.50 in, and set the Width at only around 2.24 in, which gives you very tall, narrow cells (as shown here). Now, select three photos and turn on the Identity Plate feature (in the Page panel), make it larger, and click-and-drag it so it's centered below your images, giving you the look you see here (I also turned off the Show Guides checkbox). *Note:* If you like this layout, you can save it as a custom preset (see page 369).

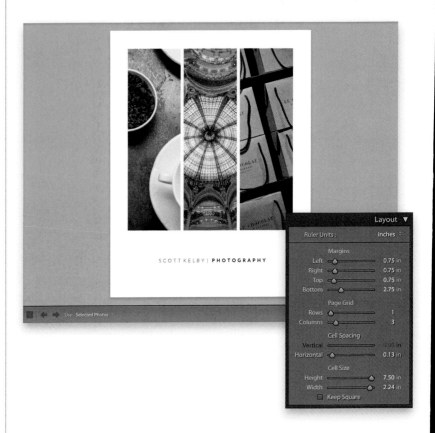

Step 14:

Now let's create four panorama layouts in one photo (you don't need to use real panos—this creates fake panos instantly from any photo you select). Start by turning on the Zoom to Fill checkbox and setting your Rows to 4 and Columns to 1. Then set your Left and Right Margins to 0.50 in, and set the Top to around 0.75 in or 0.80 in. Set your Bottom margin to 1.50 in. Turn off the Identity Plate checkbox in the Page panel, then increase your Cell Size Width to 7.30 in, and your Cell Size Height to 1.81 in to give you thin, wide cells. Now, set the space between your fake panos using the Vertical slider (set it to around 0.50) to give you the layout you see here. I went and clicked on four travel photos, and got this instant pano layout here.

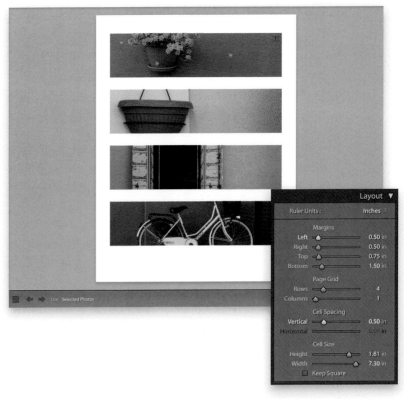

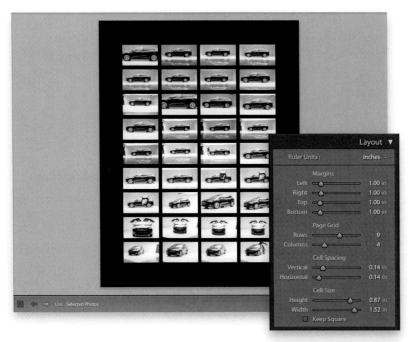

Step 15:

How about a poster, on black, with 36 wide images? Easy. Start by creating a collection made up of only wide images. Then go to the Image Settings panel and turn on the Zoom to Fill checkbox. Go to the Layout panel and set a 1-inch margin all the way around the page, using the Margins sliders. Now, set your Page Grid to 9 Rows and 4 Columns, and set your Horizontal and Vertical Cell Spacing at 0.14 in. Lastly, in the Page panel, turn on the Page Background Color check-box, then click on the color swatch to the right of it, and choose black for your background color. If you have a white border, click on the Page Setup button and choose borderless printing.

Step 16:

Okay, this one's kinda wild—one photo split into five separate thin vertical cells. Here's how it's done: You start by clicking the Page Setup button (at the bottom left), and set your page to be Landscape orientation. Then Right-click on a photo in the Filmstrip and choose **Create Virtual Copy**. You need to do this three more times, so you have a total of five copies of your photo. Now, in the Image Settings panel, turn on Zoom to Fill, then in the Layout panel, set your Margins to 0.50 in all the way around the page. For your Page Grid, choose 1 Rows and 5 Columns. Add a little Horizontal Cell Spacing—around 0.25 in. Then, drag the Cell Size Height slider to around 7.50 in and the Width to around 1.80 in. Select all five photos in the Filmstrip, then you'll click-and-drag each of the five images around inside their cells—dragging left and right—until they appear to be one single image (like you see here).

Creating Custom Layouts Any Way You Want Them

In Lightroom, Adobe also gives you the option to break away from the structured cell layouts of earlier versions to create your own custom cell layouts in any size, shape, and placement, using a Print layout style called "Custom Package." Here's where you can create photos in any size and any layout you want, without being tied into a grid.

Step One:

Start in the Layout Style panel by clicking on Custom Package (we want to start from scratch, so if you see any cells already in place, go to the Cells panel and click the Clear Layout button). There are two ways to get photos onto your page: The first is to go down to the Filmstrip and simply to drag-and-drop images right onto your page (as seen here). The image appears inside its own fully resizable cell, so you can just drag one of the corner handles to resize the image (this image came in pretty small, so I resized it to nearly fill the bottom of the page). It will resize proportionally by default, but if you turn off the Lock to Photo Aspect Ratio checkbox (at the bottom of the Cells panel), then it acts like a regular cell with Zoom to Fill turned on, in that you can crop the photo using the cell. More on that in a minute.

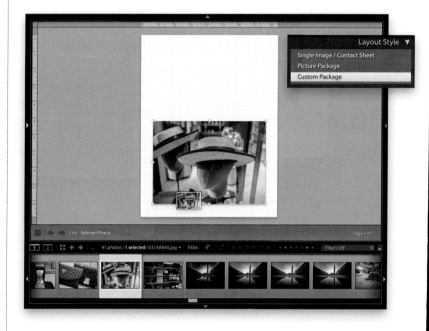

Step Two:

Go ahead and hit the Clear Layout button, so you can try the other way to get your images into your layout, which is to create the cells first, arrange them where you want, then drag-and-drop your images into those cells. You do this by going to the Cells panel, and in the Add to Package section, just click on the size you want. For example, if you wanted to add a 3x7" cell, you'd just click on the 3x7 button (as shown here) and it creates an empty cell that size on the page. Now you can just click inside the cell and drag it anywhere you'd like on the page. Once it's where you like it, you can drag-and-drop a photo into that cell from the Filmstrip.

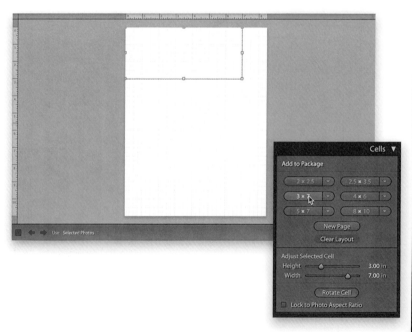

Step Three:

Let's create a layout using these cell buttons, so hit the Clear Layout button to start from scratch again. Click the 3x7 button to add a long, thin cell to your layout, but then click the Rotate Cell button to make this a tall, thin cell. This cell is actually pretty large on the page, but you can resize it by first making sure the Lock to Photo Aspect Ratio checkbox is turned off, then by grabbing any of the handles, or using the Adjust Selected Cell sliders to choose any size you'd like (here, shrink your Height to around 5.59 in and Width to around 2.21 in). Now, we need to make two more cells just like this one. The quickest way to do that is to press-and-hold the **Option (PC: Alt) key**, then click inside the cell and drag to the right to make a copy. Do this twice until you have three cells and arrange them side by side, as seen here (as you drag a cell, you'll feel it snap to an invisible alignment grid that's there to help you line things up. If you don't feel the snap or see the grid, go to the Rulers, Grid & Guides panel, turn on the checkboxes for Show Guides and Page Grid, and make sure Grid is selected from the Grid Snap pop-up menu).

Step Four:

Next, let's add a larger photo to the bottom of our layout. Click the 4x6 button and it adds a larger cell to the layout, but it's taller and not quite as wide as our three thin cells above. So, set the Height to 3.96 in and the Width to 7.62 in (as seen here). The layout's done, but before you start dragging-and-dropping images, there are two things you need to change first: (1) Because the cells at the top are tall and thin, the checkbox for Lock to Photo Aspect Ratio must be off (we already did this). Otherwise, when you drag-and-drop photos into those thin cells, they will just expand to the full size of the photo. (2) You'll also need to make sure the Rotate to Fit checkbox at the top of the Image Settings panel is turned off, so wide images won't rotate to fit the cell.

Continued

Step Five:

Now you're ready to start dragging-and-dropping photos into your layout. If you drag one that doesn't look good in your layout, just drag another right over it. You can reposition your photo inside a smaller cell by pressing-and-holding the Command (PC: Ctrl) key, then just dragging the image left/right (or up/down), so just the part you want is showing. (*Note:* I turned off the Show Guides checkbox in the Rulers, Grid & Guides panel, here.) Don't forget to save any of these that you like as a custom preset (see page 369 for more).

Step Six:

You can stack images so they overlap, almost like they're Photoshop layers. Let's start from scratch again, but first click the Page Setup button (at the bottom left), and turn your page orientation to Landscape. Now go back to the Cells panel, click the Clear Layout button, then click the 8x10 button, resize it, and position it so it takes up most of the page (as shown here). Now, click the 2x2.5 button three times, make each cell a little wider (like the ones seen here), and position them so they overlap the main photo, as shown. Drag-and-drop photos on each cell. You can move the photos in front or behind each other by Right-clicking on the photo, and from the pop-up menu, choosing to send the photo back/forward one level or all the way to the bottom/top of the stack. To add a white photo border around your images (like I did here), in the Image Settings panel, turn on the Photo Border checkbox (turn on the guides to see this better, if you turned them off).

Step Seven:

Want a different look really quick? Try switching your page orientation back to Portrait (tall) and see how that looks. For example, I thought it might make a good wedding book layout, and when I rotated the page, this is pretty much the layout I got without really doing much. Well, I did click-and-drag the side of the main photo to make it a little wider, then I turned off the Photo Border checkbox, turned on the Inner Stroke Border checkbox (also in the Image Settings panel), and added a 2-pt black stroke.

Step Eight:

Here's an alternate look to the page you just created, and it only took about 60 seconds to get from the layout in Step Seven to what you see here. I just changed the Inner Stroke Border to white, and I dragged all of the small images over to the right, so they appear over the main image (instead of peeking in from the side). I also dragged out the sides, top, and bottom of the main image to make it fill the page better. (*Note:* If you saved this layout as a custom preset, you can update it with the changes you made to it by Right-clicking on it in the Template Browser and choosing Update with Current Settings. Again, see page 369 for more on saving custom layouts.)

Adding Text to Your Print Layouts

If you want to add text to your print layouts, it's pretty easy, as well, and like the Web and Slideshow modules, you can have Lightroom automatically pull metadata info from your photos and have it appear on the photo print, or you can add your own custom text (and/or Identity Plate) just as easily. Here's what you can add, and how you can add it:

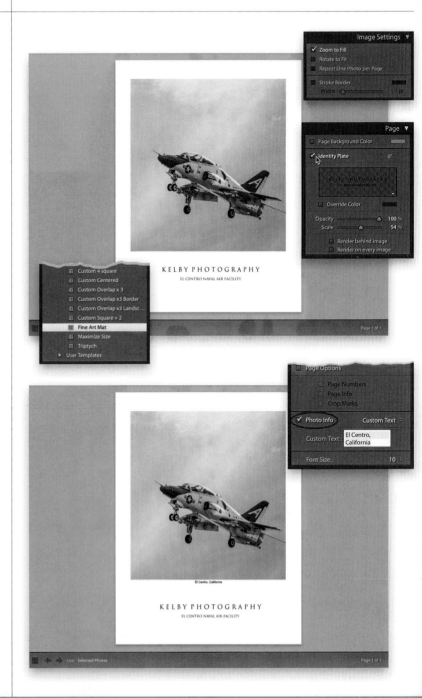

Step One:
Select a photo, then choose the Fine Art Mat template in the Template Browser and turn on the Zoom to Fill checkbox. The easiest way to add text is to go to the Page panel and turn on the Identity Plate checkbox (see Chapter 4 for how to set it up). Once it's there, you can click-and-drag it right where you want it (in this case, drag it down and position it in the center of the space below the photo, as seen here). Here's the trick I used to get two lines of text, centered, below my photo: I went to my Mac's TextEdit application (any regular text editing application should work), typed and formatted my text there, and copied it into memory. Then, I went to Lightroom's Identity Plate Editor and pasted my copied text (the ol' copy-and-paste routine), and it kept the formatting.

Step Two:
Besides adding your Identity Plate, Lightroom can also pull text from your metadata (things like exposure settings, camera make and model, filename, or caption info you added in the Library module's Metadata panel). In the Page panel, turn on the Photo Info checkbox and choose which type of info you want displayed at the bottom of your cell from the pop-up menu on the right. Here, I chose **Custom Text,** and in the text field that appeared, I typed in the location where the shot was taken (El Centro, California), and you can see it appears directly below my image. You can also change the size of your text from the Font Size pop-up menu right below it.

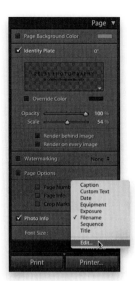

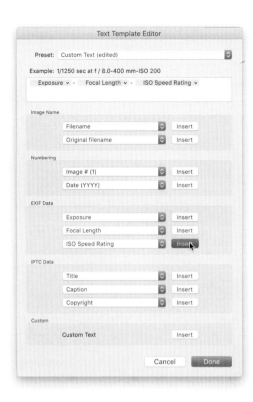

Step Three:

You can also create your own custom list of data that Lightroom will pull from a photo's existing metadata and/or camera data and print under that photo. To do that, in the Page panel, from the Photo Info pop-up menu, choose **Edit** (at the bottom of the menu) to bring up the Text Template Editor (seen here). This is where you choose what info is pulled from the image's metadata, and in this case, I went to the third section down, EXIF Data, where I chose to add text showing the exposure, lens focal length, and ISO by choosing them from the pop-up menus, then clicking the Insert button beside each of these fields. I also typed a dash (on my keyboard), in the text field up top, between each click of the Insert button, so it didn't all run together (it needs that visual separator if you ask me). Now, I can't imagine why anyone would want that type of information printed beneath a photo. But you know, and I know, there's somebody out there right now reading this and thinking, "All right! Now I can put the EXIF camera data right on the print!" The world needs these people.

Step Four:

If you're printing pages for a photo book, you can have Lightroom automatically number those pages. In the Page panel, turn on the Page Options checkbox, then turn on the checkbox for Page Numbers. Lastly, if you're doing a series of test prints, you can have your print settings (including your level of sharpening, your color management profile, and your selected printer) appear near the bottom of the print (as seen here) by turning on the Page Info checkbox.

Printing Multiple Photos on One Page

You saw earlier in this chapter how to print the same photo, at the same exact size, multiple times on the same print. But what if you want to print the same photo at different sizes (like a 5x7" and four wallet sizes)? That's when you want to use Lightroom's Picture Package feature.

Step One:

Start by clicking on the photo you want to have appear multiple times, in multiple sizes, on the same page. Go to the Template Browser in the left side Panels area and click on the built-in template named (1) 4x6, (6) 2x3, which gives you the layout you see here. If you look over in the Layout Style panel at the top of the right side Panels area, you'll see that the selected style is Picture Package (as seen here). *Note:* Here, I made sure the Show Guides checkbox was turned on (in the Rulers, Grid & Guides panel), along with the Image Cells checkbox, so you can see how the cells fit on the page.

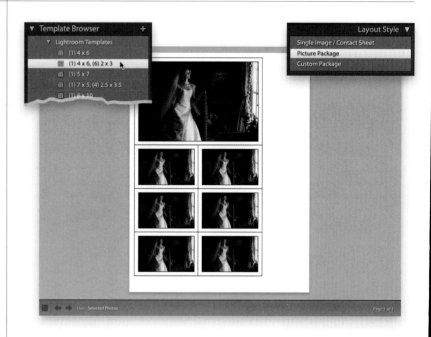

Step Two:

By default, this template puts a white border outside each photo. If you don't want the white border, go to the Image Settings panel and turn off the Photo Border checkbox (as seen here), and now the images will be snug up against each other.

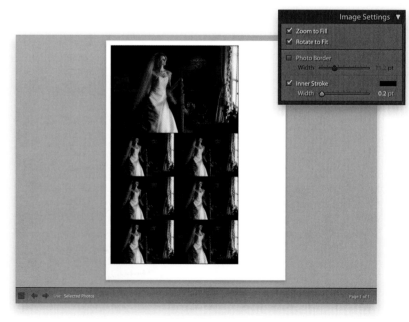

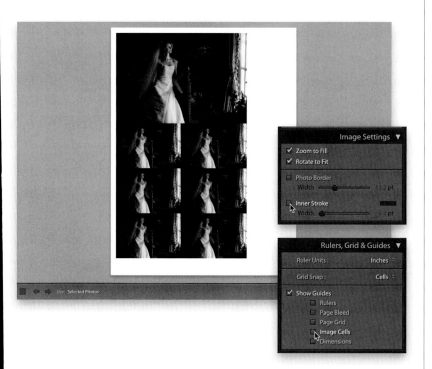

Step Three:
Another option it has on by default is that it puts a black stroke around each image (you can control the size of this stroke, using the Width slider right below the Inner Stroke checkbox). To remove this stroke, turn off the Inner Stroke checkbox (as shown here. You'll still see a thin stroke that separates the images, but don't worry, that doesn't print—that's just the Image Cells guide you're seeing. You can go ahead and turn it off now in the Rulers, Grid & Guides panel, as I have here). Now your images are back to their original cropping, they're right up against each other (there's no extra white border), and you've removed the black stroke around the photos (by the way, if you like this layout, don't forget to save it as your own custom template by clicking on the + [plus sign] button on the right side of the Template Browser header).

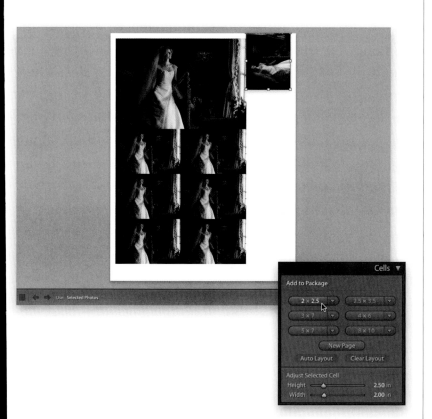

Step Four:
Adding more photos is easy—just go to the Cells panel (in the right side Panels area), and you'll see a number of pill-shaped buttons marked with different sizes. Just click on any one of those to add a photo that size to your layout (I clicked on the 2x2.5 button, and it added the new cell you see selected here). So, that's the routine: you click on those buttons to add more photos to your Picture Package layout. To delete a cell, just click on it, then press the **Delete (PC: Backspace) key** on your keyboard.

Continued

Step Five:

If you want to create your own custom Picture Package layout from scratch, go to the Cells panels and click on the Clear Layout button (as shown here), which removes all the cells, so you can start from scratch.

Step Six:

Now you can just start clicking on sizes, and Lightroom will place them on the page each time you click one of those Add to Package buttons (as seen here). As you can see, it doesn't always place the photos in the optimum location for the page dimensions, but Lightroom can actually fix that for you.

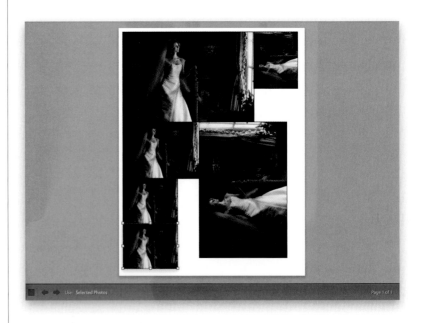

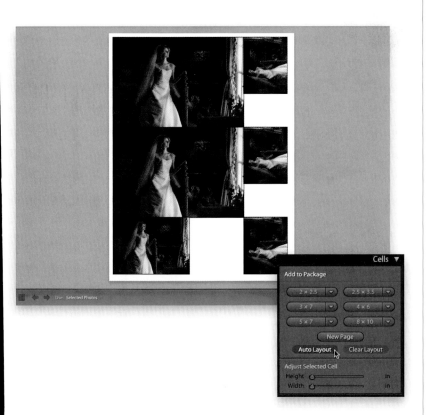

Step Seven:

If you click on the Auto Layout button, at the bottom of the Add to Package section (as shown here), it tries to automatically arrange the photos so they fit more logically, and gives you extra space to add more photos. Okay, click the Clear Layout button and let's start from scratch again, so I can show you another handy feature.

TIP: Dragging-and-Copying

If you want to duplicate a cell, just press-and-hold the **Option (PC: Alt) key**, click-and-drag yourself a copy, and position it anywhere you'd like. If one of your photos overlaps another photo, you'll get a little warning icon up in the top-right corner of your page.

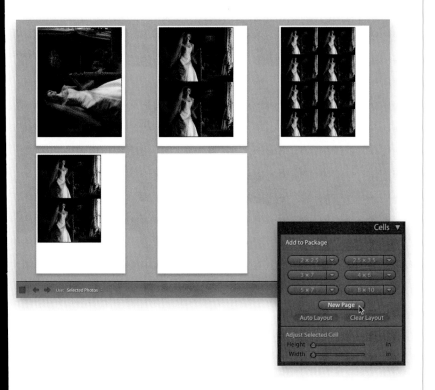

Step Eight:

If you add so many cells that they can't fit on one page, Lightroom automatically adds new pages to accommodate your extra cells. For example, start by adding an 8x10, then add a 5x7 (which can't fit on the same letter-sized page), and it automatically creates a new page for you with the 5x7. Now add another 5x7 (so you have two-up), then eight wallet-sized 2.5x3.5s (which won't fit on the same page), and it will add yet another page. Add a couple of 4x6s, and it adds another page. Pretty smart, eh? Also, if you decide you want to add another blank page yourself (this lets you drag an image from one page and drop it on this empty page anywhere you want it), just click on the New Page button (as shown here).

Continued

Step Nine:

If you want to delete a page, just hover your cursor over the page you want to delete, and a little X appears over the top-left corner (as seen here, on the third page). Click on that X and the page is deleted (I already deleted the last two pages we created in the last step, here).

TIP: Zooming In on One Page

Once you have multiple pages like this and you want to work on just one of these pages, you can zoom right in on the page by clicking on it, then clicking on Zoom Page on the right side of the Preview panel header (at the top of the left side Panels area).

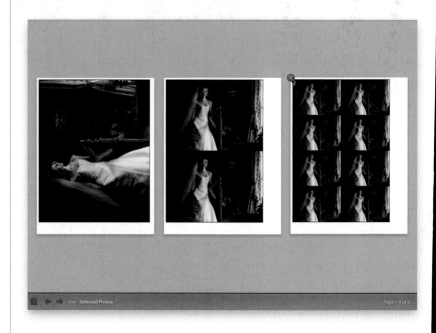

Step 10:

You can also manually adjust the size of each cell (which is a handy way to crop your photos on the fly, if you have Zoom to Fill turned on). For example, go ahead and delete the bottom 5x7 image on the second page. Now, click on the top image (to bring up the adjustment handles around the cell), then click-and-drag the bottom handle upward to make the cell thinner (as seen here). You can get the same effect by clicking-and-dragging the Adjust Selected Cell sliders, at the bottom of the Cells panel (there are sliders for both Height and Width), and you can also press-and-hold the Command (PC: Ctrl) key and click-and-drag on the photo to move it within the cell.

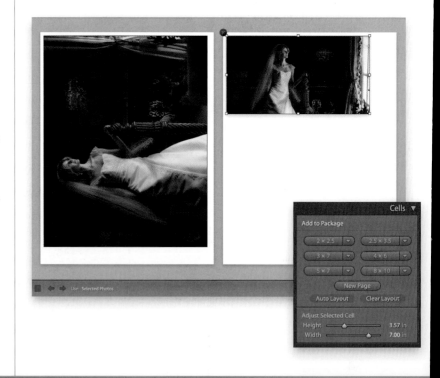

If you've come up with a layout you really like and want to be able to apply it at any time with just one click, you need to save it as a template. But beyond just saving your layout, print templates have extra power, because they can remember everything from your paper size to your printer name, color management settings, the kind of sharpening you want applied—the whole nine yards!

Saving Your Custom Layouts as Templates

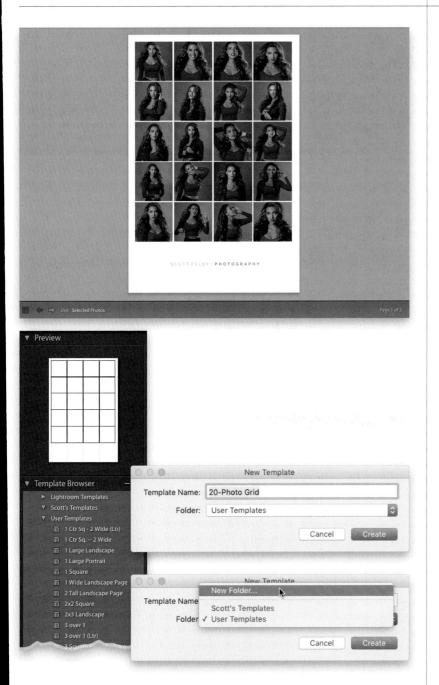

Step One:
Go ahead and set up a page with a layout you like, so you can save it as a print template. The page layout here is based on a 13x19" page (you choose your page size by clicking the Page Setup button at the bottom of the left side Panels area). The layout uses a Page Grid of 5 Rows and 4 Columns. The cell sizes are square (around 3 inches each), and the page has a 1/2" margin on the left, right, and top, with a 3.69" margin at the bottom. I turned on the Stroke Border checkbox and changed the color to white, and turned on my Identity Plate. Also, make sure the Zoom to Fill checkbox (in the Image Settings panel) is turned on.

Step Two:
Once it's set up the way you like it, go to the Template Browser and click the plus sign (+) button on the right side of the header to bring up the New Template dialog (shown here). By default, it wants to save any templates you create into a folder called User Templates (you can have as many folders of print templates as you like to help you organize them. For example, you could have one set for letter-sized, one set for 13x19", one set for layouts that work with portraits, etc.). To create a new template folder, click on the Folder pop-up menu (shown here at bottom), and choose **New Folder**. Give your template a name, click Create, and now this template will appear in the folder you chose. When you hover your cursor over the template, a preview of the template will appear up in the Preview panel at the top of the left side Panels area.

Having Lightroom Remember Your Printing Layouts

Once you've gone through the trouble of creating a cool print layout, with the photos right where you want them on the page, you don't want to lose all that when you change collections, right? Right! Luckily, you can create a saved print, which keeps everything intact—from page size, to the exact layout, to which photos in your collection wound up on the page (and which ones didn't) and in which order. Here's how ya do it:

Step One:

Once you make a print, and you're happy with the final layout (and all your output settings and such, which we'll get into in a bit), click on the Create Saved Print button (shown circled here) that appears above the top-right corner of the center Preview area. This brings up the Create Print dialog (shown here). Here, you'll be saving a print collection. The key thing here, though, is to make sure the Include Only Used Photos checkbox is turned on. That way, when you save this new print collection, only the photos that are actually in this print are saved in it. Also, in the dialog, you'll have the option of including this new print collection inside an existing collection—just turn on the Inside checkbox and then choose the collection or collection set you want it to appear within.

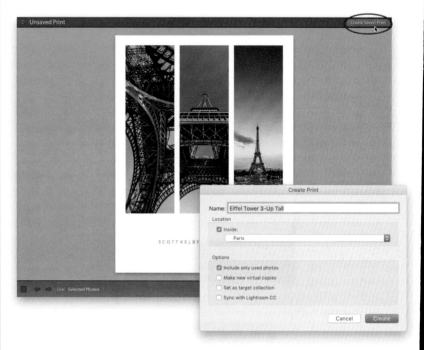

Step Two:

Now click the Create button, and a new print collection is added to the Collections panel (you'll know at a glance that it's a print collection because it will have a printer icon right before the collection's name). That's it! When you click on that print collection and select all the photos in it, you'll see the layout, just the way you designed it, with the images already in order ready to go, including all your output settings (like which printer you printed to, your sharpening and resolution settings—the works!), even if it's a year from now. *Note:* If all your images don't appear in the layout, just go to the Filmstrip and select them all—now they'll appear in your layout.

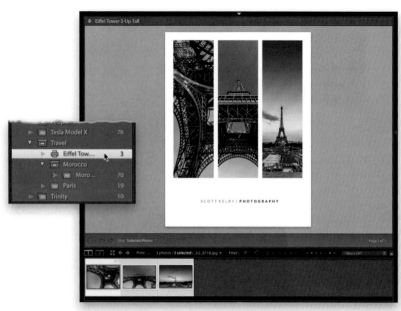

For all the wonderful things Lightroom's Print module does, one feature it doesn't have is one that lets you backscreen a photo (a staple in most wedding albums). So, I came up with a workaround, where we can use a backscreened image as our page background, and then put another non-backscreened image in front of it on the same page. It's easy, but not really obvious.

Creating Backscreened Prints

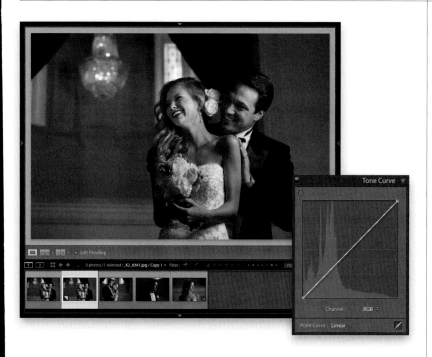

Step One:
Choose the photo you want to use as your backscreened image, then create a virtual copy of it by pressing **Command-'** (apostrophe; **PC: Ctrl-'**). We'll use this virtual copy to make our backscreened image, so our original stays intact. Once you've created your virtual copy, go to the Develop module's Tone Curve panel. Make sure the Point Curve is visible (if yours has more sliders below it, and doesn't look like the one you see here, just click on the little Point Curve icon at the bottom-right corner of the panel).

Step Two:
To create the backscreened look, click-and-drag the bottom-left corner point straight up along the left edge until it's about 3/4 or so of the way up to the top (as seen here).

Continued

Step Three:

This is an optional step, but you see this often enough that you might want to consider converting the image you just backscreened to black and white. The advantage is it creates more contrast with the image you're going to put on top of it. To make it a black-and-white image, just go to the top of the Basic panel and click on Black & White (as shown here). That's it—it's black and white. (Note: Because the image is backscreened, we can get away with this one-click black-and-white conversion. Otherwise, we'd use the technique for creating high-contrast black-and-whites found in Chapter 7). Now, switch to the Print module, click on the Page Setup button, and choose a borderless 8.5x11" landscape page.

Step Four:

Then, click on Custom Package in the Layout Style panel at the top of the right side Panels area and scroll down to the Cells panel. Click the Clear Layout button, then make sure the Lock to Photo Aspect Ratio checkbox is turned off (turning this off allows you to drag a photo out larger than the page size if necessary). Now, click on your backscreened image, and drag it onto the page. To make your backscreened image fill the page, click-and-drag the image up to the top-left corner of the page, then grab the bottom-right corner point and just drag it out until it fills the entire page, edge to edge (as shown here). If your image won't stretch large enough to extend off the page, that's because you didn't turn off the Lock to Photo Aspect Ratio checkbox at the beginning of this step.

Step Five:

Getting another image to sit on top of this backscreened image is actually easy, but you kind of have to know a trick. The problem is if you add a new cell (like, for example, a 2.5 x 3.5 cell) it doesn't appear on the same page as your backscreened image. Instead, it creates a new page and adds the cell there. So, what you'll need to do is just click-and-drag your full-color photo into that new cell on the extra page (as seen here). Then, click-and-drag the cell onto the first page, and it appears over your backscreened image (as seen in the next step).

Step Six:

You can now position the image wherever you'd like (you'll see that now-blank additional page is still there, but to get rid of it, just click on the round X button in the top-left corner and it's gone). Here's the final page with the backscreened image and the second image on top of it. I also added a line of text (using the Identity Plate in the Page panel), using the handwritten font, Rough Beauty Script by Pedro Teixeira (from MyFonts.com—I got it on sale for $7).

The Final Print & Color Management Settings

Once you've got your page set up with the printing layout you want, you just need to make a few choices in the Print Job panel, so your photos look their best when printed. Here are which buttons to click, when, and why:

Step One:

Get your page layout the way you want it to look. In the capture shown here, I clicked on Page Setup at the bottom of the left side Panels area, chose a 17x22" page size, set my page to a wide (land-scape) orientation, and then I went to the Template Browser and clicked on the Maximize Size template. I set my Left, Right, and Top Margins sliders to 2.00 in, and my Bottom Margins slider to 5.00 in. I also turned on the Zoom to Fill checkbox. Lastly, I added my Identity Plate below the photo, and I lowered the opacity to make it appear gray. Once that's done, it's time to choose our printing options in the Print Job panel, at the bottom of the right side Panels area.

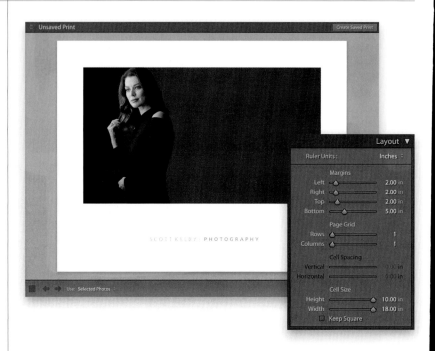

Step Two:

You have the choice of sending your image to your printer, or just creating a high-resolution JPEG file of your photo layout (that way, you could send this finished page to a photo lab for printing, or email it to a client as a high-res proof, or use the layout on a website, or…what-ever). You choose whether it's going to output the image to a printer or save it as a JPEG from the Print To pop-up menu, at the top right of the Print Job panel (as seen here). If you want to choose the Print to JPEG File route, go to the next tutorial in this chapter for details on how to use the JPEG settings and export the file.

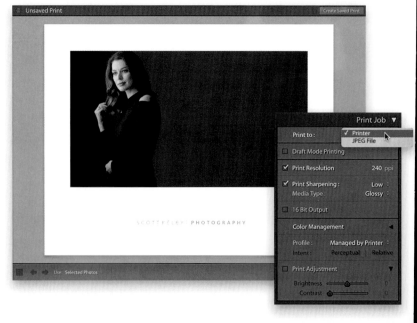

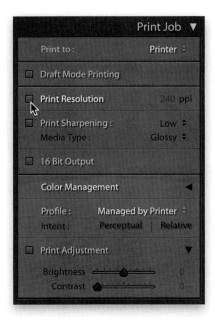

Step Three:

Since we've already started at the top, we'll just kind of work our way down. The next setting down in the panel is a checkbox for Draft Mode Printing, and when you turn this on, you're swapping quality for speed. That's because rather than rendering the full-resolution image, it just prints the low-res JPEG preview image that's embedded in the file, so the print comes out of your printer faster than a greased pig. It works beautifully—the small images look crisp and clear. However, I would only recommend using this if you're printing multi-photo contact sheets. Notice, though, that when you turn Draft Mode Printing on, all the other options are grayed out. So, for contact sheets, turn it on. Otherwise, leave this off.

Step Four:

Make sure the Draft Mode Printing check-box is turned off, and now it's time to choose the resolution of your image. For me, this is really simple—I print all my images at the file's native resolution, which means I turn the Print Resolution checkbox off. (*Note:* You'll still see 240 ppi grayed-out in the resolution field to the right when you turn this off.) I would only turn this checkbox on if I need to choose a different resolution (perhaps to up-sample my image size), but I can't even remember the last time I did that. If you search this topic online, you'll find a bunch of outdated posts from 2012, with people arguing back and forth about which setting is right, and they range from 180 to 720 (literally). Again, I don't type in a resolution; I turn off the checkbox and use my image's native resolution, whether I'm printing to my in-house Canon print-ers or sending my images out for printing at a photo lab. (I also, generally, don't use super-high megapixel cameras. By the way, most of my prints come from an 18-mega-pixel camera, which by today's standards is low, seeing as $350 entry-level DSLRs are now around 24-megapixel).

Continued

Step Five:

Next is the pop-up menu for Print Sharpening. When you tell Lightroom which type of paper you're printing on and which level of sharpening you'd like, it looks at those, along with the resolution you're printing at, and it applies the right amount of sharpening to give you the best results on that paper media at that resolution (sweet!). So, start by turning on the Print Sharpening checkbox (I always turn this on for every print, and every JPEG file I save), then choose either Glossy or Matte from the Media Type pop-up menu (based on whichever one you're printing to). Now choose the amount of sharpening you want from the Print Sharpening pop-up menu (I generally use High for everything these days. The Low setting seems so subtle that I can't tell it did any sharpening at all, and Medium seems kind of "meh" to me. But, after you do a test, if you think High is too high, then Medium is your next stop). That's all there is to it—Lightroom does all the math for you.

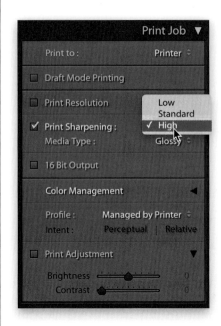

Step Six:

The next checkbox down reveals another feature: 16 Bit Output, which theoretically, gives you an expanded dynamic range on printers that support 16-bit printing. However, as it always is when it comes to printing, there is considerable debate on whether turning this 16 Bit Output checkbox on actually makes a visual difference in your prints—some folks claim you cannot see any difference with the naked eye whatsoever, and others argue it makes a difference. The important thing is: people are arguing about stuff online, and that's what keeps the Illuminati running the show (and it's why we can't have nice things). So, what do I do in regards to the 16 Bit Output? I leave it turned on. It might help, and "it couldn't hurt." (Plus, it gives me something to argue about online.)

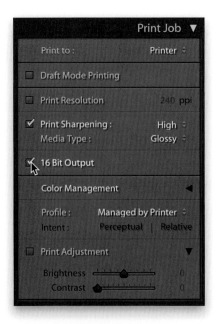

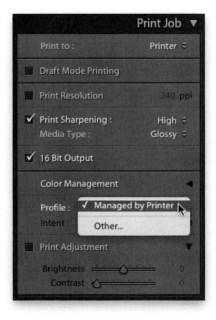

Step Seven:

Now it's time to set the Color Management options, so what you see onscreen and what comes out of the printer both match. (By the way, if you have any hope of this happening, you've first got to use a hardware monitor calibrator to calibrate your monitor. Without a calibrated monitor, all bets are off. More on this in a bit.) There are only two things you have to set here: (1) you have to choose your printer profile, and (2) you have to choose your rendering intent. For Profile, the default setting is Managed by Printer (as shown here), which means your printer is going to color manage your print job for you. This choice used to be out of the question, but today's printers have come so far that you'll actually now get decent results leaving it set to Managed by Printer (but if you want "better than decent," read on).

Step Eight:

You'll get better looking prints by assigning a custom printer/paper profile. To get these, go to the website of the company that manufactures the paper you're going to be printing on and download their free ICC color profiles for your printer. So, if I was printing to my Canon imagePROGRAF PRO-1000, on Hahnemühle Photo Rag® Ultra Smooth paper, I'd go to Hahnemühle's website, click on ICC Profile, then click on Download Center, and I'd find the profile that matches my Canon printer (as shown here, where I chose my brand and model from their pop-up menus near the top of the page). Then, I'd download and install the free color profile for my printer. On a Mac, the unzipped profile file should be placed in your Library/ColorSync/Profiles folder. To get to that folder (it's hidden), press-and-hold the Option key, then go under the Go menu, and choose **Library**. There, you'll find the ColorSync folder, and within that, you'll find the Profiles folder. Just drag-and-drop it in there. In Windows, just Right-click on the unzipped file and choose Install Profile.

Continued

Step Nine:

Once your color profile is installed, click-and-hold on the Profile pop-up menu (right where it says Managed by Printer), and choose **Other**. This brings up a dialog (shown here) listing all the color profiles installed on your computer. Scroll through the list and find the paper profiles for your printer, then find the profile(s) for the paper(s) you normally print on (in my case, I'm looking for that Hahnemühle Photo Rag® Ultra Smooth paper for the Canon imagePROGRAF PRO-1000), and then turn on the checkbox beside that paper (as seen here). Once you've found your profile(s), click OK to add it to your pop-up menu.

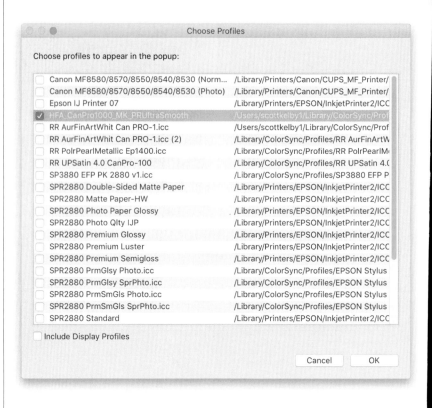

Step 10:

Return to that Profile pop-up menu in the Print Job panel, and you'll see the color profile for your printer is now available as one of the choices in this menu (as seen here). Choose your color profile from this pop-up menu, if it's not already chosen. In my case, I would choose the Hahnemühle paper profile for my Canon PRO-1000 printer, but in the pop-up menu seen here, they use the cryptic code-name "HFA_CanPro1000_MK_PRUltraSmooth." (They do that to throw off the North Koreans.) Okay, now you've set up Lightroom so it knows exactly how to handle the color for your particular printer, using this particular brand and style of paper. This step is really key to getting the quality prints we're looking for.

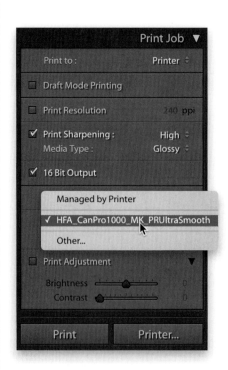

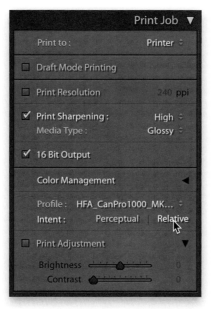

Step 11:
Next to Intent, you have two choices: (a) Perceptual, or (b) Relative. Theoretically, choosing Perceptual may give you a more pleasing print because it tries to maintain color relationships, but it's not necessarily accurate as to what you see tonally onscreen. Choosing Relative may provide a more accurate interpretation of the tone of the photo, but you may not like the final color as much. So, which one is right for you? The one that looks best on your own printer for the particular image you're printing. Relative is probably the most popular choice all around, and since you have to pick one, I'd go with that (chances are it will look the best, but to really find out which ones looks best to you, you have to do a couple of test prints and see for yourself). Try one print with Perceptual and the same image with Relative—when the prints come out, you'll know right away which one looks best to you (but know that this is somewhat image dependant). We'll cover the last option, Print Adjustment, after you make your first print.

Step 12:
Now it's time to click the Printer button at the bottom of the right side Panels area. This will bring up the Print dialog (shown here. If you're using a Mac, and you see a small dialog with just two pop-up menus, rather than the larger one you see here, click the Show Details button to expand the dialog to its full size, more like the one shown here).

Continued

Step 13:

Click-and-hold on the Print dialog's main section pop-up menu, and choose **Color Matching** (as shown here). By the way, the part of this dialog that controls printer color management, and your pop-up menu choices, may be different depending on your printer, so if it doesn't look exactly like this, don't freak out. On a PC, click on the Properties button next to the printer Name pop-up menu to locate it instead.

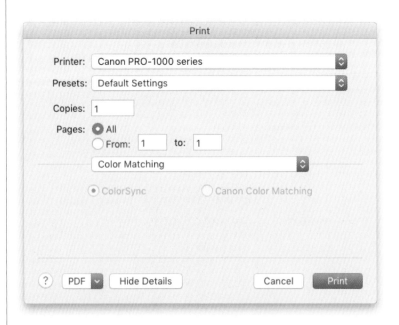

Step 14:

When the Color Matching options appear, you'll see your printer's color management may be turned off already, since you're having Lightroom manage your color (you don't want the printer also trying to manage your color, because when the two color management systems both start trying to manage your color, nobody wins). So, if it's not already set that way, be sure to turn it off. On a PC (this may be different, depending on your printer), on the Main tab, under Color/Intensity, click the Manual radio button, then click the Set button on the Matching tab, under color correction, choose **None**, then click OK. Here, mine was automatically turned off, and grayed out so I couldn't change it.

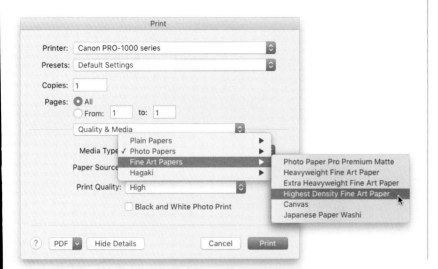

Step 15:

Now, choose Quality & Media from the pop-up menu (or go to Media Type on a PC) in the Print dialog (again, your pop-up menus may be different, and on a PC, these will be in the Properties dialog for your printer), and for Media Type, choose the paper you'll be printing to from the pop-up menu. (as seen here, I chose Highest Density Fine Art Paper). If your printer supports 16-bit output, turn it on.

CANON U.S.A., INC.; SCOTT KELBY

Step 16:

In that same Quality & Media section, select **High** from the Print Quality pop-up menu. Again, this is for printing to a Canon printer using Hahnemühle paper. If you don't have a Canon printer, choose the one that most closely matches the paper you are printing to. On a PC, for Print Quality, choose High from the pop-up menu. Now sit back and watch your glorious print(s) roll gently out of your printer. So far, so good.

Continued

Step 17:

Once your print comes out of the printer, now it's time to take a good look at the print to see if what we're holding in our hands actually matches what we saw onscreen. If you use a hardware-based monitor calibrator, and you followed all the instructions up to this point on downloading printer profiles and all that stuff, the color of your image should be pretty spot on. If your color is way off, my first guess would be you didn't use a hardware-based calibrator (the X-Rite ColorMunki and the Datacolor Spyder5 [shown here] are both pretty popular) and using one is seriously a no-brainer. You put it on your monitor, launch the software, choose "easy-you-do-it-all-automatically-for-me" mode (not it's actual name), and in about four minutes your monitor is calibrated. This is such a critical step in getting your color right that without hardware calibration of some sort, you really have little hope of the colors on your monitor and your print actually matching.

Step 18:

If you've used a hardware calibrator, and followed the instructions in this section of the book, your color should be pretty much spot on, but there's another printing problem you're likely to run up against. Your color probably matches pretty darn well, but my guess is that the print you're holding in your hand right now is quite a bit darker than what you see on your screen. That's mostly because, up to this point, you've been seeing your image on a very bright, backlit monitor, but now your image isn't backlit—it's flat on a printed page (imagine how a backlit sign looks when you turn off the back lighting. Well, that's what you're holding). Luckily, Adobe addressed this problem with the Print Adjustment option at the bottom of the Print Job panel (shown here).

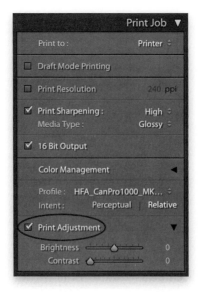

Step 19:

The thing that's so awesome about Print Adjustment is that it doesn't mess with the brightness or contrast of your actual image—your image doesn't change at all, just the print. It literally only affects the brightness of the print, while leaving the image at the same brightness as you had it onscreen. That is incredibly helpful. So, how do you know how much to increase the brightness of the print so it matches your screen? You do a test print. In fact, you kind of have to do a test print, since the changes you make with the Brightness and Contrast sliders aren't seen onscreen (they're only applied as the image is printed). Your test prints don't have to be output on big, expensive, 16x20" sheets of paper—they can be small 4x6" prints.

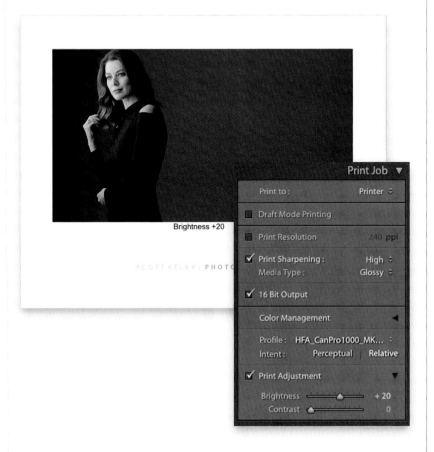

Brightness +20

Step 20:

Once you've made a few test prints at different brightness amounts, compare their brightness to what you see on your screen, and you'll know which ones look right (this is one of those cases where you should add a caption with your brightness setting appearing below the image, like Brightness +10, then Brightness +15, and then a third with Brightness +20. You add these captions in the Photo Info section of the Page panel; we looked at this feature on page 362). Once you see which setting nailed the brightness, that is your Print Adjustment Brightness setting from here on out. I haven't had to increase the Contrast to match my monitor, but if you see a loss of contrast, once you have the Brightness amount nailed down, do test prints to find out the Contrast amount, and you'll be set. *Note:* Different paper types (matte, glossy, fiber, fine art, etc.) display brightness differently, so you may need to do another test for brightness if you change papers and the brightness no longer matches.

Step Five:

Below that are the Custom File Dimensions. If you leave the checkbox turned off, it will just use whatever page size you had chosen in the Page Setup dialog. If you want to change the size of your JPEG, turn on the Custom File Dimensions checkbox, then move your cursor over the size fields and use the scrubby slider to change sizes (as shown here, where I changed it to 8.50x11". Depending on the layout, you may have to adjust your margins and cell sizes if you do this).

Step Six:

Lastly, you set your Color Management Profile (many labs require that you use sRGB as your profile, so ask your lab). If you want a custom color profile, go back to the last project for info on how to find those, and you can find info on the rendering Intent setting there, too. Now just click the Print to File button at the bottom of the right side Panels area to save your file.

I wish Lightroom had the built-in ability to add custom borders, edges, and frames around your photos, but unfortunately it just doesn't. However, you can do a little workaround that lets you use your Identity Plate, and a special option in the Identity Plate section, to get the same effect right within Lightroom itself. Here's how it's done:

Adding Custom Borders to Your Prints

Step One:

You can buy royalty-free stock edges, frames, and borders from AdobeStock .com (or any stock photo agency for that matter). But, here, I created our border (in this case, a frame with a matte) from scratch in Photoshop. I've made a short video (it's on the book's downloads page) to teach you exactly how I made it (you'll be stunned at how easy it is). Keep in mind, our border file can't have a solid white background, or it will cover our photo when we bring it into Lightroom. Instead, the background has to be transparent. So, once you build your frame, go to the Layers panel and drag the Background layer into the Trash (at the bottom of the panel; the checkerboard area is transparent). Now, save the file as a PNG, so Lightroom will honor that transparency when you use this frame image.

Step Two:

All right, that's all the prep work in Photoshop—back to Lightroom. Click on the photo you want to have an edge frame, then go to the Print module. In the Page panel, turn on the Identity Plate checkbox. Then, in the Identity Plate pop-up menu, choose **Edit** to bring up the Identity Plate Editor seen here. Click on the Use a Graphical Identity Plate radio button (because we're going to import a graphic, rather than using text), then click on the Locate File button, locate your saved PNG frame file, and click Choose to load it into your Identity Plate Editor (you may not be able to see the edge frame graphic in the small preview window, as shown here).

Continued

Step Three:

When you click OK, your edge frame will appear, hovering over your print (almost like it's on its own layer). The size and position won't be right, so that's the first thing you'll want to fix (which we'll do in the next step, but while we're here, notice how the center of our frame is transparent—you can see right through it to the photo below it. That's why we had to save this file without the Background layer, and as a PNG—to keep that transparency intact).

Step Four:

To resize your border, you can either click-and-drag a corner point outward (as shown here), or use the Scale slider in the Page panel. Once the size looks about right, you can reposition the frame edge by simply clicking-and-dragging inside its borders. You may need to resize your image, as well, using the Margins sliders in the Layout panel.

Step Five:

When it's right where you want it, just click your cursor outside the border and it will deselect. The final photo with the edge frame border is shown here. Now, if you decide you want to keep this border and use it in the future, go back to the Identity Plate Editor and from the Custom pop-up menu at the bottom-left corner of the dialog, choose **Save As** to save this frame border as an Identity Plate you can use anytime to add a quick border effect.

TIP: Frames for Multiple Photos

If you have more than one photo on the page, you can have that Identity Plate frame added to all the photos on the page automatically by going to the Page panel and turning on the Render on Every Image checkbox.

Step Six:

We created a horizontal frame, but how do you add this frame edge to a vertical photo, like the one shown here? If you change your page setup to Portrait (by clicking on the Page Setup button at the bottom of the left side Panels area), the Identity Plate will rotate automatically. If you are printing a vertical photo in a Landscape setup, you can rotate the Identity Plate by clicking on the degree field that appears to the right of the Identity Plate checkbox in the Page panel and choosing the rotation angle (as shown here). You'll probably have to resize and reposition the frame (as I did here) to make it fit just right, but now your single frame edge is doing double duty.

VIDEO
working with video shot with your camera

When you think of Lightroom, you don't think of video, right? What's the first thing you think of? That's right—light. In a room. Which is why the original working title for Lightroom (11+ years ago when it was still in Beta) was actually "table lamp," and it was nearly released as TableLamp 1.0, until someone in marketing at Adobe brought up the fact that just because there's light in a room doesn't mean the light has to come from a lamp on a table. It could come from a hanging lamp, or one of those lamps attached to the underside of a ceiling fan, or just a light fixture in the center of the ceiling, and well…the whole idea just fell apart. For a brief time (I think it was Beta 6, Build 1.3), they considered naming it "Light that hangs from the bottom of a ceiling fan," which internally went by the simple acronym "LTHFTBOACF." That was hard to pronounce, but in print, if you squinted, it looked kinda like "LIFEBOAT," but the "BOA" part is also a real name (well, a nickname for a boa constrictor), so some folks on the engineering team referred to it internally as LIFESNAKE, although some preferrred the more casual SnakeBoat 1.0, with the upper/lower case treatment with InterCaps. Then, an astute quality control expert at Adobe's Seattle office (yes, Adobe also has an office in Seattle, acquired with their purchase of Aldus in August 1994) noticed that the first three letters, "LTH," are, not coincidentally, the Airport Code for Lathrop Wells Airport in Nevada (I am not making this up). So, the Seattle office felt this was a sign, and if it hadn't been for a dyslexic typographer in Adobe's package design department, we'd all be using LathropSnakeLampBoat Classic to this very day. True story.

Trimming Your Video Clips

I think you'll be surprised at all the things you can do with video in Lightroom, and if you don't mind a few simple workarounds, you can pretty much even make your movies (complete with titles, transitions, music, and audio) and save them in HD format. But, before we get to all that (don't worry, it's all amazingly easy), let's start with the thing we usually need to do first—trimming our video clips.

Step One:

You import a video into Lightroom just like you would a photo, but you'll know it's a video because you'll see a video camera icon in the lower-left corner of its thumbnail when it appears in the Import window (Lightroom supports most major DSLR video formats). Once it's in Lightroom, you can put it in a collection, add flags, metadata, and so on, and you'll see the length of the video displayed in the bottom-left corner of its thumbnail (as seen here, where the length of the selected video clip is 11 seconds). You can see a preview of what's on a video clip by moving your cursor over the thumbnail itself and dragging either left or right to quickly "scrub" through the video.

JUAN ALFONSO

Step Two:

If you want to watch your entire video clip, double-click on it and it opens in Loupe view (as seen here). To play the video, you can click the Play button (duh) in the control bar under the video, or just press the **Spacebar** on your keyboard to start/stop it. You can also scrub through the video (kind of like manually fast-forwarding or rewinding) by just dragging the playhead in the control bar. When you play the video, it plays both the video and audio, but there's no volume control for the audio within Lightroom itself, so you'll have to control the audio volume using your computer's volume control.

Step Three:
If your video needs to be trimmed down to size (maybe you need to cut off the end a bit, or crop the video so it starts after a few seconds or so), click on the little gear icon on the far-right side of the control bar and the trim controls pop up (seen here). There are two ways to trim: Just click on an end marker handle on either side of the video clip (they look like two little vertical bars) and drag inward to trim your clip (as shown here). The other way to trim is to set Trim Start and Trim End points (which basically means "start here" and "end here") by hitting the Spacebar to let the video play, then when you reach the point you want your video to actually start, press **Shift-I** to set the Trim Start point. When you reach the point where you want the rest trimmed away, press **Shift-O** to set your Trim End point.

Step Four:
When you trim your clips, it doesn't permanently trim your video—it's non-destructive, so the original is always protected. The trimming is applied to a copy when you export the file (more on exporting later), so while that exported video will be trimmed (and what you see in Lightroom will be trimmed, as well), you can always come back to the original video clip anytime and pull those trim handles right back out (as shown here).

Choosing the Thumbnail for Your Video Clip

Have you ever seen a video (maybe on a blog or on Facebook), and the thumbnail for that video shows them frozen in mid-sentence with their mouth gaping open? Not the most flattering look, right? That's because the thumbnail is chosen randomly from a frame a few seconds into the video clip. Luckily, in Lightroom, you actually get to choose which individual frame becomes the thumbnail you see when your video clip is in Grid view or down in the Filmstrip.

Step One:
Being able to choose your video thumbnail (called a "poster frame" in video speak) is helpful if you have four or five similar-looking clips—you can choose thumbnails that show which video has which important part in it (but, you don't just see it here in Lightroom, that thumbnail goes with it when you export it outside of Lightroom, too). To choose your custom thumbnail, first double-click on your video to see it in Loupe view (as seen here), then play the video until you find the part you'd like as your thumbnail, and then stop (hit the **Spacebar** on your keyboard).

Step Two:
Now go down to the control bar, click-and-hold on the little rectangle icon to the left of the Trim Video button, choose **Set Poster Frame** (as shown here), and now your video clip will have that current image as your thumbnail.

It's called "grabbing a still," where you can take any single frame from your video and make it its own separate JPEG image (this will come in really handy a little later in this chapter, so let's go ahead and learn it now).

Pulling a Photo from Your Video Clip

Step One:
To pull a single frame out of your video and make a still image from it is pretty much the same technique as setting your thumbnail (from the previous page), with just one small exception. You start by playing your video in Loupe view (double-click on the video thumbnail to enter Loupe view), and then stop the video when you see the frame you want to pull out as a still.

Step Two:
Now go down to the control bar, click-and-hold on the little rectangle icon to the left of the Trim Video button, but this time choose **Capture Frame**. This creates a second file (a JPEG image file just like any other photo) and puts it to the left of your selected video clip in the Filmstrip (as seen here). By the way, if you haven't added this video to a collection yet, instead, the JPEG image gets stacked with your video clip and you'll see a "2" in the upper-left corner of your thumbnail (that's letting you know you have two images in your stack. To expand the stack and see both the video and the still, click on the stack and press the letter **S** on your keyboard). Again, you only have to do this if your video wasn't already in a collection.

Editing Your Video Clip (the Easy, but More Limited, Way)

If you take a video clip over to Lightroom's Develop module, it will bring up an alert letting you know "Video is not supported in Develop," but there's another way to do simple edits to your entire video clip at once—stuff like converting it to black and white, making it brighter/darker, adding more contrast, and a handful of other simple things like that—all without going to the Develop module.

Step One:

To do this simple style of editing, you'll need to stay in the Library module, so double-click on the thumbnail you want to edit, so you see it much larger in Loupe view. Now head over to the Quick Develop panel near the top of the right side Panels area. Quick Develop is a simplified version of the Develop module's Basic panel, but instead of using sliders, it uses one-click buttons to make your adjustments. The weird thing is, you can use Quick Develop to edit your video clip.

Step Two:

For example, if you want to make your entire clip black and white, in the Quick Develop panel's Saved Preset section, choose **Black & White** from the Treatment pop-up menu (as shown here). That's it—your entire clip is now black and white. If you want to make it brighter, click the Exposure single-right-arrow button once to increase the brightness 1/3 of a stop, or click the Exposure double-right-arrow button once to increase it a full stop. Some of the adjustments here will be grayed out, so you can't do everything you normally could to a photo in Quick Develop, but you can sure do a lot, like add Contrast, or adjust the White Balance Temperature or Tint, or adjust the Whites and Blacks, as well as the Vibrance amount. If you mess up, you can always Undo any button clicks **(Command-Z [PC: Ctrl-Z])**, or you can click the Reset All button at the bottom of the Quick Develop panel to reset your video clip to how it looked when it was first opened.

While it is true that when you take a video clip over to the Develop module it says "Video is not supported in Develop," that's not actually true. It's more like "Video is not supported in Develop unless you bring a friend (a still photo) along, and then you can edit in the Develop module using a lot more goodies (everything from Curves to Split Toning and more)!" Kinda weird that you can do this workaround, but it's also kinda cool that you can.

Serious Video Clip Editing (Using Lots of Goodies!)

Step One:
You'll start this video-editing-in-the-Develop-module workaround by pulling a still photo from your video, so double-click on your clip to enter Loupe view, then play the video and find a frame you want to pull out as a still. Now, go down to the control bar, click-and-hold on the little rectangle icon, and choose **Capture Frame**. This creates a JPEG file and puts it to the left of your selected video clip in the Film-strip (if your video is in a collection). Click on the JPEG file first, then press-and-hold the Command (PC: Ctrl) key and click on the video clip (so they're both selected, as shown here, but the JPEG will look brighter because it's the "most selected" of the two thumbnails).

Step Two:
Now press **D** on your keyboard to jump over to the Develop module, and your JPEG image will appear onscreen (since it's selected—and besides, it can't display the video clip). At the bottom of the right side Panels area, make sure you see "Auto Sync" (as shown here. If not, flip on the little switch to the left of Sync to turn it on). What Auto Sync does is this: whatever you do to this selected photo, it also does to the other selected photo (but in this case, the second photo isn't a photo, it's a video, but for some unknown reason, this still works). Now, whatever effects or changes you apply to that JPEG photo, those same changes are applied to your video clip. Freaky, I know. Let's give it a try!

Continued

Step Three:

Let's start by going to the Basic panel and clicking on Black & White in the top right. While we're here, let's increase the Contrast amount to +30. Now, scroll down to the Split Toning panel, and let's apply a duotone effect by dragging the Shadows Saturation slider to around 24 and the Shadows Hue slider to 40 for a brownish tint. Okay, now let's go to the Tone Curve panel, click once right in the center of the curve (the diagonal line), and drag it a little toward the bottom right (as seen here) to bring down the midtones a bit.

TIP: Using Presets in Quick Develop

If you create a cool look in the Develop module and want to use that exact look later on another video clip, save it as a preset (see Chapter 7). That way you can apply it right in the Library module, from the Saved Preset pop-up menu at the top of the Quick Develop panel.

Step Four:

Next, go to the Detail panel, and in the Sharpening section, increase the Amount to 50, then go down to the Effects panel, to the Post-Crop Vignetting section, and drag the Amount slider to the left to –11, so it adds a subtle amount of darkening all around the edges. Now, did you notice that while we were jumping from panel to panel and making edits like we always do, down in the Filmstrip, the video clip's thumbnail is updating, too? It's getting all these same adjustments and effects applied as if it were another still image. How cool is that? *Note:* There are some things in the Develop module that won't affect your video (even though they're not grayed out and it seems like they would). Stuff like profiles, or Clarity, Highlights, and Shadows, or anything in the Lens Corrections panel, and you can't use the Adjustment Brushes either.

Can you really make a wedding video, or a behind-the-scenes video, or an interview or promo right here in Lightroom, with background music, mixing video clips with stills that are animated with movement and smooth transitions, and opening and closing titles, and the save the whole thing in HD format, all without breaking a sweat? Believe it or not, you can (and it's way easier than you'd think).

Let's Make a Short Movie (and Even Save It in HD Quality)!

Step One:

The first step is to simply put all your video clips (trim them first, so this doesn't hold you up later; see page 392) and your final photos (already sharpened, edited, etc.) into a collection. Once they're all in that collection, put them in the order you want them to appear in your video (I try to use a few photos, then a video clip, then a few more stills, then a video clip, etc., just so there's not too much of one format). What's nice is, we're going to add movement to our stills—a Ken Burns–like pan and zoom—so they blend nicely with the moving video clips. So, get them in the basic order you want them (it's a collection, so you'll be able to reorder them later if you need to) by simply dragging-and-dropping them.

Step Two:

Once your images are in order, head up to the taskbar and click on Slideshow to take this collection over to the Slideshow module (that's what we're using to make our movie. Don't worry—it's better than it sounds). In the Template Browser panel near the top of the left side Panels area, click on Widescreen for your template (it's a clean, simple template), but then go over to the Options panel in the top of the right side Panels area and turn on the Zoom to Fill Frame checkbox (as seen here), so you don't have thick black bars at the top and bottom of your slide show…errr… movie. *Note:* You'll find a bonus chapter on using the Slideshow module on the book's companion webpage, mentioned in the book's introduction.

Continued

Step Seven:

At this point, we're ready to look at our movie, so hit the Preview button at the bottom of the right side Panels area and it will play a preview of your video in the Preview area. If you want to see the full-screen version, hit the Play button (to the right of the Preview button). So why would you ever hit Preview instead of Play? It's often smoother and ready to play faster than the full-screen production, so I use Preview just for the sake of time and smoother playbacks, while I'm still in the editing/tweaking phase.

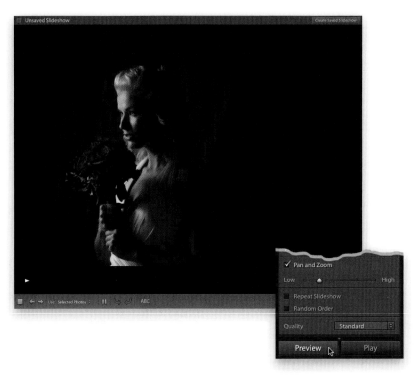

Step Eight:

When you're happy with how everything sounds and looks, hit Play to render the full-size, full-screen version. If it all looks good, it's time to export a copy in whichever format you need. So, click the Export Video button at the bottom of the left side Panels area and it brings up the Export Slideshow to Video dialog. At the bottom, there's a Video Preset pop-up menu where you choose which size/quality to export. For the highest quality (which also means the largest file size), choose **1080p (16:9)** (that's HD quality and size). If you choose each of the four sizes, a description appears right there next to it, so you know which preset is for what. Choose the one that fits how you're going to share your video and it does the rest. After a few short minutes of rendering, your video is ready to share. That's really all there is to it (and you didn't even have to leave Lightroom).

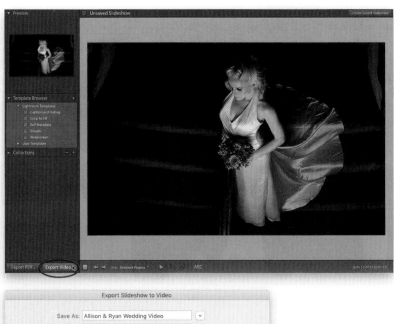

TIP: Posting Directly to Facebook

You can post your video directly to Facebook using Publish Services (see Chapter 9 for more on how to use them, but I thought you'd want to know you can post your video directly from Lightroom).

Step Nine:

Another way to export your video clips is to use the standard Export button when you're in the Library module (see Chapter 9 to learn all about exporting). When the Export dialog appears, if you scroll down a bit, you'll see an area dedicated to exporting video (seen here). Since you clicked on your video clip to export it, the Include Video Files checkbox should already be turned on, so all you have to do is make two simple choices: (1) Which video format do you want to save your clip in? I use H.264, as it's a widely supported format and makes the file size smaller without losing much (if any) visible quality (kind of like JPEG does for image files). But, of course, how much it's compressed is based on (2) the Quality setting you choose. If you're going to be sharing this somewhere on the web (YouTube, Animoto, etc.), then you'll probably want to consider a lower quality than Max (the physical size and fps will appear to the right when you choose a Quality size from the pop-up menu, so you know what each delivers). However, if you're taking this video over to a dedicated video editing application, that's when you'd want to choose Max quality.

TIP: Video Preferences

There are only two video preferences and they're found in the Library View Options (press **Command-J [PC: Ctrl-J]**), on the Loupe View tab. In the General section, at the bottom, Show Frame Number When Displaying Video Time does just what it says—it adds the frame number beside the time (yawn). The option beneath that, Play HD Video at Draft Quality, is there to make sure the playback of your HD video is smooth if you don't have a super-fast computer—the lower-resolution draft-quality video takes less power to display the video in real time than the full HD version does.

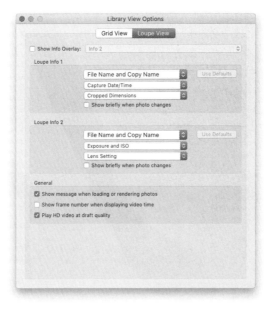

GOING MOBILE
using Lightroom on your phone/tablet & more

This chapter used to be called "Lightroom Mobile" because the app itself used to be called Lightroom Mobile, but Adobe renamed the app "Lightroom CC," probably because they realized that it was too descriptive, too obvious, and made too much sense. Actually, the full name of the app is not Lightroom CC, it's "Adobe Photoshop Lightroom CC," which is what you see on the splash screen that appears for a moment when you first launch the app. But, if you click on the LR icon in the top-left corner, it takes you to the developer credits page, and only there do you see the full and complete name for "the app previously known as Lightroom Mobile," which is (and this is its legal name, and I only know this because a Lightroom rumors site pointed this out and it was listed on a trademark registration page made public by the Freedom of Information Act) "Adobe Photoshop Tito Jermaine Jonathan Livingston Seagull Gordon Lightfoot Keanu Cher Longoria Bailey Hutchinson The Rock Sergio Mendes Marlon Lightroom CC, Sr., III, Esq." It's right there on the registration papers; you can look for yourself. That's a little long if you ask me, and if it were me, personally, I'd drop Gordon, The Rock, and Mendes, making it the shorter, and easier to remember, "Adobe Photoshop Tito Jermaine Jonathan Livingston Seagull Lightfoot Keanu Cher Longoria Bailey Hutchinson Sergio Marlon Lightroom CC, Sr., III, Esq." Apparently, also in that same trademark registration, Adobe is planning on adding a couple additional sliders to Lightroom CC, and the names of these two new sliders would be "Ointment" and "Curd." I can't imagine what those new sliders would actually do, but I know this: I'm not using them during dinner.

Four Really Cool Things About Lightroom CC on Your Mobile Device

You can extend Lightroom's power to your smartphone and tablet using Lightroom mobile (now officially called "Lightroom CC," but we'll call it Lightroom mobile here, for clarity's sake), giving you the option to edit your images pretty much anywhere. Here are four really cool things about the whole "mobile" part of your Lightroom experience:

#1: It Has a Killer Camera App!

Lightoom mobile has its own built-in camera and it's pretty darn awesome. It has a Pro mode where you can manually choose your f-stop, shutter speed, ISO, and white balance, and it even has effect presets you can apply before you take an image. If your camera supports it (like recent iPhones or Samsung phones), you can shoot in RAW. It has a great HDR feature (using the same math from Lightroom Classic on your desktop), and the high-res RAW photos you take with the camera are automatically synced back to your computer. Plus, it has a built-in leveling feature, highlight clipping warnings, and the easiest-to-use Exposure Compensation feature ever (see page 434 for more on using the camera).

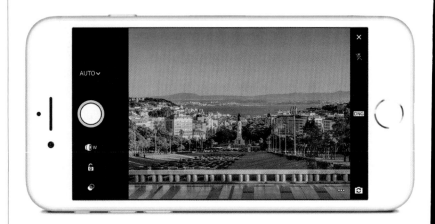

#2: You Can Sync Collections from Your Computer

When you first turn on Sync, nothing happens—all your images don't try to stuff their way onto your phone (who has that much free space on their phone, right?). You'll choose which collection(s) in Lightroom Classic (on your desktop) you want synced over to your mobile devices (if any). You turn on a checkbox and it goes over—easy as that. Once it's there, you can do most of the same stuff you do on your desktop, but now on your mobile device—everything from editing your photos to ranking, sorting, and sharing them. By the way, it doesn't sync the full high-res images over, instead it sends smart previews, which look and act like the high-res originals, but only take up around 1 megabyte of space on your mobile device.

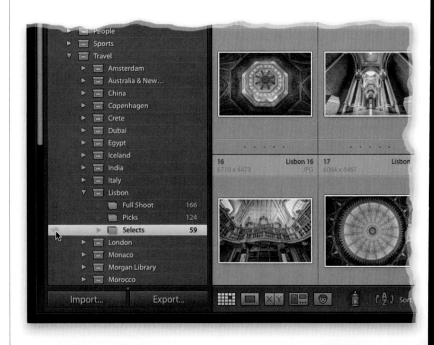

#3: You Already Know How to Use It

That's right. It's based off the features in Lightroom Classic, so when you open it and go to edit your images, you'll see all the same familiar sliders you're already used to working with—Exposure, Contrast, Shadows, Highlights, Whites, Blacks, Clarity, Dehaze, and White Balance Temp and Tint. It's the same stuff, using the same math, so really it's just about learning some of the simple interface stuff, and you're off and running. Best of all, the current version of Lightroom mobile's interface is the most like Lightroom Classic on your desktop, so you'll have no trouble getting up to speed fast (well, especially after this chapter).

#4: Your Changes Go Everywhere

When you make an edit on your mobile device or on your computer, that change is automatically updated everywhere. It all stays in sync, so it doesn't really matter where you edit your images—on your phone, tablet, or on your computer—all your changes are reflected everywhere, and it's all handled for you automatically. So, it's pretty much Lightroom wherever you are. Beyond that, your synced images aren't just on your phone, tablet, and desktop, they are also on the web, ready for you to share. Don't worry—it's all password protected, so only you can access them. But, if you want, you can share any collection with friends, family, or the public—all they need is a web browser to see them.

Setting Up Lightroom on Your Mobile Device

This is really easy, but kind of "pain-in-the-butt," stuff because you might have to log into your Adobe account in a couple different places. But, what's nice is, once you've done it, you're done, and it really doesn't get in the way again. Here's how to get up and running quickly:

Step One:
You start in regular ol' Lightroom on your desktop (Lightroom Classic): just click where the Lightroom logo lives (up in the top-left corner of the interface) and a menu will pop down asking if you want to Sync with Lightroom CC. Click on Start. If you're not already, you'll need to sign in with your Adobe ID and password. Simple enough.

TIP Three Ways to Get Images into Lightroom Mobile
(1) You can sync collections from Lightroom Classic on your desktop or laptop computer; (2) you can import photos already on your mobile device from your camera roll; or, (3) you can use Lightroom's built-in camera to take photos and, of course, they go straight into Lightroom on your mobile device.

Step Two:
Now, go to the App Store (on your iPhone or iPad), or Google Play (on your Android phone or tablet), and download the Lightroom CC app (it's free). Once you download it, launch the app and sign in with your Adobe ID and password (this is how it knows Lightroom Classic on your computer and Lightroom on your mobile device are linked to each other). At this point, you won't see any photos in Lightroom mobile (errr, I meant "CC") because you haven't chosen any collections from Lightroom Classic on your desktop to sync over to your mobile device yet (but there will be in a page or two). For now, I just wanted you to get up and running.

You'll notice I said "Collections"—that's a key point because you can't sync folders in Lightroom Classic over to Lightroom mobile; it only syncs collections. So, if you don't have the images you want in Lightroom mobile in a collection, now would be an ideal time to do that (see page 37 for more on how to make a collection out of a folder).

How to Sync Collections over to Lightroom CC (Mobile)

Step One:
Once you turn syncing on in Lightroom Classic on your desktop (we'll just call it "Lightroom desktop" from here on out), you'll see a new little checkbox appear to the far left of each collection's name. To sync one of your collections over to Lightroom mobile, just click on that checkbox, and a little sync icon will appear (as seen here).

Note: Like I mentioned, Lightroom mobile only works with collections from Lightroom desktop, not folders. So, if you have a folder in Lightroom desktop you want synced, you have to make it a collection first by Right-clicking on it in the Folders panel and choosing **Create Collection** from the pop-up menu. You can now sync that collection.

Step Two:
Now, head over to your mobile app (doesn't matter on which device—it syncs to any mobile device you have Lightroom mobile installed on), and you'll see that collection appear in Albums view (as seen here). That's really all there is to it. If you decide you don't want a particular collection synced to Lightroom mobile any longer, just go back to Lightroom desktop and click on that little sync icon to the left of your collection's name, and it no longer syncs.

Note: Adobe no longer calls them "collections" once they hit Lightoom mobile. They now call them "albums," so from here on out, that's what we're callin' 'em, too! Albums.

Working with Your Albums

Here's how to get around the main screen (kind of your Library module in the mobile version), and how to use a new type of Grid view that I wish Adobe would add to the desktop version. *Note:* As luck would have it, the Android version of Lightroom CC for your mobile device was developed quite a bit after the iPhone/iPad version, so it has always lagged behind on features. It's nearly caught up now, and much of it is exactly the same, but don't let it throw you that on an Android device, here and there, things are sometimes just different enough to drive us both mad.

Step One:
When you launch Lightroom CC (just a reminder, that's what the Lightroom mobile app is now called) on your mobile device, you're in Albums view. In this view, small thumbnails for all your collections appear in a tall vertical column, or if you're using a tablet, they appear in two side-by-side columns (as seen here).

TIP: Automatically Add Photos
You can automatically have any photos added to your mobile device's camera roll added to an album by tapping on the three dots to the right of an album's name and tapping **Enable Auto Add**.

Step Two:
To see the images inside any album (collection), just tap on a thumbnail and it shows you the images in the standard Grid view (as seen here). You can change the size of the thumbnails in Grid view by pinching out/in to zoom in/out. I will tell you, though, that this "pinch to zoom to resize thumbnails" is a bit finicky, so you might have to try it a couple of times before they actually change size (not sure why it's so finicky, but that's been my experience on multiple mobile devices, so I guess that's just how it is).

Step Three:
There are actually two different Grid views: the standard Flat view (seen in Step Two), and a Segmented view (seen here), which separates your photos by date or time. To enter Segmented view, tap the three dots in the top right, then in the pop-up menu, tap Grid View, and then tap **Segmented** to give you the date-based layout you see here (tap the three-dots again to hide the pop-up menu). You can set it to segment your photos by year, month, day, or the hour the images were taken by tapping-and-holding on the date displayed near the top left, and a list of choices will appear (as seen here in the inset).

TIP: Reordering Your Thumbnails
If you want to change the order of your photos, in Flat Grid view, tap the three dots in the top right, tap on Sort By, then tap Custom, and then tap directly on the little pencil icon to the right, which takes you to the Reorder screen, where you can tap-and-drag your photos into the order you want them (seems like an awful lot of work to do this, but that's how it is. Whew).

Step Four:
Lightroom mobile doesn't support collection sets created in Lightroom desktop, but you can create a mobile version of a collection set that acts exactly like a collection set, just with a different name—here in Lightroom mobile, it's called a "'folder." You can move albums right into these folders, just like you do with collection sets on your desktop. To create a folder, in Albums view, tap the + (plus sign) icon near the top right, and in the pop-up menu that appears, tap **Create Folder.** Now, just tap on the three dots to the right of an album's name, tap **Move To**, then tap on the new folder in the Destination screen, and then tap Move in the top right. So, if you have a collection set in Lightroom desktop that you want in mobile, start by creating a folder in mobile, and then when those albums are synced over, move them into that folder.

Continued

Step Five:

There is a bunch of hidden information you can display on the thumbnails in Grid view—just tap with two fingers on the screen and it will cycle through the various displays. For example, by default, you see a small badge with the file type (RAW, JPEG, etc.) in the top right of the thumbnail. Tap with two fingers, and it will display any flags or star ratings you assigned to the photos in this album. Two-finger tap again, and it displays the capture date and time, pixel dimensions, and file-name of each image. Two-finger tap again, and it displays the f-stop, ISO, and shutter speed for each image (as seen here). Two-finger tap again, and it shows any "likes" or comments for these images (more on this part later), and one more two-finger tap hides all the data and just shows you the thumbnails (that's the view I stick with—I just want photos, not a bunch of data, but hey, that's just me).

Step Six:

If you want to add a photo to your existing album, go to the bottom-right corner of the screen and tap either the Add Photos icon to add an image from your camera roll (or from all the photos you have synced in Lightroom mobile), or tap the camera icon to take a photo using Lightroom mobile's built-in camera (the photo you take will be added to the currently visible album).

Step Seven:

To see an image larger, just tap on it and it zooms to the Loupe view size you see here. To hide any extra onscreen info and the toolbars, and just see your image presented full screen, tap once on your image and it all quickly hides away. To return to regular Loupe view, just tap the screen once again. To see a filmstrip of the rest of the images in your album across the bottom of the screen:

iPad: Tap the Filmstrip icon in the bottom right of the screen.

Android Tablet: Tap the star icon near the bottom right of the screen.

iPhone/Android Phone: Tap on the Panels pop-up menu in the top left, then tap on Rate & Review.

TIP: Seeing Your Photo's Metadata

To see everything from copyright info to title, caption, and file info, on a phone, tap on the Panels pop-up menu in the top left, then tap **Info**. On an iPad/Android tablet, tap the round "i" icon in the bottom right.

Step Eight:

If you want to copy or move images from one album to another, or even remove images from an album or delete them altogether, in Grid view, tap the three dots in the top right, then tap on what you want to do in the pop-up menu, and then tap on the image(s) you want to do it to (select multiple images by just tapping on them). For example, if you've chosen to move images, tap on them, then tap the arrow in the top right to see a list of albums. Now, just tap the box beside the album where you want to move them to, and then tap **Move** in the top right. To cancel the move (or copy), tap the "X" in the top left. The other functions (Remove from Album and Delete) work similarly. *Note:* Remove from Album removes the image(s) here, and back in the collection in Lightroom desktop, but it does not delete the original file—that's still in the original folder on your computer.

Adding Pick Flags and Ratings to Photos

Adding Pick flags and star ratings is definitely more fun here in Lightroom mobile than it is in Lightroom desktop. Plus, it's nice to just sit back after a shoot, get comfy on the couch, pour a glass of Silver Oak (er, I mean VitaminWater, or tea…yeah…tea), and just swipe through your images, tagging your favorites.

Step One:
You add Pick flags and star ratings in the Rate & Review panel. To get there, you start by tapping once on a photo to enter Loupe view, then:

iPad/Android Tablet: Tap the star icon (circled here in red) near the bottom right of the screen.

iPhone/Android Phone: Tap the Panels pop-up menu in the top left (to the right of the back arrow icon), and then tap on **Rate & Review**.

This adds a row of stars and a flag (or two on an iPad/Android tablet, as seen here below the Filmstrip) that you can tap to add a star rating or Pick flag (or Reject flag), but there's actually a faster way—it's called "Speed Rating."

Step Two:
To flag an image as a Pick, just swipe up/down on the *right* side of the screen and a pop-up display will appear in the center, where you can choose which flag (Pick, Unflagged, or Reject) you want (as seen here). To add a star rating, just swipe up/down on the *left* side of the screen and a pop-up display will appear in the center with 5 stars (as seen here in the inset). Just stop on the star you want. Now, swipe to the right to bring up the next image and do it all again. It's a really quick way to go through a shoot.

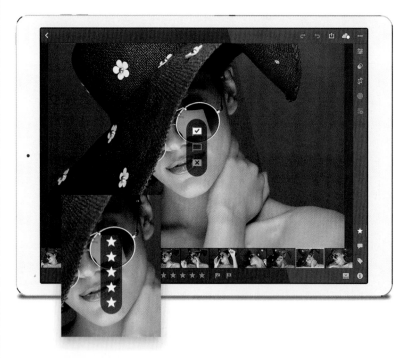

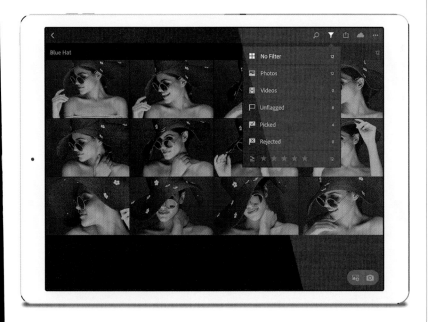

Step Three:
To see just your Picks (or just your star-rated images), tap the back arrow icon (in the top left) to return to Grid view, and then tap the little funnel-like icon in the top right to bring up a filtering pop-up menu. You'll see Unflagged (and the number of images you didn't flag listed to the right of it), Picked (and how many images you flagged as Picks), and Rejected (and how many rejects you have, which I'm hoping is not many because if it's a lot, we might need to have an entirely different discussion, but I digress). Tap on any one of those and just your Picks, Unflagged images, or Rejects are displayed. At the bottom of the menu are your star ratings, where you can just tap on the star rating for the images you want to see (hopefully, you're tapping the fifth star because there are so many awesome shots with that rating). To turn all these filters off, just tap **No Filter** (or **Show All**) at the top of the menu, and now all your images in that album are visible again.

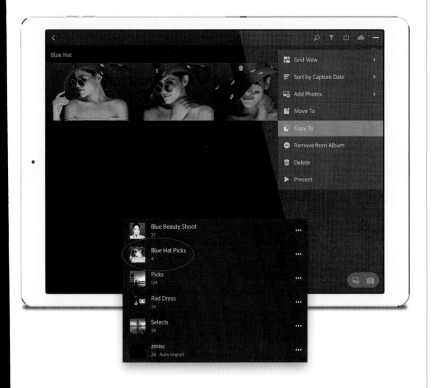

Step Four:
If you want to put your Picks, or maybe your 5-star images, into their own separate album, first turn on the Picked (or star rating) filter, then tap the three dots in the top right, choose **Copy To** in the pop-up menu, then tap on all your Picks (or 5-stars) to select them (on an Android device, you'll select them first, then tap Copy to Album). Now, tap the right arrow icon in the top right to choose their destination. This will bring up the Destination screen with all of your albums, but you'll want to tap the + (plus sign) icon in the top right and then tap **Create Album** in the pop-up menu. Name your new album, tap OK, then tap Copy in the top right to copy your Picks into this new album. When you tap the back arrow icon in the top left, it returns you to Albums view, and you'll see your new Picks album listed there alphabetically.

Editing Your Images on Mobile

Good news: you already know this stuff—it's the same sliders that do the same things, using the same math. The interface is slightly different if you turn the screen sideways (it's more like Lightroom desktop, with your panels and sliders on the right side), than if you use it tall (it's a more mobile-like interface, with the sliders along the bottom), but either way, you're already most of the way there, bunky.

Step One:

To edit an image, first tap on the image to enter Loupe view, and then:

iPad/Android Tablet: Tap the Edit icon near the top right of the screen (shown circled here in red) and the Edits panel pops-out on the right.

iPhone/Android Phone: Tap the Panels pop-up menu in the top left (to the right of the back arrow icon), then tap on **Edit** and a row of icons appears across the bottom of the screen. If you turn your phone sideways, the icons move to the right side of the screen, and it's more like Lightroom desktop.

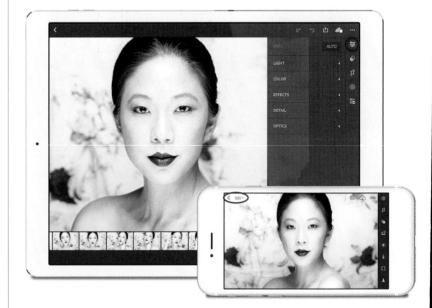

Step Two:

The color and creative profiles (see Chapters 5 and 7) are all here in Lightroom mobile. Tap the Browse button (its icon looks like three photos stacked on one another), and the Profiles browser pops out. As in Lightroom desktop, these thumbnails give you a preview of your image with each look applied. There is no live preview for your image, though—tap to see one applied. If you don't like the look, tap on a different profile. If you don't like any of them, tap the curved left-facing arrow at the top right of the screen or the little X at the top right of the browser (the checkmark at the bottom is the "done" button). To change to a different set of profiles, tap on a different set or tap the menu at the top of the browser where you can choose the same ones from Lightroom desktop. An Amount slider appears below your image for those profiles that allow you to adjust the amount of the effect.

Step Three:

In the Edits panel, Adobe rearranged the sliders in each section, so they make more sense together. Each section (or icon, if you're using a phone) you tap on brings up another set of sliders. For example, tap on Light (or the icon that looks like the sun) and all the sliders that have to do with light (Exposure, Contrast, Highlights, Shadows, Whites, and Blacks) appear (as seen here). At the top of this section is a button for Curves. Just tap along the diagonal line to add a point to the Curve, then drag up to brighten, or down to darken the tones in that area. To remove a point from the Curve, double-tap on it.

Step Four:

One of my favorite features from Lightroom desktop is here in mobile—it's just kind of hidden—and that's the ability to get a clipping warning if you're blowing out your highlights. You can see this warning onscreen when adjusting the Exposure, Shadows, Highlights, Whites, and Blacks by just pressing two fingers anywhere on the slider you're adjusting. The image will turn black and only display any areas that are clipping the highlights. Here, cranking up the Whites too much clipped her skin in just the Red channel, but clipped all three channels on her forehead, which is some pretty serious damage, and now I know to back down the Whites (or lower the Highlights) to avoid this clipping.

Continued

Step Five:

The vastly improved Auto tone button made its way over to mobile, as well (it's at the top right of the Edits panel. On a phone, its icon looks like a photo with little sparkles on the top right). Just one tap on it and it either looks good or you'll tap the Undo button up top to undo it (like, in this case, where it looks bad—well for beauty-style post-processing anyway).

TIP: There's an Undo button

If you make a mistake, tap the curved left-facing arrow in the top right of the screen to undo your last step. Luckily, you can tap it again and again to keep undoing your last steps.

Step Six:

To change your white balance, tap on Color (its icon looks like a thermometer) and the Temp, Tint, Vibrance, and Saturation sliders appear. Near the top center of this section is a pop-up menu of White Balance presets (it's a longer list if you shot in RAW; quite short if you shot in JPEG). The White Balance Selector tool that you know and love (see page 137) is also here (to the right of the WB pop-up menu)—tap on it and it brings up a loupe that you can drag over your image. The preview is live, so as you move it over your image, you'll see how it affects the color as you drag-and-release. When you find an area where the white balance looks good, tap the checkmark on the loupe and it returns to base. To cancel, just tap the eyedropper icon again.

Step Seven:

While we're still in the Color section, there's a B&W button here to convert your image to black and white, but I would avoid this button because it creates a very flat black-and-white. Instead, use the B&W profiles in the Profile browser (seen in Step Two). To the right of the B&W button is an HSL Color Mix button that brings up the HSL sliders to adjust individual colors in your images. (*Note:* The Targeted Adjustment Tool, or "TAT" as it's known, is here, too, once you tap the HSL Color Mix button. It's at the top of the Color Mix section—tap on it to activate it, then tap-and-drag up/down over the area of color in your image you want to adjust.)

TIP: Resetting and Starting Over

If you really mess up and want to reset and start over from scratch, just tap the Reset icon (the downward-facing arrow with a line beneath it) beneath the panels. A pop-up menu will appear asking how much you want to reset: tap Adjustments for just the adjustments you've made; tapping All reverts you back to the original image; To Import takes it back to how it looked when you first opened the image in Lightroom mobile (so it undoes what you did here in mobile, but not stuff you did to it in Lightroom desktop); and To Open will reset it back to when you last opened it.

Step Eight:

The Effects section has sliders like Clarity, Dehaze, and Vignette Amount, and they work the same way they do in Lightroom desktop. There's also a button here for adding color Split Tone effects (hey, shouldn't that be in the Color section? [Insert sound effect of crickets here]). Tapping Detail (the triangle icon) will bring up the same Sharpening sliders you're used to using in Lightroom desktop (as seen here), along with the Noise Reduction sliders. Nothing much to see here, folks. Move along.

Continued

Step Nine:

Besides all the sliders, three of the awesome adjustment brushes and filters made it over to mobile (the Adjustment Brush, the Graduated Filter, and the Radial Filter), and applying them with your finger is actually pretty great. Tap the round Selective Edits icon (the one with the dotted circle around it, shown circled here in red) and a big + (plus sign) icon appears in the top-left corner of the screen. Tap on it and the three adjustment tools appear. Tap on the one you want (we'll tap on the Adjustment Brush here), and a menu pops out from the left center for brush size, feather (softness), and flow. Tap on one, and then drag up/down to change the setting.

TIP: Seeing a Before/After

To see what your image looked like before you started adjusting it, just tap-and-hold on it (you'll see "Before" appear above the image).

Step 10:

Once you tap one of these tools on your image, you'll then need to "Set Adjustments for Your Selection," so tap the adjustment for what you want to do (Light, or Color, or Effects, and so on), then start painting with your finger to adjust that area (if you're using the Graduated Filter, you can tap-and-drag down with your finger, or if you're using the Radial Filter, you can just tap-and-drag outward to create your pool of light). A pin will appear where you first tapped, and if you tap-and-hold on that pin, a menu will appear with options, like for showing the mask as you paint, duplicating the brush edits, or removing the brush edit altogether. When you're done with your adjustments, tap the Done button (or the checkmark icon, if you're using a phone) to apply your edits, or tap Cancel (or the small "X") to cancel your selective edits.

Step 11:
Tapping the Presets icon (the two overlapping circles) gives you access to a ton of Develop module presets, and each one has a tiny preview beside it. These presets are literally just one-tap effects—tap one and it applies a look. If you like the look, tap the Done button (or checkmark icon)—boom—done! There are seven sections of presets—Color, Creative, B&W, Curve, Grain, Sharpening, and Vignetting—and all you have to do is tap on any one, then tap the Done button to apply it. Of course, once we apply a preset, we can still make adjustments with our sliders (Exposure, Contrast, etc.). *Note:* Currently, you cannot import custom presets you bought or created in Lightroom desktop into Lightroom mobile. Don't shoot the messenger.

Step 12:
In some cases you can "stack" presets—having one add its effect on top of another—and a great place to see this in action is when you use presets that add things like vignette looks (darkening the outside edges of your image) or noise (grain), or apply Curve adjustments. The reason these add on is that most of them don't use the Split Tone sliders or the Color Mix sliders or any other options that might get changed by applying another preset. For example, if you apply a B&W preset, then apply a Color preset, the color overrides the black and white and changes the image back to color. But, adding noise (grain) or a vignette adds on to the look you applied with the first preset because it doesn't use any of the same sliders. Here, I started by applying the B&W preset, B&W Soft. Then, in the overlay, I tapped on the Grain presets and added Medium to enhance the grainy film look.

Continued

Step 13:

One of the most powerful time savers from Lightroom desktop is here, too: the Apply Previous button. It takes the adjustments you made to the previous image and applies them to the current image with one tap (super handy and fast!). To use it, tweak a photo the way you like it, then bring up the Filmstrip, swipe to the image you want to apply this look to, and tap on it. Now, in the Edit panel, tap on the Previous icon (it looks like three sliders with a right-facing arrow) and a pop-up menu appears (seen here), asking if you want just the basic tonal edits you applied, or everything you did to the previous photo, including cropping, rotating, etc. Make your choice and the edits are applied immediately.

Step 14:

There's one more way to get edits from one image applied to another (or a bunch of other images): you can literally copy-and-paste the edits you've made. Once you've applied the edits you want to copy, tap the three dots in the top right and, from the pop-up menu that appears, choose **Copy Settings**. Turn on/off the settings you want to copy in the Copy Settings dialog, and tap OK. Now find an image where you want to apply those same settings, tap the three dots again and, from the pop-up menu, choose **Paste Settings**. That's all there is to it. You can paste those settings to as many images as you'd like.

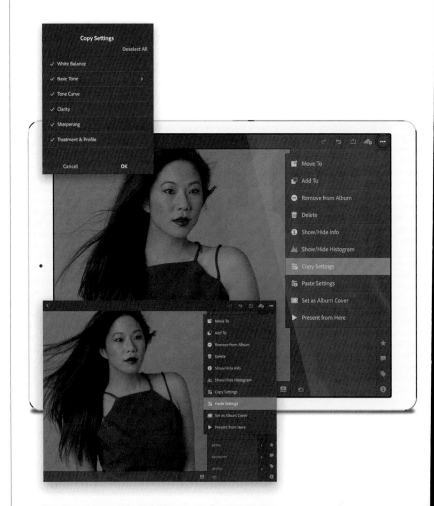

Step 15:

If you have an image with lens issues, you can apply a lens correction profile by tapping on Optics (the lens icon) and then turning on Enable Lens Corrections. It will choose a built-in lens profile for your particular lens make and model (if one is available, of course). If it doesn't find one, well…you're out of luck. Well, I guess not entirely—you could go on to the next step.

Step 16:

Tap on Geometry (its icon looks like… well…geometry), and you'll find the Upright features, which are automated one-tap fixes for common lens problems (like buildings leaning back, or not being horizontally centered in your image). Upright will even fix a crooked image for you. You'll see the manual sliders in this panel (Distortion, Vertical, Horizontal, Rotate, and Aspect, just like in Lightroom desktop), but at the top, to the right of Upright, you'll see "Off." Tap this to bring up the Upright menu (Auto, Level, Vertical, etc. See page 252 for more on the Upright features). Also in this menu is Guided, which lets you tap-and-draw out lines along parts of your image that are supposed to be straight (for more on Guided Upright see page 256). This feature works really well on mobile devices—it feels more natural than on your desktop. You can draw out up to four lines. If you don't like the results, just tap the trash icon. If you're happy with the results, tap the Done button. Easy as that. There's also a Constrain Crop button near the top of the panel that auto crops away white gaps that may be created when applying either Upright or Guided Upright (I usually leave this turned on. It's a big timesaver most of the time).

Cropping & Rotating

If there's one thing that really translated well on a mobile device, it's cropping and I gotta tell you, I'm not sure if I don't like this better here, than in Lightroom desktop. It really feels quick and intuitive, and you can pretty much do all of the same stuff you do on your computer. But, somehow, it seems smoother and easier here. In short, you'll dig it.

Step One:
If you need to crop your image, just tap on the Crop tool icon. You'll know it's active because it puts a cropping border around your entire image (as seen here), and the Crop and Rotate panel pops out (or if you're using your phone, a row of icons appears along the bottom, or the side, depending on if you have your phone tall or turned sideways). Here, you'll find all the different cropping options from Lightroom desktop.

Step Two:
To apply any of the preset cropping ratios (1x1 Square, 4x3, 16x9, and so on), just tap on the Aspect pop-up menu (or on the icon with the stacked rectangles, if you're using your phone), then tap any preset and your image is cropped to that ratio. Here, I tapped on **16x9** and the cropping border updated to the new ratio. The areas that will be cropped away are still visible, but they're shown in dark gray (you can see here a horizontal strip would be cropped off along the top and bottom if I were to go with this cropping ratio). Now that you've applied a crop, you can reposition your image within that cropping border by just tapping-and-dragging the image right where you want it.

TIP: Resetting the Crop
To return to the original uncropped image, just double-tap anywhere within the cropping border.

Step Three:

Besides just cropping ratios, there's a Locked icon, which gives you a free aspect option. This means you're not constrained to any preset ratio, so once you tap on it to unlock it, you can tap on any corner or side of the cropping border and drag just that part right where you want, without affecting the other three sides (it's like clicking on the Unlock icon for the Crop Overlay tool in Lightroom desktop). Here, I tapped on it to unlock it, and then just tapped-and-dragged each side of the cropping border right where I wanted them. In the Rotate & Flip Image section, if you tap the Flip H icon (the one with the two horizontal triangles), it flips your image horizontally (like I did here—her arm is now on the right side of the image), and of course, tapping the Flip V icon (the one with the two vertical triangles) flips your image upside down.

TIP: Changing the Crop Overlay

When you choose the Crop tool, you can have it temporarily display a Rule of Thirds overlay grid by just two-finger tapping within the cropping border.

Step Four:

If you want to rotate your image within the cropping border, just tap-and-hold outside the cropping border and drag up/down and the image will rotate within the cropping border (so you're rotating the image, not the border). Here, I tapped-and-dragged outside the border and rotated her a little to the left.

TIP: Flipping the Crop to Tall

By default, a crop is applied wide (landscape), but if you want to flip it to the same ratio, but tall (portrait), tap the icon with the rectangle and upward- (or downward-) facing arrow in the Aspect section (or in the top-left corner), and it flips to a tall crop.

Sharing Your Lightroom Albums on the Web

When you sync albums (collections) from Lightroom desktop, of course they are synced to your phone and/or your tablet, but those same albums also appear on a special, private website (that only you have access to). The advantage of having "Lightroom Web" is that you can use it to share your albums with any individual (or the public on social media, if you choose), and it has lots of interesting options and features wrapped around it.

Step One:

While this is an extension of Lightroom mobile (because it's based on syncing one or more albums [collections] from your desktop), you actually don't access this feature through mobile—you access it from a web browser on your desktop (well, I guess you could technically launch a browser on your phone or tablet and see it there, but you already have access to those albums on your mobile device). To see your synced albums, in Lightroom desktop, go under the Help menu and choose **View Your Synced Collection on the Web** (as shown here). If you don't see that option under the Help menu, just go to http://lightroom .adobe.com.

Step Two:

That launches your web browser and takes you to Lightroom Web (your images are password protected, so you might need to sign in with your Adobe ID and password). Here, you'll see all your synced albums right on the web. So, what's the advantage of having them here? Sharing! It makes sharing your albums with anyone really easy. For example, let's say you shot a high school football game and you wanted to share the images with the other parents. You could share that album individually (by emailing or texting the parents), or publicly (by sharing the album directly to Facebook, Twitter, or Google+).

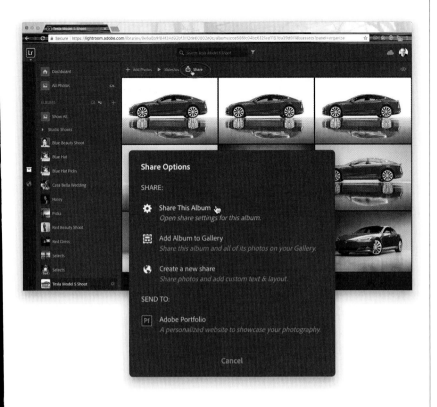

Step Three:
To share any album, click on it and then click on Share near the top of the page (as shown here). This brings up a window asking if you want to Share This Album or Create a New Share (which is a page where you add text and tell a story with your photos). For now, just choose Share This Album. That brings up another window, letting you know it's private, blah, blah, blah, so just click the Share This Album button.

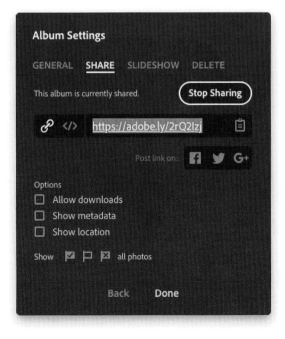

Step Four:
This brings up the Album Settings window. There are four tabs here, but by default, the Share tab will be visible because that's the one you'll use the most. In this tab, it shows you the web address where this album is posted. Click on the clipboard icon to the right of that web address to copy it into memory, so you can email or text this address to a friend or client. If you want to share it publicly, click the Facebook, Twitter, or Google+ icon. Below that are some options for this posted album: you can allow downloads (if you shot that football game, this would allow other parents to download low-resolution photos of their kids); turning on Show Metadata would include your f-stop, shutter speed, camera info, etc., for each image; and turning on Show Location would share any embedded GPS added by your camera. If you only want to show the Picks, unflagged images, or Rejects in this album, click on the flag option (I'm interested in finding the photographer who wants to share their Rejects. They'd make a great Oprah guest).

Continued

Step Five:

When someone types that web address into their browser, they'll see what you see here on the right. They can click on any image to see it larger, they can scroll through the images using the arrow keys on their keyboard, and they can hit the Play icon in the top-right corner to see a slide show, complete with transitions (you can choose your slide show options in the Slideshow tab in that Album Settings window seen back in Step Four). When they're viewing a larger image (as seen in the next step), they can see any metadata or GPS info by clicking on the little "i" icon on the right side of the page, and a panel will slide out with those details. That's pretty much all they can do—they can view your images in any web browser, but that might be enough.

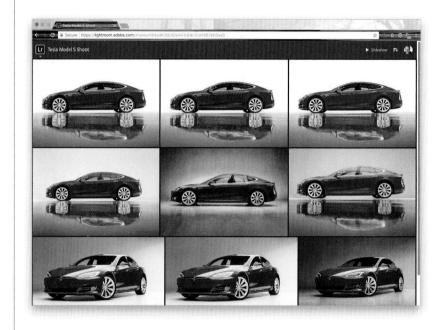

Step Six:

If you want the person/client you shared this album with to be able to choose their favorite images or even leave comments to you about a particular shot, then they'll need an Adobe user account (with a user ID and password). Luckily, they are free, so they could just sign up for one. But, what I do is create an account for my clients (just one generic account— like access@KelbyPhoto.com—with a simple password—like "client"). This isn't banking info, so simpler is better, and they'll only see the shoot I'm sharing at that web address, so they can all use the same user ID and password. Now they can log in, and if they see an image they like, they can click the heart icon, and if they want to leave a comment, they can click the comment icon (both in the bottom left), and their comments will appear right within Lightroom desktop.

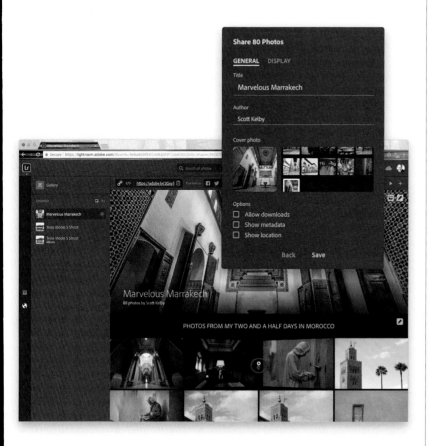

Step Seven:

When the person you shared your album with marks a photo as a favorite or leaves you a comment, Lightroom lets you know by adding a yellow comment icon to your collection in Lightroom desktop (you'll also see it as a thumbnail badge, like the one shown circled here). To see their written comments (or even respond back), go to the Comments panel at the bottom of the Library module's right side Panels area (as seen here).

TIP: Editing Images in Web

If you want to make edits to your images while you're in Lightroom Web, no problem—the Basic panel adjustments are available right online. Just click on a photo to select it, then tap on the Edit This Photo button in the top-left corner, and the Edit sliders pop-out from the right side.

Step Eight:

If, instead of just sharing an album, you want to use that Create a New Share feature (so you can add text and do some storytelling, like sharing your vacation photo story with friends and family), then back in the Share Options window, click on Create a New Share, give your story a title, and choose a cover photo. Luckily, Adobe has done a great job of putting buttons where you can add text, so you'll have no trouble with that part, but one thing that is kind of hidden is how to create a divider between photos, so you can separate them and add more text. You have to hold your cursor between two images and a break appears, like the images are opening a door to a little + (plus sign; as shown here). Click on it, and it creates a separation at that point, and a new text block button appears, so you can add text. When you're done formatting your story, the share link is already visible in the top-left corner of the page, ready for you to text, email, or post to social media.

Sharing a Live Shoot to a Phone, Tablet, or the Web

I think this is one of the coolest features of Lightroom mobile, and it really impresses clients because the technology here is really pretty cool. We're going to set things up so that, during a live shoot, we can hand our client our tablet and not only can they see the images coming in live as we shoot, they can make their own Picks, comments, and even share the link with someone at a different location, so they can be part of the shoot, and the approval process, too!

Step One:

You're going to need to shoot tethered, so when you take a shot with your camera, it goes directly into Lightroom desktop (well, in this case, it's going to my laptop, but you know what I mean. See Chapter 3 for how to set up to shoot tethered). Here's a behind-the-scenes shot from a fashion shoot, and as I shoot the images, they come straight into Lightroom Classic on my laptop. I want to be able to hand my client my iPad (or Android tablet) and let them see the images from the shoot on that iPad as I take them, but I also want control over which images my client sees (more on why in a moment).

Step Two:

First, create a new collection in Lightroom desktop/laptop, and when the Create Collection dialog appears, give it a name (I named mine "Red Dress Shoot"), then turn on the Set as Target Collection checkbox (a very important checkbox for this all to work). Also, turn on the Sync with Lightroom CC checkbox (also very important). What that "target collection" stuff means is this: any time I see a photo from this live shoot that I want my client to see on the iPad they're holding, I press the letter **B** on my keyboard. That takes the photo and adds it to that collection (my target collection). I only want my client to see my best shots—not the ones where my subject's eyes are closed, or the flash didn't fire, or my timing was off—so I only tap the B key when I see a good shot.

Create Collection

Name: Red Dress Shoot

Location
☑ Inside a Collection Set
 Fashion

Options
☑ Set as target collection
☑ Sync with Lightroom CC

Cancel Create

Step Three:

Now that everything's set up and ready to go, I launch Lightroom CC (mobile) on my iPad and there's my newly synced collection (well, it's an "album" in Lightroom mobile on my iPad). I tap on that album and hand it to my client, or art director (or friend, assistant, guest, etc.), who is there on the set, well behind the position where I'm shooting from (most photographers don't like someone looking over their shoulder when they're trying to shoot).

Step Four:

Now I start the shoot, and when I see a shot a like (one I want the client to see), I simply reach over and tap the letter B on my laptop. That image now goes to that targeted collection on my laptop, is synced to the iPad my client is holding, and right there in Lightroom mobile they see the shot. I let my client (friend, family member, etc.) know that if they like the shot, they can tap the Pick flag at the bottom of the screen. Now, if for any reason, you're uncomfortable with handing your client your iPad/tablet, or if you don't have one yet, then instead you'll use Lightroom Web (see page 426), share that synced album, and just text them the album's web address (the one you targeted), and it will work pretty much the same way, but they'll see the images in their web browser, rather than on your iPad. Also, they will use the heart icon to mark their favorites, instead of a Pick flag. They can also leave comments, if they have (or you give them) an Adobe user ID and password (mentioned on page 428). The cool thing about doing it this way is that they can now share that web address with other people (maybe folks back in their office), so they can watch the shoot live, too, right from their web browser. How cool is that?!

Lightroom Mobile's Advanced Search

As a country, as a world, we can't agree on many things these days, but one thing we all can agree on, regardless of our background, is that having to do keywording stinks (and, of course, I wanted to use a stronger term, but you get the gist). Anyway, Adobe knows you hate keywording and that's why you'll love their keywording-free, magical-unicorn-style search feature, which lets you search by describing what you're looking for, like "cars," "guitars," "pizza," or "the kids," and so on. It's another feature powered by Adobe Sensei, and the weird thing is, for the most part, it works pretty darn well.

Step One:

In Albums view, tap on the magnifying glass icon (shown circled here) up in the top-right corner to bring up the Sensei-powered search field. You'll type in a description of what you're looking for and it will use its artificial intelligence to visually search for images that contain that object (no keywording necessary).

TIP: Safe In-Person Sharing

If you want to hand someone your mobile device, so they can see your images, but without accidentally adding or changing anything (Pick flags, star ratings, edit sliders, etc.), before you hand them your device, turn on Present mode—it disables all that stuff, so you don't have to worry about them accidentally changing anything. Tap the three dots (…) in the top-right corner, then tap on **Present** in the pop-up menu. When they hand your mobile device back to you, just tap the X in the upper-left corner to exit Present mode.

Step Two:

In this case, I wanted to find all my football images, so I typed "football" in the search field, then tapped the Search button on the keyboard. In literally just a second or two it displayed all my images that visually matched that search term, as seen here where it found a bunch of football photos, all from different albums.

Step Three:
Once your results appear (and they will appear almost immediately), you have a few sorting options. Tap the three dots in the top-right corner and in the menu that pops-up, you'll see that, by default, it sorts by relevancy. Tap on Sort by Relevancy to bring up the other Sort options. If you choose to sort by Capture Date (as I did here), it puts your most-recent images at the top. To reverse the order (and see the oldest shots appearing first), tap the icon to the right of Capture Date (the three lines with the down-facing arrow).

TIP: Save RAW Photos Taken with Lightroom Mobile's Camera App to Your Camera Roll
By default, RAW photos taken with Lightroom mobile's built-in camera app go directly into Lightroom mobile, not into your cell phone's Camera Roll (or Gallery). But, if you want to save one of those RAW images to your Camera Roll (apparently, a lot of folks want to do this), here's how: Tap on the image you want to save to your Camera Roll, then tap on the Share icon up top. In the pop-up menu, tap on Export Original, then tap on **Camera Roll** (or **Gallery**) and the RAW image will be saved to your Camera Roll. Easy as that.

Step Four:
When you start a search from Album view (where all your collections…er…I mean "albums" appear), by default, the Sensei find feature searches through all the images you have in Lightroom mobile. However, if you just wanted to search within a particular album, first tap on that album to display its contents (as I did here), then tap on the magnifying glass icon up top. Now, type in your search term (in this case, I typed in "bouquet") and the results that appear (shown in the inset) display the only two shots in this album where you can see a bouquet.

The Built-In Camera (It's Pretty Sweet!)

I mentioned at the beginning of this chapter that Lightroom mobile has a pretty killer built-in camera feature, and once you start using it, you won't be able to go back to the regular camera app that comes with your phone. Here's how to unlock all those features that take it over-the-top when it comes to usability and results.

Step One:

If you're in Albums view, or if you're in an album, you'll see a blue pill-shaped button in the bottom-right corner of the screen. Tap the camera icon on the right side of that button to bring up Lightroom mobile's camera. If you click on the camera button when you're in an album, the images you shoot with the camera will appear in that album. Otherwise, they will appear in All Photos at the top of Album view.

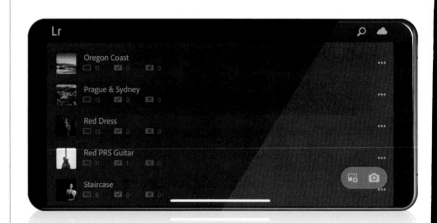

Step Two:

When the camera appears, it's in Automatic mode, by default, which works like the camera app on your phone (boooo!)—it makes all the exposure decisions for you; you just point-and-shoot (snore). However, if you want full control over the white balance, ISO, shutter speed, and aperture, individually, like you would on a DSLR or mirrorless camera, tap on **Auto** just below the shutter button and a menu will pop-up with different choices, including High Dynamic Range (more on this in a moment), but for now just choose Professional mode (as shown here).

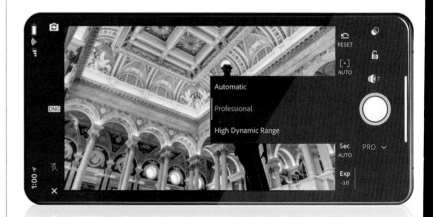

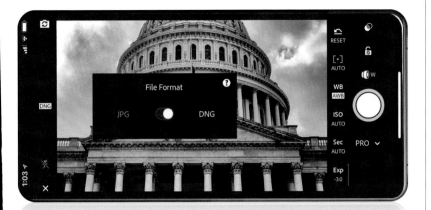

Step Three:

All the Pro adjustment icons will now appear to the left of the shutter button (as seen here). Tap on any one of them and a slider will appear (or icons if you choose White Balance). Also, by default, your camera will be shooting in JPEG format, but if your camera can shoot in RAW format (like the iPhone 6 and up, and many high-end Android phones), just tap on JPG on the left side of the screen and the File Format options will appear (as shown here). Just tap on the button to toggle over to shoot in DNG (Adobe's RAW image format).

Step Four:

When it comes to focusing, it works pretty much like every other camera—you tap-and-hold on the thing you want in-focus and a square focus area box appears. If you want to adjust the exposure (using Exposure Compensation), you can do that easily by tapping-and-dragging left (to darken the exposure) or to the right to brighten it (as seen here). It's quick and easy, and it shows you (in stops) how much Exposure Compensation has been applied by your swiping.

Continued

Step Five:

The three icons above (or to the right of, if you're holding your phone vertically) the shutter button give you (from top to bottom/right to left): live shooting effects (more on this in a moment); an Exposure Lock feature (just tap on the lock icon to lock your exposure, as you recompose your image); and a way to toggle between wide angle and telephoto (if you have a phone that has this two-lens feature built-in, like on an iPhone with two lenses). The live shooting effects feature is cooler than it sounds, because it lets you see and apply a preset effect before you even take the shot. So, you can see, before you even tap the shutter button, if a particular image would look good as a black and white, or with a contrast effect, or creative look applied. When you tap on this option (its icon [circled here] looks like two circles overlapping), a row of live effects appear at the bottom of your image preview area. Tap on one to apply it to your image before you shoot. *Note:* These are non-destructive, so if after you take the shot you change your mind, you can reset the image to the normal look without an effect.

Step Six:

If you tap the three dots in the top left (or top right) of the screen, additional options pop out from the side (or down from the top): Tap on the gear icon for some capture setting preferences for the camera app. The triangle icon turns on/off the Highlight Clipping warning (clipped highlight areas appear with a moving zebra pattern over them). Tap on the grid icon for Grid & Level overlay options (seen here) or to turn on auto level (with haptic feedback on newer iPhones). There's also a self-timer icon, and the last icon lets you choose the aspect ratio of images taken with the camera.

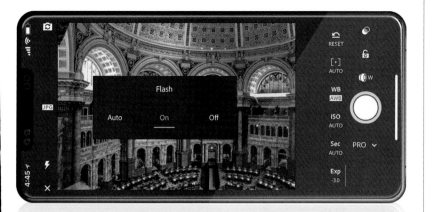

Step Seven:

At the bottom left (or at the top left) is an icon for turning on/off your built-in flash. Just tap on it and the menu you see here pops up. You can choose Auto mode (it senses low-light situations and turns itself on automatically), On (the flash always stays on regardless of the lighting situation), or Off. For the sake of your photography's quality, the right answer is always "Off." (Yes, really.) If you want to take a selfie, there's a camera icon with a circular arrow in the top-left (or top-right) corner and tapping that switches you to the back camera, so you can take your selfie.

Step Eight:

One of my personal favorite features is the built-in HDR mode, which uses the same technology as Lightroom Classic, so you can capture a wider tonal range in situations where you need it. Take, for example, this image I took inside a restaurant. With my Lightroom mobile camera set to Pro mode (seen at the top here), the detail in the textured/glazed glass is gone, and the highlights are blown out so much you can't even make out anything outside the windows. When I switch it to shoot in HDR mode instead, look at the difference (seen here below)—you can see the patio outside, and the texture/glaze in the glass. Even look at the lamp on the table—the detail is back there, too, and the shadow areas are brighter where the champagne bottles are on the far right. It captured a much wider range of tones by combining multiple exposures into one image automatically.

The Desktop Version of Lightroom Mobile Is Lightroom CC

Okay, now that you've learned how to use Lightroom mobile, I wanted to give you a quick look at the desktop version of the mobile app, called "Lightroom CC," which has the same limited number of features, it uses nearly the same layout (no modules—everything's in one place), and even uses albums and folders, just like Lightroom mobile. Lightroom CC on the desktop is the cloud-storage-based version of Lightroom that I mentioned back in the book's introduction (on page xii). Here are the basics:

Step One:
Importing in Lightroom CC on the desktop is the one area that's somewhat different than Lightroom mobile. This is about as simple as it gets because there are hardly any decisions to make here. You don't have to choose where to store your images—they're going to Adobe's cloud storage (there really are barely any options here, well at least compared to Lightroom Classic's Import window). In fact, the only two things you can do here are either uncheck any photos you don't want imported or choose which existing album to add your images into (at the top center, click on Add to Album). You can choose to put them into a new album (as shown here) and that just brings up a naming dialog. That's pretty much it.

Step Two:
This window should look familiar, because it's pretty much the same as Lightroom mobile's main screen, with your folders and albums on the left side, and if you click on an album it shows you the images inside it, just like mobile. At the bottom center are your Pick flags and star ratings. Below the bottom left of your thumbnails, you can choose your different views and sorting options. There's also a Search bar at the top that uses the same Sensei searching that mobile uses.

Step Three:

Just like on mobile, the tools are along the right side—click on one of those icons (here, I clicked on the Edit icon) and your panels pop out. These are the same ones that are in mobile, in the same order, in the same groupings, and they do exactly the same thing (as you can guess). It's literally the same stuff (and it works exactly like the sliders and controls that you learned about in this chapter and in the Develop chapter, starting on page 127). The difference is you tap on the screen in mobile, and you click with a mouse in Lightroom CC on your desktop. Take a look at the iPad version in the inset shown here. It's the same app, with some minor user-interface changes to accommodate a mobile touch screen.

TIP: Don't Use Classic and CC

Adobe recommends using either Lightroom Classic or Lightroom CC—not both at the same time. One reason is if you use Lightroom CC, and then use the mobile app with it, those changes won't sync back to Lightroom Classic, only to Lightrom CC, and confusion will reign as things are out of sync. So, just stick with Classic, and then Lightroom mobile will keep your collections in sync with no issues.

Step Four:

In case you were wondering, yes the Adobe color, camera, B&W, and creative profiles are all here, as well (they're in everything now—in Classic, CC, and mobile). Here, I clicked on one of the B&W profiles to convert my color image to black and white. There are no other modules to choose in Lightroom CC (no Map module, no Print module—in fact, there's just no printing at all—no Slideshow, no Web, no Book module, among lots of other things). Over time, it will get more features, but at this point, it's just what's in the mobile app (with a limited feature set), in a desktop version.

MY WORKFLOW
here's my typical start-to-finish project

For the past few editions of this book, I've been wrapping up the book with a special bonus chapter where I share my own Lightroom workflow. It's a typical start-to-finish project, where I show everything I would do to a particular image so you can see how I deal with different parts of the process. Now, I have to be honest with you, I had fully written this chapter, but then I did the image again, and had to rewrite the whole thing, and each time I reprocessed that image, I wound up having to rewrite the entire chapter. Here's why: I'm old and forget everything. Physically, I'm just in my 50s (and you know what they say, 50s are the new teens), but mentally I'm in my late 90s to early 100s, and I not only can't remember which order to do things in Lightroom, I can't remember where I put my laptop. I was using it yesterday, so I know it's here somewhere. Anyway, instead of fruitlessly rewriting this

chapter on a laptop whose location I can't quite pinpoint in my own home, I thought I would instead make some simple drawings on bar napkins, and that would give you a general idea of what I do in Lightroom. However, I did encounter two minor issues when I started this "napkin notation" process. The first was: without having Lightroom open in front of me, I can't always remember the official names of stuff, so in many cases, I had to describe steps very casually, like "Click that thing up in the right corner by the other thing," or "Go under the menu up top and chose the one that changes the look," or even just "Move the slider that makes the photo look better." I'm pretty sure with the hand-drawn illustrations alongside, it will all make sense. The second problem is that the pen I need to make the drawings and hand-written notes is in my laptop bag. This getting older thing is a blast.

It Starts with the Shoot

What you're about to learn is my typical day-in, day-out, workflow, and it doesn't matter if I'm doing a landscape shoot, portrait shoot, or a sports shoot, I pretty much use Lightroom the same way, in the same order, every time. For this particular example, I'm doing a landscape shoot, so it actually starts with me on location, in this case, in northern Italy's Dolomites mountains. According to my GPS, it says this was taken in "Livinallongo del Col di Lana."

The Location:

My brother Jeff and I drove past this spot on our way to a dawn shoot, and on our way back, we pulled off the road (that's the road at the top of the embankment on the left) and wandered down to this still-water, small lake. The sun wasn't very high in the sky yet, still mostly behind some of the mountains, and the light was still pretty nice. Because of the relatively low-light (it was darker than the behind-the-scenes shot here shows), I used a tripod, and to get a lower perspective, I splayed the legs of the tripod out wide (as seen here). The tripod itself is the Albert model from UK-based tripod designers 3 Legged Thing.

The Camera Info/Settings:

I took the shot that we'll be using in this workflow tutorial (don't forget, you can download it and follow along—see page xii) with a Canon EOS 5D Mark IV, using a Canon 24–70mm f/2.8 lens. I took it in aperture priority mode at f/11, 1/15 of a second shutter speed, and at 100 ISO. Once I'm done with the shoot and back in my hotel, the very first thing I do is back up my photos to a portable 2-terabyte external hard drive (so I have one copy on my memory card and a second copy on that external drive). If I have a decent Internet connection, I also save my Lightroom Picks to Dropbox, so I have a cloud backup, too. At the right here, I swung the camera over from my shooting position to catch a photo of my brother Jeff. He has nothing to do with the tutorial; I just wanted to show you my awesome bro. :)

Once I get back from my trip (or if I have enough time while I'm on the trip), I import the images into Lightroom. By the way, of course, I'll always be importing to an external hard drive, whether I'm home or on the road (where I carry a lightweight WD Elements 2-terabyte external drive. Why this one? I liked that, since it was so light and small, it wouldn't take up a bunch of room in my bag, but more importantly, it was on sale for around $70).

Workflow Step One: Importing Your Images

Step One:
When I'm ready to import the images from my shoot into Lightroom, I plug my memory card reader into my computer and it brings up Lightroom's Import window (seen here). At the top, from left to right, you can see I'm importing from my memory card, then at the top center, I click on Copy (so I'm making a copy of the images on the memory card), and on the far right, it shows where I'm copying them to (Scott's External Hard Drive). If I see a shot where it's so messed up I can actually see it's messed up in the thumbnail (like one that's terribly out of focus), I turn off the checkbox for that thumbnail, since I would just wind up deleting it later anyway.

Step Two:
Over in the right side Panels area, under File Handling, I choose Minimal (the fast-loading thumbnail option) because I want to see my images in the Library module quickly. Next, I never want to import duplicates, so I always leave that checkbox turned on. I also pick a simple, descriptive name for the files (like "Dolomites," in this case), in the File naming section, and then I have Lightroom sequentially number them, starting with "-1." Lastly, in the Apply During Import section, from the Metadata pop-up menu, I apply my copyright metadata information to each photo as it's imported (see Chapter 3 for how to create a copyright template). It's a pretty simple and straightforward importing process. Now, I just hit the Import button and we're off and running!

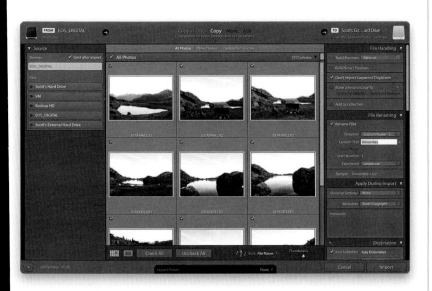

Workflow Step Two: Sorting Your Images

Okay, your photos are in Lightroom, and it's time to start the process of finding our best shots. I use the SLIM system (we looked at this in Chapter 2) for my shoot organization, so we'll be creating a collection set, finding our Picks, then finding our Selects and sorting those into their own collections inside our collection set. Here's the exact process I use for all my shoots:

Step One:

At this point, your images have been imported, but we haven't done anything with them yet. So, in the Library module, go to the Collections panel (in the left side Panels area), click on the + (plus sign) button on the right side of the panel header, and choose **Create Collection Set** from the pop-up menu (as seen here). When the Create Collection Set dialog appears, give your new collection set a very descriptive name (I named mine "Dolomites with Jeff"), then in the Location section, choose the collection set you want this new set to appear inside (I put this inside my Landscape collection set), and then click the Create button.

Step Two:

We're going to create a new collection inside our Dolomites collection set for all the images from the shoot (I do this for every shoot). So, press **Command-A (PC: Ctrl-A)** to select all the photos you just imported, then press **Command-N (PC: Ctrl-N)** to bring up the Create Collection dialog (seen here). Name your collection "Full Shoot," and for Location, choose that collection set you just created in the previous step (in this case, it's Dolomites with Jeff). In the Options section, the Include Selected Photos checkbox should be turned on by default, but if it's not, turn it on (and leave the other options off), then click the Create button.

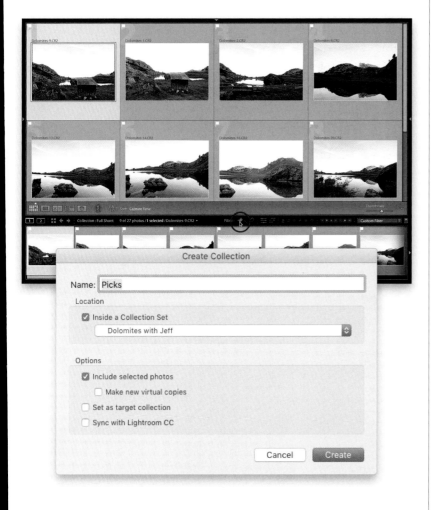

Step Three:

Now it's time to find our "keepers" from the shoot. So, click on the thumbnail for the first image you imported, then press **Shift-Tab** to hide all the panels (or press the letter **F** on your keyboard if you want to do this part in Full Screen view). Then, start moving through your images. If you see an image you like, press the letter **P** to mark it as a Pick (you'll see "Flag as Pick" appear right onscreen, as seen here. If you're in Full Screen view, you'll just see a tiny, white pick flag appear at the bottom center instead). Press the **Right Arrow key** on your keyboard to move to the next image, continuing through the rest of your images, marking the good shots as Picks, and just ignoring them and moving on if they're not.

Step Four:

Now, let's turn on a filter that just shows our Picks (after all, this is what this is all about—separating our Picks from the rest of the shoot). Make sure the Filmstrip along the bottom is visible, and near the top center, to the right of Filter, click twice on the white Pick flag (shown circled here in red) to filter your images, so only the Picks are showing. *Note:* If you don't see three Pick flags to the right of Filter, just click directly on the word Filter to have them slide out. Now, press Command-A (PC: Ctrl-A) to select all your Picks, press Command-N (PC: Ctrl-N) to create a new collection, name this new collection "Picks," turn on the Inside a Collection Set checkbox, and from the pop-up menu, choose the Dolomites with Jeff collection set. Make sure the Include Selected Photos checkbox is turned on, and click the Create button. This saves your Picks in their own collection inside your Dolomites with Jeff collection set. So, to recap: at this point, we have a Dolomites with Jeff collection set, and inside it, we now have two collections: Full Shoot and Picks.

Continued

Step Five:

It's time to narrow things down even further, and take our time now, as we get down to the final images we'll be tweaking, and then maybe sharing online or printing, etc. In the Collections panel, click on the Picks collection we just created, then click on the first image (the one up in the top-left corner of the Preview area), and now let's go find the very best shots from our shoot—our "Selects." I do the same Shift-Tab routine to hide the panels, but since all these images already have a Pick flag, I tag my best of these images with a 5-star rating. So, as I come to an image I really like—one of the best images from this shoot—I press the number **5** on my keyboard, and it applies a 5-star rating (as seen here, where it says "Set Rating to 5" onscreen).

Step Six:

Go through your Picks collection, using the Right Arrow key on your keyboard, until you've tagged your very best shots as Selects (5 stars). When you're done, turn on the filter, so we just see the 5-star images in our Picks collection, by going to the top of the Filmstrip and clicking on the 5-star filter (shown circled here in red). Now, just your very best images from the shoot are visible.

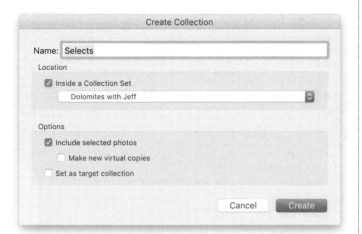

Step Seven:

Press Command-A (PC: Ctrl-A) to select all your 5-star images, then press Command-N (PC: Ctrl-N) to create a new collection, name it "Selects," and then save this new collection inside the Dolomites with Jeff collection set. That's the process. We have a Dolomites with Jeff collection set, and inside it, we now have three collections: Full Shoot, Picks, and Selects.

Step Eight:

If you look in my Collections panel here, you'll see how this organization looks (and it should look familiar with what you learned back in Chapter 2). Inside my Landscape collection set, you'll see the Dolomites with Jeff collection set, and inside that, you'll see three collections:

(1) Full Shoot

(2) Picks

(3) Selects

The only images I would actually be tweaking, cropping, editing, or sharing would be the ones inside that Selects collection. That's how I sort and organize every shoot, whether it's a wedding, travel, portrait, or sports shoot, or whathaveya.

Workflow Step Three: Editing Your Selects

Now that you've whittled things down to the images you're going to tweak, let's get to work. Here, I'm going to take you through how I'd edit one of my Selects from start to finish, starting with the RAW, out-of-the-camera photo.

Step One:

Here's the original RAW image in the Develop module (download this image from the book's companion webpage, mentioned in the book's introduction). It has lots of work that needs to be done, starting with the fact that I didn't have an ND (neutral density) gradient filter with me, so the sky is overexposed and kind of washed out. The foreground is a bit backlit and in the shadows, and we've got some jet contrails in the sky, a few weeds that need pruning, and well…let's just say the image needs some TLC. I start by applying a color profile to the RAW photo. In this case, I applied the Adobe Vivid profile, but you can see in the before/after it didn't do that much to the image, but that profile will help down the road.

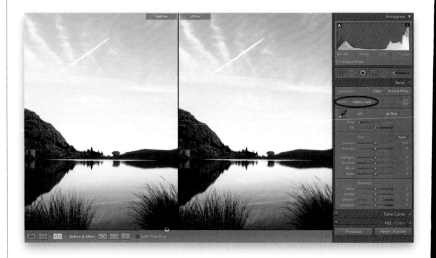

Step Two:

I'm going to start in the Basic panel by doing a simple technique—one that I've been using that works like a charm for dealing with washed-out skies in situations like this. I simply lower the Exposure amount until the sky looks pretty good, and then I deal with the foreground being in shadows, which is often easier to fix than a messed-up sky. So, that's what I did here—I dragged the Exposure down to –1.55 (as seen here). You can see what it did for the sky (versus how it looked in Step One), but it also made our foreground fairly dark. We can deal with that. Also, just so you can see the difference the color profile really makes, go back and switch the profile to Adobe Color. Ahhhh, big difference, right? Okay, switch it back to Adobe Vivid.

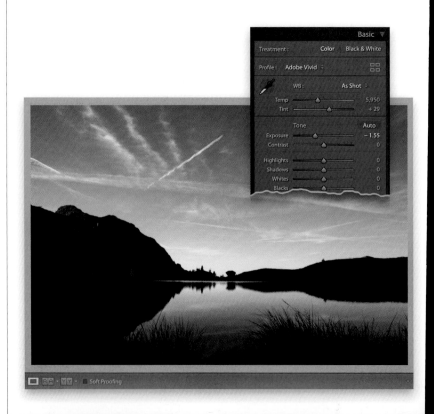

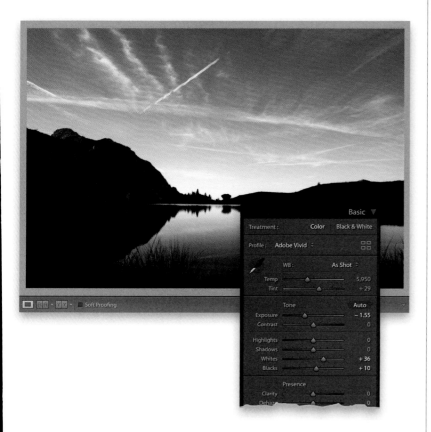

Step Three:

Now, let's expand the tonal range by setting our white and black points (well, by having Lightroom do it for us). Press-and-hold the Shift key and double-click directly on the word "Whites," then on "Blacks," and it sets the white and black points for you automatically. There are plenty of deep shadows in this image, so it didn't do that much with the Blacks slider, but it did kick up the Whites to +36.

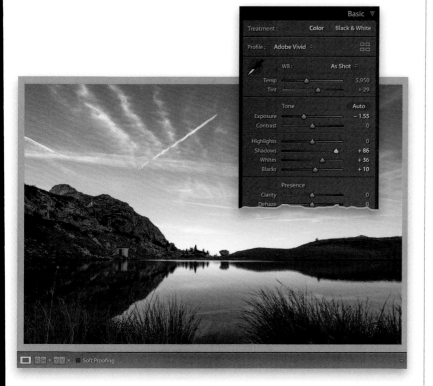

Step Four:

To bring out detail in the hills and grass, drag the Shadows slider to the right until it looks good to you (in this case, I dragged it over to +86, opening up those shadow areas quite a bit). I went a bit farther than I needed to because I know I'll lose some of that when I increase the Contrast in the next step.

Continued

Step Five:

Let's kick up the Contrast a bit to make the brightest parts of the image brighter and the darker parts darker. I kick this up quite a bit usually, but in this case, I could only take it to +50 without the foreground getting too dark again, but that's still a pretty decent amount. Also, to enhance the definition in the sky, I'm going to pull back on the Highlights a bit, lowering them to around –40. That makes quite a difference in the sky.

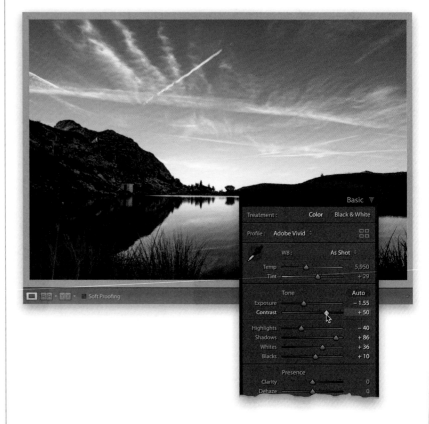

Step Six:

Next, to bring out some details in the mountains and in the grass, I would add some Clarity (in this case, I dragged the slider to the right to +23), and to make the colors a bit more "colorful," I increased the Vibrance amount just a little (to +6, as seen here).

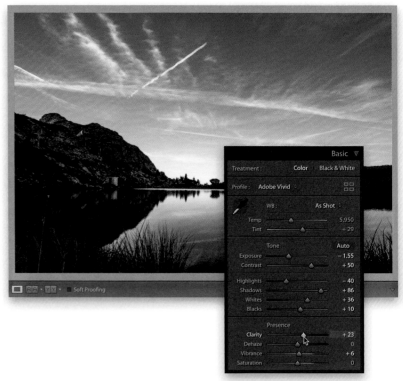

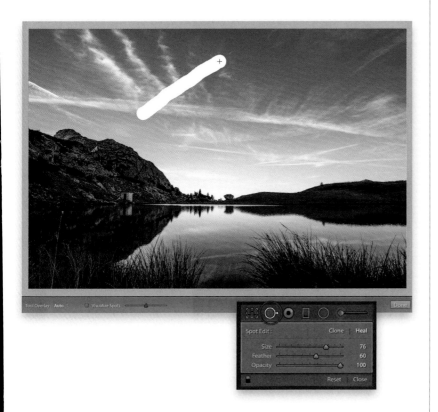

Step Seven:

Now let's get rid of some of the more distracting contrails in the sky (we can't get rid of them all because some are pretty large, like that one going horizontally across the center of the sky, and Lightroom just isn't cut out for this level of retouching—it would be a bit of a sticky retouch, even in Photoshop). Get the Spot Removal tool **(Q)** from the toolbox in the top of the right side Panels area (shown circled here), and start by painting a stroke over that contrail near the top-left corner (as you see here).

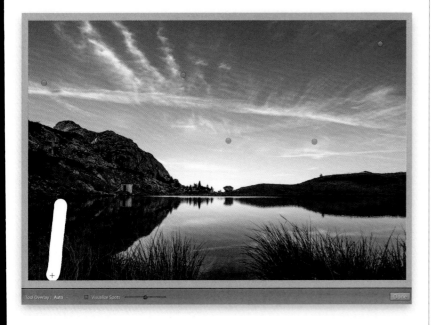

Step Eight:

There are a few more you can get rid of, and once the sky looks pretty decent, then you can move on to getting rid of some of that grass sticking up on the left side (as shown here). You might have to reposition the sample area a bit on those weeds (well, I did anyway) by clicking-and-dragging the sample area over to the left to find a better area. Be patient, and make your brush size just a little larger than the contrail or piece grass you want to remove, and don't be afraid to drag the sample area to a new spot if it looks funky (we looked at using the Spot Removal tool in Chapter 8).

Continued

Step Nine:

Next, let's enhance that sky a bit more by adding an ND gradient effect. Get the Graduated Filter tool **(M)** from the toolbox near the top of the right side Panels area (we looked at this tool in Chapter 6), double-click on the world "Effect" in the options below to zero all the sliders out, and then drag the Exposure slider to the left quite a bit to darken the exposure (here, I dragged it over to –0.89). Now, press-and-hold the Shift key (to keep it straight), then click-and-drag the tool from the top center of the image to just past the water's edge to darken the sky and have it graduate slowly down to transparent (as seen here). If you think the sky needs to be a little richer in color, you can crank up the Contrast at bit (that's what I did here, increasing it to 35 just in the areas affected by the Graduated Filter adjustment).

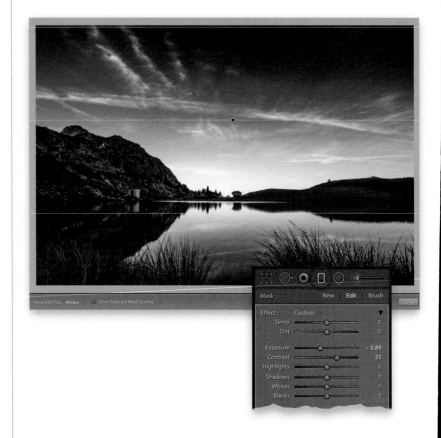

Step 10:

When we dragged the Graduated Filter down to the water's edge in the previous step, besides just darkening the sky, of course it darkened that rocky hill on the left, as well. Normally, we'd switch to the Erase brush and carefully paint away that area, but since we have the much more accurate and infinitely faster Range Mask feature now, we'll use that instead. So, go under Range Mask (at the bottom of the Graduated Filter options), and choose **Color**. Now, click on the eyedropper, and then click it on the color we want to keep (we can press-and-hold the Shift key to add up to a total of five color samplers). In this case, I tried clicking the eyedropper in a few places, but it kind of trashed the sky, so instead, I clicked-and-dragged over a range of colors (as seen here), and it perfectly masked the hills, removing the darkening immediately. Ya gotta love that!

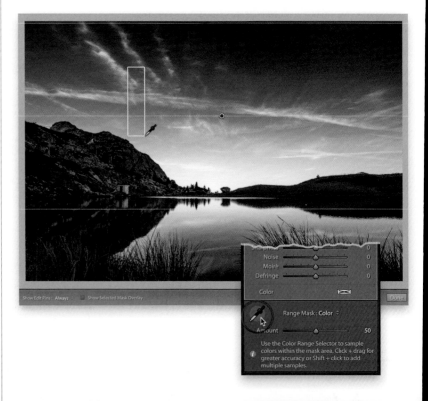

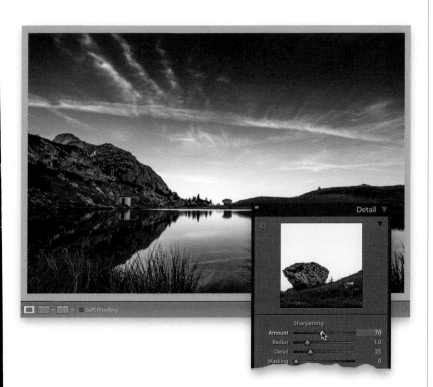

Step 11:

Now we've just got to sharpen this puppy, and we're good to go. So, head down to the Detail panel and, in the Sharpening section, drag the Amount slider over a bit until it looks good to you (remember, to really see the effects of the sharpening, click on the exclamation point warning icon in the top left of the panel, and it'll zoom you in to a 1:1 actual size view. We looked at sharpening in Chapter 8). Here, I cranked the Amount to 70, but I wouldn't go much more than that—if you feel you want more sharpening, you can raise the Radius amount to 1.1, but that should do it. Okay, I think we're looking pretty decent. Let's see a before and after (below).

Step 12:

Press the letter **Y** on your keyboard to see a side-by-side before and after of where you started and where you wound up. If you decide you want to see a little more detail in the hills, you could take the Adjustment Brush **(K)**, zero all the sliders out, increase the Exposure amount to around +0.50, and use a small brush to paint over the hills in the background, but instead I just increased the Shadows slider by +10 (going from +86 to +96). Also, I thought the overall image now looked at little too colorful, so I went back and lowered the Vibrance amount from +6 to −3). That's my pretty typical start-to-finish workflow .

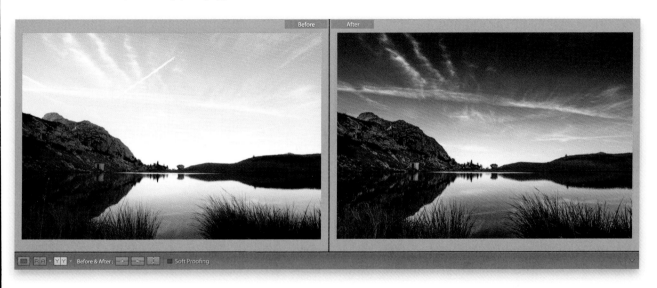

Workflow Step Four: Getting Client Feedback

If you're working for a client, or for a magazine or blog, or for a company's social media team, you might want to share some of the final images for feedback or advice on which image they want to use. Here's how I would create a quick online gallery, where they can mark which images are their favorites and even send direct feedback that you can view right within Lightroom.

Step One:

Once your images look okay, now it's time to share this Selects collection with your clients (if you're not doing client work, you can do this to share a collection with friends or family). In the Library module, make sure you have Sync with Lightroom CC turned on (click on the Lightroom nameplate in the upper-left corner to check; we looked at doing this in Chapter 14), then go to your Selects collection set in the Collections panel, and click the little sync checkbox to its left (it's circled here in red). By the way, if you want to change the name of this collection before your client sees it, Right-click on the collection's name and choose **Rename** (I renamed it "Dolomites Selects," as seen in the next step, only because I'm sharing this with a client).

Step Two:

Now that you've synced this collection, you can view it on the web (from any web browser), by going under the Library module's Help menu and choosing **View Your Synced Collections on the Web**. That will bring you to a private webpage created for you at lightroom.adobe.com, where you can sign-in with your Adobe username and password to see a list of your synced collections. When you see Dolomites Selects, click on it to see your Selects collection on the web. At this point, only you can see these images, so to share them, click on the Share button near the top center (as shown here).

Step Three:

This brings up a Share Options dialog, asking you how you want to share these images. Choose Share This Album, and in the next dialog, click the Share This Album button (yeah, it asks you the same thing twice). You'll then see the Album Settings dialog you see here, and that web address you see highlighted is the address where people can see your Selects collection. Click on the little clipboard button to the right to copy that address into memory, so you can easily paste it into a text message or email to your client (or friends). There are a few more options here, but if you want to learn more, head back to Chapter 14.

Step Four:

When your client clicks that link, it'll launch their web browser, where they'll see your Dolomites Selects collection (and only that collection), and if they click on any of the thumbnails, they can see an image larger (as seen here). But, that's pretty much all they can do—view your images. If you want them to give you feedback (mark images or send you comments), they'll need to have an Adobe username and password (it's free). I usually either just create one for them or give them a "house account" I created for my clients to use. When they click on the little heart icon (to "like" an image) or the comment icon, both in the bottom left, the Activity panel will slide out from the right (seen here), and it will prompt them to log in to "like" an image or add a comment. If they do like a photo, or add a comment, you'll see a little yellow comment icon appear with your Selects collection in Lightroom on your computer. To see the comment(s), scroll down to the Library module's Comments panel in the right side Panels area (seen here), where you can then comment back and forth, just like a text message. Now I can see which image they want to go with, and the one I'll be using to make a large-sized print for them.

Workflow Step Five: Printing the Image

Okay, we've sorted and organized our images, we've edited the Selects, and our client has given us feedback on which image they want to use. Now, I'm going to make them a large-sized print, which is typically what I would do, even though I don't generally tell the client they're getting a big print—I do it as my way of saying thanks.

Step One:

Click on the image you want to print, then go to the Print module and, in the Template Browser, click on whichever template you want to use (I chose a preset I created earlier for the image you see here). The default page setup for this template is US Letter (8x11"), so I had to click the Page Setup button (at the bottom of the left side Panels area) and choose a larger size. When the dialog appears, choose the printer, paper size, and orientation, then click OK to apply these settings. You might need to tweak the margins a bit after choosing a new page size, since it doesn't automatically adjust everything.

Step Two:

Now it's time to print the image (this is covered in-depth back in Chapter 12). Scroll down to the Print Job panel (in the right side Panels area), and from the Print To pop-up menu at the top, choose **Printer**. Then, for Print Resolution, since I'm printing to a color inkjet printer, I can leave it at 240 ppi. Make sure the Print Sharpening checkbox is turned on, choose the amount of sharpening from the pop-up menu on the right (I generally choose High), and then choose the type of paper you'll be printing on from the Media Type pop-up menu (I chose Matte here). If your printer supports 16-bit printing, then you can turn on the 16 Bit Output checkbox. Then, in the Color Management section, choose your Profile and set your rendering Intent (again, covered in Chapter 12). I chose Relative here.

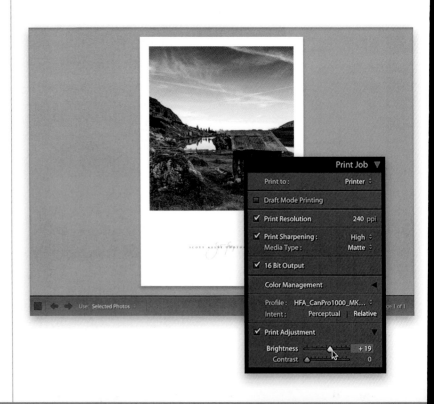

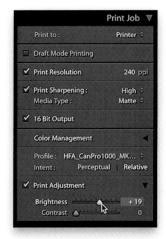

Step Three:
Now, click the Printer button at the bottom of the right side Panels area, and the Print dialog appears (the one shown here is from a Mac, but the Windows print dialog has the same basic features, just in a different layout). Your options will vary depending on your printer, but you'll want to make sure your printer's color management is turned off and you'll want to choose the type of paper you're printing to.

Step Four:
Let's print a proof. Click the Print button at the bottom of the right side Panels area, sit back, and wait for that puppy to roll out of the printer. Chances are your print is going to be darker than what you see on your super-bright, backlit computer screen. If so, turn on the Print Adjustment checkbox (at the bottom of the Print Job panel), drag the Brightness slider to the right a bit, and then make another test print to compare to your screen. It might take a couple of test prints to get it right, but once you know how much brighter to make it, remember that setting for other prints on the same type of paper (you can adjust the contrast the same way). However, if there's a color problem, like the image looks too red, or too blue, etc., then you'll need to jump back to the Develop module, go to the HSL panel, and lower the Saturation for that color, then make another test print. There you have it—my workflow, from beginning to end. Remember, this workflow stuff is at the very end of the book for a reason: because it only makes sense after you've read the rest of the book. So, if anything didn't make sense, make sure you go back and reference the chapters I gave you here, so you can learn about anything you might have skipped over or didn't think you'd need.

Other Ways You Can Continue Learning With Me

If this way of learning Lightroom resonated with you, and now you want to learn more about Lightroom (or Photoshop), or even just how to take better photos, I've got you totally covered! Here's a little bit about another book that I've written, using the same style and feel that I've written this book in, as well as some other cool resources. Hope you find these helpful.

Photoshop for Lightroom Users

As you saw a couple times here in the book, there are things that Lightroom still can't do and times when you'll need to jump over to Photoshop, so I created a book for Lightroom users to teach just those things photographers need to do over in Photoshop, without duplicating things we can already do in Lightroom. So, you're not going to learn all of Photoshop, just the stuff for photographers that you can't do here in Lightroom.

My Site: LightroomKillerTips.com

It's the #1 Lightroom blog on the planet, and it's where I post Lightroom tips, tutorials, and techniques most weekdays, along with Lightroom expert Rob Sylvan. We answer a lot of questions, do fun giveaways and contests, have free preset downloads, and it's just a really great community of Lightroom users. Go to LightroomKillerTips.com and bookmark it (or follow the RSS feed, if you like). There's nothing to sign up for or register—just come and hang out. You'll dig it.

Our Full-Length Online Training Classes on Lightroom

My full-time job is CEO at KelbyOne.com, where we teach tens of thousands of photographers all over the world how to become absolute sharks in Lightroom. We've got more than 50 full-length, in-depth online courses on Lightroom from the best-known Lightroom instructors in the world, including Matt Kloskowski, Serge Ramelli, Terry White, Lightroom Mobile Product Manager Josh Haftel, and yours truly (among others). Besides Lightroom, we've got literally hundreds of courses on everything from lighting to Photoshop, from posing to landscape photography, and everything in between, from instructors you know and trust. It's super-affordable (starting at just $10 a month), and you can be a monthly member or an annual KelbyOne Pro plan member, but either way, you'll be amazed at how fast you get really, really good! The full scoop is at KelbyOne.com.

Come Learn from Me Live

I'm out on the road doing live full-day Lightroom seminars all over the US, Canada, and in the UK, so if you get a chance, I hope you'll come out and spend the day with me. You can find my current seminar tour schedule (upcoming cities and dates) at KelbyOneLive.com, and I hope to meet you in person at one of my seminars this year!

Index

' (apostrophe) key, 187
\ (backslash) key, 29, 44, 71, 141, 169
[] (bracket) keys, 165
/ (forward slash) key, 222, 246
1:1 previews, 12
5-star images, 45–47, 446
16-bit printing, 376
18% gray card, 139–140
32-bit HDR images, 224–227
100% view, 12, 27

A

AAC file format, 401
A/B brushes, 169, 221–222
about this book, xii–xv
actions (Photoshop), 304–311
 droplet creation, 309–310
 Export, 277, 310
 recording, 304–309
 testing, 309
 using in Lightroom, 311
Actions panel (Photoshop), 304, 309
Activity panel, 455
Add Frame droplet, 310, 311
Add Layer Mask icon, 301
Add Photo Text option, 324, 339
Add Photos icon, 412
Adjustment Brush, 164–176
 Auto Mask feature, 166, 167
 B&W conversions and, 205
 beams-of-light effect, 221–223
 brush options, 169
 Clarity adjustments, 175, 228
 Contrast adjustments, 228
 Dehaze adjustments, 156–157, 223
 Edit Pins, 165, 167, 168, 169, 170, 176
 Effect pop-up menu, 175
 Erase brush, 167
 Exposure adjustments, 165, 166, 167, 168
 individual area adjustments, 164–169
 Lightroom mobile version of, 420
 Luminance Range Mask adjustments, 183–184
 mask overlay view, 165, 170
 noise reduction using, 172, 232, 236
 options for working with, 169
 resetting sliders in, 164, 171
 resizing, 165
 retouching with, 175–176
 Sharpness slider, 173, 175
 sun flare effect, 214
 tips on using, 170
 wet street effect, 228–229
 white balance adjustments, 167, 171
Adobe Bridge, 127
Adobe Color profile, 132
Adobe ID, 408, 428
Adobe Landscape profile, 132
Adobe Monochrome profile, 202
Adobe Photoshop. *See Photoshop*
Adobe Photoshop Lightroom. *See Lightroom*
Adobe Standard profile, 131
Adobe Stock, 288, 387
Adobe Vivid profile, 132, 133, 448
After Export pop-up menu, 277, 310, 311
Album Settings window, 427
albums
 overview of working with, 409–413
 sharing on the web, 426–429, 455
 See also collections
Align with Photo checkbox, 328
aligning
 book text, 328, 340
 HDR images, 226
Amount slider
 Adjustment Brush, 170
 Color Range Selector tool, 181, 182
 Detail panel, 263
 Lens Corrections panel, 252, 260, 267
 Lightroom mobile, 416
 Profile Browser, 191, 204
 Vignetting, 196
Android devices, 410
Angle tool, 243
Apply Background Globally checkbox, 337
Apply During Import panel, 17, 90, 212
Apply Previous button, 422
As Shot white balance, 135, 137
aspect ratios, 51, 241, 424
Aspect slider, 176, 254
attributes search, 64, 73
Audio Balance slider, 401
Auto Advance option, 40
Auto Align checkbox, 226

Auto button, Basic panel, 128, 143
Auto Crop checkbox, 218, 219
Auto Dismiss checkbox, 138
Auto Hide & Show feature, 26
Auto Layout panel, 316, 322–325
Auto Layout Preset Editor, 322
Auto Mask feature, 166, 167
Auto straighten button, 243
Auto Sync feature, 397
Auto Tone feature, 128, 143, 225, 418
Auto Upright correction, 253
Auto white balance, 136
automatic page numbering, 332–333
Auto-Stack by Capture Time option, 53

B

B&W button, 419
B&W panel, 202
B&W profiles, 204–205, 206
Back Up Catalog dialog, 74
Backblaze.com website, 5
Background Color picker, 341
Background layer
 deleting, 82, 83, 283, 387
 removing images from, 305
Background panel, 336–337, 341
backgrounds
 book, 336–337, 341
 photos as, 337, 371–373
 print, 349, 371–373
backing up
 catalog, 74–75
 cloud services for, 5, 442
 hard drives for, 4
 workflow for, 442
backlit photos, 151, 232–233
backscreened effect, 371–373
badges, thumbnail, 113
Balance slider, 215
Basic panel, 128–159
 Auto Tone feature, 128, 143
 Blacks slider, 144–145, 233
 Clarity slider, 152, 199, 450
 Contrast slider, 148, 199, 233, 450
 Dehaze slider, 154–156
 editing order using, 159
 Exposure slider, 146, 147
 features overview, 128–129

Highlights slider, 150, 199
Profile options, 132
Saturation slider, 153
Shadows slider, 151, 199, 232, 449
Temp and Tint sliders, 136
Vibrance slider, 153, 200
White Balance controls, 135–138
Whites slider, 144–145
beams-of-light effect, 220–223
Before and After views, 141
 backlit photos, 233
 Color Range Mask, 182
 Dehaze adjustments, 155
 edge vignetting fixes, 261
 editing workflow and, 453
 lens distortion fixes, 255, 258
 Lightroom mobile feature for, 420
 spot removal, 247
 spotlight effect, 187
 white balance settings, 138
bit depth settings, 296
black point, 144, 449
black-and-white conversions, 202–205
 auto conversion, 202
 backscreened effect and, 372
 duotones made from, 206
 grain effects added to, 205, 302
 manually creating, 202–203
 previews for, 204
 profiles for, 204–205
 video clips and, 396
blackout mode, 92–93
Blacks slider, 144–145, 233
blemish removal, 173
blend modes, 300, 306
blended images, 298–302
Blue channel adjustments, 216
Blurb books, 314, 315, 321, 335
bonus chapters, xiv
Book module
 Auto Layout panel, 316, 322, 325
 Background panel, 336–337, 341
 Book Settings panel, 317, 335
 Cell panel, 327
 Guides panel, 338
 Page panel, 332
 Preferences dialog, 314–315
 Text panel, 328–329, 331, 339
 Type panel, 329–330, 331, 333, 340

Book Settings panel, 317, 335
books, 313–343
 adding pages to, 319
 Auto Layout for, 316, 322, 325
 backgrounds for, 336–337, 341
 Blurb service for, 314, 315, 321, 335
 building from scratch, 316–321
 captions added to, 328–331
 collections for, 316
 cover text for, 339–341
 custom pages for, 326–327, 342–343
 dust jacket option for, 335
 Filler Text for, 315
 guides used for, 338
 layout templates for, 318, 334–335
 money-saving options for, 335
 numbering pages in, 332–333
 page layouts for, 318, 320
 preferences for, 314–315
 presets for, 322–324, 331
 Print module layouts, 342–343
 printing, 338
 removing photos from, 319, 343
 resolution warning, 319
 saving PDF or JPEG, 338
 sizes and types of, 315, 317
 spine text/color for, 341
 text added to, 328–331, 339–341
 two-page spreads for, 320
 view modes for, 317
borders
 cell, 353
 frame, 307, 387–389
Boundary Warp option, 218
bracketed exposures, 224
brightness adjustments, 128, 146, 147, 383
Brightness slider, Print Job panel, 383
Browse icon, 416
Brush Picker (Photoshop), 301
Brush tool (Photoshop), 301
brushes
 flow controls, 169
 size adjustments, 165, 169
 softness adjustments, 169
Build Previews pop-up menu, 11
Build Smart Previews checkbox, 19

C
calibrating monitors, 377, 382
Calibration panel, 268–269
Camera Landscape profile, 132
Camera Matching profiles, 133, 134
camera profiles, 130, 131–134
Camera Raw, 24, 276, 287
Camera Roll, 433
Camera Vivid profile, 132
cameras
 calibration of, 268–269
 GPS data from, 65
 importing photos from, 13–18
 Lightroom mobile, 406, 434–437
 metadata embedded by, 99–100
 profiles for, 130, 131–134
 shooting tethered from, 78–81
Candidate images, 49
Canon cameras, 80
Canvas Size dialog (Photoshop), 305
captions
 book, 328–331
 metadata used as, 100
Capture Frame option, 395, 397
capture sharpening, 262
capture time, Auto-Stack by, 53
Catalog panel, 71, 96
Catalog Settings dialog, 23, 101
catalogs, 34–36
 backing up, 74–75
 combining, 34–35
 creating new, 35
 exporting, 102–104
 finding, 106
 importing, 34–35
 location for storing, 26
 repairing corrupt, 75, 105
 restoring, 75, 105–106
 searching, 63
 syncing, 102–104
Cell panel, Book module, 327
cell phone GPS data, 67
Cell Size sliders, 347–348
cells
 book layout, 318, 319, 327
 print layout, 347–349, 353, 358–359, 365–368
 view options for, 28, 112
Cells panel, Print module, 358, 360, 365–366, 368

Channel pop-up menu, 216
Character color picker, 330, 340
chromatic aberrations, 266–267
circles, creating, 185
Clarity adjustments
 Adjustment Brush, 175, 223, 228
 Basic panel, 152, 199, 450
 Radial Filter, 214
Clear Layout button, 322, 325, 358, 359
client feedback, 454–455
clipping warning, 145, 149, 417, 436
Clone Spot Removal option, 250
cloud backups, 5, 442
Cloudy white balance, 136
collapsing stacks, 53
collection sets
 creating, 37, 38–39, 42, 444
 Lightroom mobile folders as, 411
 organizing collections inside, 33
collections, 32–33
 adding photos to, 42–43
 book, 316
 creating, 32, 37, 42
 deleting, 39
 exporting as catalogs, 102–104
 finding photos in, 63
 folders made into, 37
 naming/renaming, 42, 454
 organizing photos in, 33
 Picks made into, 45, 445
 print layouts and, 370
 Quick Collections, 95–96
 Selects made into, 47
 sets of, 33, 37, 38–39, 42, 444
 smart collections, 50–51
 sorting photos using, 32–33
 stacking images in, 52–53
 syncing with mobile device, 406, 409
 target collections, 97–98
 video clips in, 399
 See also albums
Collections panel
 Library module, 38–39, 447, 454
 Print module, 346, 370
color channel adjustments, 216
color fringes, 266–267
Color icon, 418
color labels, 41, 73

color management, 377–379, 380
Color Matching options, 380
color noise reduction, 234
color picker
 Background, 336, 341, 349
 Character, 330, 340
 Graphic, 337
Color Priority style, 197
color profiles, 377, 416
Color Range Masks, 181–182, 452
Color Range Selector tool, 181
color space settings, 296
color swatches, 215
color tints, 206, 215
colors
 adjusting individual, 194–195
 book background, 336, 337
 camera calibration for, 268–269
 desaturating, 200
 vibrance added to, 153
Colors panel, 123
Columns slider, 331
comments, 428, 429, 455
Comments panel, 429
Compact Cells view, 112, 115
Compare view, 49
comparing photos
 Compare view for, 49
 Survey view for, 48–49
completion sounds, 22
computers
 external hard drives for, 2
 recovering from crashed, 106
Constrain Crop checkbox, 244, 253
contact information, 91
contact sheets, 350–357, 375
Content-Aware Fill (Photoshop), 257
contiguous photo selections, 16
contrast adjustments
 Adjustment Brush tool, 228
 Basic panel, 148, 199, 233, 450
 Dehaze slider, 155
 Detail panel, 235
 Print Job panel, 383
control points, 207
Copy as DNG option, 17
Copy Settings dialog, 422
copying-and-pasting

images, 299
 settings, 422
copyright information, 91, 100
correcting problem photos. *See fixing problem photos*
corrupt catalogs, 105–106
courses, online, 459
cover image for stacks, 53
cover text for books, 339–341
Create a New Share feature, 427, 429
Create Album option, 415
Create Collection dialog, 42, 68, 98, 430, 444
Create Collection Set dialog, 38, 42
Create Droplet dialog, 310
Create New Action icon, 304
Create Print dialog, 370
Create Smart Collection dialog, 50
Create Snapshot command, 238
Create Virtual Copy command, 192
creative profiles, 190–191, 416
Crop and Rotate panel, 424
Crop Frame tool, 241
Crop Overlay tool, 239–241, 242, 243, 244, 254, 257
Crop tool, 424–425
cropping photos, 239–242
 aspect ratio for, 241
 and canceling crops, 241
 grid overlay for, 239, 240, 425
 lens distortion fixes and, 253, 254, 257
 Lightroom mobile options for, 424–425
 Lights Out mode for, 242
 locking in crops, 240, 241
 panorama cropping, 218
 post-crop vignettes and, 196, 197
 rotating and, 244
 Upright feature and, 253–254, 257
cross-processing effect, 215–216
curves control. *See Tone Curve panel*
custom book pages, 326–327
custom layouts
 for photo books, 342–343
 for printing images, 358–361
Custom Package layout style, 343, 358–361
Custom white balance, 136
customizing Lightroom, 109–125
Cylindrical panorama, 217

D

Darken slider, 251
darkening individual areas, 177–179
date information
 file naming with, 87–88
 organizing photos by, 8
 searching photos by, 71–72
 smart collections using, 50
Daylight white balance, 136
Defringe options, 267
Deghosting feature, 226–227
Dehaze slider
 Adjustment Brush, 156–157, 223
 Basic panel, 154–156
deleting
 Background layer, 82, 83, 283
 collections, 39
 control points, 207
 corrupt catalogs, 106
 Edit Pins, 167
 file naming tokens, 86
 gradients, 178
 keywords, 56
 metadata presets, 91
 pages, 368
 presets, 211
 print layout cells, 365
 rejected photos, 41, 44
 virtual copies, 193
 See also removing
Density slider, 170
desaturating colors, 200
Deselect command, 306
Destination panel, 18, 89
Destination screen, 411, 415
detail enhancements, 129, 152
Detail panel
 Noise Reduction sliders, 234–235
 preview zoom feature, 262–263
 sharpening images using, 205, 262–265
 toggling changes made in, 264
Detail slider, 234, 235, 263
Develop module, 25, 127–161
 Adjustment Brush, 164–176
 Auto Sync feature, 397
 Auto Tone feature, 128, 143
 Basic panel, 128–159
 Before and After views, 141

Develop module (continued)
black-and-white conversions, 202–205
Calibration panel, 268–269
Clarity adjustments, 152, 199
color channel adjustments, 216
contrast adjustments, 148, 199
Crop Overlay tool, 239–241, 242, 243, 244, 254, 257
Dehaze slider, 154–156
Detail panel, 234–235, 262–265
editing cheat sheet, 128–129
Effects panel, 197–198
exposure adjustments, 143–151
Graduated Filter tool, 177–179
high-contrast effect, 199–201
Highlights slider, 150
History panel, 237–238
HSL panel, 194–195
Lens Corrections panel, 196–197, 252, 259–260, 267
local adjustments, 164–187
Match Total Exposures option, 158
Noise Reduction feature, 234–235
order for editing in, 159
presets, 208–212, 421
Profile Browser, 132–134, 190–191
Radial Filter tool, 185–187
Red Eye Correction tool, 251
Reference view, 142
Reset button, 193, 210, 244
Shadows slider, 151, 232, 449
Split Toning panel, 206, 215
Spot Removal tool, 173–174, 245–250
Tone Curve panel, 207, 371
Vibrance adjustments, 153, 200
video clip workaround, 397–398
virtual copies, 192–193
White Balance controls, 135–138
workflow for using, 448–453
See also Quick Develop panel
digital cameras. *See cameras*
disaster recovery, 105–107
distortion, lens, 252–255
distraction removal, 451
DNG format
advantages/disadvantages of, 24
converting photos into, 24
exporting files in, 272
metadata info and, 24, 101
panoramas rendered in, 219
preference settings, 24
saving RAW files in, 286
dodging and burning, 164
downloading
Develop module presets, 212
export plug-ins, 289
images for this book, xii
Lightroom CC app, 408
presets for free, xv
Draft Mode Printing option, 375, 384
dragging-and-dropping
book layout photos, 319
folders in Folders panel, 3
importing photos by, 13
keywords, 56
pages in books, 320
print layout photos, 360
drop shadow, 282
droplets (Photoshop), 309–310
Dual Display feature, 117–120
duotone effect, 206, 398
duplicate photos, 14
duplicating
cells, 367
spotlights, 186
dust jacket for books, 335
dust spot removal, 248–250

E
edge vignetting
adding, 196–198, 200
fixing, 259–261
Edit in Adobe Photoshop option, 297
Edit Metadata Presets dialog, 91
Edit Original option, 303
Edit Photo with Adobe Photoshop dialog, 297, 303
Edit Pins
Adjustment Brush, 165, 167, 168, 169, 170, 176
Graduated Filter, 178
Lightroom mobile, 420
Radial Filter, 214
Edit Smart Collection dialog, 51
editing
cheat sheet for, 128–129
History feature for, 237–238
in Lightroom mobile, 407, 416–423
in Lightroom Web, 429
metadata presets, 91

offline images, 19
order for Basic panel, 159
photos in Photoshop, 297–302
and undoing edits, 237–238
workflow for, 448–453
Edits panel, 418
educational resources, 458–459
Effect pop-up menu, 175, 177
effects
 backscreened, 371
 beams-of-light, 220–223
 cross-processing, 215–216
 duotone, 206
 film-grain, 205
 filter-like, 190–191
 gradient, 177–179
 HDR, 224–227
 high-contrast, 199–201
 Lightroom mobile, 419
 matte look, 207
 panorama, 217–219
 skin softening, 175
 spotlight, 185–187
 sun flare, 213–214
 video, 398, 401
 vignette, 196–198
 wet street, 228–229
Effects panel, 197–198
emailing photos, 284–285
Embedded & Sidecar preview, 12
embedded metadata, 99–100
Enable Profile Corrections checkbox, 259
Erase brush, 167, 179
event photography, 9
EXIF metadata, 99–100, 363
Expanded Cells view, 112, 114
expanding stacks, 53
Export Actions, 277, 310
Export as Catalog dialog, 103
Export dialog, 272–279, 310, 311
Export Negative Files checkbox, 103
Export Slideshow to Video dialog, 402
Export with Preset option, 279
exporting, 271–293
 catalogs, 102–104
 emailing and, 284–285
 file format options for, 275
 images as JPEGs, 272–279

metadata with photos, 276
naming/renaming files for, 274, 278
photos from Lightroom, 272–279
plug-ins for, 289
presets for, 273, 277–279
publishing and, 288–293
quality settings for, 275
RAW photos, 286–287
sharpening images for, 276
sizing images for, 275
slide shows to video, 402
video clips, 274, 402–403
watermarking and, 276, 280–283
web gallery images, 279
exposure adjustments, 143–151
 Adjustment Brush and, 165, 166, 167, 168
 Auto Tone feature and, 128, 143
 Blacks slider and, 144–145, 147
 Contrast slider and, 148
 Exposure slider and, 146, 147
 Graduated Filter and, 177, 178, 180
 Highlights slider and, 150
 Histogram panel and, 149
 Match Total Exposures option, 158
 overview of sliders for, 128
 Radial Filter tool, 185, 186, 187
 recommended order for making, 159
 Shadows slider and, 151
 video clips and, 396
 Whites slider and, 144–145, 147
 workflow for, 448–450
Exposure Lock feature, 436
Exposure slider
 Adjustment Brush, 165, 166, 222
 Basic panel, 146, 147
 Graduated Filter, 177, 178, 180
 Radial Filter tool, 185, 186, 187
External Editor options, 296
external hard drives
 backing up photos to, 4
 catalog backup to, 74
 finding missing photos on, 3, 69
 importing photos on, 10
 off-site storage of, 4
 organizing photos on, 38–39
 storing photos on, 2
eye retouching, 175
Eyedropper tool, 341

F

Facebook
 posting video to, 402
 publishing images to, 288
face-tagging feature, 58–61
 confirming faces in, 61
 people keywords and, 61
 removing images from, 59
 stacks used in, 60
 tagging faces in, 59, 60
facial retouching, 173–176
favorites
 book layouts as, 334
 profiles saved as, 134
 selected by clients, 428, 431
 tagging photos as, 41
Feather slider, 169, 186, 198, 221, 246
feedback from clients, 454–455
file format options
 for editing in Photoshop, 296
 for exporting photos, 275
File Handling panel, 11
file naming templates, 86–89
File Renaming panel, 18, 86
Filename Template Editor, 86–89
Filler Text for books, 315
Filler Text guide, 338
film-grain effect, 205
Filmstrip
 customizing display of, 121
 exporting photos from, 272
 Lightroom mobile, 413, 422
 shortcut for hiding, 26
Filter bar, 63, 93
filter-like effects, 190–191
filters
 attribute, 64
 collection, 44
 keyword, 57
 Lightroom mobile, 415, 420
 metadata, 64
 Pick flag, 44, 64, 445
 text search, 63
finding
 catalog files, 106
 geographic locations, 66
 missing files/folders, 3, 69–70
 photos by searching, 63–64, 72

Fine Art Mat template, 346, 362
Fit in Window view, 27
Fit to Music button, 401
Fixed Layout option, 322
fixing problem photos, 231–269
 backlit subjects, 232–233
 camera calibration issues, 268–269
 chromatic aberrations, 266–267
 cropping images, 239–242
 edge vignetting, 259–261
 exposure problems, 128
 lens distortion problems, 252–258
 noise reduction, 234–236
 red eye removal, 251
 sharpening images, 262–265
 spot removal, 245–250
 straightening images, 243–244
 undoing edits, 237–238
flagging photos, 40, 43–44, 113, 414, 445
flash feature, 437
Flat Grid view, 411
flat-looking photos, 129, 148
flattening images, 302
Flickr website, 288–293
flipping images, 425
Flow slider, 169, 221
Fluorescent white balance, 136
fog reduction, 129
folders
 collections made from, 37
 exporting as catalogs, 102
 finding missing, 3, 69–70
 Lightroom mobile, 411
 organizing photos in, 6–9
Folders panel, 32
Foreground color setting, 301, 306
frame borders, 307, 387–389
frame captures, 395, 397
Fringe Color Selector tool, 267
Full Upright correction, 253
full-screen view, 29

G

geographic locations, 66
Geometry icon, 423
global adjustments, 164
Google Maps, 66
GPS metadata, 65–68

adding in Map module, 66
cell phone photos with, 67
creating collections based on, 68
metadata field displaying, 65
grabber hand cursor, 84, 240
gradients, 177–179
Graduated Filter tool, 177–179, 180
Color Range Mask adjustments, 181–182
sky darkening technique, 177–179, 452
grain effects, 205, 302
graphics
book background, 336
Identity Plate, 124–125, 387
watermark, 282–283
gray card, 139–140
Green channel adjustments, 216
Green Filter preset, 209
grid overlay
non-printing, 94
rule-of-thirds, 239, 240
Grid view, 28
Lightroom mobile, 410–411, 412
view options, 112–115
Guided Upright corrections, 256–258, 423
guides
non-printing, 94
photo book, 338
Guides panel
Book module, 338
Print module, 353

H

H.264 video format, 403
Haftel, Josh, 459
hair retouching, 176
halo prevention, 263
hard drives
importing photos on, 10
storage space required on, 2
See also external hard drives
hardcover books, 317, 335, 341
haze reduction
Adjustment Brush, 156–157
Basic panel, 129, 154–156
HD quality movies, 402
HDR images, 224–227
auto alignment of, 226
bracketed exposures for, 224

Deghosting feature for, 226–227
faster processing of, 224
Lightroom mobile feature for, 437
previewing, 224
selecting photos for, 224
tonal range in, 226, 227
HDR Merge Preview dialog, 224
Heal Spot Removal option, 250
Healing Brush tool (Photoshop), 245
hiding
crop overlays, 240
Filmstrip, 26
info overlay, 323
panels, 25–26, 92, 116
rule-of-thirds grid, 240
Tethered Capture window, 79
toolbar, 28, 93
High Dynamic Range images. *See HDR images*
high-contrast effect, 199–201
Highlight Priority style, 197
highlights
adjusting, 150, 199
clipping warning for, 145, 149, 417, 436
histogram showing, 149
Highlights slider, 150, 199
histogram, 135, 146, 149
Histogram panel, 149
History panel, 237–238
horizon line, 243
Horizontal slider, 254, 354
Horizontal Type tool (Photoshop), 308
HSL Color Mix button, 419
HSL panel
individual color adjustments, 194–195
Targeted Adjustment tool, 195
HSL/Color panel, 194, 202
Hue sliders
Calibration panel, 269
HSL panel, 194
Split Toning panel, 206, 215

I

ICC color profiles, 377–378
Identity Plate Editor, 122–125, 387, 400
Identity Plates, 122–125
borders saved as, 389
graphical, 124–125, 387
print layouts using, 356, 362

rotating, 389
 saving custom, 123
 slide shows using, 400
Image Cells checkbox, 364
image files for book, xii
image overlay feature, 82–85
Image Settings panel, 349, 350–351, 355, 357, 364
Import button, 10, 86
Import from Catalog dialog, 104
Import window, 10, 15, 20, 86
importing photos, 2–29
 backup strategies for, 4–5
 catalog synchronization, 104
 DNG format and, 24
 drag-and-drop for, 13
 file handling options for, 11–12, 17
 folder organization for, 6–9
 image overlay feature and, 82–85
 metadata options, 23, 90–91
 naming/renaming options, 18, 86–89
 organizing and, 42–47
 preference settings for, 21–23
 presets used for, 20
 rendering previews and, 11–12
 selection process for, 16
 shooting tethered and, 78–81
 smart preview creation and, 19
 storage location for, 18
 viewing imported photos, 27–28
 workflow process for, 443
importing video clips, 392
impromptu slide shows, 96
info overlays, 110–111, 323, 346
information resources, 458–459
Inner Glow layer style, 306
Inner Stroke checkbox, 365
Insta-Clarendon Look preset, 211, 212
Intro Screen checkbox, 400
Invert Mask checkbox, 187
IPTC metadata, 91, 100

J

JPEGs
 books saved as, 338
 camera profiles for, 130
 editing in Photoshop, 297
 exporting photos as, 272–279
 in-camera processing of, 130
 metadata embedded in, 100
 printing to, 343, 384–386
 saving images as, 272–279
 tethered shots as, 80
 video frames as, 395

K

KelbyOne.com website, xii, xv, 459
Keyword List panel, 56–57
Keywording panel, 54–55
keywords, 54–57
 advice on choosing, 55
 assigning to images, 54–57
 dragging-and-dropping, 56
 filtering, 57
 Painter tool, 57
 people, 61
 removing or deleting, 56
 sets of, 55
 sub-keywords and, 56–57
Kloskowski, Matt, 459
Kost, Julieanne, 342

L

labels, color, 41, 73
Landscape camera profile, 130
landscapes
 Highlights slider and, 150
 workflow for, 442–457
laptop computers, 17, 19
layer blend modes, 300, 306
layer masks, 301
layer styles, 306
Layers panel (Photoshop), 298, 299, 300, 306, 387
layers (Photoshop)
 blend modes for, 300
 creating new, 306, 307
 flattening in Photoshop, 302
 keeping intact in Lightroom, 303
 working with, 298, 299, 300
layout overlay feature, 82–85
Layout panel, 347–348, 353, 356–357
Layout Style panel, 346, 358, 364
layouts
 book, 318–325, 334–335, 342–343
 print, 346–370
Leading slider, 341

Lens Corrections panel
 chromatic aberration fixes, 267
 edge vignetting fixes, 259–260
 Manual sliders, 260
 profile corrections, 219, 252, 259
 vignette creation, 196–197
lenses
 chromatic aberrations from, 266–267
 correcting vignetting from, 259–261
 fixing distortion from, 252–258
 Lightroom mobile fixes for, 423
 profiles for, 219, 252, 259, 423
Level Upright correction, 244, 254
Library Filter, 63–64, 71
Library module, 25, 32–107
 collections, 32–33
 Compare view, 49
 date information in, 71–73
 exporting photos from, 272
 Filmstrip, 26, 121
 finding photos in, 3, 63–64
 Folders panel, 32
 Grid view, 28, 112–115
 keywords used in, 54–57
 locating missing photos in, 69–70
 Loupe view, 27–28, 110–111, 118–119
 metadata options, 99–101
 Publish Services panel, 288, 290, 291, 292–293
 Quick Collections, 95–96
 Quick Develop panel, 160–161, 396, 398
 renaming photos in, 62
 smart collections, 50–51
 sorting photos in, 32–33, 43–49
 stacking photos in, 52–53
 Survey view, 48–49
 viewing photos in, 27–28
Library View Options dialog
 Grid view options, 112–115
 Loupe View options, 110–111, 403
Light icon, 417
Lightroom
 Classic vs. CC versions of, xii, 439
 customizing, 109–125
 dual-monitor setup, 117–120
 information resources, 458–459
 interface tips, 25–26
 mobile version of, 405–439
 Photoshop integration, 296–311
 troubleshooting, 105–107

Lightroom CC desktop, 438–439
Lightroom mobile, 405–439
 albums in, 409, 410–413
 Before/After views, 420
 camera feature, 406, 434–437
 clipping warning, 417, 436
 copying-and-pasting settings in, 422
 cropping images in, 424–425
 desktop version of, 438–439
 Develop module presets, 421
 editing photos in, 407, 416–423
 flagging and rating images in, 414–415
 four cool things about, 406–407
 Grid view in, 410–411, 412
 metadata viewed in, 413
 Present mode, 432
 resetting in, 419
 rotating images in, 425
 saving to Camera Roll from, 433
 search feature in, 432–433
 setting up, 408
 sharing albums from, 426–429
 shooting tethered to, 430–431
 syncing collections to, 406, 409
 thumbnail options in, 410, 411, 412
 zooming with, 410, 413
Lightroom Publishing Manager dialog, 288, 289
Lightroom Web, 426, 429
LightroomKillerTips.com website, 458
Lights Dim mode, 92
Lights Out mode, 92–93
 Crop Overlay tool and, 242
 tethered shooting in, 81
Link All checkbox, 327
links, photo, 70
live shoots
 sharing to Lightroom mobile, 430–431
 See also tethered shooting
local adjustments, 164–187
 gradient filter effects, 177–179
 how to make, 164–169
 noise reduction, 172
 portrait retouching, 173–176
 range masking, 180–184
 spotlight effects, 185–187
 tips for making, 170
 white balance fix, 171
 See also Adjustment Brush
Locate photo dialog, 70

Lock icon, 239, 257, 425, 436
Lock to Photo Aspect Ratio checkbox, 359
logos
 Identity Plate, 124–125
 watermark, 282–283
Loupe Overlay options, 83
Loupe view, 27–28
 dual display setup, 118–119
 Lightroom mobile, 413
 Spacebar for displaying, 27
 videos watched in, 392
 view options, 110–111
lrcat file, 36, 75, 104
lrdata file, 36
luminance noise, 234, 235
Luminance Range Masks, 183–184
Luminance sliders
 Detail panel, 235
 HSL panel, 195

M

Magic Wand tool (Photoshop), 257
magnifying glass cursor, 28
Managed by Printer option, 377
Map module, 65–68
 creating collections in, 68
 finding locations in, 66
 GPS-embedded images and, 65, 66–67, 68
 pin markers used in, 65, 66
 Saved Locations panel, 67
 view options in, 68
Map Style pop-up menu, 68
margins, print, 355
Margins sliders, 355, 388
mask overlay, 165
Masking slider, 264–265
Match Long Edges option, 334
Match Total Exposures option, 158
Matte control, 85
matte look, 207
McNally, Joe, 78
Media Type pop-up menu, 376, 381, 456
memory cards, 13–18, 443
menu bar, 93
metadata
 caption, 100
 copyright, 100
 DNG file, 24, 101

embedded, 99–100
exporting with images, 276
GPS data, 65–68
preferences, 23
presets, 90–91
printing photos with, 362
RAW file, 23, 24, 101, 286, 287
saving to a file, 23, 113
searching photos by, 64
seeing in Lightroom mobile, 413
templates, 90–91
XMP sidecar files, 23, 101
Metadata panel, 99–100
Midpoint slider, 196, 200, 260
midtone adjustments, 152
Minimal preview, 11
missing files/folders, 3, 69–70
mobile app. *See Lightroom mobile*
Modify Page pop-up menu, 327, 334, 343
modules
 navigating between, 25
 See also specific modules
monitors
 calibration of, 377, 382
 Dual Display feature, 117–120
Move tool (Photoshop), 305
movies. *See video clips*
MP3 file format, 401
Multi-Page View mode, 335
multi-photo print layouts, 350–358, 364–368
music for slide shows, 401
Music panel, 401

N

nameplate creation, 308
naming/renaming
 collections, 42, 454
 exported photos, 274, 278
 imported photos, 18, 86
 photos in Lightroom, 62
 Photoshop actions, 304
 presets, 208
 system for, 87–88
 template for, 86–89
Navigator panel
 history states in, 237
 previewing presets in, 208, 211
 viewing photos in, 27–28

white balance adjustments and, 138
neutral density gradient filter, 177, 452
New Action dialog (Photoshop), 304
New Develop Preset dialog, 211
New Metadata Preset dialog, 90–91
New Preset dialog, 324
New Snapshot dialog, 238
New Template dialog, 369
Nikon cameras, 80
noise in images, 172, 232, 234–236
Noise Reduction sliders, 234–236
Noise slider, Adjustment Brush, 172, 232, 236
non-destructive edits, 393, 436
non-printing guides, 94
Normal blend mode, 306
numbering
 book pages, 332–333
 photos, 88

O

Offset slider, 328, 329
one-click presets, 208–212
online galleries. *See web galleries*
online training classes, 459
Opacity settings
 background image, 336
 grid overlay, 94
 overlay image, 85
 Photoshop layer, 308
 watermark, 281, 282
Optics icon, 423
Organize pop-up menu, 18
organizing photos
 collections for, 32–33, 37
 date feature for, 71–72
 folders for, 6–9
 importing and, 42–47
 keywords for, 54–57
 located on hard drive, 38–39
 metadata info for, 99–101
 Quick Collections for, 95–96
 renaming process for, 62, 86–89
 shooting tethered and, 79
 smart collections for, 50–51
 stacks used for, 52–53
 workflow for, 444–447
 See also sorting photos

output sharpening, 276, 385
ovals for vignettes, 185
overexposed shots, 224
Overlay blend mode, 300
overlays
 book info, 323
 image layout, 82–85
 Lightroom mobile cropping, 425
 non-printing grid/guide, 94
 text/info, 110–111, 346
Override Color checkbox, 400

P

Padding sliders, 327
Page Bleed guide, 338
Page Grid sliders, 353, 354
page numbering, 332–333
Page panel
 Book module, 332
 Print module, 352, 357, 362–363
Page Setup dialog, 342, 346
Page Text checkbox, 340
Paint Overlay style, 197
Painter tool, 57
painting with light, 164
Pan and Zoom checkbox, 401
panels
 hiding, 25–26, 92, 116
 Solo mode, 116
 See also specific panels
Panels pop-up menu, 416
Panorama Merge Preview dialog, 217
panoramas, 217–219
 Boundary Warp option, 218
 cropping, 218
 fake, in print layout, 356
 lens profiles for, 219
 merging images into, 219
 previewing, 217, 218
 projection methods, 217
 successfully shooting, 217
paper selection options, 381
Paper Size pop-up menu, 342
paper/printer profiles, 377–378
Paste Settings command, 422
patterns, background, 337
PDF books, 338

People view, 58–61
 confirming faces in, 61
 people keywords and, 61
 removing faces from, 59
 stacks used in, 60
 tagging faces in, 59, 60
Perceptual rendering intent, 379
Perspective panorama, 217
photo books. *See books*
Photo Cells guide, 338
Photo Info checkbox, 352, 362
Photo Merge
 HDR option, 224
 Panorama option, 217
Photo Text checkbox, 328, 339
Photoshop
 actions, 304–311
 blending images in, 298–302
 book about using, 458
 droplet creation/use, 309–310
 editing photos in, 297–302
 exporting photos to, 277
 frame border preparation, 387
 jumping to/from, 297–302
 layered files from, 303
 layout overlay preparation, 82–83
 preparing files for, 296
 saving edits in, 302
Photoshop for Lightroom Users (Kelby), 458
Photoshop Lightroom. *See Lightroom*
Picks
 Auto Advance for, 40
 collections made from, 45, 445
 filtering, 44, 64, 445
 flagging photos as, 40, 43–44, 113, 414, 445
 removing flags from, 45
 selecting in Lightroom mobile, 414–415, 431
 star ratings for, 45–47
 viewing only, 415
Picture Package feature, 364–368
Play button, 392, 402
Playback panel, 401
playing video clips, 392
Plug-in Manager, 107
plug-ins
 downloading, 289
 troubleshooting, 107
PNG file format, 82, 283

Point Curve icon, 371
Portrait camera profile, 130
portraits
 retouching, 173–176
 sharpening, 264–265
post-crop vignetting, 196, 197
poster frames, 394
posters, multi-image, 357
Post-Processing options, 277
Preferences dialog, 21–22
Present mode, 432
presets
 adjusting, 209
 applying, 209, 212
 book, 322–324, 331
 built-in, 208–210
 creating your own, 210–211
 deleting, 211
 Develop module, 208–212, 421
 downloading/importing, 212
 email, 285
 export, 273, 277–279
 file naming, 86–89
 free downloadable, xv
 import, 20
 Lightroom mobile, 421
 metadata, 90–91, 100
 one-click, 208–212
 previewing, 208, 211
 Quick Develop, 398
 renaming, 208
 saving, 89, 211, 324
 search, 72
 stacking, 421
 updating, 211
 video clip, 398
 watermark, 283
 white balance, 135–136
Presets icon, 421
Presets panel, 208, 211
previews
 1:1 (one-to-one), 12
 B&W conversion, 204
 HDR image, 224
 panorama, 217, 218
 preferences for, 22
 preset, 208, 211
 render options for, 11–12

second monitor, 120
slide show, 402
smart, 17, 19
thumbnail, 11–12, 16
video clip, 392, 402
Previous Import option, 44
Print Adjustment sliders, 383, 457
Print dialog, 379–381, 457
Print Job panel, 374–379, 382–386
Print Adjustment option, 382–383
Print To option, 343, 374, 384, 456
Print module, 346–389
book layouts, 342–343
Cells panel, 358, 360, 365–366, 368
Collections panel, 346, 370
Custom Package feature, 343
Guides panel, 353
Image Settings panel, 349, 350–351, 355, 357, 364
keyboard shortcut to, 348
Layout panel, 347–348, 353, 356–357
Layout Style panel, 346, 358, 364
Page panel, 352, 357, 362–363
Page Setup dialog, 342, 346
Print Job panel, 343, 374–379, 382–386
Rulers, Grid & Guides panel, 359
Template Browser, 346, 350, 364, 369, 456
Print Resolution checkbox, 375
Print to File button, 386
printer/paper profiles, 377–378
printing, 345–389
16-bit, 376
backgrounds for, 349
backscreened effect, 371–373
books, 338
collections for, 370
color profiles for, 377–378
contact sheets, 350–358
custom layouts for, 358–361, 369
draft mode option for, 375
frame borders for, 387–389
Identity Plates for, 356, 362
individual photos, 346–349
to JPEG files, 343, 384–386
multiple photos per page, 350–358, 364–368
page orientation for, 361
Print Adjustment sliders for, 383
quality settings for, 381, 385
resolution settings for, 375, 384, 456

saving layouts for, 369, 384–386
setting options for, 374–383
sharpening photos for, 276, 376, 385, 456
templates for, 346, 350, 352, 369
text added for, 362–363, 373
workflow for, 456–457
problem photos. See fixing problem photos
Process Version checkbox, 250
Profile Browser
B&W profiles, 204–205, 206
creative profiles, 190–191
Lightroom mobile, 416
RAW profiles, 132–134
Profile pop-up menu, 134, 378
profiles
B&W, 204–205
camera, 130, 131–134
creative, 190–191, 416
lens, 219, 252, 259, 423
printer/paper, 377–378
RAW image, 128, 131–134
saving as Favorite, 134
ProPhoto RGB color space, 296
PSD files, 100, 272, 296
Publish Services panel, 288, 290, 291, 292–293
publishing photos, 288–293
Pupil Size slider, 251
Purchase Book dialog, 321

Q
Quality settings
exported photo, 275
print, 381, 385
video clip, 403
Quality slider, 275
Quick Collections, 95–96, 113
Quick Develop panel, 160–161
presets saved to, 212, 398
situations for using, 160–161
video clip options, 396
See also Develop module
Quick Selection tool (Photoshop), 298

R
Radial Filter tool
spotlight effects, 185–187
sun flare effect, 213–214

Radius slider, 263
Ramelli, Serge, 459
Range Mask adjustments, 181–184
 Color Range Mask, 181–182, 452
 Luminance Range Mask, 183–184
Range slider, 183
Rate & Review panel, 414
Rating Footer, 115
rating photos
 in Lightroom Classic, 40, 41, 45–47, 64, 115, 446
 in Lightroom mobile, 414–415
 See also Picks; Rejects
RAW photos
 camera profiles for, 128, 131, 132–134
 contrast adjustments for, 148
 converting to DNG format, 24
 default sharpening for, 262
 editing in Photoshop, 297
 exporting, 286–287
 HDR images rendered as, 225
 in-camera handling of, 131
 JPEG previews of, 131
 metadata for, 23, 24, 101, 286, 287
 panoramas rendered as, 217
 saving to Camera Roll, 433
 tethered shots as, 80
recording actions, 304–309
Red channel adjustments, 216
Red Eye Correction tool, 251
Reference view, 142
Rejects
 deleting, 41, 44
 flagging, 40, 43, 414
 Lightroom mobile, 414–415
Relative rendering intent, 379
relinking photos, 70
removing
 background images, 337
 book photos, 319, 343
 chromatic aberrations, 267
 faces from People view, 59
 facial blemishes, 173
 flags from Picks, 45
 images from Survey view, 48
 keywords from photos, 56
 ovals for spotlight effect, 186
 photos from Quick Collections, 96
 red eye from photos, 251

spots from photos, 245–250
wrinkles from faces, 174
 See also deleting
Rename Files checkbox, 18, 86
Rename Photos dialog, 62
renaming. *See naming/renaming*
rendering intent options, 379
Repair Catalog button, 75, 105
Reset button, 193, 210, 244
Reset Preferences option, 107
resetting
 Adjustment Brush sliders, 164, 171
 Quick Develop settings, 396
 virtual copies, 193
Resize to Fit checkbox, 275
resizing. *See sizing/resizing*
resolution settings, 296, 319, 375, 384, 456
resources
 educational, 458–459
 See also web resources
restoring catalogs, 75, 105–106
retouching photos
 Adjustment Brush for, 175–176
 landscape workflow for, 448–453
 Spot Removal tool for, 173–174
 See also fixing problem photos
Rotate Cell button, 359
Rotate slider, 244
Rotate to Fit checkbox, 349, 351, 355, 359
rotating
 Identity Plates, 389
 images, 244, 349, 351, 425
 print layout cells, 359
 spotlights, 186
 watermarks, 281
Rough Beauty Script font, 373
Roundness setting, 198
rule-of-thirds grid, 239, 240, 425
rulers, displaying, 306
Rulers, Grid & Guides panel, 359

S

sampling image areas, 246
Saturation sliders
 Basic panel, 129, 153
 Calibration panel, 269
 HSL panel, 194–195
 Split Toning panel, 206, 215

Save As dialog, 82
Saved Locations panel, 67
Saved Preset pop-up menu, 212
saving
 books as PDFs or JPEGs, 338
 custom book pages, 327
 Identity Plates, 123
 layered files, 303
 metadata to a file, 23, 113
 photos as JPEGs, 272–279
 Photoshop edits, 302
 presets, 89, 211, 324
 print layouts, 369, 384–386
 profiles as Favorites, 134
 Quick Collections, 96
 templates, 89
 See also exporting
Scale slider, 255, 388, 400
scrubby slider, 386
search presets, 72
searching for photos
 in Lightroom Classic, 63–64, 72
 in Lightroom mobile, 432–433
Second Window button, 117, 118, 119
Secondary Window pop-up menu, 118, 119
Segment Photos By Shots feature, 78–79, 81
Segmented Grid view, 411
Select images, 45–47, 49, 446–447
Selective Edits icon, 420
seminars on Lightroom, 459
Send Book to Blurb button, 321
Set as Target Collection checkbox, 98, 430
Set Default Settings option, 269
sets
 collection, 33, 37, 38–39, 42
 keyword, 55
Shade white balance, 136
shadows
 adjusting, 199
 drop shadow, 282
 duotone effect, 206
 noise in, 172, 232
 opening up detail in, 151, 226, 449
Shadows slider, 151, 199, 232, 449
Share Options dialog, 455
sharing
 albums on the web, 426–429, 455
 from Lightroom mobile, 426–431

live shoots, 430–431
 workflow for, 454–455
sharpening images, 262–265
 B&W conversions and, 205
 editing workflow and, 453
 exporting and, 276
 output sharpening, 276
 portrait sharpening, 264–265
 preview window for, 262–263
 print settings for, 276, 376, 385, 456
 sliders for, 263–264, 265
 smart previews and, 265
 zooming in for, 263
Sharpness slider, 173, 175
Shift-Tab shortcut, 26, 29, 92
shooting tethered. See tethered shooting
Shot Name dialog, 81
Show Deghost Overlay checkbox, 227
Show Edit Pins pop-up menu, 170, 176
Show Fewer Options button, 20
Show Guides checkbox, 360
Show Image Info Tooltips checkbox, 112
Show Info Overlay checkbox, 110, 111, 346
Show Loupe checkbox, 137
Show More Options button, 20
Show Second Monitor Preview option, 120
Single Image/Contact Sheet layout, 346
sizing/resizing
 brushes, 165, 169
 exported photos, 275
 frame borders, 388
 print layouts, 386
 thumbnails, 16, 27
 watermarks, 281
skin softening effect, 175
sky darkening technique, 177–179, 452
slide shows
 exporting, 402
 impromptu, 96
 Lightroom mobile, 428
 movies made from, 399–403
 music added to, 401
 pan and zoom effect, 401
 previewing, 402
 titles for, 400
sliders
 resetting, 171
 See also specific sliders

Slideshow module, 399–403
 bonus chapter on, xiv, 399
 Music panel, 401
 Playback panel, 401
 Template Browser panel, 399
 Titles panel, 400
slimming effect, 176
smart collections, 50–51
smart previews, 17, 19
 exporting with catalogs, 103
 filenames indicating, 36
 sharpening applied to, 265
 synced with Lightroom mobile, 406
Smoothness slider, 183, 234
snapshots, 238
Snapshots panel, 238
soft spotlight effect, 185, 196
Soften Skin effect, 175
Solo mode, 116
sorting book pages, 335
sorting photos
 collections for, 32–33
 color labels for, 41
 comparing and, 48–49
 flags used for, 43–44, 113, 414
 in Lightroom mobile, 411, 433
 star ratings for, 40, 41, 45–47
 workflow for, 444–447
 See also organizing photos
sound settings, 22
Spacebar
 Loupe view display, 27
 video control, 392, 393, 394
special effects. *See effects*
Spherical panorama, 217
spine of books, 341
Split Toning panel, 206, 210, 215, 398
split-screen view, 141
Spot Removal tool, 245–250
 brush size for, 249
 portrait retouching with, 173–174
 removing distractions with, 451
 spots in photos removed with, 245–247, 249
 synchronizing settings for, 250
 Visualize Spots feature, 248–249
spotlight effect, 185–187
sRGB color space, 275, 386

Stack with Original checkbox, 296
stacks, 52–53
 Auto-Stack feature, 53
 cover image for, 53
 expanding/collapsing, 53
 grouping photos into, 52
 People view, 60
Standard preview, 12
star ratings
 in Lightroom Classic, 40, 41, 45–47, 64, 115, 446
 in Lightroom mobile, 414–415
 See also Picks; Rejects
stock photo agencies, 387
straightening photos, 243–244
Stroke Border checkbox, 349
Stroke dialog (Photoshop), 307
Style pop-up menu, 197
sub-keywords, 56–57
sun flare effect, 213–214
Survey view, 48–49, 118, 193
Swap button, 49
Sylvan, Rob, 458
Sync with Lightroom CC checkbox, 430
Synchronize Settings dialog, 250
synchronizing
 automatic, 397
 catalogs, 102–104
 collections, 406, 409, 454
 Lightroom mobile, 406, 409
 slide shows to music, 401
 spot removal, 250

T

tagging photos, 54–57
target collections, 97–98
Targeted Adjustment tool (TAT)
 HSL panel, 195
 Lightroom mobile, 419
 Type panel, 331
taskbar, 25, 26
Teixeira, Pedro, 373
Temp slider
 Adjustment Brush, 171, 223
 Basic panel, 136
 Graduated Filter, 180
Template Browser

Print module, 346, 350, 364, 369, 456
Slideshow module, 399
templates
 book layout, 318, 334–335
 file naming, 86–89
 metadata, 90–91
 print, 346, 350, 352, 369, 456
 saving, 89
 slide show, 399
Tethered Capture Settings dialog, 78, 139
Tethered Capture window, 79–80, 140
tethered shooting, 78–81
 advantages of, 78, 80
 camera functions and, 80
 equipment setup for, 78
 layout overlay feature, 82–85
 Lightroom mobile and, 430–431
 shortcut for triggering, 81
 white balance settings and, 139–140
text
 book, 328–331, 339–341
 formatting, 330, 331, 340
 Photoshop, 308
 print layout, 362–363, 373
 searching by, 63
 shared photo, 429
 slide show, 400
 watermark, 280–282
Text panel, Book module, 328–329, 331, 339
Text Safe Area guide, 338
Text Template Editor, 363
thumbnails
 badges in, 113
 Lightroom mobile, 410, 411, 412
 preview, 11–12
 Profile Browser, 134
 reordering, 411
 resizing, 16, 27
 video clip, 394
Thumbnails slider, 16, 27
TIFF files, 100, 272, 296, 297
Tint slider
 Basic panel, 136
 Calibration panel, 268
title bar, 93
Titles panel, 400

tokens, file naming, 86, 87, 88
tone adjustments, 128, 449
Tone Curve panel
 backscreened effect, 371
 color channel adjustments, 216
 matte look, 207
Tool Overlay pop-up menu, 240
toolbar, 28, 29, 93
tooltips, 112
topic folders, 6–7
Tracking slider, 341
Transform panel
 Aspect slider, 176, 254
 Horizontal slider, 254
 Rotate slider, 244
 Scale slider, 255
 Upright feature, 244, 253–258
 Vertical slider, 254
Transform Selection option (Photoshop), 306
Trash icon, 82, 283
trimming video clips, 393
tripod tether setup, 78
troubleshooting, 105–107
Tungsten white balance, 136
two-page spreads, 320
type. See text
Type panel, 329–330, 331, 333, 340

U

Uncheck All button, 16
underexposed shots, 224
undoing edits, 143, 190, 237–238, 418
unflagging photos, 40, 43, 45
Unlock icon, 425
Unstack option, 53
updating user presets, 211
Upright feature, 253–255
 Auto button, 253
 cropping options and, 253–254
 Full button, 253
 Guided button, 256–258
 Level button, 244, 254
 Lightroom mobile, 423
 Vertical button, 254
USB cable, 78

V

Vertical slider, 254, 353
Vertical Upright correction, 254
Vibrance slider, 129, 153, 200
video clips, 392–403
 collections for, 399
 editing in Develop module, 397–398
 effects applied to, 398, 401
 exporting, 274, 402–403
 frame capture from, 395, 397
 icon indicating, 392
 importing, 392
 music for, 401
 playing, 392
 posting to Facebook, 402
 preferences for, 403
 presets saved for, 398
 previewing, 392, 402
 quality setting for, 403
 Quick Develop options, 396, 398
 slide shows as, 399–403
 thumbnails for, 394
 titles for, 400
 trimming, 393
Video Preset pop-up menu, 402
video tutorials, xv, 387
viewing photos, 27–29
 Compare view, 49
 full-screen view, 29
 Grid view, 28, 112–115
 Lights Dim mode, 92
 Lights Out mode, 92–93
 Loupe view, 27–28, 110–111, 118–119
 People view, 58–61
 Survey view, 48–49
vignettes
 adding to photos, 196–198, 200
 fixing, 259–261
 off-center, 185
 post-crop, 196, 197
Vignetting Amount slider, 196, 197, 200
Vignetting slider, 260
virtual copies, 192–193
 deleting, 193
 print layout using, 357
 resetting, 193

Visualize Spots feature, 248–249
Vivid camera profile, 130

W

washed-out look, 233
Watermark Editor, 280–283
watermarks, 280–283
 exported image, 276
 graphic, 282–283
 saving as preset, 283
 text, 280–282
WB pop-up menu, 135
web galleries
 exporting JPEGs for, 279
 getting client feedback using, 454–455
 sharing albums on, 426–429
Web module, bonus chapter on, xiv
web resources
 bonus chapters, xiv
 image files for book, xii
 options for further learning, 458–459
 video tutorials, xv
wedding photography, 9
wet street effect, 228–229
white balance
 adjustment options, 135–138
 gray card for setting, 139–140
 Lightroom mobile options, 418
 local adjustments, 167
 presets, 135–136
 sliders for adjusting, 129
 tethered shooting and, 139–140
White Balance Selector tool, 137–138, 140, 418
white point, 144, 449
White, Terry, 206, 459
Whites slider, 144–145
workflow process, 441–457
 backing up photos, 442
 editing selected photos, 448–453
 getting client feedback, 454–455
 importing photos, 443
 printing photos, 456–457
 shooting photos, 442
 sorting photos, 444–447
wrinkle removal, 174

X

XMP sidecar files, 23, 24, 101, 286, 287

Z

Zoom Photo to Fill Cell option, 323
Zoom slider, 319
Zoom to Fill Frame checkbox, 399
Zoom to Fill option
 Book module, 314, 323
 Print module, 347, 350, 352, 355
Zoom to Fit option, 314, 323
zooming in/out
 of mobile app, 410
 of pages, 368
 of photos, 27

ACCESS TO
8,000+ LESSONS
700+ COURSES
200+ TUTORIALS
300+ WEBCASTS
& MORE

Master Lightroom
Photoshop & Photography

With OnlineTraining Taught by 120+ of the World's Best Instructors

Scott Kelby

Lindsay Adler

Joe McNally

kelbyone

DEVELOP MODULE WHITE BALANCE CARD

From Scott Kelby's *The Adobe® Photoshop® Lightroom Classic CC Book for Digital Photographers*